DENNIS KELLY
PLAYS TWO

Dennis Kelly

PLAYS TWO

TAKING CARE OF BABY
ORPHANS
DNA
THE GODS WEEP
OUR TEACHER'S A TROLL

INTRODUCTION BY ALEKS SIERZ

OBERON BOOKS
LONDON

WWW.OBERONBOOKS.COM

First published in this collection in 2013 by Oberon Books Ltd
521 Caledonian Road, London N7 9RH
Tel: +44 (0) 20 7607 3637 / Fax: +44 (0) 20 7607 3629
e-mail: info@oberonbooks.com
www.oberonbooks.com

A catalogue record for this book is available from the British
Library.

PB ISBN: 978-1-78319-012-6
E ISBN: 978-1-78319-511-4

Printed, bound and converted
by CPI Group (UK) Ltd, Croydon, CR0 4YY.

Contents

Introduction

The noughties was an explosive decade for new writing in British theatre. Over the first ten years of the new millennium something like three thousand new plays were staged in the UK. Everywhere you looked, there was a huge variety of new work by a huge variety of new writers, young, old and all ages in-between. In order to make sense of this festival of talent critics naturally characterise new playwrights on the basis of their first couple of outings: she's the one who writes about ill-matched couples, he's the one who writes about quirky brothers, she is obsessed with storytelling and he is addicted to explicit sex scenes, she loves references to nature, he tells stories of imaginary historical encounters, she's a Beckett for today, he's a Churchill. If the playwright in question dares to write a new play outside of their characterisation they risk incomprehension (at best) and hostility (at worst). Well, Dennis Kelly, who kick-started his career during this decade, has successfully managed to wrongfoot critical expectations by constantly changing the form and content of his plays, while remaining true to his own distinctive individual voice.

The first play in this collection, *Taking Care of Baby*, is an astonishing genre-bending exercise that gobsmackingly defies categorisation. The blurb on the back cover of the original playscript summarises the story: '*Taking Care of Baby* tackles the complex case of Donna McAuliffe, a young mother convicted of the murder of her two infant children. In a series of probing interviews, the people in this extraordinary story, including Donna herself and her bewildered mother Lynn, reveal how they may have harmed those they sought to protect.' Other interviewees include Martin McAuliffe, Donna's estranged husband, Dr Millard, a psychologist, Mrs Millard, his wife, political activists and politicians such as Jim and Brian, a reporter, plus assorted nameless members of the public. But the playtext's claim to be a piece of verbatim theatre, a documentary in which 'everything is in the subjects' own words' (p. 5), is – and anyone who doesn't want to read a spoiler should turn the page right

now – untrue. Despite the fact that this looks like an example of verbatim theatre, a highly popular form of playwriting that uses edited versions of real words spoken by real people (and which was extremely common in British theatre during the noughties), it is not – everything about the play is a work of complete fiction. Although the work is convincing in its intense focus on detail, and its layout – with stage directions printed in bold – mimics that of other examples of verbatim drama, a simple google search for the notorious case of Donna McAuliffe will soon convince you that this story is an imaginative fabrication.

What's so gripping about the play is the immediate force of Kelly's imagination. For a story that is partly a satire on verbatim theatre and partly a serious enquiry into the nature of truth, and justice, the writing is audacious in its precision and its psychological reality. Two early examples are instantly striking: in prison, Donna fears attacks from other inmates and finds relief by dreaming that her crimes were themselves actually just a dream (p. 8). This is followed by her mother Lynn watching two chavs, a mother and daughter, on a train and immediately thinking that their relationship is inappropriate. Then it hits her: 'Suddenly it dawned on me that they loved each other' (p. 9). The story has been so powerfully imagined that the drama amply repays re-reading: even when you know that it is something of a hoax it still feels unsettling – a feeling symbolised by the declaration at the start of each section that 'The following has been taken word for word from interviews and correspondence', a piece of writing that is repeated but which gradually collapses into gobbledegook. Similarly disquieting is the sense that we are eavesdropping on real people. It is also a very rich text, typified by the details about the Leeman-Keatley Syndrome, and the suggestion that psychological explanations of horror are themselves fictional constructs. By contrast, the mutual suspicion and emotional tangles of Donna and Lynn root the work in mundane domesticity.

In Kelly's hands, the play – which was staged at the Birmingham Rep and the Hampstead Theatre in Anthony Clark's compelling production in 2007 – is much more than the story of a mother who is arrested for killing her kids. It is also

the tale of the quest for truth which, as it crosses society, reveals the tensions between amateurs and professionals: the conflict between the professional psychologist and the judge, an amateur when it comes to science; between journalists and members of the public; and finally the mother who starts off as an amateur and becomes a professional politician. In this network of social tensions, it is clear that when it comes to parenting, to taking care of baby, we are all amateurs.

Orphans, which was staged in Roxana Silbert's tense production for Paines Plough in 2009, is the play in this collection that is most similar to those in *Plays One* in that Kelly's early plays – *Debris*, *Osama the Hero*, *After the End* and *Love and Money* – feature characters who have a desperate need to believe that there is more to life than the brutal reality they find themselves in. The situation of *Orphans*, which has three main characters, is simple: Danny and Helen, a young married couple who have one child and are expecting another, are enjoying a quiet dinner when Liam, Helen's brother, arrives unexpectedly. The stage direction describes his appearance: '*He has blood all down his front*' (p. 97). From this vivid image, Kelly writes a series of explanations which Liam gives for what has happened to him until finally the horrendous truth, the brutal reality, engulfs them all.

The title refers to Helen and Liam, whose parents died when they were small, and the intensity and tension of the drama is based on the deep knowledge that all of the characters have about each other – and the twists arise from the fact that this knowledge might not be one hundred percent right. The energy and pace of the narrative, as the three characters decide what to do about the first story that Liam tells, is instantly apparent, as is Liam's distinctive habit of drifting off the point. A typical line is 'Jesus, I'm just jabbering shit, sorry, sorry' (p. 133). Is this a result of shock? Or due to his bad faith? Or his inability to articulate his true feelings? Perhaps all three. At one point, Liam even tells a story about stories 'that never go anywhere' (p. 120). Very ironic.

In each of the play's four sections, Kelly writes his characters into a corner that seems to trap them and then, with an enormous effort of will, writes escape routes for them. This tendency is typical of his writing and always creates a tense edginess. My

favourite stage direction is when Helen responds to Danny's wish that she keeps the new baby: *'Pause. They are looking at her. Cornered'* (p. 149). During the play, all three find themselves, in different ways, at one point or another, cornered. Each moment of decision is also a moment when an ethical question is asked: how should we behave? What is the right thing to do? As with *Taking Care of Baby*, this is a play about how the stories we tell can obscure as well as illuminate the truth, which in the end is more dreadful that we could have imagined. Liam's narratives of what happened to him are constantly revised and changed, and this gradually strips away the veneer of whatever charm that he has. But, and this is what makes the drama so taut, all of the characters suffer the same fate. In the end, both Helen and Danny are changed, and in ways that they couldn't have expected – and probably don't want.

DNA, which Kelly wrote for the National Theatre's Connections youth theatre festival in 2007-08, is – next to *Matilda the Musical* – his most successful. It has become a GCSE core set-text and is now studied by some 400,000 students every year. The story is that of a perfect crime. A group of ordinary school kids bully Adam, one of their number, and this leads to his death. They panic until the laconic Phil, who has a real talent for organisation, suggests a plan to shift the blame. Based on our awareness of how forensic science has improved, it involves a fiendishly clever use of DNA. Kelly recounts the events of this thriller in a fascinatingly oblique and indirect way. The result is an account of peer pressure, a longing for connection, and the corrosive effects of guilt. It is also a story about story-telling. The writing is impressively tight and constantly surprising, with the themes of death, sex, and the relationship between the individual and the group emerging from the distinctive characters of the kids. One theme concerns the young person's experience of what commentators call the culture of fear, which has become so much more intense since 9/11. For example, the chatterbox Leah has a short speech about being 'scared' and about 'the fear' of 'the brutal terror' (p. 197), and this is echoed by Mark's memory of Adam's 'fear' (p. 207). But, as well as these themes, Kelly's writing also ranges across a variety of subjects, which illuminate the main

concerns in an oblique way: Leah's account of the empathy felt by bonobos (p. 210-11) or her idea of the strains of appearing to be happy (p. 214). If Kelly's dialogue – especially when Leah is talking – sometimes drifts off into delightful inconsequence, his storytelling is compelling and the Part Three plot twist completely unexpected. As the kids struggle to cope with each new challenge that the adult world throws them, gradually the presence of a wild dark forest seems to invade the psyches of all of them. The result in the theatre is a remarkably enthralling and creepy evening that appeals to our sense of ethical discovery as well as to our fears about teenage misbehaviour.

Perhaps the most extraordinary play in an extraordinary career is *The Gods Weep*, which Kelly wrote for the Royal Shakespeare Company, and which was staged at the Hampstead Theatre in 2010 in Maria Aberg's epic production (with a cast led by Jeremy Irons). Once again, the most immediately striking thing is the audacity and originality of Kelly's imagination. Written as a contemporary response to Shakespeare's *King Lear*, the play opens with a man of power dividing up his kingdom. But Kelly's old man is no king, but a businessman, Colm, the CEO of a huge multinational company. In the first scene, a lesser playwright might have shown Colm dividing up his company at a typical board meeting, using the bureaucratic language beloved of business. Not Kelly. His Colm begins the play by sharing a nightmare that he has experienced: '...absolute panic, terror, sweating, drenched, I was drenched in my own sweat, all over my brow, my armpits, my chest covered, my groin, the backs of my knees and my upper lip, and I was screaming, although I wasn't screaming' (p. 251). His colleagues are not only stunned by this story, but are also flabbergasted by his decision to divide his company between two of his subordinates, Richard and Catherine. At the same time, he removes Jimmy, his son, from control of the country of Belize, and thus unleashes a power struggle that results in civil war. It's an amazing piece of writing, and a thrilling example of free storytelling, high in imagination and full of potent, and poignant, verbal flights.

In this dystopic epic, Belize becomes the focus of the conflict between father and son. Falling into an emotional tangle with

Beth, a married woman, Jimmy attempts to insure a project that will lease out the country's entire farmland to Western companies. But while Colm struggles to keep control of his pet humanitarian interventions, the logic of corporate greed wins out. Colm's plans soon founder as competition between Catherine and Richard rapidly escalates into open conflict, and the violence inherent in the capitalist system arrives with a shocking ferocity. Soon private security forces are roaming over Belize and beyond as the entire global economy pitches head first into chaos. Mobs rampage, and betrayal is signalled by abrupt shifts in allegiance, and random executions. Death is meaningless. It's a grimly surreal vision of war and terror. Kelly clearly isn't interested in a journalistic account of modern business practices; his mission is to convey a sense of the nightmarish darkness in the unregulated free market. As gun-toting soldiers cross and re-cross the stage, the brutality of violence is powerfully conjured up.

Kelly's writing is not only Shakespearean in inspiration, but flinty and poetic in its resonance. Influenced no doubt by Edward Bond, Howard Barker and Caryl Churchill, he mixes imaginative leaps with gritty bad language and vivid word pictures that seem to wink at you before they disappear, and the struggle moves on. Out of more than a dozen memorable speeches, a handful stand out. Two from Colm: 'I used to believe that the universe was cruel, that gods made things this way so that cruelty was the only way of existence. But now I see the truth. That they watch us and what we make and what we do with our lives to each other and they weep. They watch us and weep' (p. 332) and 'The gods we made in our dreams. We dreamt such terrible gods and they throw down their agony into our lives for no other reason than to keep themselves amused' (p. 328). These speeches not only echo lines from Shakespeare – 'As flies to wanton boys are we to the gods' – but also from Bond's *Lear*. Elsewhere, Kelly describes passionate love with enormous poetic and visceral power: Catherine says, 'Do you know what I feel when you say that you loved her? I feel a pain like you can't imagine, like a piece of metal, a piece of ice cold metal has somehow materialised inside my chest, into the place just under and slightly to the back of my heart. And maybe the metal is not metal, because it runs out into my veins,

so maybe it's liquid metal, yes, liquid metal suddenly runs through my veins and into my capillaries' (p. 315). Which contrasts nicely with Richard's military craziness: 'I have mastered the skies. Take this betrayal into your hearts, pump it like blood through your limbs. Now is the time for madness, lose sense, lose intellect. Kill all the prisoners' (p. 327). An *Apocalypse Now* moment. Similarly, in Beth's rebirth as a millenarian guerrilla leader, there is an echo of a medieval religious vision meeting a lust for revolution: 'A tyrant death, gone, over, gone. Now is a new, now is our, now is a new time, our time. We shall remake the world in our image' (p. 337). In this play, the protagonists not only remake the world but they refashion language as well.

The play is full of larger-than-life characters, from Colm's henchman Carlisle to the Astrologer. Above all, however, it is Colm's story. Since the narrative is seen largely through his eyes, the sincerity of the lead actor's performance dominates the evening. As he makes the journey from twisted dissatisfaction with absolute power through mental breakdown – which involves an episode of infantile dependency – to not one, but two, rebirths, the play turns from epic war saga into a outdoor domestic drama. By the Third Act, Colm finds himself living in a rural backwater with Barbara, the daughter of former rival that he once relished destroying. But instead of religious redemption, Kelly offers us a picture of how two antagonistic individuals can learn to live together in an everyday situation. As an image of truth and reconciliation, it's impressive and haunting. After the storms of the previous acts, these quiet, and occasionally comic, scenes are among the best in the play. *The Gods Weep* is a welcome example of really ambitious new writing, a kind of play-making that throws away the rule book and freewheels into uncharted territory. And, however imperfect – there are moments when the focus blurs – the play offers both a study in characters whose ambition has pushed them to the limits of existence and a powerful metaphor for rampant capitalism. Sure, it won't please those who demand that their plays are snapshots of real life, but sometimes the truth is more complex and, yes, more strange than what you read in the newspapers.

The final work in this collection is *Our Teacher's a Troll*, a

play for young people which toured Scotland in Joe Douglas's production in 2009. Like *Matilda the Musical*, this is a great story influenced by Roald Dahl and given a vivid and independent life by Kelly's imagination. It is a beautifully balanced and exceptionally fitting tale that is both funny and moving. Once again, the speed of the storytelling and the flexibility of the staging make this a joy to read as well as to see on stage. Like all the best stories about school kids it has sharply drawn characters, a rich language palette and a highly emotive sense of both justice and parental incomprehension. Sean and Holly, the 'terrible twins' (p. 385), are confronted by a familiar problem: when their new headmaster turns out to be a flesh-eating Troll (no, really), the adults don't understand and can't do anything to help them. It's a 'new regime' (p. 393) at the school, a form of words which immediately gives their problem a wider connotation, and the new system involves child labour and tyrannical punishment. But when they become 'more than just a bit frustrated at the inability of grown ups to grasp the simplest of concepts' (pp. 404-5), it's clear that they have to find a solution by themselves. Fuelled by a deep sense of injustice, they hit upon a cunning plan. Which neatly produces the (more or less) happy ending. As with all the plays in this collection, it is a great story told in a thrillingly inventive language. Without doubt, Kelly is one of the most multi-talented British playwrights to emerge in the past decade.

Aleks Sierz
London, October 2013

TAKING CARE OF BABY

Characters

DONNA MCAULIFFE, early thirties

LYNN BARRIE, early fifties

DR MILLARD, early fifties

MARTIN MCAULIFFE, mid thirties

JIM, fifties

MRS MILLARD, early forties

REPORTER, forties

BRIAN, thirties

WOMAN

OLD MAN

MAN

JANE

WAITRESS

Note: stage directions are in bold.

Hampstead Theatre and Birmingham Repertory Theatre Company present *Taking Care of Baby*. It was first performed at Birmingham Repertory Theatre on 3 May 2007.

DONNA MCAULIFFE, Abigail Davies
LYNN BARRIE, Ellie Haddington
MRS MILLARD/WOMAN/WAITRESS, Zoe Aldrich
DR MILLARD/OLD MAN, Christopher Ravenscroft
MARTIN MCAULIFFE/REPORTER/MAN, Nick Sidi
JIM/BRIAN, Michael Bertenshaw

All other parts played by the company

Director, Anthony Clark
Design, Patrick Connellan
Lighting Design, James Farncombe
Sound Design, Dan Hoole
Video Design, Clive Meldrum
Assistant Director, Noah Birksted-Breen
Company Stage Manager, Patricia Davenport
Deputy Stage Manager, Steph Curtis
Assistant Stage Manager, Sarah McNichol
Set, costumes and props made by Birmingham Repertory Theatre

The following has been taken word for word from interviews and correspondence. Nothing has been added and everything is in the subjects' own words, though some editing has taken place. Names have not been changed.

DONNA: And so I'm, erm, just erm, standing there, standing there and this girl, there's this girl lying on the top bunk and she's not saying – she had thinning hair on one side, alopecia, I think it was – and she's not saying a word, she's just staring at the ceiling and I was too scared to move really, so I just stood there, I mean, and the door's, erm, closed, just closed behind me and I'm, erm, you know, in this cell with this girl and she's not – do you want all this?

Beat.

and she's not looking, she's not looking at me.

So I just put my stuff on the, er, er, I put it on the er, bottom bunk, I was gonna put it on, erm, on the er, cupboards, shelf drawers, I was going to put it in the drawers but I didn't know which were hers and I didn't want to, I didn't want to open them or anything.

Oh yeah, and there were people in, erm, on the landing, I mean in the other cells on the landing, women, I mean, and they were like hissing and sometimes calling, you know, things… You know, killer, er, murderer, bitch…you murderer, you bitch, you murdering bitch, we're going to kill you you murdering bitch…cunt, things like that. And I just lay, I just lay on my bunk with my things there around me because I was too scared to, I didn't even take my shoes off actually, I was still wearing my shoes, but I was like that for about forty minutes and then this girl, the girl above me, er, she suddenly spoke and she had this, I think she was either from the, either from Wales or the West country because her accent was quite, it was a mixture,

or, but I couldn't tell and she said, erm, she said 'Don't speak' she said, erm, 'Don't speak because I'm trying not to hurt you. I've got six months left so I'm trying not to hurt you, so if you make me hurt you, I'm really, really gonna fucking hurt you.'

Beat.

And, and she meant it as well. She was really trying her hardest not to hurt me. I mean not for me, for her, you know.

Silence.

And, erm, then she erm, she kept saying what she was going to do if I made her hurt me and it was like, it was like cutting my eyes and stamping on my stomach and my face and putting bleach in my eyes after she'd cut the er, sliced the er, made a cut in, sliced the er, eyeball and things, it was a lot about the eyes, actually, she concentrated a lot about, on and around the eyes and that went on for about two hours.

Beat.

That was my first night in prison.

Lynn approaching a door.

LYNN: So I'm on this train coming back from Thornton and I was absolutely at my lowest ebb, I mean I think that was my darkest hour. My family was collapsing. My community, my friends – well, who I thought were my friends – were suddenly crossing the road to avoid me. And I mean literally. Someone actually did that, someone I knew very well saw me coming and just as I was hoisting a smile on she actually crossed over. You think 'I'm living with the tragedy of having lost my boy, how bad can it get, oh look, I've lost a grandchild, how bad can it get, oh, I've lost another one, how bad can it get, oh, my daughter's in prison, how bad can it get?' and it just keeps getting worse. And at the time, well I'd been a district councillor for the last twelve years and I was actually being considered as a candidate for parliamentary elections, which, for someone like me, was really exciting and I'd just had a meeting with

Michael, Michael Dunn the district party chairperson in Thornton, and he's said 'Look, Lynn, I'm going to stand by you whatever your decision is' which in the Labour Party is code for 'Step down, Lynn, no one's going to vote for you now'. And I know that doesn't seem like much compared to the other things, but for some reason it really hurt. I don't know why but it just seemed really, it just felt really…

personal.

You know, like the other things you think 'be strong and with God's help you'll get through, be strong and with God's help…' but for some reason with this thing I just thought 'Okay God: you really are taking the pee now.'

She knocks on the door.

And then

something happened.

She knocks again.

I'm sitting there on this train, feeling that everything has collapsed, when this woman and her daughter –

The door opens. A woman comes out.

Hello there, how are you?

WOMAN: Alright.

LYNN: Good, good. I won't take up much of your time, my name's Lynn Barrie and I'm running as an independent candidate in the local elections, will you be voting this time round?

WOMAN: No.

LYNN: Can I ask you why?

WOMAN: Coz you're all cunts.

She slams the door shut.

Beat.

LYNN: when this woman and her daughter get on the train…

DONNA: Every day it was threats, every day. But nothing happened. I mean things like shit in my food and stuff,

human, er, excrement, but nothing violent. I think I was lucky. I was only there for three weeks before segregation, but you're, you know, every minute you're waiting for the attack, even when I was sleeping, I was er, I used to dream on edge. Worst thing was when I, er, dreamt, I used to dream that it was all a dream. I'd dream that it was all a dream and that everything went back to normal and that I wasn't in prison and that nothing had happened, and I'd feel so relieved, like you do when you wake up from a horrible dream, like, erm, relief, erm, flooding, you know, washing over you and then I'd wake up and realise that it wasn't a dream after all, it was real and that that was the dream and that I'd just woken up from it and it was gone and that this was my life and I was in prison for murdering my children.

Little laugh.

Beat.

Thinks.

That felt really bad.

Lynn approaching a door.

LYNN: And when they've first got on I thought they were two kids because the woman is so small, she was tiny, but not a dwarf or anything but just very, very tiny and she looked just like a boy, she had this blonde hair that just hung straight down either side of her head like a page-boy and she had white shell-suit bottoms and a black vest and it was very hot, it was a very hot day so the daughter just wore nothing on her top at all, she must've been about eight or nine, but still, she was quite a big girl so she was bigger than her mother, so at first I thought they were kids. And for some reason this woman sits next to me and that's annoying me straight away because it's practically an empty carriage and she could've sat anywhere. And the daughter's sat opposite and they're completely oblivious of me. And their behaviour, it just irritated me from the start, I mean they were clowning, like kids, you know, you couldn't tell which one was the mother, they were

throwing bits of paper at each other and giggling, and then the mother gets up and the daughter's putting some cream on the mother's lower back where she's just had a tattoo done and it's very painful and she's arring and ouching, quite loudly, quite dramatically, like a child actually, and I'm fuming. I mean this is all I need. My life has crumbled into pieces, my faith even in God himself is being challenged here on this train and suddenly I've got these two idiots with an entirely inappropriate relationship. And I don't know how I knew but I knew that the mother didn't have custody of the girl the whole time, something in their behaviour, I think actually she might have been a lesbian, but on a council estate, which is a lot harder than going out and joining the gay scene, I imagine, but some people do it and that's the way it is, you become accepted. And I just wanted to turn and say 'You're doing this wrong! You've got this wrong, that's not how a mother-daughter relationship is supposed to be, who's the mother? Who's the daughter? What kind of human being are you?'

And

She stops.

suddenly it dawned on me that they loved each other.

Pause.

I mean it was

it was

it was

like a light going on. It was like being punched in the stomach, it was such a shock because in that moment I realised so much about who I was and who I'd become and how I'd judged and what I'd come to…think like.

They loved each other.

She knocks.

Who was I to judge them? And when had I become like this? When had I learnt that people only mattered if they had status or power or…money, I don't know…

9

I mean I was never like that when I was younger. I was an idealist. I believed in people. And somewhere along the line I'd lost that.

Knocks again.

An old man answers the door.

OLD MAN: Hello?

LYNN: Hello there, how are you?

OLD MAN: Very good, thank you. And you?

LYNN: Oh, very good, very good.

OLD MAN: Good.

LYNN: Good, good. I won't take up much of your time, my name's Lynn Barrie and I'm running as an independent candidate in the local elections,

OLD MAN: Oh yes.

LYNN: Can I ask if you'll be voting?

OLD MAN: Yes, indeed you may, I shall be voting.

LYNN: Good, good, and can I ask who for.

OLD MAN: Yes you may. I shall be voting Conservative.

LYNN: Okay, and is there a reason for that?

OLD MAN: Yes there is a reason for that, I have voted conservative for thirty-five years and I shall continue to do so.

LYNN: No chance of changing your mind?

OLD MAN: No, there is no chance of changing my mind.

LYNN: Would you like a leaflet?

OLD MAN: Yes, I would like a leaflet but I shall not be changing my mind and I shall be voting Conservative as I have done for the last thirty-five years.

LYNN: Well here's a leaflet for you, enjoy the rest of the day.

OLD MAN: Thank you, I will.

He closes the door.

DONNA: They, erm, well, they have to keep child-killers segregated but because I think I was known, or, or, they

put me in a, in a higher segregation than I should have been. You know, the er, well it was the highest segregation you can get. So I was in with women who really, really did terrible things, all to, er, children, they'd done terrible things to children and that was strange. They had a strange way of relating to each other. Like they were children. Like one would say, you know, they'd all call each other honey or sweetheart or darling and they would sometimes talk in sulky baby voices, you know the way some people do that when they want to get something, but it was funny because they all did 'Alright, honey, how are you?' 'Not too bad sweetheart, not too bad.'

Beat.

Sort of like that.

And everything was light.

They kept everything light like 'Not too bad sweetheart.'

And then you'd remember that they'd sexually abused their children to death or, you know, photographs of, like for money as well and stuff like that and you couldn't not remember that.

It was difficult.

You'd think 'This is strange.'

I was safe in there. But I didn't like it.

I didn't fit in.

Pause.

I've started seeing someone, so that's good, that's…

Beat.

A positive…

That might help me with –

It's not serious, not a serious, with some things it might…

I dunno.

LYNN: I suppose it doesn't sound much when I say it now, but it meant everything. It got me through those times, I just kept hold of it, I kept it in my back pocket and when things got too much I would go and find a quiet place, all to

myself and I would pull it out and look at it, that moment on that train. And when things became really bad I would – I hope this doesn't make me sound like some sort of – well, I would pull out the universe.

She laughs.

Okay, now you know I'm crackers crackpot.

She laughs.

But I would pull out the universe and I would look at it, and I would think of God's incredible creation, the billions of galaxies, the planets, the stars. And I would imagine some rock on a planet on the other side of the universe in some huge, beautiful canyon and I would think 'Okay, Lynn: it's not all just about you.'

Beat.

Look, I'd love to say that I wouldn't change a thing, but that's just rubbish. There's not an hour that passes that I don't miss my grandchildren. And I would give my eyes to have my daughter's life back. But all the other things, my position in the community, the party… Sometimes you can care about something so much, that in order to get it you become willing to destroy it. That's not right, is it?

She knocks. Waits. Laughs.

Sorry, does that sound pretentious?

The door opens. A man comes out.

Hello, there, how are you?

Pause.

MAN: Lynn Barrie?

LYNN: Erm…yes.

MAN: Lynn Barrie?

LYNN: Yes, yes, that's me.

MAN: I used to vote for you!

LYNN: Really? Oh, well thank you very –

MAN: JANE? JANE!

LYNN: Will you be –

MAN: JANE! My wife loves you, we used to vote for you every time!

LYNN: Well, that's great, will you be –

MAN: JANE! FUCKING HELL, JANE IT'S LYNN BARRIE!

LYNN: Will you be voting this time?

MAN: JANE FOR FUCK'S SAKE!

I used to vote for you every time!

LYNN: That's good.

MAN: Yeah, yeah. My wife loves you!

This is mad!

Jane turns up.

JANE: What?

MAN: It's Lynn Barrie!

JANE: I'm running a bath

She goes.

MAN: She loves you. We voted for you every time.

LYNN: Good, good, well this time I'm running as an independent candidate, and I'm campaigning against –

MAN: We'll vote for you again.

LYNN: Oh, well that's great. I'm campaigning against the new development up at –

MAN: Doesn't matter! We're gonna vote for you.

LYNN: Well that's great, we need every vote if we're going to stop the –

MAN: You got ours.

LYNN: Don't you want to know about the –

MAN: No.

LYNN: Do you want a leaflet?

MAN: No.

LYNN: It shows you what we're campaigning –

MAN: We're gonna vote for you anyway! You were great on Richard and Judy.

LYNN: Oh. Oh, well thank you.

MAN: Ohhhhh.

Beat.

My wife is just gonna be…so happy. We're glad you're back Lynn.

Closes the door and goes back inside.

LYNN: I'm campaigning against a planning application that's going through for a new super-mall just outside of Brewood. I campaigned for the application to go through when I was a member of the party. I knew it was wrong. I knew no one wanted it, I knew it was going to destroy businesses, shatter a community that can trace its roots back to the Saxon invasion, I knew that it was potentially damaging to the ecosystem on the heaths, despite what the developers say, but I campaigned for it. Because that's what the party wanted.

She laughs.

The Right Honourable Lynn Barrie! Has a ring to it, doesn't it. Bloody ambition! You sacrifice everything to it.

Beat.

It's not a huge story, it's not glamorous, it's not going to set the world on fire. But it is right. I haven't got a chance of winning. I know that's not going to happen. But for the first time in many, many years I'm not fighting to win. I'm fighting because it's right.

She begins to go. Stops. Turns back, smiles.

Isn't that mad.

She goes.

DR MILLARD: Generally speaking, lying doesn't really work. When you think about it. Whether you're lying to yourself or to another human being, we sort of know the truth. Somewhere. Generally. Generally somewhere we know the truth. Not always, but…

Do you know why you have such a large brain? In primates brain size is directly proportional to the size of

the social group that the animal lives in. Colobus Monkeys are a social animal and live in small groups, so their brain size proportional to their body size is larger than say a Bush Baby which lives on its own. Chimpanzees live in larger groups again, and their brain-to-body-size ratio is again larger. And the Geladas of Ethiopia live in groups of well over five hundred giving it one of the largest brain capacities for its size in the animal kingdom. What is all this extra processing power for? Society. Living within the group and working out what the situation is at any given time. And the primate with the largest brain size of all? Humanity. Which can be found living in groups of up to fifteen million or more. People like to think that we've evolved our intelligence to make things, tools, the wheel, domestication of animals, but it's not true. Technology is just a side effect. The only reason you have all that intelligence is to work out what the other fucker is thinking.

So do you really think that it's possible for one human being to lie to another? Generally not. Generally we know. Generally a lie is me and you both pretending to believe in something that's untrue, and then agreeing not to talk about it.

DONNA: I feel like they're always with me. Always, in some way. I don't care what other people, er, say about that. I just do feel like they're always there. I think it's because they died so young, you know, they don't know anything other than their mum. And they don't hold anything against me, they really don't. They understand. So I do feel that they are with me, and it's not a bad feeling, I mean sometimes I'm sad, because I can't you know, er

Beat.

reach out and touch them, and that, I can't tell you how much that sort of, hurts or something, but sometimes I feel warm

because they are with me.

Beat.

Except in prison.

15

That was the only time I felt that they weren't with me.

Beat.

That was the lowest I think. The absence of them. That was –

Beat.

Nothing has been harder than that

She goes.

Dr Millard smiles.

DR MILLARD: I spoke to one mother who had left her child next to a radiator turned up to full for nearly six hours. It caused extreme dehydration in the infant, almost leading to death and certainly contributing to some quite severe brain damage. The reason why was that she walked past the same beggar every day on her way to nursery. We only discovered this after a year and a half of intense psychotherapy she just thought that she was a terrible human being. But actually the empathy she had developed in order to care for her child was causing her terrible pain, making her feel raw, and every time she saw this man, smacked out of his head, covered in scabs, only twenty-five and stinking she would think of the man as an infant and her heart would break. Her feelings were confusing and painful, so she lashes out at the cause of her pain, which is, when you think of it, a natural response. But what is the cause of her pain? The junkie? Maybe, but she can't really do much about him any more than another LKS sufferer can cure global warming or stop the Americans bombing the shit out of Tehran. Her feelings, then? You can't attack your feelings. The thing that has caused her to feel this empathy, this is what she attacks. She suddenly finds herself being cruel to the thing that she loves most in the world. Her child. It's very confusing.

MARTIN: Dear Mr Kelly

Thank you for your letter of July the fourteenth. I have to confess that I am a little confused as to what you are doing. If I understand it right it sounds like you are making

an entertainment of the greatest tragedy of my life. Is this correct? Your letter was very polite and sincere and I'm sure that you think you are doing the right thing, but I have to say that if this is the case I must ask you not to proceed any further and to leave well alone. I hope I have misunderstood you and that you will not take this any further. I cannot begin to describe the pain I have felt, nor what my family has been through. To have this played out for the entertainment of others would be the greatest insult I can imagine. I hope I have understood this wrong and if this is the case then please accept my apologies, but if it isn't then from one human being to another, please, please do not do this.

Yours sincerely,

Martin McAuliffe

DR MILLARD: What makes me really cross is when people characterise these women as evil. I mean, Christ. If you saw the pain. If you saw that mother, she used to come in every day shaking, trembling with fear because of how those sessions left her feeling, and every day I would drag her back into that agony, and she would, she would go, she did it, because she needed to find out why.

Such courage. I've never seen pain like this.

Actually I'm ashamed to say I…well I drank quite a lot during that one…

Little laugh.

You know, you're supposed not to be affected, but…

Beat.

I always worried when I was training that I was doing it for the wrong reasons, you know, money, success, fame…

Smiles.

I was so naive. But the fact of the matter is that when you see someone suffering, whether you're paid or not, you help. That is one of the most beautiful things about humanity. We are capable of such horror and evil, yes, but we also have these vast reservoirs of kindness.

Isn't that crazy? Working with mothers who've tortured their children has restored my faith in humanity.

Beat.

Don't tell the Daily Mail!

Laughs. Stops laughing. Thinks.

MARTIN: Dear Mr Kelly

No, I would not like to be interviewed for your project. I thought my last letter made it very clear how I felt about the whole thing. And as for your assertion that this is my opportunity to get my side of the argument across, well if you didn't bring the matter up in the first place then there would be no need for anyone's side. You say that you are not a journalist and are not interested in sensationalism, but I'm afraid from where I am sitting I can see no difference. I am now seriously considering consulting my solicitor as I feel that this is a gross invasion on my privacy. Please do not contact me again.

Yours faithfully

Martin McAuliffe

DR MILLARD: Leeman-Keatley Syndrome or LKS is a rare psychiatric disorder that affects mostly young mothers of children in their early years, where a normal loving mother is driven to perform acts of cruelty on their own child, the most extreme cases leading to the death of the infant.

Many new mothers report an increased sensitivity to the world around them so that both local and world events seem to affect them more deeply. In the Leeman-Keatley sufferer this natural impulse has run riot so that these feelings take on a pathological dimension. The world is falling to pieces; global warming, terrorism, tsunamis, hurricanes, new imperialism, Islamic fundamentalism, Christian fundamentalism, every page of every newspaper contains a thousand contradictory reasons not to bring a child into this world. And yet here the mother is with this precious little bundle of life.

And here's where it gets a bit more complicated, because
it's not just about bad things, bad things have always
happened, but this heightened awareness makes you raw
to the sort of general background level of untruth that we
all have to live with these days, personally and socially.
You know…the hypocrisy of newspapers full of naked girls
exposing sex offenders, supermarket chains telling us they
love us and then destroying our high streets. Politicians
make speeches knowing full well that no one believes
them, but it doesn't matter, they carry on doing it, no one
believes journalists, advertisers are essentially thought of as
liars, lawyers are people who get money for being outraged
about things they don't care about and don't even start me
on estate agents

Laughs. Stops.

So do you see?

MARTIN: Dear Mr Kelly

Yes I am sure. No, I have absolutely no interest in taking
part whatsoever and no you can not - I repeat - can not
use this correspondence in your work. I do not wish to be
interviewed, I do not wish to be spoken to, I wish to get on
with my life and grieve for my children in peace. Me and
my family have been through the mill. Is it too much to ask
that now we be left in peace? I do NOT approve of what
you are doing and can only hope that you fail utterly. I am
now seeking legal advice.

Martin McAuliffe

DR MILLARD: The Leeman Keatley experiments are a series
of experiments that Dr's Leeman and Keatley carried out
in the 1930's for the American military. Basically they took
two study groups of army volunteers and over a period of
months subjected them to various stresses, ranging from
mild verbal abuse to electric shocks, water submersions,
sleep deprivation, some of it was quite severe actually. The
difference was that in the first group they would always tell
them what was going to happen: I'm gonna shout at you
for five minutes, you get shouted at for five minutes, I'm

going to apply an electrical current to the soles of your feet until you pass out, you have an electrical current applied to the soles of your feet until you duly pass out, you get the picture. But in the second group they occasionally lied and would throw in a positive thing, so they would say in ten minutes we're going to submerge you in an ice cold bath for an hour and ten minutes later they'd come in with a great big ice cream for you to eat, or they'd say we're going to make you stand in an uncomfortable position all night and then they'd show you to a nice comfy bed. Now. The interesting thing was that despite the possibility of being treated to something pleasant, the stress level amongst the second group was almost three times as high, and whereas in the first group there was almost a one hundred per cent completion rate of the months of what is practically torture, almost forty per cent of the participants dropped out of the second group.

What Leeman-Keatley discovered is that we like to know where we are and that when we don't there is a severe psychological penalty. This has actually formed the basis for most interrogation techniques since then; everyone's heard of good cop bad cop, but very few people are aware that it's a direct result of Leeman-Keatley.

You see it's not just about bad things. What we really can't stand is being lied to.

MARTIN: Dear Mr Kelly

Your statements about truth are meaningless. Your continued promises are meaningless. Your continued requests for my co-operation are insulting. I am left stunned by your inability to comprehend my point of view, that I find your project is filthy and pointless and that I do not wish to be of any help to you at all. As you now know I have sought legal advice on this matter and there is no point in pretending that there is anything I can do about this due to the ridiculous and stupid nature of our legal system which has failed me utterly yet again. So in case you haven't yet quite got the picture let me be clear: I think you are a parasite. I think you are a maggot. I think

you are a piece of scum, something undigested and rotting, the lowest form of life, a monster, a vulture, a sickening little piece of shit and I can only pray that you get some kind of terminal illness like cancer before your project is concluded. I hope I make myself clear. Please do not contact me again.

He goes.

DR MILLARD: Once upon a time the beggar would be run out of town. I'm not saying that's right, God no, but it is at least honest. These days we all care about the beggar. You, me, politicians, newspapers, celebrities, we all care about the beggar, oh God, we really care about the beggar. But the beggar is still there. And, in fact, there are more and more beggars, and the more beggars there are the more we care, we really do, gosh, we care so much, yet the beggar is still there. D'you see? It's the contradiction. It's the disparity between what society says it thinks and with what its actions tell us it thinks.

It's not bad things, humanity has learnt to live with bad things. But today we have so much information – do you know that the average broadsheet contains more information than someone in the middle ages would have assimilated in their entire lifetime? We *watch* the famine, we are *in* Darfur, running from the militia, we *see* the polar bear drowning in the arctic, we *are on* the British street with the beggar, yet this is something our social, economic and political systems weren't designed to cope with, they are rooted in different time. They're left floundering in the wake of all this information, gasping, dying, really. But they just carry on because we haven't yet figured out another way. And so the beggar stays on the street.

Most of us can cope with this, most of us just think 'Oh well, so the world's not perfect, fuck it, let's watch the fat one off Big Brother instead', but for some people this disparity works its way into them. This is not about society or social welfare, that's just an example. It's about truth. It's about the feeling that – and if we're honest, we probably all feel this a little – the feeling that truth has become

compromised. It's about the feeling that truth doesn't matter.

The key to treating Leeman-Keatley is teaching people that truth is relative.

He starts to go.

Stops. Turns.

I mean it isn't. But we have to think that to live, don't we.

He goes.

Lynn bursts on, clutching a sheet of paper, followed by Jim.

LYNN: DONNA? DONNA?

JIM: I can't believe this, this is

LYNN: DONNA!

JIM: I mean this is really

LYNN: DONNA!

JIM: this is fantastic, Lynn

LYNN: it's early days yet, Jim, so

JIM: Oh it's early days, yeah, yeah,

LYNN: so we shouldn't get too excited

JIM: Oh yeah, it's early days yet and we shouldn't get too excited but this is fantasti –

This is brilliant!

LYNN: Well, it's good

JIM: You deserve this.

LYNN: I wouldn't say brilliant

JIM: you deserve

LYNN: not brilliant, not yet

JIM: This is an endorsement.

LYNN: Is it?

Donna enters.

JIM: Of course it is.

DONNA: Hello Jim.

JIM: Donna, your mum's third!

DONNA: What?

LYNN: I'm third, Donna, look, I'm third in the

DONNA: Third?

JIM: She's third, she's third, she's third place in the, third –

LYNN: Calm down, Jim.

JIM: Sorry. Sorry. It's an endorsement, Donna.

DONNA: Is it?

LYNN: Well, it's good, it's a good

JIM: It's an endorsement, Lynn! It's a mandate. I mean it's early days but –

LYNN: It's not a mandate it's good, it's, it's the first poll, Donna, I'm in third place.

JIM: I mean we've only just started!

DONNA: You're third…?

LYNN: I'm above the Tories.

DONNA: Are you?

JIM: What, two hundred, three hundred doors we've knocked on and you're already in third? That's gonna scare them!

LYNN: Don't count your chickens before they're

DONNA: Ahhh Mum, that's great!

LYNN: Well… No, it is good. Isn't it?

JIM: It's fantastic, Lynn!

LYNN: I mean I am quite pleased with

JIM: It's brilliant, I mean we haven't even started, this is, this is

DONNA: Oh, Mum! This is brilliant!

LYNN: Okay, okay, let's not get, because all I wanted to do is give them a run for their money and –

Donna hugs her mother. Lynn hugs back. Jim laughs.

JIM: Champagne! Champagne all round! Well, tea at least.

The hug still goes on, intimate.

> **Frozen, gripping each other. There might be tears.**

> **Jim stands there.**

(**Singing**.) We are the champions…

> **He laughs. They are still hugging.**

> **He stands there, not quite knowing what to do.**

LYNN: Come on you, silly…

> **Lynn breaks the hug. Though she pretends she isn't she is crying as well.**

all that, don't, you'll get me, you'll get me going with all the…

JIM: This is great. Great.

LYNN: It's only third so

> **They are all smiling. They can't help it.**

JIM: This is the community saying we accept you.

LYNN: No, I don't think –

D'you think?

JIM: 'We accept you, Lynn!'

> **Pause.**

'And Donna'

DONNA: well…

LYNN: I think people are just sick of the Labour Party…

JIM: Of course they are, they're sick of the lies, they want you Lynn!

LYNN: Oh, Jim, don't be so, he can be so

JIM: 'Honest Lynn!'

LYNN: Oh, stop!

DONNA: It is good, Mum.

LYNN: Yes. Yes it is.

> **Beat.**

I'm gonna get out a bottle of wine.

JIM: Here we go!

LYNN: And you behave yourself!

JIM: Not changing the habits of a lifetime!

They laugh, Jim the most. Lynn goes.

Silence between Donna and Jim.

This is good

DONNA: Oh, it's really, really

JIM: news, it's such

DONNA: it is, isn't it?

JIM: Oh it really is. It really…

DONNA: Brilliant.

JIM: Great.

DONNA: Yeah.

JIM: Yes.

Great.

Silence for ten seconds.

You, you, you doing, are you doing, you alright, you doing okay, you doing

DONNA: Yes.

JIM: alright then, Donna?

DONNA: Yep.

JIM: Great, things, things good?

DONNA: Yeah, yeah, you know.

JIM: Good. Good.

Beat.

Good.

DONNA: Yes.

Silence for fifteen seconds.

Donna turns to Jim, opening her mouth to speak.

Lynn enters with a bottle of wine.

LYNN: Vino…

JIM: Vino, hooray!

DONNA: Fantastic, hooray, yes!

JIM: Fantastic! In vino veritas!

LYNN: It's not much, it's just

DONNA: Wine, wine!

JIM: Hail the conquering hero!

LYNN: Stop, you silly…

JIM: Third place and this is just the first poll, I mean I'm not counting chickens but this is, this is…

DONNA: Let's get drunk.

LYNN: Let's not get drunk!

JIM: Let's get drunk!

LYNN: Tell you what: let's get drunk.

They go, but Jim turns back.

JIM: I'll tell you a story about Lynn. When Donna was at university she got into a bit of trouble. I think she got in with the wrong crowd, she was always a bit quiet, you know, so I think actually I think she was probably pushed around a bit at school, which is, you know, if you've got a mum who's known in the community it can be difficult. Lynn is a hard act to follow.

He laughs. Stops.

Donna was a bit of a wallflower.

So when she went to university she went a bit wild. And that's okay up to an extent, I mean we like a laugh, I like the old…

Indicates smoking a joint.

you know what I mean?

Laughs.

You know, eh?

Laughs.

Does 'smoking a joint' again.

Yeah, you know.

But I think Donna went a bit wild. In fact I know she did because Lynn told me, I mean we're practically best friends, so…

Anyway, she got in with some heavier drugs, you know, and I think this crowd, I don't think they respected her and one or two of them I think were, well if they weren't serious gangsters they were training to be, I mean they were contenders, let's put it that way. So Lynn gets a call from Donna at eleven o'clock at night, crying, no sense, out of the blue, out of it, out of her, just completely out of her mind saying she was scared, crying, you know. Things. Then she hangs up. Lynn gets in her car, drives all the way to Leeds and with absolutely no idea where she is, never having been there before and now being there at three thirty in the morning, finds Donna within forty-five minutes. She doesn't take no for answer, that's how she can be. Tracks her down. This dirty flea-bitten squat, doors open, Lynn goes in. I mean can you see the picture? Someone like Lynn walking into a place like that? Goes in the front room, bunch of these lads and Donna lying half naked in the corner. Suddenly these lads are up in her face, calling her a bitch and whatnot, coz they've got drugs in the room I suppose, and firearms, maybe, because a lot of these people, and she calmly walks up to the biggest one and says 'I have come for my daughter. And you are not stopping me. And if I have to kill you to walk out of here with my little girl in my arms I will do my best to do that.'

Five minutes later and she's putting Donna – still asleep, face like an angel, Lynn said it was like she was five again – onto the back seat of the car. Just walked out of there, right through all of those big lads, her daughter asleep in her arms.

Beat.

That's the sort of woman Lynn is.

Bright light suddenly on Donna.

Never told anyone about that just me. We're very close.

Beat.

Nothing like that

Laughs.

Just close.

You can use that if you want.

He begins to go.

Stops. Turns around.

It's okay, she won't mind. She said I could tell you that one.

He goes.

Reporter runs on.

The following has been word from taken word for interviews and correspondence. Everything is in the subjects' own words and place, nothing has been added though some has taken editing. All names have been changed.

REPORTER: Sorry, sorry, sorry, I'm late, sorry, the train, fucking hoodies on the train giving it all that, streak of piss in a uniform, standing there taking it, I mean they're only kids, what kind of country is this, you can't give them a fucking slap, fuck me, fuck me, look at the, look at the, look at the, look at the tits on that.

That

is

beautiful. A thing of fucking… Please, baby, please serve me, I'll give you such a tip, I swear…

Sits.

Beat.

Sorry. It's the heat. Making me randy. Permanent fucking hard fucking cock, feel like I'm sixteen again.

(**Singing.**) Feeling

like I'm almost sixteen again…

Laughs.

You know that one? The Buzzcocks, love the fucking Buzzcocks, used to love all that.

Right.

Pulls newspapers out of a bag.

Picks one. Reads.

'Grieving mother, Donna McAuliffe was yesterday being interviewed by police in connection with the death earlier this week of her five-month-old son, Jake McAuliffe. Police

were called in when a social worker interviewing Mrs McAuliffe became suspicious of circumstances surrounding the infant's death. A police statement said that Mrs McAuliffe was helping police with their enquiries.'

That's it.

Beat.

That's the first mention of this story anywhere.

Beat.

Quite proud of that.

DONNA: What?

Beat.

Are you comfortable?

DONNA: What? Yes, yes, I'm…

Why do you ask that?

Beat.

You looked uncomfortable.

DONNA: Oh.

Oh, right, no, I'm, I'm fine.

I see, sorry I thought…

Sorry, I…

Little laugh.

Beat.

No, I thought, you know. More in general so –

No, I'm fine, thank you. I thought you meant, I thought it was a more, like comfortable at the moment, or…

Beat.

A more general, like you were asking was I comfortable at the moment. With life.

Beat.

Which you weren't.

Beat.

And which you wouldn't.

Not that you wouldn't, I mean you would, or you might,
I mean you can, that's not a, not at all a problem, but I
mean you wouldn't say it in that, would you, you'd phrase
it, that's not the way you'd ask, you'd ask that question
differently, you'd put it in a different way, so I thought you
meant something else. Which you didn't.

Little laugh.

Sorry.

Beat.

Anyway, the answer's yes to both, so…

Not that you're –

Beat.

I'm thinking of doing a course. Or learning a, doing a
course, you know, because I'd like to, that's a bit stupid
isn't it, doing a course I mean, but learning, I'm thinking
of learning a language because we don't, do we, English
people never, and you always feel a little bit embarrassed
when other like Swedish or something speak perfect
English, and not even Swedish, sometimes French or
Chinese or French Canadian, they speak perfect English
and we don't speak anything do we and you think 'What
am I going to do about that?' because –

I was thinking Italian.

Because it's so beautiful.

Beat.

But then I thought no one speaks that, do they, just Italians,
which I like, it's not that I don't like, I like Italians or the
ones I know, I don't know that many, but it's not very
useful so I thought French or Spanish but then I thought
that that was only because they were colonial powers and
that feels a little bit like our language is dominant because
it's colonial, and then you learn another language which
has been colonial and that feels like you're rewarding
dominance and something, something that's wrong with
the world so I thought Italian again but then you think,
you know, Mussolini, I mean they've got their own, but we

should move on from that, that's stupid, that would be like not speaking German because of Hitler so where does that leave you?

Pause.

Are you sure you're ready to talk about this now?

REPORTER: Here she comes…

Watch this. Have a bit of fun with her.

Winks.

Waits.

Just a laugh, watch this.

Waitress comes over.

WAITRESS: What can I get you?

REPORTER: I'll have a cup of tea and, er, a couple of buns.

WAITRESS: What?

REPORTER: Couple of buns? Nice couple of buns?

WAITRESS: Sorry?

REPORTER: What?

WAITRESS: What?

Beat.

REPORTER: No I was just having a laugh.

WAITRESS: What are you talking about?

REPORTER: No I was just…

WAITRESS: We don't do buns.

REPORTER: Yeah, I was just –

WAITRESS: It's just what you see on the menu, okay?

REPORTER: Okay, yeah, I was just –

WAITRESS: What do you want?

REPORTER: Cheese and ham toastie, please.

WAITRESS: Thank you.

She goes.

Beat.

REPORTER: 'Cot Death Mother's First Child Also Died'.

'Donna McAuliffe's first child suffocated to death two years ago, The Mercury can exclusively reveal today. Donna McAuliffe, currently being questioned by the police in connection with the death of her infant son, Jake, last week, had a daughter, Megan McAuliffe, who died two years ago. Husband, Martin McAuliffe, found nine-month-old Megan entangled in her duvet and not breathing. Despite attempts to revive the infant she was declared dead on arrival at St Luke's Hospital, Kent. After an investigation the coroner's report declared that the cause of Megan's death was "accidental suffocation". Lewisham social services said yesterday that suspicion had been aroused because of circumstances surrounding baby Jake's death, but refused to be drawn on what those circumstances were. The family of Donna McAuliffe were unavailable for comment and a police spokesman said that Mrs McAuliffe was helping with a police investigation.'

Now. This is the time when I started getting the red-tops interested. Hard at first, but once I got them they all came to me coz I'd been in on the ground, I'd talked to Donna, I'd talked to Lynn, they loved me. I just had to get the style right.

Pulls out another paper.

'Mother Murders Babies For Love'

See?

See?

DONNA: What? Yeah, no, I'm fine. Why? I mean…yeah. Yeah, I'm…fine.

Beat.

Are you still seeing that man?

DONNA: What?

That man that you were seeing. Are you still –

DONNA: Why? Why do you want to know that?

I want to get a picture –

DONNA: I…don't think I want to talk about…

33

Okay.

DONNA: Sorry, I don't want to –

I thought you just wanted me to say what happened?

I do.

DONNA: you know, I thought you wanted me to say…

We can do this any way you want.

Pause.

DONNA: It's fine he's really –

I mean we're not really seeing, in that way just…

I'm probably not the best person at the moment and I don't want to hurt or, there's these suspicions you become, but I'm not talking about that so…

Beat.

It's nice. He's nice. Kind.

Pause.

Sometimes I feel good, but then it can be like suddenly looking down and realising you're two thousand feet in the air and your stomach drops and you feel sick and you want to –

Do you want all this?

Yes.

DONNA: I mean is this…?

Yes.

It gives context.

DONNA: Right.

Because I thought you wanted me to say what happened when Jake died.

Okay.

What happened when Jake died?

Beat.

DONNA: What, you just want me to say…

Yes.

Pause.

Donna?

Pause.

Are you okay?

DONNA: Yeah. No, yeah, I'm, it's just a bit…

We don't have to do this now.

DONNA: No, I want to do this now.

Pause.

I could get Lynn.

DONNA: What for?

Just to be –

DONNA: I don't want her –

Just to be here.

DONNA: I don't want her to be here.

Beat.

I mean, I'm fine on my own. Don't…disturb her.

Ask me something.

Beat.

Like what?

DONNA: I don't know. Ask a question.

Beat.

Is it better if we come at it from another angle?

DONNA: Is that your question or are you asking me?

No, I'm asking you.

DONNA: Right.

Have you done this before?

Pause.

No.

Beat.

DONNA: Ask me some things around, like, you know…

Pause.

Tell me about your daughter.

DONNA: What?

Tell me about your daughter.

DONNA: Why?

Because…

DONNA: Oh yeah, I see.

Just to start.

DONNA: Yeah. Yes. Okay.

Megan…

Pause.

was

a lovely girl.

She was beautiful, actually.

She smiles.

She was so er, you know, beautiful that I kept crying. Honestly, I did. And, and it wasn't just me, it was, I mean from the moment she was, you know, born, nurses, er, doctors, everyone, erm, she was really, just really beautiful. She just, she just looked so lovely that you had to keep looking at her.

Little laugh.

It was her funny mouth. She had a funny…

She was very difficult. She had colic, which isn't, it's not, er, dangerous, it's just uncomfortable for them, so she wasn't, she was quite grumpy and she cried a lot. Martin was always going on about it, I mean not negative because he was a great, he was a brilliant father, but worried, you know, thinking there was something wrong, like there was a bit he had to, to twist or to, to add and then she'll be fine.

Pause.

I did think about killing myself when she died.

REPORTER: Lynn? Absolutely fucking wonderful. Lovely woman, honestly. She'd have a giggle with you. I mean her grandchildren have been murdered by her daughter and she'll have a laugh with you. When it gets to press

camping on her fucking lawn she brings you out a cup of tea. Always got a smile 'Alright, David, how are you?'

Donna? Face like a slapped arse. I mean look, fair enough, she was going through whatever, but we're just doing our jobs.

Rifling through the papers.

'Loved To Death'… 'Double Death Mother Pleads Innocent'… 'Double Death Donna in Affair Claim' that proved false so… 'Why I can't lose another child', that was Lynn, the mother, she was very, an interview, she was very… 'Love Mother Collapses in Court'… 'Love Mother Rejects Doctor's Report'… Here we go:

Pulling out a paper.

'Don't Dig Up My Baby'

'Double Death Mother, Donna McAuliffe has applied for a court injunction to stop authorities from exhuming the body of her daughter, Megan. In what some have seen as a blatant attempt to infringe on the powers of the prosecution, McAuliffe's lawyers filed an injunction yesterday morning with Bow Street Magistrates' Court, raising the possibility now of a counter suit from the prosecution for "attempting to pervert the course of justice".

'McAuliffe's mother, Lynn Barrie, has distanced herself from the move saying "Justice should run its course, no matter how painful that may be to us."'

There. Can you see the change in style? Now *that's* red-top.

DONNA: Martin was amazing. He was… I was in a trance, four, about four months, he just looked after me, he just, he was incredible. I mean maybe he was throwing himself, you know, into me or something, distracting, looking after me or I dunno, but I would've died without him, so I don't care what anyone says. He was incredible.

Beat.

Is this…

Is this good?

Yes.

DONNA: I mean is this what you want?

Yes, yes, it is.

Pause.

DONNA: I remember finding myself with all these pills and I'd no idea where I got them, but he was taking them out of my hands, just really quietly, really gently just popping them back in the bottle, while I sat there staring at him. Imagine going through all that and going through your own grief as well. He was amazing.

Did you kill Jake?

REPORTER: Oh my God. Oh…my… looklooklooklooklooklooklooklooklooklook, look, look, look!

Ohhh, you missed it. She was bending over.

I love women. Can't help it, always have. Never been faithful, never once, and that includes the current. Love her to bits, but I can't help it. I'm a sex addict. No, I mean like proper. It's an illness. I never knew that. I went to SAA. Got a sponsor and everything. Off the wagon now, last eighteen months, feel like shit. It's tits, tits, tits, tits, tits, tits, tits, can't stop looking at tits. Drugs, you get sympathy, alcohol, you get sympathy, sex you get derision. I'm not complaining, I love a fuck. What can I do? Four months ago I slept with my best friend's wife. He don't know that, so that's strictly off the record. (**Laughs.**) Kill me he would. I feel terrible.

(**Singing.**) I'm an orgasm addict.

Buzzcocks again. Ahead of their time.

'We Will Appeal!'

'Lynn Barrie, mother of Double Death Murderer Donna McAuliffe, claimed yesterday that they will appeal against Justice Brompton's sentence. Donna McAuliffe was last week sentenced to life for the murder of her five-month-old son, Jake McAuliffe, narrowly escaping a second life sentence for the murder of her daughter Megan when the

Crown Prosecution decided that there was insufficient evidence to bring the case to court. Brave Lynn has always campaigned for her daughter's innocence of the charge of murder, claiming that she suffers from the rare psychological disorder Leeman-Keatley Syndrome. Lynn said yesterday: "This decision is not justice, it is the absence of justice, it is justice perverted. My daughter should not be imprisoned, she should be cared for and understood." However, it is not known in what form the appeal will be submitted, as McAuliffe, who has always claimed her complete innocence, is refusing all contact with her mother. McAuliffe believes that it is the idea that she suffers from this condition that has lead to her being convicted.'

DONNA: No. No I didn't kill my son.

I'm sorry. I don't think you did.

DONNA: Then why did you ask?

Sometimes I'll ask direct questions that I know the answers to because it helps to shape your answers as a statement when I take out my questions. I just want it to be your words. I'm sorry.

DONNA: I understand.

I'm sorry.

DONNA: I understand.

It makes it more…dynamic.

DONNA: No, no, I, it's, I, it's, I understand. Don't ask that again.

I won't. I'm sorry.

Do you have any contact with your husband?

DONNA: No.

Is that your choice?

Beat.

Or his?

DONNA: His.

Would you like to see him again?

Would you like to see him again?

Beat.

DONNA: No. Yes. No, I'd like to see him but just to let him know that I'm okay.

Do you feel betrayed?

DONNA: No.

He still thinks you're guilty.

DONNA: He loved Jake.

What about you?

DONNA: I don't want to talk about it, yes, he loved me.

Okay.

DONNA: I don't want to talk about him.

Okay. Do you want to stop?

DONNA: No I just don't want to talk about him.

I think you're very brave.

DONNA: Great.

REPORTER: 'Lynn On Talk Show'.

That's a, er, local, there, that's…

Would you like to tell me what happened?

Beat.

With Jake?

Would you like to tell me what happened when your son died?

Beat.

Donna?

The waitress slaps down a tea and a toastie.

REPORTER: Thank you, my love. Keep the change.

She looks into her hand as if he had left a turd in it.

Glares at him. Goes.

'FREE!'

In capitals, this actually nearly, *nearly*, made the front page, I would've had a national front page, but Kylie had cancer,

so… But nearly though. And this story was actually carried on some terrestrial news channels, even the BBC, though by the News at Ten it had been knocked off, but still, I mean still.

'Double Death Mother Donna McAuliffe yesterday walked free from court. Justice William Woods yesterday overturned the earlier ruling of Woolwich Crown Court. McAuliffe, who has served fourteen months of her sentence, left the court yesterday in tears, free, reunited with her mother Lynn Barrie who has tirelessly campaigned for her release. Justice Woods said that he "had seen no compelling evidence that this woman had murdered or indeed harmed her children, or that she suffered from anything other than a general feeling that the world was a sometimes difficult place". He attacked what he called "psychiatric hyper-babble" and said that in this country we do not practise the law of "supposition and probability". He said that the family had been through enough hardship and that it was time for "this tragedy to draw to a close". However, he did not exonerate McAuliffe entirely, saying that "there was only one person who knew the truth of this case and that person was in the dock", but that it was impossible in this country to convict someone without proving beyond reasonable doubt that they were guilty.'

Pause.

There you are.

That's the lot. Quite a fucking ride I can tell you, I would ride that, I would ride that, I would ride that like a cowboy riding a whale, made a lot of money on this, all gone. Sex, drugs and alimony.

Only in this sick and twisted society could we actually make up an illness, that's how twisted we are, lying fucks, we manufacture illnesses.

Do I think she did it?

Beat.

Course she did it.

Come on. Two kids dying?

I got five children by three different women, not one of them has died. She's got away with murder.

Where's the husband? If she's innocent, where's the husband?

Lying to a court? Piece of piss, could do it in my sleep, twelve men good and thick as shit. Lying to your husband…now that's hard.

DONNA: We were arguing. It was over something really silly. I don't know what it was, it was, it was something on the telly, something, really stupid and

I just

felt this scream in my stomach. I know that sounds

odd, but that's what I felt. It's what I felt. And I knew something was wrong. And I ran upstairs, mid-sentence, I mean everything it just stopped, I dropped whatever and I ran upstairs and he's looking stunned because one minute I'm shouting at him if that's what I was doing, I don't think I was shouting I was probably just saying something emphatically, and halfway through a word, probably, I get this scream in, er, in my er, belly, and I run upstairs. And I go in the bedroom. And Jake's dead. I know he's dead

in my heart

though my mind is saying no

and I

pick him up

and

I don't remember, I think he's calling, I think he's calling

an ambulance

and I'm bouncing Jake, walking him up and down and I don't remember and there's an ambulance man's face, and I remember his face because it's suddenly in front of mine and I'd never seen him before and he's suddenly in front, halfway through a sentence that I don't remember him

saying because I haven't seen him before. And he takes
Jake off me.

Very gently.

He was, he was very kind.

He was very kind, I remember

and the scream in my stomach, well I was screaming, then.

Pause.

I've said that in other ways so that people can understand
it but that's what actually happened. So I'm saying it like
that now. I'm saying things the way I want to. Because it's
the truth.

It's the truth I'm interested in.

DONNA: Is it?

Yes.

DONNA: Well that's the truth.

Pause.

Thank you.

DONNA: What for?

For telling me.

Long pause.

DONNA: You're welcome.

Lynn enters.

**The reporter sits there eating his toastie and
smiling.**

Suddenly thinks.

REPORTER: You're not gonna make me look like a cunt, are
you?

LYNN: I suppose you've been wondering exactly what it is I'm
campaigning against.

Well…

Underhill is one of these huge out-of-town shopping
developments that's planned near Brewood. And I mean
huge. It's got a bowling ally, restaurants, eight-screen

cinema, and that's on top of all the superstores, B&Q, Ikea, PC World, then you've got a retail park with over three hundred shops in it, I mean it'll be one of the largest in the United Kingdom. And where are they going to build this? Brewood. It's a village! I mean they're going to plonk this practically on top of a village, okay, it's down the road, and they might offer to move it another one hundred metres or so, but it's five square miles of development, it's larger than the village itself.

And they're saying, oh, it's going to serve at least four to five major towns in the area, well they say 'serve' but if you ask local businesses they say 'slay'. And how are people from Milton Hill and Thornton going to get there? No, not from the service roads, they'll drive straight through Brewood. The car-parking alone is one and a half times the size of the village, so what's that going to do to traffic? And you know what they've come back and said to the locals? It'll create jobs. That's right, it will; five thousand jobs. In a village of less than two thousand people? That's the bloody problem, you're not listening, no one's bloody listening!

So I'm going to make them listen, or at least I'm going to try.

I've missed the buzz.

Laughs.

There. I confess! You've got me. I have missed the buzz. And the people, this house used to be full of people, always something, always someone, some problem or other. And they'd come here, to me, to Lynn, which is…

And you know what's nice? I can see that now for what it was. Vanity. I'm fine here. With my daughter. Alone. And the friends I've got, you know, Jim and, real friends, not like those other…

DONNA: The worst thing about Jake's death was when they said they were reopening the file on Megan. I know that sounds funny, but er, when they er, when they, when they er said they were going to

Beat.

exhume Megan, that was the most pain I've ever felt in my
entire life. I remember when my brother died, standing
at his grave and thinking 'Okay, you're there, in this
wooden box under six feet of earth and you're rotting.
Your muscles are decaying, your bones are slipping out
of position, your flesh is liquefying into the white silk of
the casket' and I'd think like that every time I visited his
grave and I know it sounds morbid. But it would help me
come to terms with his death. But with Megan, not for one
second ever could I think like that, but when they used
words like 'exhume' and 'disinter' it forced me after two
years of blocking it out to think about her

Pause.

Dr Millard comes on, laughing to himself.

The pause lasts for ten seconds.

body, which was quite difficult. That was the worst thing.

LYNN: … full of people, full, and about now, I mean at this
stage of the process I'd be, cocktails and, you know, I'd
be having my cocktail parties, everyone knew about my
cocktail parties and they'd all be there, here, I mean. I was
known for my cocktail parties, it was like an event.

Well. All gone now.

Beat.

Good riddance!

DR MILLARD: You know, initially I wasn't going to call it
Leeman-Keatley Syndrome at all. Initially I was going to
call it Medea Syndrome. You know after the Greek tragedy
of Medea, who kills her children for revenge on her
husband. But my publisher said it sounded too much like a
seventies film. 'The Medea Syndrome'.

Laughs.

Brian enters.

LYNN: Who said: 'Politics is like parenting: the more you do it
the less you believe in it.'?

DR MILLARD: And also it wasn't really representative of what was happening, you know, Medea was a heartless murderer, so…

Pity, though. Sounds good, doesn't it.

Laughs again. Leaves.

BRIAN: Is this, er…

Beat.

Is this, er…

LYNN: What?

BRIAN: I mean what, what exactly…?

LYNN: Oh, no, don't worry, Brian, don't worry about

BRIAN: alright, is it?

LYNN: don't worry about that.

BRIAN: It's okay, is it, it's…

LYNN: Yes, yes, it's just this thing they're doing on me.

BRIAN: Oh right. Yes, good.

Like a documentary, or…?

LYNN: Sort of.

They laugh.

BRIAN: Good, good.

Beat.

Everything you say shall be taken down and used in evidence…

He laughs. She doesn't.

He stops laughing.

Beat.

Yes.

Thanks for seeing me, Lynn.

LYNN: Oh no, no, it's a pleasure, Brian.

BRIAN: I really appreciate you taking the time

LYNN: Not at all

BRIAN: I just think it's good to talk, and you know, these days it's all, everything's oppositional

LYNN: yes, yes

BRIAN: and reactions to rather than for

LYNN: yes, yes

BRIAN: Just talk, just say something, just act like human beings, for heaven's sake!

He laughs.

Stops. Beat.

How are you?

LYNN: I'm really well thank you.

BRIAN: And your daughter?

LYNN: Oh, she's good.

BRIAN: Is she? Is she good?

LYNN: Yes, she is.

BRIAN: Oh, fantastic!

LYNN: Yes.

BRIAN: Fantastic! Oh that is good!

LYNN: Yes, it is.

BRIAN: Oh well, good for her!

LYNN: Yes.

Beat.

BRIAN: And I'm really pleased you're doing well in the polls, I mean I know I shouldn't be…

He laughs.

LYNN: (**Smiling.**) Well…

BRIAN: Don't record that!

They laugh.

Don't record that, you're going to get me into trouble!

He laughs.

No, but seriously, we're in opposition and as much as I never want to see an opponent do well, I'm pleased to see an opponent do well.

LYNN: Oh, thank you, Brian. That really means a lot to me, honestly.

BRIAN: Not at all, no I mean it, I really do.

Beat.

Have you seen, have you seen this morning's…?

LYNN: Second place.

BRIAN: Second place, yes, second place, that's really going to put the wind up the Labour Party.

LYNN: Well, it's not about that.

BRIAN: Oh no, I know, but that will really teach them.

LYNN: Yes, but it's not about that.

BRIAN: Oh, no, I know, I know, completely, but it does serve them right for –

LYNN: It's not about that, Brian.

BRIAN: Exactly.

Beat.

I just thought we should talk because we have a lot more in common that you might at first think.

LYNN: Okay.

BRIAN: For a start, we are one hundred per cent against this development.

LYNN: Really?

BRIAN: Absolutely.

LYNN: But you voted for it.

BRIAN: We…voted for it, yes we did.

LYNN: You voted for it, Brian.

BRIAN: At the early planning stages yes, but that was before the impact studies came in.

LYNN: You didn't just change your mind then?

BRIAN: No. No, we didn't

LYNN: because you've got a new leader?

BRIAN: No, we didn't, we were for it before the impact studies came in, but once we saw the impact studies and the environmental reports we re-evaluated our position.

LYNN: Right.

BRIAN: We acted on new information, Lynn.

LYNN: Wasn't just that you were wrong, then?

BRIAN: We weren't wrong.

LYNN: when you voted for it, before

BRIAN: We weren't wrong given the information at that time.

LYNN: It wasn't just that you were wrong and you changed your mind?

BRIAN: No, we weren't wrong at the time we voted for it, we definitely weren't, and actually you voted for it yourself, Lynn.

LYNN: Yes.

BRIAN: I seem to remember...

LYNN: Yes.

BRIAN: I'm not being rude, but I seem to remember you voted for it

LYNN: Yes I did.

BRIAN: yourself Lynn. Exactly.

LYNN: Yes. I was wrong.

I was wrong and I changed my mind.

Pause.

BRIAN: The Conservative Party has always been the party of rural affairs. And I think that given both of our current positions – no matter how we arrived at them – there is the possibility that we can actually work together, as crazy as that seems.

LYNN: It doesn't seem crazy. I think that people should work together.

BRIAN: Do you?

LYNN: Yes. I didn't used to, but I do now.

BRIAN: Well, so do we.

LYNN: Do you?

BRIAN: Yes!

LYNN: Would you work with the Labour Party?

BRIAN: We would work with anyone as long as it was consistent with our aims.

LYNN: And you'd work with an independent?

BRIAN: We would work with anyone as long as it was consistent with our aims.

LYNN: The Liberals?

BRIAN: Hang on, Lynn, you've got to draw the line somewhere.

He laughs. She doesn't.

Lynn, we would work with whomever. We are sick of the bickering, the British public is sick of the petty party politics and so are we. And we really do believe that we could work with you.

LYNN: After the election?

BRIAN: Of course.

And…maybe before.

LYNN: Pardon?

BRIAN: Maybe, you know…

She stares at him.

before.

Pause.

LYNN: How?

Beat.

BRIAN: Okay. The Conservative Party is changing. It is changing radically. We are a party that cares, we care about people, we care about the environment, we care about business, we care about England. Our aims and your aims are so similar, Lynn, and I am not going to lie to you, we have been very impressed by your campaign and what you have achieved so far.

LYNN: Thank you.

BRIAN: Very, very impressed.

LYNN: Thank you. I still don't get it.

BRIAN: You don't need to be without a party. Not someone like you. Someone like you, with your ability, with your talent, with your unique experience, with the things you have been through and triumphed over, fought your way back from, I think you deserve to be a member of a party, and a party that understands loyalty.

LYNN: And that's the Conservative Party?

BRIAN: Yes.

Beat.

LYNN: Are you asking me to run as the Conservative candidate for Thornton?

BRIAN: I am asking you to run as the Conservative candidate for Thornton. With our full backing, with our financial backing, our manpower, with our full spiritual backing, Lynn.

LYNN: Right.

BRIAN: I am not going to lie to you, we have not done well in either the local or parliamentary elections here.

LYNN: Not for years.

BRIAN: Not for years. But who isn't disillusioned with the current political machine? Why do they deserve to be returned back to power, after the lies, the untruths?

LYNN: Right.

But that's a parliamentary issue.

BRIAN: Sorry?

LYNN: That's a parliamentary ambition, Brian. These are local elections.

BRIAN: Which we want to win.

LYNN: Fine, but that doesn't help you in parliament.

BRIAN: No.

LYNN: So…

BRIAN: So…

> **Pause.**

LYNN: I mean are you saying…

> Are you saying that you might put me forward as a
> parliamentary candidate as well?

BRIAN: Well…

> **Pause.**

> Let's not run before we can walk.

LYNN: So you're not, then.

BRIAN: No, no, I didn't say that.

LYNN: Well are you or aren't you?

BRIAN: Well…look, we already have a parliamentary
candidate…

LYNN: Who has lost in three elections.

BRIAN: Yes, who has lost in three…

> Tom's a good man, he's tried his best, but…

> **Beat.**

LYNN: But?

BRIAN: But…we might be willing, we might…want to think
about another candidate. Someone who has more support.
Local support.

LYNN: Right.

> Gosh.

BRIAN: Yes.

LYNN: I mean this is…

BRIAN: Yes. It is.

LYNN: Thank you, I mean this is…

BRIAN: We are changing, we **have** so much in common and I
think you would be perfect **for us** and I think we would be
perfect for you. (**Laughing.**) God, I feel embarrassed!

LYNN: Don't feel embarrassed, **that's** silly.

> **Pause.**

BRIAN: Lynn; would you consider running as our candidate.

She thinks.

LYNN: Brian; I'd rather eat glass.

(**To the audience.**) People, sneering, people sneering, yes, yes, sneering, looking at you 'oh, look at her, look at her fall from grace who does she think she is, well look at her now, not so fucking clever now is she, Miss Smarty Arse' staring, I've had people cross the road, people I've worked with, lived with, voted with, people I've campaigned for and against, the smell of it, it's like you smell something bad, death, like your family smells of death, and they all want to say it, they want to run up to you and shout in your face 'Your family smells of death you, you're not so clever now you, who do you think you are you, what sort of mother are you you?'

Make me sick.

Double standards.

Two-faced.

Lying. Cheating.

They make me sick. Round here. They make me sick.

I never want to be like them again.

Donna suddenly wakes up screaming from deep inside, the sound of someone ripping pain out of their body.

Lynn runs to her, tries to put her arms round her.

LYNN: Jesus, Donna, Donna –

DONNA: Nonononononononononononono…

LYNN: Donna, stop it, stop –

DONNA: Nonononononono…

LYNN: Donna, it's me, it's –

DONNA: Me, me, nononononono…

LYNN: come here

DONNA: They've gone, they've gone…

LYNN: come here, stop now

DONNA: they've gone, they've gone, who? they've, they've, they've, they've

LYNN: don't, because

DONNA: they've gone, they've

LYNN: Donna, please, stop, because I can't

DONNA: They've gone, they've, gone, gone, gone, gone, gone, they've gone, they've gone, they've gone, they've gone, they've gone, they've gone

LYNN: I can't, I can't take

DONNA: they've gone, they've gone, they've gone, they've gone, they've gone

LYNN: No, I can't take this, this

Leave us, it's alright but just –

DONNA: they've gone, they've gone, they've gone, they've gone, they've gone, they've gone

LYNN: don't record this, this

Donna, please, please, it's me, Donna

DONNA: they've gone, they've gone, they've gone, they've gone, they've gone, they've gone, they've gone, they've gone

LYNN: Donna, it's me, your, mum, it's me

DONNA: Who?

LYNN: Me, it's me, Donna!

Beat. Donna recoils from her like an animal.

DONNA: DON'T TOUCH ME!

LYNN: Donna!

DONNA: You fucking bitch, you fucking

LYNN: Please, go, leave us for a second, it's alright but

DONNA: You fucking

LYNN: she's not herself, she's

DONNA: don't touch me you fucking, you fucking

LYNN: Please

DONNA: I'll kill you, you fucking, you fucking

LYNN: stop recording, this is

DONNA: I'll cut your fucking head off, you fucking bitch, you fucking cunt, you fucking

LYNN: PLEASE!

Sudden darkness filled with white noise.

Beat.

Lights up on Donna and Lynn, calm, watching telly.

They watch. Long pause.

(**Without looking up from the set.**) You alright, sweetheart?

DONNA: Yeah. Yeah, not too bad.

LYNN: Good, good.

They watch.

Want some tea, honey?

DONNA: No.

LYNN: You sure, love?

DONNA: Yes. Thanks.

LYNN: Okay, sweetheart.

They watch TV.

The taken word for following word has been correspondence from and interviews. Nothing has been everything and words added in the subject's is own, though taken editing has pomle sace. Chamed nanges heeve ban all.

Dr Millard's wife enters.

Stands with him, supportive.

DR MILLARD: It's been very…

awkward to deal with. Quite difficult. You know, the attention and the media circus that surrounds these…

Beat.

But I do genuinely feel that what doesn't kill you makes you stronger. It's made us stronger hasn't it.

Pause.

He takes her hand.

Pause.

MRS MILLARD: Yes.

Do you want some tea or something?

DR MILLARD: No, no, I don't think –

MRS MILLARD: I could make some coffee, d'you want coffee.

DR MILLARD: No we don't want –

MRS MILLARD: I've got Colombian.

DR MILLARD: Well that's great, but we don't want it.

MRS MILLARD: Don't snap.

DR MILLARD: I'm not snapping I'm just saying I don't want coffee so it doesn't really matter where it comes from does it?

MRS MILLARD: Right. You're like this.

DR MILLARD: I'm not like anything.

MRS MILLARD: One of those moods, is it?

Beat.

We bought this house because of the trees.

We both love trees.

It was always a thing when we met, trees, I don't know why.

We ended up always meeting under trees, it sort of became a joke.

It's best with the window open because then you can see them better.

Beat.

Do you want the window open?

DR MILLARD: No.

MRS MILLARD: Why?

DR MILLARD: Because it's cold.

Beat.

MRS MILLARD: They're birches. I love birches.

DR MILLARD: Could you to leave us to…

MRS MILLARD: Do you want me to leave you?

I thought you might want support.

Beat.

DR MILLARD: No. I'll be fine.

MRS MILLARD: Fine.

This is a beautiful area.

The people are very…

The people are very…

The people are very…

The people are very…

Beat. She sits, but neutral, not in the same room.

DR MILLARD: It's been difficult for both of us. She had a lot of friends here. It's been difficult on my wife. Both of us. She's fine. I'll…talk to her later, she's…

Slowly, he sits.

Bright light suddenly on him.

Why did you agree to speak to me again?

DR MILLARD: I told you why.

I have to ask.

I have to ask you for the –

DR MILLARD: Oh yes, of course. Sorry.

Because I wanted to put the record straight.

About what?

DR MILLARD: About me.

Do you stand by Leeman-Keatley Syndrome?

DR MILLARD: Of course I stand by Leeman-Keatley Syndrome. Leeman-Keatley Syndrome is a real thing, it exists and people are suffering because of it.

How did you feel about what Justice Woods said?

DR MILLARD: A judge isn't a doctor. When I want advice on sentencing innocent women to jail and letting rapists walk the street I'll ask a judge.

You sound angry.

DR MILLARD: No, I'm not angry.

Beat.

Look, I have successfully diagnosed thirty-two women with LKS. Thirty-two women who have done inexplicably cruel things to the person who they loved the most in the world. Imagine what it feels like to know that you have left your baby in the sun for three hours. Or that you've been feeding your child a diet of salt and carbolic? These people are no different from you or me or anyone else. They cannot believe what they have done they are horrified, tormented with, and then I meet them. I trust them, I talk with them, I help them to understand the process that led them to do what they have done. Things begin to make sense, just a little, at first, but gradually they begin to be able to live with themselves, with the idea that they are ill. Then imagine some fat bastard in a wig suggesting that

your illness doesn't exist, that your illness actually doesn't exist. It doesn't help anyone.

Do you think he's got a point?

DR MILLARD: I'm not answering stupid questions.

Look, the existence of Leeman-Keatley is not under question, do you understand that? No one in my profession is doubting that it exists.

Professor Hagan doubts that it exists.

DR MILLARD: Well, yes…

Professor Marr, Doctor Leonard, Doctor Natal…

DR MILLARD: yes, yes, but

Professor Lillie, Seaton, Kingsley, Doctor Walker…

DR MILLARD: Yes, but that's nothing more than –

Beat.

Look, it is perfectly normal, in this situation, for there to be a certain amount of intellectual too-ing and fro-ing. It is normal and healthy. The reason we publish our results is so that our colleagues can examine them, refine them, hold them up to the light and help to make things clearer. It's actually a positive thing. It helps us get at the truth.

Has the

too-ing and fro-ing

increased since Justice Woods' comments?

Beat.

DR MILLARD: Are you going to continue to ask questions that you already know the answers to?

Beat.

Yes.

I have to.

That's how it works.

DR MILLARD: Jesus.

Look, don't put that in.

You know, the bit about the judges.

Pardon?

DR MILLARD: You know, the bit about them being fat bastards. Just don't put that in.

Why?

DR MILLARD: Because I don't want to look like an arsehole.

But you said it.

DR MILLARD: I know I said it but I don't want people to know I said it.

Pause.

But it's the truth.

It's what you said.

DR MILLARD: None of this is the truth, it's just people saying things, what makes you think that's the truth.

None of this is the truth?

DR MILLARD: It depends on how you slant it, I mean you're going to slant it –

MRS MILLARD: None of this is the truth?

DR MILLARD: I didn't mean it like that.

I thought this was the truth?

DR MILLARD: This is the truth, I'm saying this is the truth but I'm saying that it all depends on how you slant it, I'm saying there's more than one truth, that's what I'm saying, I'm saying –

I'm just saying that it's all, it's all subjective, there's the truth and there's what people think is the truth and that depends on how you –

and look, don't put that in about the truth, because that's really –

I want to get at the truth.

DR MILLARD: You want to get at your truth, look if you put that in I'm going.

Okay.

Beat.

DR MILLARD: Are you going to put that in?

> **Pause.**
>
> *No.*
>
> *I won't put that in.*

DR MILLARD: Really?

> **Beat.**
>
> *I promise.*
>
> **Dr Millard calms.**

DR MILLARD: This isn't about me, you know. There are patients at the centre of this. And not only the ones who I've been working with, but ones out there now, right now doing inexplicably cruel things to their children. Please don't imagine that this is about the intellectual arrogance of a couple of doctors, it's about human suffering, suffering that doesn't need to happen.

> *Are you going to get struck off?*

DR MILLARD: No, I am not going to get –

MRS MILLARD: You're under investigation.

DR MILLARD: I'm not going to get struck off, look, it's a matter for the BPS and the Professional Conduct Board, I can't tell you what they're thinking, go ask the BPS and the Professional Conduct Board if you want to know what they're thinking. And please don't say 'struck off' because it's a loaded term and it doesn't reflect the reality of the situation.

MRS MILLARD: It doesn't reflect the truth?

DR MILLARD: Yes, it doesn't reflect the truth. These things are routine, it's simply an investigation.

> *Part of the*
>
> *too-ing and fro-ing?*

DR MILLARD: Yes.

Alright, no, maybe more than that, just, but it's not the end of the world.

MRS MILLARD: Could you be struck off?

DR MILLARD: I won't be struck off.

MRS MILLARD: But that is a possibility?

DR MILLARD: Yes, it's a possibility. It's always a possibility.

Aren't they saying that your research is flawed?

DR MILLARD: No, they aren't saying that my research is flawed. The investigation has no impact on LKS. I am being investigated about a number of other –

MRS MILLARD: 'Are we to continue to imprison grieving mothers in the name of what every respected member of the medical profession has now come to understand is a work of fiction? There is no body of peer-reviewed research to underpin Leeman-Keatley Syndrome. It is a theory without science. A fictitious and fabricated illness that exists only in the mind of its inventor.'

Pause.

Do you know who said that?

DR MILLARD: The Shadow Health Secretary.

Is he right?

DR MILLARD: Have you just come here to attack me? I mean I thought I was going to get a chance to get my point across.

I'm just asking questions.

Trying to get at the truth.

DR MILLARD: I feel like you're attacking me.

Do you believe LKS exists?

I don't know.

DR MILLARD: Alright, look.

Imagine it doesn't exist. What's happened? Some women who have abused their children have been treated as if they were human beings and not monsters, some people might say that's unfair but who is really hurt, and I know that isn't an argument for making something up, it really isn't, but now I want you to imagine that it does exist, and I'm not saying that it does, well I am saying that it does because it does, but in this hypothetical world you're welcome to believe that it might not. But what I am asking

you to do is to imagine that it does exist. What about those mothers? If it does exist, what about the people forced to hurt their own children because of a condition that the world has decided is too far-fetched to exist?

MRS MILLARD: What do you think of the world?

Beat.

DR MILLARD: What?

What do you think of the –

DR MILLARD: What, the world?

MRS MILLARD: Yes.

DR MILLARD: What does that mean, the world?

Life. Now.

DR MILLARD: I think…

I think it's confusing.

I think we don't know what to think.

MRS MILLARD: Are you worried about global warming?

DR MILLARD: Of course I'm worried about global warming.

Are you worried about the neo-cons in the American government?

DR MILLARD: Well, yes, actually, I am.

MRS MILLARD: Are you worried about religious fundamentalism?

DR MILLARD: Yes, I'm –

Are you worried about poverty?

DR MILLARD: Yes.

MRS MILLARD: Consumerism?

DR MILLARD: Yes.

Third-world poverty?

DR MILLARD: Yes.

MRS MILLARD: So you're worried about the state of the world?

DR MILLARD: What's your point?

What's your point?

Nothing.

Beat.

MRS MILLARD: Why are you being investigated?

DR MILLARD: It's regarding some of my research.

On LKS?

DR MILLARD: You know it's not on LKS, if you're going to be like this –

MRS MILLARD: Why are you being investigated?

DR MILLARD: It's on some other research papers concerning a genetic predilection for violent behaviour found in some teenage boys, okay?

Pause.

They're questioning the research.

Pause.

They're questioning whether I published it too early, but it has no impact on –

They don't think your research is thorough enough?

DR MILLARD: They are asking that question.

MRS MILLARD: They're wrong about you 'grasping for sensational results' then?

Beat.

DR MILLARD: LKS exists.

MRS MILLARD: Does Donna McAuliffe have LKS?

DR MILLARD: In my opinion she does.

MRS MILLARD: So the judge was wrong?

DR MILLARD: Let's be very clear about what the judge said. The judge said that we couldn't convict with insufficient evidence, that it had to be beyond reasonable doubt.

MRS MILLARD: So the judge was wrong?

DR MILLARD: The judge was doing his job as a judge, I do my job as a psychologist.

MRS MILLARD: How many times did you examine Donna McAuliffe?

DR MILLARD: I didn't examine her, I had a session with her.

MRS MILLARD: You had a session with her? One?

DR MILLARD: Yes, one, I had one session with her but in my opinion

MRS MILLARD: How long did this session last?

DR MILLARD: based on the facts of the case

MRS MILLARD: How long did this session last?

DR MILLARD: The post mortem revealed extremely high levels of salt in the infant, how do you explain –

> *That wasn't the cause of death.*

DR MILLARD: It couldn't be established that that was the cause of death, no –

MRS MILLARD: Was it the cause of death?

DR MILLARD: You know it wasn't the cause of death, but –

> *When the coroner testified that salt levels in an infant that young were 'extremely hard to quantify' was he lying then?*

DR MILLARD: Look, there are the levels that things should be at and there are abnormal levels, what he was talking about are the levels that can be clearly defined as fatal –

MRS MILLARD: He said that it could've come from anywhere.

DR MILLARD: He said that it was possible that it could've come from anywhere.

MRS MILLARD: He said that it was no more than could be found in a spoonful of ketchup.

DR MILLARD: How many people do you know who would feed a five-month-old child a spoonful of ketchup.

> *Why does the Infant Mortality Society disapprove of what you are doing?*

DR MILLARD: They have a legitimate concern that mothers who have lost children through SIDS will find themselves in court, but that will not happen, it's –

MRS MILLARD: Donna McAuliffe found herself in court.

DR MILLARD: Are you actually going to let me finish a sentence?

Is it true that the widow of Professor Leeman has asked you to rename Leeman-Keatley Syndrome?

DR MILLARD: No, it is not true, Jesus Christ, where did you hear –

He gets up.

Look, I haven't agreed to this to be attacked, I'm sitting here being fucking attacked!

Did you make LKS up?

MRS MILLARD: For your career?

Beat.

Did you make LKS up for your career?

MRS MILLARD: Did you make LKS up?

Did you?

Did you?

Did you make LKS up for your career?

Pause.

The people here are very…kind.

She walks off.

Doctor?

DR MILLARD: This is just a story for you isn't it. It's just a game. It's people's lives! Does it matter to you that children are dying, people's careers are…

I'm not…

I'm not like that, that is not what I am –

Beat.

That's not the kind of person I am!

He goes off after his wife.

Lynn bursts on in a cocktail dress, having drinks with Jim and a few locals, the centre of attention, belle of the ball.

LYNN: Has everyone…?

Has everyone got a drink?

JIM: I could do with another!

LYNN: Everyone except you, Jim.

Laughter from the crowd.

Sudden light on Donna, blinding.

How's your boy, Lee, is he alright?

Seeing someone else.

Is that Terry? Oh my God, is that Terry?

She hugs someone.

Oh my God it's Terry! Terry, how are you doing Terry? What's this, a piercing? At your age?

Laughter from the crowd.

Got anything else pierced that we should know of?

More laughter.

You got a drink have you? That's not a drink, get a proper one!

DONNA: Errr….

Errr…

No, I don't know if I want to, erm…

That's okay.

DONNA: talk about that, erm…

That's alright.

DONNA: because it might give the wrong, erm, the wrong, erm, the wrong, erm

LYNN: right, so now I'm standing there with this dirty great apple in my hand…

Crowd laughs.

and I'm getting a bit frustrated

More laughter.

no I am, I'm getting a bit peed off

More laughter…

and this lad's looking at me and I'm thinking you keep looking at me like that, son…

Laughter…

go on, just go on, son, because this apple, right…

Laughter, nearly crying…

where the sun don't shine!

Laughter explodes.

DONNA: No, no, she's doing, she's doing, very, very well, very well, she's. Isn't she. She's doing very well. You know. They had, er, a man, a woman it was from, this man from the, er Liberals, the er Liberal Party and I think they would've, you know, like the Tories did they would have liked her to join because she's only a few points behind and now it's, now it's, who knows, and I'm really pleased, I'm really pleased, I'm really, really pleased, really pleased, really pleased, really pleased, really, really pleased, really pleased, really pleased, really pleased, really pleased, really. So yeah, okay, if you wanted to talk about…herrrr… Is that what you were… I don't know if I want to, erm… Is that what you meant?

No.

I meant you and her.

Beat.

DONNA: Me…?

Me and…

LYNN: It was very hard to get people interested at first. We had a website, which looking back, I mean I laugh now but we didn't know what we were doing.

Laughter.

It was a combination of no graphics with glitzy hyperlinks, ridiculous really, you've got a bright turquoise page with red writing telling you about this travesty of justice, this innocent mother accused of killing her baby, then you have this little Children In Need teddy bear as a hyperlink!

She laughs. They laugh with her.

Ridiculous. We didn't know what we were doing. We couldn't get any press interest, so all the press was negative. Why should you care about a woman who's murdered

her baby? And Donna, well she cut an unsympathetic character.

Laughter. Lynn as well.

No, it's true. She's always taken a terrible photo.

More laughter, as if at a joke.

I know that sounds trivial, but that's what makes people's mind up. If Peter Sutcliffe looked like David Beckham it'd be a different story. I'm serious, it's what people see makes the difference.

DONNA: Me and, me and, me and, me and –

What about when you were in prison? You weren't talking to her.

DONNA: Yes. No, no, yes, that's…

Do you want to…

Do you want to talk about that?

Yes.

Pause.

DONNA: She's had a very hard, she's had a very difficult life, look I don't want to talk about that things are good for her and I don't want to talk about that.

Okay.

How are you?

DONNA: Me?

Yes.

DONNA: How am I?

Yes.

DONNA: I'm…

really good.

I'm still seeing that, that, that man so that's, well no, not actually, we're not officially, I mean I couldn't and I didn't really like him, he was nice but I was, so it's over, no that's over, but sometimes we…

Beat.

I'm worried about you.

Beat.

DONNA: Are you?

LYNN: We had to grow up very quickly. It was a very steep learning curve. But you soon realise you're playing, not with the truth, but with the public perception of the truth. When we noticed that they were asking questions about me, about how I felt it became a different issue.

Laughter.

We soon realised that I had to be the focus of the campaign.

Laughter.

I mean if you're a hard bitten journalist what story do you want? Brooding mother who murders her own children and doesn't wear enough make-up complaining that she's innocent, or agonised mother of heroin casualty taking on the legal system in a desperate attempt to save her one remaining child?

Gales of laughter.

I had to step into the centre.

Cheer.

No, it's true.

Did you hate her?

DONNA: No, she's my mum, I love her.

When she said you had LKS, did you hate her?

DONNA: No, she's my mum, I love her.

Does she think you killed Jake?

DONNA: No, she's my mum, I love her.

Do you think she thinks you killed Jake?

DONNA: No, she's my mum I –

Long pause.

Why…

Beat.

Why are you worried about me? I'm fine.

When she said you had LKS, did you hate her?

LYNN: It was never a matter of embracing the diagnosis, let me be clear about that.

Murmur of assent.

I want to be quite clear about that. I mean officially we always disagreed with it, we always protested Donna's absolute one-hundred-per-cent innocence, tragic suffocation and a cot death.

Cheer, but from Jim only.

But we instantly knew Leeman-Keatley Syndrome was going to be news. First we heard of it, we knew. It was never a choice of it not being, it happens without you, but if you reject it it's entirely out of your control, we knew this was news and it then became a matter of how you used the news, how you let it use you, it's about managing the perceptions, and we needed, the campaign needed publicity, this was, I mean this was what we were after.

DONNA: He sort of, just, sort of, slipped away. Mark, I mean. Mum tried, you know, but he was, he was addicted, I mean he was an addict, and I was only, what, fourteen, I don't, I don't really, but my mum, she just, everything she could, she just…

Beat.

It just sort of got worse. I mean he'd been doing it for two years before we knew, and then we knew and then six months later he was dead, so, so, you know, so, you know, so…

there you are.

Beat.

Why are you telling me this?

Beat.

DONNA: What?

LYNN: So if there was an ambiguity over our stance, well, the thing is, and this is going to sound really strange but the thing is that this was good news.

Nodding of heads.

Lynn gets up and sweeps downstage dramatically.

(**To the audience.**) Suddenly we, I was everywhere, radio, papers – nationals, no longer just locals. I was interviewed on Richard and Judy, I mean this was what we were waiting for. So yes, we embraced it, we embraced the fact that it was linked to Donna, but we never embraced the diagnosis and if we did, well all I wanted to do was get my little girl out of prison and if that meant that was going to happen by saying someone's sick – even if they're not – I would've taken that.

DONNA: And she got into, like, she was, that's became more, active, and yes, that took her away from stuff, but I was happy, I was, I was happy because she wasn't, you know, crying or, or, or, or, I thought she was gonna…

What?

do something. Bad. Yes. I was fourteen, so.

LYNN: LKS is an illness. When you treat addiction you treat it like a sickness. A lot of people don't think that it is, but that's the most successful way of treating it. Treating something like an illness might have saved my little boy.

Beat. Round of applause.

When I said that on Richard and Judy their website got the third highest number of hits ever.

DONNA: You shouldn't worry about me I'm…

I'm…

I'm…

Beat.

There's so much else to worry about isn't there.

I mean it's so big. The world.

LYNN: It felt like I was born to it. It felt like I couldn't put a foot wrong. I instantly knew the best thing to do in any situation, I had an instinctive grasp of how the public felt, it's like a gift for languages or something, some people just can pick them up like that, others'll struggle for years. I just knew the language of it all.

> **Pause.**

> I thought I'd be immune to pain after Mark died.

> I was very wrong.

> I found that out when they arrested my daughter.

> The one thing you can always feel more of is pain.

> **Pause.**

> And thank you very much, I love you all!

> **Rousing cheer. Music, fanfare, Lynn carried away on the shoulders of her supporters.**

> **Pause.**

> **Donna clears up.**

> **Lynn comes back.**

> **Stops. Watches Donna.**

DONNA: Are you…

> Are you…

> Are you…

> worried

> about me?

LYNN: What?

DONNA: You know

LYNN: Am I…?

DONNA: Yes.

LYNN: Am I worried about you?

DONNA: Yes.

> **Beat.**

LYNN: No.

> You're fine.

DONNA: Right.

LYNN: You're really fine, you're doing well, love.

DONNA: Okay.

LYNN: What is all this? You're doing fine, are you okay?

DONNA: No, yes. You're not

worried, then?

LYNN: No.

DONNA: Right. Okay. Fine.

LYNN: Donna, love, come on: not now.

DONNA: Fine.

LYNN: Not now, come on, things are –

DONNA: I'm leaving.

Pause.

LYNN: What?

DONNA: I'm

moving

Beat.

out.

LYNN: What?

DONNA: I'm

LYNN: You're what?

DONNA: I'm

LYNN: What are you talking about?

DONNA: I'm

LYNN: You're…?

DONNA: I'm

LYNN: What are you talking about?

DONNA: I'm

LYNN: No.

DONNA: I'm moving

LYNN: No, no

DONNA: Yes.

LYNN: No.

DONNA: Yes.

LYNN: No, Donna, no you can't, is this, is this because

DONNA: No

LYNN: I have to have people here, I'm

DONNA: no it's not

LYNN: I'm running for, look, I'm nearly there, I've got a chance, please don't do this

DONNA: it's not that

LYNN: not now, Jesus Christ, I mean how is that going to look

DONNA: it's not

LYNN: Fucking hell, Donna!

DONNA: Mum –

LYNN: Don't mum me!

> **Beat.**

What?

What do you want, what is this?

> **Pause.**

Okay, look; not now. Alright? Not now. I mean I can have enough as well, you know, not this, not now, okay? I mean that, Donna. I mean that. I mean that.

> **Pause.**

What?

DONNA: Do you…

Mum,

do you…

Do you think I…

Do you think I…

Do you think I…

> **Pause.**

LYNN: Donna. Please. I'm asking you, please. I'm asking you, please, please, I am just about, things are just about, I am just about to get something back and –

DONNA: Do you think I killed Jake?

Pause.

LYNN: What?

DONNA: Do you?

LYNN: Why are you asking that?

What's got you asking that?

DONNA: I just

LYNN: Donna –

DONNA: Tell me.

Answer me.

Answer the question.

Pause.

LYNN: I have.

DONNA: What?

LYNN: I have already answered that –

DONNA: No you haven't.

LYNN: I mean you know what I think.

DONNA: No I don't

LYNN: Yes you do, I mean for God's sake what do you think I've been doing, I –

DONNA: I don't know

LYNN: Yes, yes you do, I've told you

DONNA: You think I'm innocent?

LYNN: I've told you, Donna

DONNA: You haven't

LYNN: What?

DONNA: You've never said

LYNN: Well I'm saying it now

DONNA: No you're not

LYNN: What?

DONNA: You're not saying it.

LYNN: I am, I –

DONNA: Say it then.

LYNN: I've just said it!

DONNA: Say it.

LYNN: I've just

DONNA: Say it.

LYNN: Yes! There, yes, I've said it, yes.

DONNA: Yes what?

LYNN: Yes, I think

Beat.

you're innocent.

There.

**Donna stares at her. Lynn cannot hold her
gaze.**

DONNA: I want to leave.

LYNN: Please don't leave.

DONNA: I can't stand this

LYNN: Please don't leave, not now, love

DONNA: This is terrible.

LYNN: Please don't leave me now, sweetheart, we're nearly
there

DONNA: This is the worst thing.

LYNN: Please don't go now, honey, not now

DONNA: I can't bear this.

LYNN: Please, I'm nearly, I'm nearly back

DONNA: I'm going to stay.

LYNN: Stay

DONNA: I'm going to stay.

LYNN: Stay, please

DONNA: I'm going to stay.

I'm going to stay, Mum.

This is the worst thing.

Martin comes forward.

MARTIN: First time I met Lynn I was out with Donna, we'd only been together three months, out for a drink with some of her mates, bit pissed, few joints, feeling happy, Donna says 'I'm gonna phone me mum' I said not now, it's midnight and you're pissed, but she phones her, and they're having a chat and I thought her mum sounds alright coz they're having a laugh, like, you know, I can hear and that. Four hours later we're at my place, few mates, bit wrecked but happy enough and we're just talking bollocks, four o'clock in the morning bollocks and Donna's nodding off and there's a knock on the door, it's fucking Lynn. Crying, fucking wailing, bursts in like Arnold fucking Schwarzenegger, like a fucking banshee, I didn't know what was going on, begging Donna to go with her, saying she's gonna take Donna, she's gonna save her, all this fucking…

Poor Donna, I mean she was mortified, she was, I mean fucking hell, Lynn was in such a state.

Beat.

I mean she only went to university to get out of that house. She told me that once. She was like a mouse in the first few months, then she just opened up. Sometimes I used to think Mark was the lucky one. Got out when he did. Never said that.

He sits. Bright light on him.

Te foling has beelown takhen wormed for wspoord frondrm intews and cughorrevieence. Nothything has been odded and evering is in the subjts' awn wongrds, tho sam editing hoes keplan tace. All nas havece been chaed.

You've agreed to be interviewed.

MARTIN: Yes.

But you only wish to answer yes or no questions?

MARTIN: Yes.

Why?

No answer.

You're not going to say anything but yes or no?

MARTIN: Yes.

Okay.

Beat.

I was hoping to get it in your own words.

I edit out the questions.

Beat.

It'll sound silly.

Five minutes of someone saying yes and no.

Beat.

Yes. Yes. Yes. No.

Yes.

Etc.

Pause.

Okay. Are you feeling comfortable?

MARTIN: No.

Did your wife kill your children?

MARTIN: Yes.

>*That's what you believe?*

MARTIN: Yes.

>*Despite the evidence on appeal?*

MARTIN: Yes.

>*Did you love your wife?*

MARTIN: Yes.

>*Do you love her now?*

>**Beat.**

MARTIN: No.

>*Does she love you?*

>**No answer.**

>*Do you feel you're moving on?*

MARTIN: Yes.

No. Yes.

>*Do you still think I'm a parasite?*

MARTIN: Yes.

>*Do you want to explain? You can have the chance to expl –*

MARTIN: No.

>*Did you change your mind because you wanted to get your opinion across?*

MARTIN: No.

>*Did you change your mind because you felt different?*

MARTIN: No.

>*Did you change your mind because I've been speaking to Donna?*

>**No answer.**

>*Do you think she's ill?*

MARTIN: Yes.

>*Do you think she suffers from LKS?*

MARTIN: Yes.

>*Despite the appeal?*

MARTIN: Yes.

Do you think she should be in prison or in hospital?

No answer.

Do you think she should be in prison?

MARTIN: Yes.

Did you love your children?

MARTIN: What?

Did you love –

MARTIN: Of course I loved my fucking children, what sort of question's that?

It's just a question.

Beat.

Sorry.

Beat.

Did you love Donna?

Beat.

MARTIN: Yes.

But you believed she killed them?

MARTIN: Yes.

Do you see Donna now?

Pause.

MARTIN: No.

Were you aware at the time that she was ill?

MARTIN: No. Not really.

Would you like to explain?

No answer.

You didn't think she was ill, but you thought something was wrong?

Beat.

She was acting strange?

MARTIN: Yes.

Do you worry about the state of the world?

MARTIN: No.

> *Never?*

MARTIN: I let the world get on with it.

> *Are you still in pain?*

MARTIN: No. Yes. Sometimes.

> *Do you regret having children?*

> **No answer.**

> *Do you regret having children?*

> **No answer.**

> *Martin?*

> *Do you regret having children?*

MARTIN: I remember this one time coming home, right, and she was in tears because she'd seen this report by the Pentagon or something that by the year 2025 we'll be fighting wars over like water, any big river, like Nile, Danube, shared by different countries, she just, she was shaking. I'd say look, you've gotta relax and she'd say how can I relax when it takes a billion years to make a drop of oil and a second to burn it, I mean how the fuck can you argue with that?

And she'd see things and say like 'Well why are they reporting that?' and I'd say 'Because it's news and they are newspapers' and she'd say 'But they don't believe it, I mean they're intelligent people they can't believe it, it just doesn't make sense' I mean who actually gives a shit? Who gives a fucking shit? But round and round, fucking hell, I mean like I come home to find Megan in her cot, ignored and Donna upstairs crying and crying with the newspapers around her. Just bawling, like. Everything; global warming, terrorism, fucking North Korea or something, threats of worldwide epidemics or, I mean, I mean, I'd say you know, but what could I say? I mean what the fuck could I say? And sometimes she just wouldn't put Megan down. I mean for whole days, ten, fifteen hours, holding Megan and I'd say 'Put her down, for fuck's sake let go of her' and she's say 'Yes, yes' but she wouldn't do it she'd –

Pause.

You couldn't reach her after Megan's death. I mean, Jesus, I mean I, as well like, you know, but in the face of all that, like, all that, anything I felt was, and I'm not saying, because it was real, it was, it was definitely, but I mean Jesus. People selling their stories, papers publishing them, you know, kiss and tell, I mean some shit like that, I mean who gives, who gives a fucking, but it would just, like you'd just feel she was coming out or something then she'd see this and bang, straight away again, unreachable.

Beat.

I came home – this was after Jake was born and I thought she'd got better because during the pregnancy she was fine, which I find strange because you would imagine that'd be the most

Beat.

And how did she know –

Pause.

How did she –

Beat.

I'm not doing this.

Just yes or no, okay? Just yes or no questions.

Okay.

Do you ever regret having children?

Pause.

MARTIN: No. I never regret having my children.

Beat.

How did she know Jake was dead? How did she know? We're rowing about something, about some stupid program and suddenly her face goes white. And she knew – I know she knew – that he was dead. It was like, it was like a realisation hitting her and she belts upstairs.

And he's dead.

And in the ambulance she's just talking to him and talking to him and I'm thinking what's going on, I mean I didn't suspect, even then I didn't suspect, but I thought I'm just a fucking onlooker. There's all this stuff going on and it's like a foreign language, it's like being in a car with three people speaking French but you can't get out because they're taking you on a tour of Paris or something and not knowing what the fuck's going on.

That psychologist was right. When he told me it was like a light being turned on. And you know all this stuff's already there, but you've never been able to put it together and look at it.

It's amazing what you're capable of not seeing if you want.

Do you blame yourself?

MARTIN: My children were beautiful

Megan was gorgeous. Jake would be three and she'd be five.

Long pause.

I nearly went to a parents' evening last week. Reception and year one. I don't know why.

Would you like to see Donna again?

He gets up and walks away.

Martin?

No answer.

Would you like to see Donna again?

But he is gone.

Huge celebrations.

Streamers,

Music,

Noise,

Cheering.

Lynn comes forward, big grin.

Quietens everything. Leans into the microphone.

LYNN: This is a victory, not for me, not for you, but for
common sense.

Huge cheers.

When I started this campaign last year, I never, ever, for
one second believed that it was possible to win. I felt that
it was not possible for someone who has been through the
things I have been through to hold office in this country. I
realise now, to my shame, that I had not reckoned with the
extraordinary nature of the British people and the capacity
for goodness contained within the hearts of each human
being. For underestimating you, I sincerely apologise.

To say that I have been overwhelmed by the affection
and warmth that I have been shown by the people of this
constituency is so much an understatement that I can
scarcely bring myself to say it. You are the most amazing,
incredible people and –

Overwhelmed.

sorry, sorry, I…

Jim at her side.

No, it's fine, it's fine…

Beat.

and I can think of no higher honour than that of being
your representative.

Beat.

There are, of course, many thank-yous. First to my team,
who have campaigned tirelessly and, I might add, for the
most part wagelessly on my behalf, particularly to Jim who
has never left my side and who has put up with my moods
and conniptions with a grace that can only be described
as saintly, thank you Jim. I would like to thank all the
people who contributed financially to that early part of the
campaign, if you hadn't I would not be here, simple as.
And I would, of course, like to thank every single person
who voted for me and if I could do it in person, I would, I
look forward to serving you over the next few years.

Beat.

Most of all, though,

I think most of all

I would like to thank

Michael Dunn, Chairman of the Labour Party here in Thornton. Thank you Michael, thank you for allowing me to run as your candidate and for welcoming me back into the bosom of the party, thank you Michael, thank you so much.

Beat.

What we have achieved with regards to the Underhill development should not be looked upon lightly. We are very close to a deal that will place Underhill on Cott's Fields, a full three hundred and twenty-five metres further from the village of Brewood. The development will secure jobs in the area, will serve at least four to five major towns in the area with high quality retail outlets, and will bring improvements and prosperity to all our lives. This is a great day.

Dark on Lynn, celebration over.

Donna remains.

Thank you for agreeing to see me again.

DONNA: You're welcome.

Why did you agree to see me again?

Pause.

DONNA: You asked.

Pause.

I just have a few more questions. Just to finish up.

DONNA: Okay.

Beat.

Can you tell me about your life now?

DONNA: Yeah. It's good.

I've just started a metallurgy course. I'm thinking of being a jeweller. Or something. But my own designs, I think more craft, but nice, I've got some good ideas.

Working with your hands.

DONNA: Yeah. Yes.

And I'm learning Italian.

Really?

DONNA: Yes.

'Ho mangiato abbastanza. Posso avere il conto, per piacere?'

What does that mean?

DONNA: 'I have eaten sufficiently. May I have the bill please?'

Beat.

And generally things are, you know. I mean I have bad days. I have really bad days. But generally I think…

Beat.

I mean it's this thing that's given to us. It's a miracle.

Beat.

When I feel good I remember that. When I feel bad I just feel it's a nightmare.

If Martin would agree to meet with you, what would you say to him.

Pause.

DONNA: I'd…

I'd ask if he was alright.

Just that?

DONNA: Yes.

Beat.

What have you learned from your experience?

DONNA: Are you taking the piss?

Sorry. That's a stupid –

DONNA: Yes.

Sorry.

Beat.

Do you think you'll stay living with your mum?

No answer.

Donna?

Do you think you'll stay living with your mum?

Pause.

DONNA: Last week I looked at a flat.

That's good.

DONNA: In Aberdeen.

Beat.

Isn't that a bit far away?

DONNA: Yes.

You seem

different.

Long pause.

DONNA: I'm pregnant.

Are you?

DONNA: Yes.

Beat.

That's

DONNA: Yeah.

That's

DONNA: Yes.

That's

DONNA: I know.

Congratulations.

DONNA: Thank you.

Are you happy?

Pause for fifteen seconds.

DONNA: Yes.

I didn't know whether I was going to say anything, so…

Anyway.

That's…amazing.

DONNA: Yeah. Anyway.

> *Are you scared?*

Pause.

DONNA: Yes. I was.

> **Beat.**

I have these pills. You know, I've got these pills because I sometime have trouble, and I bought a whole bottle of gin, they're sleeping pills because I sometimes have trouble, so I thought, you know, bottle of gin… And I tried to look it up on the internet, you know, how many you need to do it properly and everyone says there's loads of this stuff on the internet but I must be stupid or something because I couldn't find anything, I mean I had the name of them and everything and I was on there for about an hour and a half, honestly I just got frustrated in the end and I thought right, I'll, you know, hang myself, so I made a noose out of this bed sheet – the only other thing I had was a bungee cord, so you know, not a great idea – so I made this noose but there's nothing, there's no beams or, I mean where do people fasten it? So I thought right, I'll jump off Lewisham car park. I don't know why I thought Lewisham, but I did, I just, so I drove there and the traffic, I mean it took three hours, it was a nightmare, but I got there in the end and I drove to the top and I was alone.

And I went to the edge.

And the sun was setting.

And it was really fucking ugly. It's Lewisham, I mean it was a sunset, but it's Lewisham, so…

But it was a sunset. And at last I was alone.

But I wasn't.

Was I.

> **Beat.**

So I thought…you know, fuck all that. Because then I'm just what they said I was. So fuck all that.

And I just watched the sun set over Lewisham with my baby in me.

Alone. Together.

She laughs.

Lewisham sort of saved my life.

DONNA: Thank you. Me too.

DONNA: Maybe. It's too soon to tell. But maybe, yes, maybe it is.

She laughs again, finding what's been said genuinely funny.

DONNA: Well, you know. I don't know.

Pause.

No one can understand. No one can.

That, I think, is the hardest thing.

And every person who ever looks at you, every time you look at a person looking at you, or talking to you, or speaking to you, or passing you in the supermarket, you can't help but wonder if they're wondering. And I can't ever get away from that, can I. That's the hardest thing. That's the hardest thing that's been done to me.

The separation.

Pause.

Oh well.

Have you got any more questions?

DONNA: Alright then.

Bye.

She leaves.

End.

ORPHANS

Characters

HELEN

DANNY

LIAM

I'd like to thank Matthew Dunster, David Lan, Tessa Walker, Ben Payne and Mel Kenyon for their help with this script. But most of all I'd like to thank Rox, for once again being tough as fuck and not letting me get away with anything.

Birmingham Repertory Theatre Company and Traverse Theatre Company in association with Paines Plough present *Orphans* by Dennis Kelly, first performed on 31 July 2009 at the Traverse Theatre, Edinburgh with the following cast:

LIAM, Joe Armstrong
HELEN, Claire-Louise Cordwell
DANNY, Jonathan McGuinness

Director, Roxana Silbert
Designer, Garance Marneur
Lighting Designer, Chahine Yavroyan
Sound Designer, Matt McKenzie
Assistant Director, Ben Webb

Stage Manager, Paul Southern
Deputy Stage Manager, Martin Hinkins
Assistant Stage Manager, Naomi Stalker

One

HELEN and DANNY's flat.

A candlelit dinner, interrupted.

HELEN dressed up, DANNY dressed up.

LIAM stands there having just come in.

He has blood all down his front.

Pause. They stare at him.

For a long time.

LIAM Alright, Danny?

DANNY Liam.

LIAM Helen.

HELEN Liam.

 Pause.

LIAM How's it –

 How's it going, like, you alright?

DANNY What? Yeah.

 Pause.

 You?

LIAM Yeah. You know.

 Beat.

 Not too, er…

 You know.

DANNY Right.

 Pause.

LIAM Nice dress.

HELEN What?

LIAM Nice dress.

Beat.

Is it new?

HELEN Is it new?

LIAM Yeah, is it, like

HELEN Is my dress new?

LIAM Yeah, is it –

HELEN Yes. It's new, Liam.

It's a new dress.

LIAM It's nice, it's sort of –

It's one of those…

Beat.

You having dinner? Where's Shane?

DANNY He's at my mum's.

LIAM Right. Nice. So you're having like a

DANNY Yes.

LIAM what, like celebratory, celebrating

DANNY What?

LIAM like a romantic

DANNY Yeah.

LIAM What's that, salmon?

HELEN You're covered in blood, Liam.

LIAM Yeah. Sorry about that.

Beat.

It's this lad's.

HELEN This lad's?

LIAM Yeah, it's this lad's

DANNY What lad's?

LIAM blood, it's this lad's.

DANNY Are you alright?

LIAM Yes. Yes, thank you, Danny, I am alright. Sorry. You should go back to your, it looks nice, is that your, is that your basmati…?

DANNY Yeah, it's

LIAM Yeah, it's not mine, it's this lad's blood. This poor fucking, just this poor lad's.

HELEN Has there been an accident?

LIAM Coming in like this, and you're having a dinner, like a celebratory

DANNY It's okay, don't worry, it's alright

HELEN Has there been an accident, Liam?

LIAM You do that, you do that, did you do that with lemon and olive oil, Danny? That rice you do, I love that, bit of the old cracked…?

HELEN So there has been an accident?

LIAM and I'm walking in like some sort of, some sort of fucking…

HELEN What sort of accident?

DANNY Helen, please…

LIAM It's gonna get cold, get all cold, Danny it's gonna get all fucking –

 Beat.

I come round the corner and he's

like, on the

fucking

lying, on the pave–, on the tarmac, on his own.

He's lying there on his own and I thought 'ah, no. Ah fuck, ah no, he's on he's own. He's on his fucking own.' And he was like an ordinary, Danny, you know, just like I don't know, I mean he looked like a decent, he looked, alright fair enough, maybe a bit you know, but like you'd have a drink with

him though, I mean not necessarily a friend, but you might in a pub or something, if you just, if you just met, game of pool, a pint with, a decent pint with, am I rambling? I am, aren't I, I'm rambling, talking shit, fucking talking shite, and now he's lying there on his own, completely on his own. With blood. And like, and someone has…

some fucking…

someone has really –

Suddenly overcome.

They watch.

HELEN So what, there's been an accident, then?

DANNY Jesus Christ, Helen!

HELEN I'm just asking, Danny! I'm just trying to clarify –

DANNY He said it's not an accident

HELEN When? he didn't say… Liam, you didn't say

DANNY He did, he did say, he just said

HELEN He did not say that it was not –

LIAM: That wasn't an accident.

She says nothing.

DANNY D'you wanna drink?

LIAM No thanks, could I have a glass of wine?

DANNY gets him some wine.

This country. It's just…monsters and… It's dark out there.

Sorry I didn't knock, I used the key. I know it's just, emergencies and stuff but I thought this might actually be a bit of a, you know, and I was thinking what if I knocked, Hels? and you see me it's like shock, someone like this, covered, but how do you not shock when you're covered, and then I panicked coz the door slams, that door, if you let it

go, doesn't it, Danny, if you let it go it slams back, so I was gonna call out, but then I thought you'd shit your fucking bricks, and in your, Hels, you know, condition and what have you, you don't need to shit your fucking bricks in your condition and I don't mean that to sound in a patronizing way, coz it's not like you're ill, you're not ill, or like you're ill or something, it's not like that, but still if you heard someone in the hall shouting out you would just shit your fucking, and that is not right. So I've been out there for about fifteen minutes really, not really knowing what to…you know…

do.

HELEN Liam, I want you to look at me.

LIAM Yeah.

HELEN Look at me.

LIAM I am looking at you.

HELEN Look at me.

LIAM Okay.

HELEN I want you to think. And I want you to tell me.
 Who's blood is this.

 Pause.

LIAM I tried to help him.

 DANNY gives him his drink.

DANNY The lad on the tarmac?

LIAM Yeah, the lad on the tarmac, and he's been hurt

DANNY By who?

LIAM By people.

HELEN By what people?

LIAM I dunno. I dunno what people. He was bleeding.

HELEN Where was he bleeding from?

LIAM Cuts.

DANNY	From cuts?
LIAM	Yeah.
DANNY	And how did you help him, what did you do?
HELEN	Why are you asking that?
DANNY	So we know what he did.
HELEN	Is that important?
DANNY	It might be.
HELEN	Liam, what did you do?
LIAM	I shook him and said 'Mate, mate?' Like that.
DANNY	You shook him?
LIAM	Yeah, I shook him, I shook, I was just shaking him, but gently like, you know, and maybe a bit harder, because I was getting panicky
DANNY	How hard did you shake him?
HELEN	He was trying to help, Danny.
DANNY	I'm just trying to establish
HELEN	Okay, but please don't give him the second degree
DANNY	I'm not giving him the second –
	Liam, sorry, I'm not giving you the second –
HELEN	Where did the cuts come from?
LIAM	Knives.
DANNY	Knives? Someone cut him with knives?
LIAM	On his chest and face and around his arms, like… slices
DANNY	Fuck!
LIAM	I think, I mean I dunno, maybe they weren't cuts, maybe they were… tears or something, rips
DANNY	Not stabbed him? They cut him? They've sliced, they've actually…?
HELEN	Was there anyone around, were you alone?

DANNY	With knives?
LIAM	I was alone, I was completely
	I hugged him. Sorry.
	Beat.
DANNY	Was he conscious?
LIAM	No
DANNY	He wasn't conscious?
LIAM	Yes.
DANNY	He was unconscious?
HELEN	Well if he wasn't conscious, Danny…
LIAM	Yeah, he was unconscious.
DANNY	Fuck.
HELEN	Why did you hug him?
LIAM	Coz…he was hurt. Sorry.
DANNY	Jesus Christ! People have cut him with knives. They've literally cut him with knives and left him there, unconscious.
HELEN	Where was this?
LIAM	Markham Street. I mean round the corner.
DANNY	They've literally cut him with knives on Markham Street and left him unconscious.
LIAM	I was coming back from Ian's.
HELEN	What were you doing at Ian's?
LIAM	I just went to say Hello.
HELEN	I thought you didn't like Ian?
LIAM	I just went to say hello.
HELEN	I thought you hated Ian?
LIAM	Yeah, he's a cunt.

This place, Helen. They do what they want. They run fucking riot. I'm scared to get the bus. Look what happened to Danny.

DANNY That was nothing. Kids, just, you know, kids or…

LIAM It's terrifying

HELEN Is he still there?

LIAM Who?

HELEN The lad. Is he still there? lying there, bleeding…?

DANNY Liam, is the lad still there?

LIAM He's gone.

DANNY What, he just got up?

HELEN What are you saying?

DANNY I'm asking, I'm just

HELEN You sound like you're cross examining

DANNY No, fuck, sorry, I didn't mean to –

Fuck, sorry, Liam, I'm asking, I'm just

LIAM Yeah, he just got up and went.

DANNY But you said he was unconscious

HELEN Danny!

LIAM yeah, he just like, fucking, like a bolt, he just bolted up, he just bolted up and, you know, he bolted off.

DANNY What he just got up and ran off?

HELEN What is the matter with you?

DANNY I'm trying to establish

HELEN you're not fucking Petrocelli

LIAM he was just, like a bolt, Danny, he just bolted up, and he stared at me and he was covered in blood and his eyes were mad and ran off. He never said one fucking word, he just ran off.
I feel really… I feel quite bad, actually

I think you should move, Helen. You know. Shane and that.

> *Beat. Suddenly HELEN pulls at LIAM's tops, yanking it up and beginning to examine his body for marks. LIAM lets her do this, and DANNY just watches. Satisfied that he is okay, she lets him go. Beat.*

DANNY Did you call anyone? The police, or…

LIAM My phone's off

DANNY an ambulance or –

You're phone's off?

LIAM No, not off, Danny, no, not fucking

DANNY You're phone was off?

LIAM off, no, Danny, not off,

DANNY Couldn't you turn your phone on?

LIAM I mean gone, flat like, you know, my phone was, the thing was there was no juice in the

HELEN His battery was dead, Danny.

LIAM Dead, yes, thank you. My battery was dead, Danny. Look I'll show you…

DANNY You don't have to show me Liam.

> *Beat.*

LIAM I just wanted to, you know, help, but I didn't know what to do, I kept thinking what do I do, and I was thinking I should go back to Ian because Ian's done first aid, but I didn't want to leave him on his own, because Ian's a cunt anyway and because he's a person, you know, he's like a person, lying there and you can't leave a person, just lying, in the street, lying on the ground, on the tarmac

DANNY This is insane, are you okay?

LIAM Yeah, yeah, no, I'm alright. Actually. I'm fine. I'm fine, actually, yeah, this is

> *He is crying, though he tries not to.*

No, I'm…

DANNY Liam?

LIAM Ahhh, shit. Shit, shit, shit, look at me, look at this, you're having dinner, celebration, celebratory,

HELEN we're not celebrating, we're just

LIAM and I'm coming in like some sort of

HELEN Don't worry about that, Liam.

DANNY Liam, do not worry about that.

LIAM rice, and

HELEN That's fine, Liam

LIAM I think you should move, Helen. This area… Because out there…? Animals, not kids, fucking…

> *He is crying.*

> *She goes to hug him, but he pulls away.*

Nah, nah, I got blood, I got blood all on me.

Sorry, fucking tears, and, what a cunt.

HELEN You're not a cunt.

LIAM I am, I'm a cunt.

HELEN You are not a cunt.

DANNY You're not a cunt, Liam.

LIAM Do you think I could have a hug, Helen?

HELEN Come here…

LIAM *(Pulling away.)* Nah, nah, the blood, the blood

HELEN Alright, look, we're gonna get you cleaned

LIAM This top's fucked

HELEN You can wear one of Danny's, can't he Danny?

DANNY Yeah, of course.

LIAM It was a present from Jeanie. Jeanie got me this Hels, it was a

HELEN I know, but we can clean it.

LIAM Nah, it's fucked. I've fucked it

HELEN You haven't fucked it

DANNY Which one?

HELEN 'Which one'?

DANNY Just take any of them, Liam. Any of them's fine.

LIAM Thanks, Danny, thanks, you're –

 He hugs DANNY. DANNY keeps him at a distance so as not to get blood on him.

 Sorry. Sorry.

 HELEN takes LIAM off.

 DANNY sits at the table. Looks at the food, hungry. Pokes at the rice with his fork. Puts the fork down. Considers. Decides. Lifts a fork-full of rice to his mouth.

 HELEN enters and he puts the rice down. She carries a blue top.

HELEN Are you eating?

DANNY No.

HELEN I'm gonna give Liam this to wear, is that okay?

DANNY Yeah. Is that my blue one?

HELEN It's your blue one.

DANNY Don't give him that, Helen, give him the green t-shirt

HELEN Why?

DANNY Helen, please give him the green one, that's the blue one, that's new

HELEN What green t-shirt?

DANNY The one with eagle-star on it.

HELEN it's in the wash

DANNY Fucking hell, Helen…

HELEN Eagle-star?

DANNY Did you tell Liam you were pregnant?

 Beat.

HELEN Yes.

 Is that a problem?

DANNY No.

HELEN Why is that a problem?

DANNY We only found out on Monday, I mean shouldn't
 we wait until

HELEN Shit, sorry, Danny. I mean

DANNY three months or – no, no, Helen, I'm not having a,
 it's not a problem, it's a question, I'm just

HELEN Sorry, shit, I just

DANNY No, no, Helen, I'm not, its not a problem, I'm not

HELEN I just needed

DANNY having a go, or

HELEN Someone to talk to.

 Beat.

DANNY Oh. Alright.

 Pause.

HELEN Look, if you wanna eat something, just eat.

DANNY No, I'll wait for you.

HELEN Just eat.

DANNY No, I'll wait for you.

 Pause. A moment.

HELEN Fuck.

DANNY I know.

HELEN Poor Liam.

DANNY I know.

Is he alright?

HELEN Yeah. Yeah.

I think so. What do you think?

DANNY Yeah, yeah. I think he's alright.

He's strong.

HELEN He's not strong, Danny.

DANNY No, he's not strong.

HELEN Thank you for this. You know, for being so…with all this

DANNY What? Jesus, no, I mean it's, it's Liam. I mean he's…part of us…

HELEN And sorry I'm a bit…you know

DANNY No, no, god, no, you're not, not at all

HELEN Oh, I am. I am a bit.

DANNY You're not, you're really, really not.

HELEN Well. Thank you anyway. I mean that, Danny.

Pause. She looks at the food. Touches him.

So much for our special evening.

DANNY I know. Never mind.
We should be able to get another in one when Shane discovers drugs

Beat.

HELEN Are you being sarcastic?

DANNY No, it was a joke.

She is staring at him.

I was joking

HELEN Sorry, Danny. Christ, sorry.

She hugs him. He returns it.

You should make them funny, then I'd be ready for them.

They break the hug, but still close, touching.

DANNY Why did you need someone to talk to?

What, in a bad way?

HELEN No, not in a bad way, Danny, I just needed

DANNY Because you can talk to me.

HELEN I can't talk to you.

DANNY Why can't you talk to me?

HELEN Would you talk to me?

DANNY Yes.

HELEN What, you would talk to me?

DANNY Yes.

HELEN If you, like, needed

DANNY Yes, yes

HELEN to talk, chat about, you would talk with me, would you?

DANNY Yes, I would talk to you.

Beat.

HELEN Well that's not how most people work.

DANNY What did you need to talk about?

HELEN Have I done something wrong?

DANNY No, no, god, I'm not

HELEN telling my brother, did you not want me to, because

DANNY No, Helen, of course, no, no –

HELEN Good.

Beat.

DANNY Listen, Liam's going to be fine. We'll make sure he is.

She smiles at him. A moment.

HELEN I'd better give him the shirt. Eagle star?

DANNY Yeah, the green one.

 I'll call the police.

HELEN Okay.

 He goes to the phone.

 What?

 He stops. Looks at her.

 Sorry, what are you –?

DANNY Calling the police.

HELEN Right.

DANNY I mean we've got to call –

HELEN Oh yeah, course.

DANNY Don't we, I mean we have to

HELEN Oh, yeah, yeah. Course.

DANNY Shall I do it while you're in there?

HELEN Great. Why?

 Beat.

DANNY 'Why?'

HELEN Danny, hang on, just give me a minute, Liam's in there –

DANNY 'Why?' Someone's been hurt.

HELEN I know, but

DANNY So we should call the police

HELEN Just hang on, is all I'm saying, a minute,

DANNY What for?

HELEN is all I'm saying,

 look, don't do one of your panics, please, this is

DANNY What?

HELEN let's just think, for five minutes

DANNY What's there to think about?

HELEN because this is all a bit mad, and we're, you know

DANNY Are you saying we should *not* call the police?

HELEN No, definitely not.

DANNY Is that what you're saying? Are you saying that we should not –

HELEN I am definitely not saying that, that is something I am not saying, but I am saying can we just, for a minute, for five minutes, without panicking, without flapping think first, please.

DANNY I do not flap.

HELEN Because this is my brother.

DANNY I know it's your brother.

HELEN He's the only family I've –

DANNY I know he's the only family you've got.

HELEN Well don't say it like I'm boring you.

> *Beat.*

They're going to think Liam had something to do with it.

DANNY No they're not.

HELEN They are, yes, they are, because he's always, he's unlucky, Danny, you know he's unlucky, he has a record because he's unlucky, and

DANNY What are you talking about? They are not going to think that.

> *Silence. She stares at him.*

What?

HELEN Right.

Right, okay, right. You know when you were in Miami?

> *Beat.*

DANNY When?

HELEN	When you were in Miami.
DANNY	When?
HELEN	When you were in fucking, when you were –
DANNY	When? When? what time, I've been there three times, what
HELEN	The last time, the last fucking time, I'm talking about the last
DANNY	Well I don't know that, do I?
HELEN	Well why would I start a sentence like that if I didn't mean –
	The last time, Danny, the last time you were in Miami.
DANNY	Okay, okay!
	April.

Beat.

HELEN	The time before that.
DANNY	November.
HELEN	November, yes, well when you were in Miami in November this thing happened and
	and the police came round, but
DANNY	What?
HELEN	No, no, it's fine, he was completely innocent, he was with me the whole time
DANNY	The police came round?
HELEN	so it wasn't anything, you know the way he stays when you're not here, you know how protective he gets, so he was here with us, so
DANNY	The police came round here?
HELEN	Yeah, but that's not important, it was completely a mistake, they said it was a mistake and everything's fine, but the thing is

DANNY Not important? Why didn't you tell me?

HELEN Because, it's not… Danny, you're fixating on the wrong thing, it's not about that

DANNY Why didn't you say anything?

HELEN Because Liam didn't want me to.

DANNY Why?

HELEN Because he fucking adores you and he made me promise not to tell you, but that's not why I'm telling you, so can I please tell you why I'm telling you, please?

DANNY The police came round here?

 Beat.

HELEN Look, the thing is, I mean the thing is they were on a mission. They were on a mission, Danny. Right, this bloke gets hurt and someone, some scumbag said Liam's name and he's not even there, no one thinks he's there, no one, but some scumbag says Liam's name and because Liam has a record, because he's unlucky, Danny, and yes, stupid, he's done stupid things but a long time ago, but they did not give one single solitary fuck, they were on a mission.

 You see you think, right, and I'm not criticising, but you think that things work out fair, but things don't. Not for people like Liam. They really don't. This isn't the fair world you think it is, Danny, and I'm not saying what you believe and think is wrong because I love you for that, but now is not the time for that, because this is now. They are going to think Liam had something to do with this.

 Please. He can't handle this, not now. Please, Danny.

 Pause.

114

DANNY Liam's innocent, Helen. He hasn't done anything. He has nothing to fear from the police, he is innocent. There is a boy, out there now, hurt. We have to call.

 Pause.

HELEN You are so…

 you are so fucking…

 you are so…

DANNY What, what are you –

HELEN How can you be so, I mean Jesus Christ, how can you be so fucking naïve? How can you walk around like, you walk around like nothing in the world is and then these boys, these fucking boys! You know, and you go on as if they're innocent and its your fault, our fault for breath, excuse me for fucking breathing a fucking breath, I fucking…

DANNY Jesus Christ, Helen, I'm-

HELEN Alright, well let's not have this child then.

 Beat.

DANNY What?

HELEN You know, if that's…how, if you're gonna be all, if that's what you, if that's you're thinking Danny, then what's the bloody point in, let's not bloody well, we, we, we shouldn't, into this world at all, then.

 Beat.

DANNY Helen…do you mean that?

 Beat.

HELEN What?

DANNY Do you mean…?

HELEN No.

DANNY I mean do you, have you been thinking…?

HELEN Yes.

DANNY Yes?

HELEN No. Maybe.

 I don't know. Maybe. Maybe yes. Maybe I do. Shit.

DANNY Are you serious?

 Pause. She is thinking.

HELEN Okay. Look, no we can't, that's not for now, because, Liam, I mean Liam is in there, so… Yeah, yes, okay, we can talk about, like later, because now we have to take care of

DANNY Is this something you've been thinking?

HELEN so, so, so I'm just gonna, because he's in there, half naked

DANNY Fucking hell. Jesus fucking

HELEN because I've got to give him the, because he's standing in there half naked so, alright, yes, I'm just going to give him the… Okay?

 She goes. DANNY sits back down.

 Looks at the rice. Thinks.

 LIAM comes in wearing DANNY's eagle-star t-shirt.

LIAM Jeannie gimme that shirt. Helen said it'll be alright, d'you think it'll be alright?

DANNY What?

LIAM D'you think that'll come out, what gets blood out?

 DANNY just stares at him.

 It's just that Jeanie gave me that shirt. Christmas present, last thing she gave me, you think that'll just wash, just wash out Danny?

DANNY Yeah, it'll probably just wash out, Liam.

 Beat.

LIAM Thanks for lending me this.

DANNY	You're welcome.
LIAM	What deodorant do you use?
DANNY	Er, Lynx, I think.
LIAM	Yeah, nice.

Beat.

You alright, Danny?

DANNY	What? Me? Yeah, yeah, I'm fine.
LIAM	You sure?
DANNY	Yeah, I'm
LIAM	You're having dinner and this turns up.
DANNY	Liam, you're always welcome, you know you are
LIAM	Yeah, but you know…
DANNY	We gave you a key, you know you're…
LIAM	And I appreciate that. I don't forget that

Beat.

You alright after all…that?

He makes a vague gesture. At first DANNY doesn't get it, but then…

DANNY	What? Oh, yeah, yeah no it was just
LIAM	Fucked.
DANNY	Fucked, yeah, but
LIAM	I mean fucking hell
DANNY	Yeah, but you know, it's just one of those things
LIAM	There's nothing you can do. There's too many of them and they know that, the little cunts.
DANNY	They do, there was nothing -
LIAM	You're not less of a man.

Beat.

DANNY	I know.

LIAM Asians, were they?

 Beat.

DANNY Well, some of them, but I don't think –

LIAM No, I don't mean it like that.

DANNY I mean I don't think that was

LIAM Yeah, no, Danny, not at all, I mean that's all fucked
 that sort of

DANNY a factor

LIAM racial, I mean, no. Ian's like that and he makes me
 fucking sick. Giving it all 'The Asians this and the
 Asians that.'

DANNY Yeah

LIAM and 'I'd like to cut open a fucking nigger's stomach'
 makes me sick, Danny, makes me sick, that sorta
 talk. Makes me wanna fucking hit him, actually, and
 Ian gives it all that but he ain't exactly a big man,
 cut open your stomach, see what you think.

DANNY He's a bit of a prick.

LIAM Yeah.

 He's a mate though, so…

 Pause.

 You wanna talk about it?

DANNY What?

LIAM You know. Talk about it?

DANNY No. It's fine, Liam.

LIAM I'm shaking.

DANNY Are you?

LIAM Yeah, look.

 He puts his hand on DANNY's forearm.

DANNY Yeah.

LIAM Fucking hell, eh?

DANNY Yeah, you're

LIAM Like a leaf.

 Beat.

 I tell everyone about you, all my mates. You're living proof of what you can achieve. You're brilliant. This area, though, Danny, you know. You should take Shane out of here. Man of the family and all that.

DANNY Yeah, yeah. It's not that bad.

 It's good for transport. And they're opening a coffee shop round the corner so –

LIAM I hate violence. It makes me cry. Always has, you ask Helen. You ask her, you ask her about Brian Hargreaves, I cried like a baby when he got hurt. She saw me through that, she was like an angel, an angel sent from god, I used to thank god that he'd given me one of his angels for a sister, don't tell Helen that, but I did actually think that's what he'd done, Jesus, I'm just jabbering shit, sorry, sorry

DANNY It's fine, Liam.

LIAM I was so happy when you two got together. I was over the moon when she told me you were getting married. I cried when she said she was carrying your child. I always knew she'd make a great mother, she could've abandoned me, could've let them split us up, that's what they wanted, they used to look at us and think we could really place that girl, but that boy… I know that, Helen doesn't know I know, but I know. And she never once allowed that, and more than that, Danny. Never even entertained the thought.

 We're abandoned here. Government? Fucking left us to beasts, and that's not blaming it on the Asians, Danny, coz they're good people some of them, some of them are very, very good people, not the

cunts that did you, or hurt other people, go around hurting, they're scum, they're filth, but some of them…victims. Victims of prejudice.

DANNY Your hand.

LIAM What?

 Realises. Take his hand away.

 Oh, sorry, Danny, sorry, I'm fucking… Brain's gone to shit.

 Where's Shane?

DANNY At his Gran's.

LIAM Ah, shit, fuck, look at me. Gone to pieces, brain's gone all –

 HELEN comes through with the top, soaking wet. She goes straight into the kitchen without looking at them.

LIAM D'you think it'll be alright, Helen?

 But she has gone. Pause.

 Jeanie used to tell us these stories, you know, and they were shit like, you know, I mean they never used to go anywhere and afterwards we'd be like in fits of laughter coz she'd just told us this story that went fucking nowhere, fucking nowhere, Danny. Yeah. Like you'd get a bedtime story about a horse named Darby and basically it's a talking horse and it'd have an owner who'd take it to market and at the market he'd meet an old friend and go off for a drink and the friend would ask the owner if he needed a job and he'd say yes and they'd go back to this bloke's farm where they'd work together bringing in the corn and his wife would get ill but then a doctor would come and heal her, and that'd be the story, that'd be the fucking story and we'd be like in fits of laughter, but Jeanie, wouldn't get it, she'd carry on, and we're going 'but what about the talking horse' but she was never bothered like, she'd just carry on. She was an angel. We wished

we coulda stayed with her. Kept in touch all those years.

DANNY I wish I'd met her.

LIAM Thanks Danny. Thank you for that.

You think it matters how hard I shook him?

Because you asked how hard, and, I mean d'you think –

DANNY Liam, I think you were trying to help and your natural instincts wouldn't've let you do anything to harm him

LIAM D'you think so?

DANNY Definitely.

LIAM Okay. Okay.

 Beat.

Okay.

 HELEN re-enters. Long pause.

HELEN I'm not sure that calling the police will help.

 Beat.

Danny wants to call the police, Liam.

LIAM Does he?

HELEN When you were in there he said he wanted to call the police.

 Pause.

Well, did you say you wanted to call the police?

DANNY I…suggested…

Liam, I suggested

LIAM No, no, fair enough

DANNY I suggested, Liam, because

LIAM No, fair enough, Danny, you're right, course. We should, we should…

HELEN	What, call the police?
DANNY	We should, shouldn't we? Liam, I mean shouldn't we…?
LIAM	Don't you think, Hels?
HELEN	I don't know, do you?
LIAM	He was hurt.
DANNY	I mean what if it was us?
HELEN	It wasn't us.
DANNY	What does that mean?
HELEN	I'm just saying, it wasn't us, so what's the point in saying something was something when something wasn't something?
DANNY	Someone's been hurt, Helen! Someone has hurt another person. Someone is bleeding, someone is bleeding now.
HELEN	Someone who might be involved, for all we know.
DANNY	Involved? Involved in what?

> *Beat.*

HELEN	Right. Right. He got up and ran away.
DANNY	And that means he was involved in something?
HELEN	I don't know, I don't know, Danny, but there was violence. There was at least a violent thing that he might have been involved in, or might not, but just say he was and we call the police and basically put Liam through all that for someone who, well, who might be…well, dodgy.
DANNY	Dodgy?
LIAM	I don't think he was dodgy, Hels.
HELEN	I mean he got up and ran off,
DANNY	He was terrified!

HELEN	Exactly! He was hurt but he didn't stay there? What's going on, think, Danny, I mean Christ, what was he wearing?
DANNY	What's that got to do with
LIAM	ah you know
DANNY	We can't judge him on
LIAM	all the gear
HELEN	I mean round here? a lad, hurt? lying on the floor, wearing all the gear? what's he been involved in, what's he running from?
LIAM	No, Hels, I don't think, definitely, I don't think he was
HELEN	Because I tell you one thing, I am sick of this place. I am sick of the people I love, my people being subordinate to the people out there, people who basically do what they want, run around, calling me a cunt, yes, Danny, because that happens Danny, when I'm with Shane, Danny, bitch this, and bitch that and you just want to close your eyes?
DANNY	No, I don't want to –
HELEN	Show us your cunt, bitch, how's your cunt today, bitch, can I lick your cunt, bitch, show us your cunt you cunt. And you do nothing.
DANNY	What do you want me to do?
	Beat.
HELEN	All I'm saying is that Liam has a record. He has a record. I'm saying that the police are going to be suspicious.
LIAM	Are they?
HELEN	Of course they are
LIAM	Yeah. They might be suspicious.
HELEN	They're the police, Liam, they're paid to be suspicious. He has a record. He has a record,

Danny, I'm asking you please just to think about that. There is a lad covered in blood and it's all over Liam's shirt

LIAM You just washed it

HELEN That doesn't matter Liam, there'll be DNA, that stuff never comes out, and how is that going to look? The first thing we do is try and clean the evidence

LIAM Evidence?

HELEN Yes!

LIAM Does that look bad?

HELEN Washing the evidence? Does that look bad?

DANNY Then why did you wash it?

HELEN Because it was covered in fucking blood!

And will it help? Will it help anyone? This lad, who may or may not have been involved in something, and I'm not judging him, I don't know him, but I know people like him. And who are we helping? Someone who gets up with these cuts of his and runs off into the night, running from something and we don't know what that is, will it help him to call the police? Liam gets guilty if you so much as look at him.

LIAM I go bright red if I talk to the police.

HELEN He tried to help. Is that a bad thing? Should he be punished for that?

LIAM They make me feel guilty, the cunts.

HELEN For someone we've never met? My brother for some…lad we've never met?

Beat.

DANNY It's a person. There is a person out there.

HELEN Not a person I know.

DANNY What do you mean I do nothing? What do you
 expect me to do?

 Pause.

HELEN If this boy is innocent I feel very sorry for him. If he
 isn't, then I don't. But I don't know him.

DANNY Is that what the world comes down to these days,
 then? Who we know and who we don't know?

HELEN Yes.

 Yes, it does, Danny. Today. These days. These days
 that is exactly what the world comes down to. Who
 we know, and who we don't know. Sorry.

 Pause.

 What I would like you to do…

 What I would like you to do, Danny…

TWO

Later.

LIAM, HELEN and DANNY, sitting at the table.

LIAM is eating, tucking into the salmon and rice.

They watch. He eats, enjoying his food as if they weren't there.

Silence, just the sound of LIAM eating.

He finishes. Pushes back his plate

HELEN What were you doing at Ian's?

LIAM Ah, he's a mate.

HELEN He's not a mate, Liam

LIAM No, he's not.

HELEN He's a bad influence.

LIAM That was beautiful, Danny, that was

HELEN He collects Nazi memorabilia.

LIAM He don't collect it, he's just got some. Gets it off the internet.

HELEN You shouldn't go round there.

LIAM Yeah, he's got like loads, really sick it is, got like letters, jackets, canisters of zyklon B, it's sick, it's really sick. It's mad, it's really disturbed stuff, Danny, though some of it is amazing.

HELEN You should stay away.

LIAM I said to him, that's sick and he just laughed. Some of it is really amazing, though, he's got a Lugar with SS on the hilt

HELEN That's sick

LIAM That's what I say, it's sick, but it's amazing as well and he's getting into all modern stuff, got this machete, reckons it's from Rwanda, getting all into all stuff from Iraq and Afghanistan, reckons he's gonna get a severed hand from the Democratic

Republic of Congo. Downloads all those videos, like violence, gang violence and shooting beatings and beheadings, jihadist whatnot, he loves all them sites.

HELEN Were you watching them?

LIAM No.

> *Beat.*

Some of them are terrible.

HELEN You shouldn't see him.

LIAM I don't even like him, but he's a mate, you know.

We was at school together, so.

> *He gets up. Stands there.*

HELEN What are you getting up for?

LIAM No reason.

HELEN Why don't you sit down?

LIAM Okay.

> *He sits. Long pause.*

Can't just abandon people.

That rice was lovely, Danny. Simple, just simple ingredients, that's what I love about your cooking: lemon, cracked pepper and a good olive oil – what could possibly go wrong? Just simple, Italian, it's quite Italian really, see I wouldn't think about that, I love cooking but I'm a vulgar cook, I'd put loads in, spices, herbs, oils, pastes, fucking shitloads, I make food like I'm mixing cement, I know I'm doing it but I can't stop, the only thing I can really make is chilli, I'm a vulgar cook, Danny. That was fucking beautiful.

DANNY I can't believe we're doing this.

HELEN No, well, we are. We've made a decision so let's –

DANNY I know we've made a decision, I'm just saying.

> *Silence.*

LIAM	There's… There's a steam fair up the park, did you see that, Danny?
DANNY	No.
LIAM	Yeah. No, not now, next week, the weekend, they're having it like, there's posters up there, you know. Steam fair next week, sort of thing.
DANNY	Is there?
LIAM	Yeah.

Beat. He stands up.

Yeah, it's good they do that sort of thing, they do a lot of that sort of thing in that park, it's good.

DANNY	What's a steam fair?
LIAM	I'm not sure, as it goes.
DANNY	Is it a fair?
LIAM	No, it's not a fair.
DANNY	Not rides
LIAM	No, I don't think so, I mean if it is I don't think it's very quick coz it's all steam.
HELEN	Why don't you sit down?
LIAM	Yeah, it's like steam things, just like big steam, like a steam tractor or a big fucking steam, engine, or something.
DANNY	Right.
LIAM	Maybe like a carousel, but like it's steam, you know, so it's not gonna go very fast.
HELEN	Why don't you sit down, Liam?

He sits.

LIAM	Tea cups, you know.
HELEN	Tea cups?
LIAM	Yeah.

No I mean if you sit in a tea cup or something.

HELEN What tea cups?

LIAM It's for the kids, you know them things, them rides,
 for

HELEN No, I don't know

LIAM for kids, where they're in a tea cup, carousel, you
 know the things.

HELEN No, I don't know steam-powered carousels with tea-
 cups for kids.

LIAM Well, I think it might be like that, I dunno, I'm just
 guessing.

 Pause.

 I was thinking of taking Shane.

DANNY Oh.

 Yeah, yeah, he'd love that.

LIAM Thinking of taking him at the weekend.

DANNY Yeah he'd love that, Liam.

LIAM Great.

HELEN What are you talking about?

 Beat.

LIAM Taking Shane –

HELEN In the park?

LIAM Yeah.

HELEN It's in the park?

LIAM Yeah, but it's –

HELEN You're thinking of taking a five-year-old to a fair in
 that park?

LIAM Yeah, but it's in the day, Helen.

HELEN A fair? Kids hanging out and stabbing each other?

DANNY It's a steam fair, Helen.

HELEN	You don't even know what a steam fair is, you're worse than him.
LIAM	It's in the day, it'll be fine, it's a family thing.
HELEN	He's not going up that park.
DANNY	It's in the day…
HELEN	Are you two insane, he's just walked in covered in blood!
DANNY	It's in the day
HELEN	No way.
LIAM	He'll love it, Hels, it's like these steam engines and stuff, it's a family thing, there's gonna be families there and –
HELEN	Do you want some coffee?
LIAM	No.
HELEN	Do you want some coffee?
DANNY	No.

LIAM gets up.

What are you getting up for?

LIAM	I dunno. I just feel a bit… Is it hot in here?

I think I'll stay up.

HELEN	Sorry, I'm snapping, but…you know. I don't mean to snap, but…
DANNY	What time is it?

HELEN looks to LIAM.

LIAM	My phone's dead.

She gets up. Goes to her phone. Looks. Sits back down.

HELEN	Five past nine.
DANNY	Do you think he's alright? What past nine?
HELEN	Five past.

Long pause.

LIAM Fucking tense this, innit.

DANNY Maybe we should go out and look for him?

HELEN What, now?

DANNY Yeah. Check he's

 I mean alright, we've made a decision and we're
 not calling, and I agree, I'm with that, but he's out
 there, maybe hurt, maybe, I don't know, so maybe
 we should…check.

HELEN Out there?

DANNY Yeah.

HELEN Could do. Yeah, I suppose we could do. But…

 I mean the sun's gone down. It's dark…

DANNY He's a human being. Whatever else he's done,
 he's a human being, and I agree, we've got to look
 after Liam and, and ourselves, but aren't we a bit
 responsible for

HELEN Yeah, we are, you're right, but…

DANNY our fellow, I mean isn't that what we hate?

HELEN Oh we do, yeah, but

DANNY fuck you and I'm alright Jack and all that old

HELEN Oh, yeah, we do, definitely, hate that, you're right,
 but, I mean it's dark

DANNY It is. But this is important.

HELEN On your own?

DANNY What? No, well I was thinking me and Liam…

HELEN Liam can't go.

LIAM I'm not going out there, Danny

HELEN He's gotta stay away from it.

LIAM I'm shitting it Danny, I can't go out there

DANNY Right, right, fair enough.

HELEN You wanna go on your own? At this time?

DANNY Well…

HELEN After dark?

LIAM I admire that. After what happened to you

DANNY Oh, just kids and

LIAM Kids? Cunts.

DANNY and I was a bit drunk, so…

HELEN Maybe it's not a bad idea. To see.

DANNY Yeah, yeah. Maybe.

Which, which way did he go, Liam?

LIAM Away from the shops.

DANNY Right.

Into the…

LIAM Into the estate, yeah.

DANNY Right. Right.

Right.

Pause.

HELEN I think you should stay here with us.

DANNY You're probably right.

Silence. They wait.

LIAM Tense.

Pause.

Shanie excited?

No answer.

Little brother? Bet he's excited. Or sister, could be, couldn't it, sister, little sister, that'd be lovely, I bet he'd love a little

HELEN Don't say anything to Shane, Liam.

LIAM What? No, no, if you don't want me to –

HELEN I mean that, don't you say anything to –

LIAM No, no I won't

HELEN Don't you fucking say a word to –

LIAM I won't, Hels, I won't!

 Pause.

 Why?

HELEN Because…

 Pause.

LIAM What?

 Beat.

 What?

 Hels? What?

 Pause.

HELEN Look, we're not

 one hundred percent…about…

 Pause.

LIAM What?

HELEN It's just

LIAM You're joking.

 Why?

 She says nothing.

 Why?

HELEN I don't think this is the right time to discuss

LIAM Yeah, course, sorry, no.

 Beat.

 Don't. Please don't.

 Sorry, fuck, sorry. Sorry, Danny. Sorry, Hels, none of my business, none of my fucking, but don't, Hels. I mean Christ, you're such, you two are such great parents and Shanie's such a great little man.

HELEN I don't think

this is the right time to talk about

LIAM I'm so sorry Hels, I'm so sorry Danny, this isn't the right time to talk about this at all, and it's none of my, not at all

But I don't understand why? I thought you wanted more?

HELEN Yeah, we…we do originally, I mean originally

LIAM I thought that was the plan

HELEN That was, yes, the plan originally, originally that was…

DANNY Originally?

Beat.

HELEN Look, nothing's decided, Liam, we haven't even, I mean me and Danny haven't even really, have we, properly yet, so. But we were thinking that maybe, with the way things are, the question is, circumstances, you know living here and, and, and giving up my job as well, that's definitely, and at the moment maybe that isn't the right…possibly.

LIAM I don't understand.

HELEN Look. We just think maybe this isn't the right –

DANNY You.

Pause.

HELEN What?

DANNY You just think. Not we. You.

Beat.

I want it. I want our child. I don't understand why you don't. Why don't you want it?

HELEN I…

DANNY I keep touching your stomach. Haven't you noticed me touching your stomach? I keep touching your stomach because I want to touch it, him, her, I want

to touch him or her, I want to touch him or her and I want to push love for him or her through my hand, through your stomach, through your womb and into our child so that he or she knows that he or she is loved.

HELEN I didn't

I didn't say I didn't want it.

I said…there's a –

you're not making this, Danny, this is –

I said there's a…doubt.

DANNY Why is there a doubt? Why do you have a doubt? I don't have a doubt, why do you have a doubt? Why do you now have a doubt about having this child with me?

Pause. They are looking at her. Cornered.

HELEN You want me to…?

DANNY Yes.

HELEN You want me to say, in front of…?

DANNY Yes

Pause.

HELEN I'm not…

When I look at this, our life, or lives, here, I'm not, if I'm honest, one hundred percent that it is entirely working or working out to, or in such a way, as, as, as well as we might have

been led to believe that

expectations…allow.

Beat.

DANNY What?

HELEN I'm, you know, I think, maybe this has made me think about

DANNY Expectations?

HELEN and on balance, looking at everything, and are
 we comfortable bringing another, and it's just a
 question, I'm not accusing and it's me, us, both,
 Danny, but the question is still there.

DANNY Expecta…? What fucking question?

HELEN Look.

 Alright, Danny, Look. I'm… I'm just not one
 hundred percent sure our life, its what we

DANNY You

HELEN thought it was going to be when, when, when we

DANNY When you

HELEN Danny, that's not helping, that really…

 Beat.

 Look, I'm, I'm not saying that we are

DANNY You are

HELEN That we are talking about

DANNY that you are talking about

HELEN I'm not saying that we are talking about.

DANNY you're not saying that you are talking about

HELEN ending, no, not at all, because we are

DANNY You are

HELEN You are such a piece of shit, you are such a piece
 of shit sometimes, sometimes you are such, such a
 fucking piece of…

 Sometimes I look at you and I fucking…

 I fucking…

 Beat. She sits.

 Silence. For a long time.

LIAM You been up the grave?

 Long pause.

136

HELEN	Mum and Dad's or Jeanie's?
LIAM	Jeanie's.
HELEN	Yeah, I was up there…

Beat.

Not in a while.

LIAM	no, no, she won't mind, she knows how busy you are, and I was up there last week, so…

What about Mum and Dad's?

Beat.

HELEN	I've been meaning to.

I was thinking of going next week.

LIAM	Ah, that's great, Hels, yeah.
HELEN	Yeah, maybe Tuesday.
LIAM	I could come with you if you like.
HELEN	Yeah. No, I've got an early on Tuesday, so
LIAM	Right
HELEN	Maybe, later
LIAM	Yeah, course
HELEN	Maybe Friday. Maybe I'll go Friday.

You wanna come on Friday?

LIAM	Yeah. Brilliant.

Beat.

I always say hello anyway, when I go up I say hello for you. I say 'Helen says hello.' I tell them what you been up to.

HELEN	Thanks.
LIAM	They're so proud.

They're so proud of you, Helen. You and Danny, and everything you are, you know.

Long pause.

HELEN	I'm sorry, Danny, that was a bit, you know. But you…
	Pause.
	So it's a family thing? This Steam thing?
LIAM	Yeah, I think so, I asked the guy up there and he said it's just for the kids.
HELEN	Right.
LIAM	Yeah. He said it'll be full of families.
	Beat.
	Plus the odd dirty old man with a beard.
	Beat.
HELEN	What?
LIAM	What?
HELEN	Is that supposed to be a joke?
LIAM	What?
	Beat.
	Oh, no, not
HELEN	Is that supposed to be funny?
LIAM	No, no, I wasn't, I don't mean, not paedo
HELEN	That's not funny, Liam.
LIAM	enthusiasts, like steam
HELEN	You said dirty old men with beards
LIAM	I meant enthusiasts, not paedos
HELEN	You said –
LIAM	I meant steam enthusiasts
HELEN	You said…
LIAM	God, no, I'm sorry, I'm sorry, Helen, I meant like dirty because of the engines and –
	Ah, Jesus, what am I saying…
	I'm sorry, Helen, I don't know what I'm saying

HELEN It's alright

LIAM I'm all, look at me, I'm all

HELEN It's alright, Liam.

LIAM Is it fucking hot in here or what?

HELEN What time would he be back?

LIAM Oh, it's a morning thing, have him back here by one.

HELEN Right.

Well, maybe…

Pause.

I think I'm meeting Sarah on Friday, but maybe we could go to see Mum and Dad some time the week after.

DANNY So we're going to let whatever's going to happen to him happen to him. Because he's not one of us.

They stare at him.

No, I just want to be clear. Because if we're going to do this we should be clear.

HELEN We're not doing anything.

DANNY Because we've made a decision, haven't we. We've looked at the situation, accepted it, summed it up and made a decision to do nothing. Because he's not one of us.

HELEN Danny…

DANNY So if we choose, knowing that he's hurt – not by us, by someone else, but still – but we choose to do nothing and if he's losing blood and that's hurting his body, if that is causing damage to his system, then we are choosing to allow something that causes damage to his system and is that the same as choosing to cause damage to his system?

LIAM Do you think it's damaging his system?

139

DANNY I don't know Liam, that's what bleeding is.

HELEN Why are you doing this? Don't, Danny, really don't

LIAM I mean do you think he's in danger?

DANNY I don't know, Liam. But just say that we knew he was going to die…

HELEN For fuck's sake, Danny!

DANNY No, I'm just saying that if we did know that, and we took a decision to let him die, then what sort of people would we be?

HELEN He's not going to die

DANNY because he's a lad, he's wearing

LIAM I mean d'you think he's… How long does it take?

DANNY What, to bleed?

HELEN He's gone to a hospital, Liam, he's probably in a hospital right now –

DANNY To bleed to death?

HELEN Don't say bleed to death!

LIAM But if he didn't, Hels, if he didn't go

DANNY If he didn't we don't know, Liam, I mean how bad was he hurt?

HELEN He got up and ran off!

DANNY There was a lot of blood

HELEN Danny, please

DANNY I'm just saying

HELEN I know you're just saying but you're winding Liam up and he's winding you up and together you're blowing this all out of proportion

 Beat. Pleading look from HELEN.

DANNY Okay, right, okay; he's not going to die, this boy

LIAM D'you think so?

DANNY I don't know, Liam, but say he isn't. Alright? Say he isn't, but what if that's wrong? And what if he is, what if he is in fact going to die?

HELEN Jesus Christ…

DANNY And forget the courts and prosecution and charges, the courts, even if no one ever finds out that we do nothing, we deliberately did nothing, we took a choice to do nothing, and he dies, how do we live with that?

LIAM because he looked hurt.

HELEN You prick.

LIAM because he looked hurt bad, actually, Hels, I'm a bit worried as it goes

HELEN He'll have gone to hospital, Liam he will now be in a –

LIAM What if he couldn't?

DANNY well if he couldn't I don't know, there was a lot of blood.

HELEN Danny, please don't, because this is too serious, to

DANNY What? What's the matter?

HELEN You know. You know what's the matter.

DANNY What, is this not meeting your expectations?

HELEN You are such a fucking coward

DANNY Oh, here it comes.

HELEN This is your answer? Is this your fucking answer?

DANNY Yes. This is my cowardly answer.

HELEN And you wonder why, if, you wonder why –

LIAM But say if he didn't, Hels?

HELEN Who?

LIAM The Asian lad

 Pause. Silence.

HELEN	What Asian lad?
LIAM	What?
HELEN	What Asian lad. You didn't say he was Asian.
LIAM	Didn't I?
HELEN	No.

Beat.

LIAM	Well he was
HELEN	You didn't say
LIAM	I didn't think
HELEN	Right
LIAM	it was important
DANNY	He was Asian?
LIAM	Yeah, but I didn't think
DANNY	You didn't say he was Asian
LIAM	I just didn't think it was, you know…
DANNY	Okay.
LIAM	Coz it doesn't really

matter, because I'm not really, you know, his colour, his creed, I'm not really, all that sort of, you know, doesn't bother, I'm not, I'm not –

Sorry, why? Why d'you think it matters, I don't think it…

He was hurt. He was a hurt person. He was a hurt Asian person Danny.

DANNY	Okay. Alright.

Pause. Silence.

So what do you mean, 'if he didn't'?

LIAM	What?
DANNY	What do you mean 'if he didn't'?

LIAM	Well, you know…with that amount of blood, what if he didn't get up and run off, d'you think he would've been alright?
DANNY	What if he didn't run off?
LIAM	Yeah, would he be alright, d'you think
DANNY	Did he run off?
LIAM	Yeah, he did, but I'm saying if he didn't
DANNY	What, run off?
LIAM	Yeah.
DANNY	Did he run off?
LIAM	Yes, but
DANNY	So what does it matter?
	What does it matter what would've happened if he didn't run off?
LIAM	It don't matter.
	No, it doesn't matter, it –
	Why? I mean…you know…
	Beat.
	It's hypothetical
HELEN	Why are you being hypothetical?
	Silence.
	You're hiding something.
LIAM	No. I'm not, I'm not hiding
DANNY	Are you, Liam? Are you hiding something?
LIAM	No, I'm not, I'm not hiding –
	Pause. They are staring at him.
	I don't believe you're…fucking
	being like… For him? You don't even… I'm your brother, Helen, and Danny I thought we was, you don't even know what sort of person…

143

Beat.

Alright. Alright, he was, yeah, he was dodgy. Alright? He was a little fucking, a dodgy little, and that's not racist, but he was involved in all sorts. He was involved in –

And, I'm not casting aspersions but all I'm saying is, right, alright, I'll tell you what, all I'm saying is you don't know what sort of person he is alright? I mean I don't either, fair enough, but you said, Helen, you said that he was probably, so it's me over him, I don't understand why you're taking the side of a dodgy…

 Pause.

HELEN Did he get up and run off, Liam?

LIAM Yes.

HELEN Then tell me.

 Beat.

LIAM Helen. I swear to you, on mum and dad's grave, he got up and ran off.

HELEN Okay. Right. Okay.

 Pause.

So what is it you're hiding?

LIAM I'm not –

DANNY What aren't you telling us, Liam?

LIAM Don't start, Danny

DANNY Why are you saying he's dodgy?

LIAM He said it, okay? Happy? I didn't wanna say anything coz I didn't wanna say anything bad about him, but he told me, from what he said, piecing it together, fragments, he told me he was involved in, in stuff, indicated that he was involved in all sorts, and you don't know this world, Danny, you're a nice bloke and I like you but you don't know, not

144

really, not when it gets, bad things, essentially, fighting and money and stuff like that. That's what he was involved in.

DANNY He told you this?

LIAM Yes.

DANNY He just volunteered this information?

LIAM He was hurt so, in a state of, and I was helping him

DANNY He just came out and told you this stuff?

LIAM Yes. Yeah, I'm saying…

I pieced it together. Yes. From what he, ramblings and

DANNY When did he tell you this?

You said he was unconscious. You said he was unconscious, Liam.

Silence.

Liam?

LIAM What?

DANNY You said he was unconscious.

LIAM Yeah.

HELEN So when did he talk to you?

LIAM When he…

When he – hang on, hang on, okay – when he…

got up and ran off.

DANNY No.

LIAM No?

DANNY No. Not then. You said 'he got up, opened his eyes, stared at me through the blood and ran off.'

HELEN Were you lying?

LIAM No, no, of course not, you're confusing me now.

HELEN When did he speak, then?

145

LIAM Before.

HELEN Before what?

LIAM Before, he, before, when I found him, he was
 talking, like

DANNY But you said he was unconscious.

 Beat.

LIAM Alright, look, stop it. You're confusing me, so just
 stop and…

 and…

 Alright.

 Beat.

 I found him. He was unconscious. He wakes up and
 started talking but then he passed out again, which
 is when I got blood all on me, because I held him in
 my arms, I didn't want him to bang his head and I
 put him down and then, a minute, and then he gets
 up and bolts off.

 They stare at him.

 And that's what happened. And I don't, I can't
 explain why I didn't say it was like that but I didn't.
 Alright? I didn't. Are you gonna believe me? That's
 all you've got to ask yourselves.

 Are you

 going

 to believe me.

HELEN Liam –

LIAM No. No Liam, because you're my sister and I'm
 telling you something, you are my sister and I'm
 telling you something. So, Danny, so Helen…are
 you going to believe me? Yes or no?

 Yes or no, are you going to believe me?

 Beat. Suddenly a phone goes off.

Cheesy ring tone.

No one moves.

Rings again.

Rings again.

Rings again.

LIAM takes it out of his pocket and turns it off.

Puts it back.

Silence.

He just come out at me.

He just, I was scared like and he, he just come out at me like that and I didn't, I just lashed out. You know, an impulse or, I think he thought he was with his mates coz he's not a big lad, and there's no way, I mean he's not gonna come out at me on his own, I thought he thought he was, you know it's an alley and he's come out at me, you know, to do something quite bad, actually, to hurt, or rob, or, just hurt, I was scared anyway coz it's dark that alley and he just come out at me like a fucking, steam train, Danny, you know. And I just turned and, lashed, and, lashed out, and, caught him, and…. And he went down. And –

Beat.

I just kept hitting him. I mean I was crying, I was crying but I was smacking him and pounding him and he's on the floor, silent, not saying anything like, and I couldn't work out why and I'm hitting and hitting coz I'm shitted right up and I think I might of, you know, started cutting –

Like, I had this blade?

Ian

He was showing me these little throwing knives he's got, tiny, little heavy fat knives for throwing, blade about an inch and a half long, but he keeps

147

them really sharp, like, and we're talking and he's showing me other stuff and what have you and I didn't know I still had it, til I saw the blood coming out of these cuts I'd made with it.

On this boy.

I was so angry, I was just 'why d'you come out at me, you little cunt' and he's not answering, he's not saying a word, which is making me angrier, and I stop and there's, just like blood, blood, and he's unconscious. That's, that's why he's not said anything. He's unconscious straight away, like, and I was, I kept, y know…

> *Beat.*

I hugged him.

> *Pause.*

Hels? Hels?

Danny?

> *Beat.*

Hels?

Three

LIAM alone, anxious.

Sitting. Staring.

Sniffs T-shirt.

HELEN enters.

Pause. They stare at each other.

LIAM You remember Brian,

Hels?

Brian Hargreaves? You remember him?

She doesn't answer.

You remember, at Shackleton, we was at, before we went to, we was, we hated that school, didn't we, we was always, you know, outside and. Year four they wouldn't let us be in the same class, would they. Would they, Hels, they wouldn't let us, not in the same class, I remember that Hilson, that cunt Hilson 'She's in year six, Liam. Helen has to be in with the older children' well fuck you, you beardy cunt, our parents have just been burnt to a crisp, so –

Beat.

Brian was alright, weren't he, you remember, Hels?

You remember him eating that stick? You remember that? A fucking stick, Hels, he ate a fucking stick! Big fucking stick off the floor. I mean who would eat a…

Beat.

Only one of them ever talked to me. The dirty gypo kid who eats sticks.

HELEN I remember.

Pause.

LIAM Yeah.

 I was saying to Danny. I cried when he got beaten up.

 The violence. I just cried and cried and cried.

 Beat.

HELEN You mean when you beat him up.

 He looks at her.

 What do you mean 'when he *got* beaten up'?

 You beat him up. When *you* beat him up, Liam, when you beat him up, what do you mean –

 You smashed him to a pulp.

 You hit him with a brick.

 You broke his fingers, you pulled them back, you snapped –

 We had to leave school.

 I didn't hate that school, I loved that school. That was the best school we were at. We were never at a school like that again and we had to leave. I loved that school.

 Silence.

LIAM Danny alright?

 Beat.

HELEN Yes. Yeah, he's…alright.

LIAM Reckon he's a bit shook up.

HELEN No, he's fine.

LIAM Feel a bit funny in this shirt.

 Sniffs it again.

 I've fucked up haven't I?

HELEN Yes.

LIAM D'you ever wish they split us up?

Beat. She stares at him.

No, do you, though?

HELEN	How can you say that?
LIAM	You'd've got a good family if they'd split us up.
HELEN	I've got a good family, we're a good family
LIAM	There's something wrong with me.
HELEN	You didn't mean it.
LIAM	I'm scared, Helen. What am I?
HELEN	You…you over-reacted, you just
LIAM	Are you getting rid of it coz of me, Hels?
HELEN	What?
LIAM	Am I destroying you? Am I destroying you and Danny?
HELEN	What are you talking about?
LIAM	Am I a poison?
HELEN	Liam
LIAM	Am I a cancer, am I a dirty cancer
HELEN	You are not a dirty cancer
LIAM	Are you gonna tell the police?
HELEN	No. No, god, Liam, of course I'm not –
LIAM	Is Danny?

No answer.

I'll drink bleach before I go to prison.

Beat.

HELEN	You're not going to –
LIAM	Tell him that, tell him I'll drink bleach before I go inside.
HELEN	Don't manipulate me.

LIAM I love you. I love you so much. I love Shane. I love
 Danny. But I really love you. I really, really love
 you

 I'm fucking shitting it. I'm shaking again.

HELEN Sit down.

LIAM Okay.

 He sits.

 DANNY enters.

 Pause.

HELEN How is it?

DANNY yeah, it's fine, she's gonna keep him for another
 couple of hours.

HELEN Is he asleep?

DANNY It's half nine.

HELEN He should stay there.

DANNY She doesn't want him to stay there, she's got a thing
 in the morning.

HELEN But he's asleep…

 What did you say?

DANNY I just said that we needed a few hours.

HELEN That sounds like we've got a problem.

DANNY You're right, I should've said your brother turned
 up covered in blood following an incident with a
 knife.

 You know what's she's like, she doesn't ask
 questions.

HELEN She's gonna have to wake him up now.

 Beat.

 Sorry.

 Thank you for that, Danny. Thank you for doing
 that.

152

Pause.

LIAM How's your mum, Danny?

DANNY Yeah, she's okay.

LIAM She alright?

DANNY Yeah, yeah, she's fine.

LIAM Lovely woman. She's got, got a great sense of humour.

DANNY Has she?

LIAM I thought so.

DANNY Okay.

HELEN I was saying to Liam that we're going to sort this out.

DANNY Right. How?

LIAM Sorry, Danny.

DANNY How are we going to sort this out?

LIAM I'm really fucking sorry. I'm poison, I'm a cancer, a dirty cancer.

DANNY How are we going to sort this out?

HELEN Liam wants to ask you something.

DANNY Does he?

HELEN Yes.

DANNY Okay. What does he want to ask me?

LIAM Right.

Danny, I am really sorry about all this, I mean you're, you, you're a nice bloke, a really decent, and you don't deserve this, you're not that sort of bloke and I really respect you and everything, you ask Helen, I tell my mates about you, I tell them what you're doing and how your work's going and…

Beat.

I was wondering

153

what you were thinking of doing.

DANNY Doing?

LIAM Yeah. Like now.

DANNY What I'm thinking of doing?

LIAM Yeah, what are you gonna do? Are you gonna –

Are you gonna call the police?

> *Silence.*

DANNY Liam, I'm not gonna call the police.

LIAM I love you two

HELEN See?

LIAM I love you two so much

HELEN See? I told you, I said

DANNY Of course I'm not gonna call the police

HELEN I told you, there's no need to worry, Danny's not, he's not gonna

Danny's not…

Danny is not going to –

> *Beat. Suddenly she hugs* DANNY. *Clings to him, suddenly desperate.* DANNY *returns the hug, love between them.*

> *Continues.* LIAM *doesn't know what to do. Goes to speak, doesn't. Waits… Waits…*

> HELEN *is still clinging to* DANNY.

> *They break. She pretends she has not been crying.*

HELEN Great.

LIAM Thank you, Danny.

HELEN That's…

No, I mean good.

LIAM Thank you so much.

DANNY It's alright, Liam.

HELEN Good. Great. No, that's good, that's…

LIAM	Thank you so much, I feel like crying.
HELEN	Don't cry.
LIAM	No, I'm not gonna cry, but I feel like crying, that's what I feel like.
HELEN	Great. Good. No, good, that's…
	Good. Good.
	Now we just need to sort out what we're going to say.
DANNY	What?
	Beat.
	What do you mean?
HELEN	Well, we need to sort out our story.
	If the police come here. And ask us.
	We have to say that Liam was here. With us.
	Beat.
DANNY	We have to say that Liam was here with us?
HELEN	Yes.
DANNY	To the police?
HELEN	Yes. Of course. Isn't that what we're talking about?
DANNY	No.
HELEN	No?
LIAM	No, Danny?
HELEN	Well, what are we talking about?
DANNY	We're talking about not calling the police.
HELEN	But if they ask?
DANNY	Are they going to ask?
HELEN	No, they're not gonna ask, they're never gonna ask, they're not gonna ask in a million years, but if they do ask…

Then we'd have to say that Liam was here. All night.

 Beat.

Danny?

DANNY Look, hang on

HELEN What?

DANNY You're saying lie?

HELEN Yes.

DANNY To the police?

HELEN Yes, to the police, of course to the police. Who else?

Danny?

DANNY What?

 Beat.

Doesn't that make us

accessories, or

HELEN Yes. Yes, it does.

DANNY Jesus.

HELEN Danny?

DANNY This is going too fast.

HELEN It has to go fast.

DANNY Why are you so calm?

HELEN I'm not calm.

DANNY Can we just slow, please, can we slow things down and

HELEN No, we can't slow things down

DANNY think, because

HELEN we can't think we have to do.

DANNY I mean isn't that, what you're talking about, like aiding and

HELEN Well, what do you think this is?

DANNY abbeting, or – Not that, it's not that, this is not that.

HELEN What, not calling the police? Not calling the police is not that?

DANNY No, it's not the same as

HELEN Yes. It's the same as.

DANNY No, no, I don't think it's

HELEN Yes it is, fucking hell, Danny, wake up, this is not a game, this is your family, yes it is exactly the same, don't bury your head.

DANNY No, look, this is really serious, though.

 I mean Christ, what, like in a court of law? is that what, are we saying

HELEN It's not gonna come to that

DANNY like under oath

HELEN It's not going to come to that, but yes. We are. That is exactly what we are saying.

DANNY I don't believe this. That is…serious, it's really, really serious.

HELEN Yes, it is. It is really, really serious. So can you please decide how much your family means to you.

 Pause.

DANNY No.

 No, sorry, look…

 fucking hell…

 Look, I, no, no sorry, Liam, I mean Jesus Christ, this is one thing but that, you're talking about actually fabricating and maybe in a court of law and, Christ, sorry, no, I mean we have, this is our life. We have a child. We have jobs, we have a house, we have a child. No. Sorry, no.

 Pause.

HELEN Are you saying no?

157

DANNY Yes.

 Beat. She goes to the phone, picks it up.

 What are you doing?

HELEN I'm going to call the police. I'm going to tell them what's happened.

LIAM Hels?

DANNY Right, don't start being dramatic

HELEN I'm not being dramatic

DANNY because, look, don't start

HELEN I'm not being dramatic I'm just calling the police and turning my only brother in to the custody of the law

LIAM Er, Hels?

HELEN because we either do something or we don't, Danny. We do one thing or the other, we don't do half a thing, because that's doing nothing or doing the other thing or worse, there is no half thing, there's only one thing or another, there's doing or not doing, there's having a family or not having a family, there's us and them, protect or don't.

LIAM Hels?

HELEN No, Liam, because I'm not having this hanging over our heads like some fucking, every minute of every day waiting and knowing that I have in my family, in my home, every day, every night, looking at it across the breakfast table, staring at it, watching it chewing.

LIAM Are you serious?

HELEN Yes. At least this way you tell them. You tell them, you admit, it'll be better for you. *(To DANNY.)* It's one thing or the other, Danny.

 Beat.

DANNY Is this what you did when I was in Miami?

> *She doesn't answer.*

I don't recognise this. I don't know what this is.

HELEN Are you going to help?

Are you going to help?

Are you going to –

Yes, this is what I did when you were in Miami because he was innocent, he's my brother and he was innocent.

You don't go out after dark anymore. You cross the street when you see a group of lads. You sit on the bottom deck of the bus and you stop talking when there are boys around. I need to know if you're a coward.

> *Beat.*

I hate living here, are we going to live here forever? I'm not frightened of doing things for my family. Liam would die for this family. He would die for us, he would lay down his life for Shane, he would willingly stop breathing to save you.

DANNY I'm… I am not frightened of doing things for my family either.

HELEN Are you going to help?

Are you going to help?

Are you going to –

DANNY Yeah.

> *Beat.*

HELEN Say yes then.

DANNY Yes.

HELEN Say yes, then.

DANNY Yes. I'm going to help.

And I'm not a fucking coward.

Beat. She puts the phone down.

LIAM I love you two. I love you two.

I love you two so much.

I think he was one of the lads that did you, Danny.

Beat.

There's no law out there. We're abandoned.

I love being here, coming here, you know that? I love being in this house, you two, Shane, walking in here is like walking in to, I dunno, perfume or like warm, a warm, I just love it actually. But going back out there is like walking into shit. Like walking into a soft wall of shit. Into fucking sewage, Danny. You imagine walking into sewage, Danny? well it's exactly like that, sometimes I wash the soles of my shoes, I scrub them with a nail brush.

I wanna be honest with you because you're so beautiful.

I followed him. I saw him ahead of me and I followed him. He was just walking ahead of me and I thought 'you little' and I followed him, close, just to scare 'you fucking little' and he's frightened and I'm thinking 'how'd you like it, you little fucking, hurting people I care about?' in here lending me your T-shirt, out the wash, but still, and I'm screaming at him, you know, I've got hold of him, been hitting him, hitting his face, and I'm screaming into his face, you Paki, you Arab, you terrorist, you fucking bin Laden, you beheading piece of, you not-my-colour cunt, how dare you how dare you threaten the people I –

Pause.

I dunno what come over me

I'm not like that. I'm not a racist. I dunno why

I dunno why…

I just wanted to scare him.

I dragged him into Ian's shed.

Tied him up. Hurt him. Left him there.

He's still there.

He's tied up. He's scared. There's a lot of blood.

> *Pause.*

Brian Hargreaves started saying shit about you, Hels. He said you was gonna leave me. He said you'd asked them to separate us, begged them, he said, said you'd told him, said you was gonna go off, started saying all this shit about you, about my sister, said you was gonna go off with some posh family, said it was all sorted and you was gonna leave me. He was saying shit about you, that's why…

I love you. I love both of you, all of you.

I love the fucking smell of you.

> *Silence.*

HELEN	Can…can he recognise you?
LIAM	Yes.
HELEN	He knows who you
LIAM	Yes.
HELEN	he knows who you are?
LIAM	Yes. I told him.
HELEN	Right.
LIAM	I wanted him to think he was going to die.
HELEN	Right.
LIAM	I showed him my driving licence, I wanted him to think
HELEN	So he knows who you are.
LIAM	Yes.

HELEN Right. Right.

 Beat.

LIAM Helen?

HELEN I'm…

 I'm just trying to think Liam.

LIAM Okay.

HELEN Okay?

LIAM Sorry.

HELEN No, no, I just need to

LIAM Yeah, yeah, course.

HELEN Because this is, a bit, I just need to

LIAM Yeah.

HELEN We need, we should

 talk to him.

LIAM Right.

HELEN Explain…

 We should explain, er, have a

LIAM Talk to him?

HELEN a chat, talk, just to, er

LIAM He's scared.

HELEN Yeah, yeah, but if we talk to him

LIAM He's hurt bad.

HELEN Is he?

LIAM Yeah. I think he needs a hospital.

HELEN right.

 That was a bit, that was a bit stupid, Liam, showing him your

LIAM yeah I know

HELEN Because that's

LIAM Yeah

HELEN A bit

LIAM Yeah. Sorry.

HELEN No, no, but…

 Danny?

 Beat.

 Any…?

 Any ideas?

DANNY Any ideas?

HELEN Yeah, any…

 Beat.

 ideas?

DANNY Did you hear what he just said?

HELEN Yeah, but there's no point in

DANNY A chat?

HELEN We have to be

DANNY A chat?

HELEN practical, so don't start

DANNY a chat, did you just say chat, did you just suggest
 having a chat with a tied up Asian boy?

HELEN I know you're a bit shocked, but

DANNY Are you fucking mental?

HELEN you're surprised, this is, I'm surprised as well, and

DANNY You fucking attacked this boy?

HELEN angry, even

LIAM Angry?

DANNY You cut him with a knife, you tied him up, you
 tortured him?

HELEN Alright, but let's keep this

163

LIAM Are you angry, Helen?

DANNY What was going on, how could you do that, how could he do that?

HELEN Alright, what do you want to do?

LIAM Are you angry with me, Hels?

DANNY What do I want to do?

HELEN Yes. What do you want to do, what do you actually want to physically do, when you've finished flapping, when you've finished panicking, and screaming and screeching like a child, like a little fucking girl, Danny, when you've finished thinking and fantasising that we can do nothing what do you actually want to physically do?

DANNY Don't talk to me like that.

HELEN Do you agree we have to do something?

DANNY Do what?

HELEN Well, for example, we could do nothing, we could leave him there tied up and he could starve to death.

DANNY Why are you even saying that, that's stupid, that's –

HELEN Or Ian'll come home – yes, it is, it's stupid – and find him and call the police or do whatever he does when he comes home and finds tied up Asian boys in his shed, is that what you want to do?

DANNY Obviously not,

HELEN No. So we have to do something, we have to do something to help, to help, just stop thinking of yourself, Danny, and help.

DANNY Help who?

HELEN Help the boy, the boy, help the boy who's tied up

DANNY Did you hear what he said? He has to go to fucking hospital, he's –

HELEN	Yes, exactly, he has to – right, yes, that's good, now you're thinking, that's, hospital, exactly.
	You're right, he has to go to hospital. We have to take him
DANNY	Take him?
HELEN	Yes, of course take him, he can't get there on his own, how else will he get there?
LIAM	Sorry about all this, Danny
HELEN	We can't call, that's out of the, that's an ambulance, that's the police, that's prison, we can't call
DANNY	He's gonna call the police anyway
HELEN	That's why I'm saying we have to talk to him.
DANNY	Who, the boy?
HELEN	Yes, the boy, we have to talk to him.
DANNY	Talk to the boy?
HELEN	Yes, we have to talk to the boy.
DANNY	And what are we going to say to the boy?
HELEN	We have to convince him not to say anything.
	We have to talk to him.
	We have to scare him.
	We have to frighten him. For his own good.
	Beat.
	What else can we do?
	We have to make sure that he's not going to say anything, we have to make him think that we're going to
	kill him if
DANNY	What?
HELEN	if he, yes, if he says anything, yes, yes, kill him, torture him, kill his family, whatever it takes to make him say it was a random attack.

DANNY And how are we going to do that?

HELEN You have to threaten him.

DANNY Me?

HELEN Well he's not going to be frightened of me, is he.

DANNY Me?

HELEN You can, no I mean, you wear something on your, over your head

LIAM Ian gave me a balaclava

HELEN a balaclava, you can wear a balaclava over your head and scare

DANNY I'm not wearing a

HELEN so he doesn't see you and so he thinks Liam's not just, not just an isolated, not just one person, not just on his own.

 Pause.

 Danny, I don't think, not for one, not for one minute that what he did, I don't agree with that, I'm shocked, and horrified and, but let's leave that for later, one side, and now, because he is my brother and he did this terrible, stupid thing to someone who… was he one of the boys who hurt Danny, Liam?

LIAM Yes.

HELEN Definitely?

LIAM Yes, definitely, he told me, he admitted it, he was one of those boys.

HELEN You're sure? He wasn't lying?

LIAM He wasn't lying. He was too scared to lie.

HELEN to someone who hurt you. He did it to protect you, in some way, and no matter how misguided that was he was trying to protect you and now you have to protect him because he loves you and I love you and now we have to do something.

We have to act to make it the best it can be for everyone.

Please.

Beat.

DANNY I

can't do that.

Pause.

HELEN What if it was Shane?

What if Shane came home covered in blood.

DANNY Shane is five.

HELEN He's not going to be five forever.

DANNY Don't talk about Shane coming home covered in –

HELEN What if Shane's twenty, or eighteen, or sixteen, or fourteen and he comes home covered in blood? What would you do?

Beat.

DANNY Why are you asking that?

HELEN What if it was Shane? Or

another child?

Beat.

DANNY What?

HELEN What if it was Shane, or…

or another child?

Pause.

DANNY What other child?

HELEN Another child.

DANNY We don't have another child.

HELEN No. We…could. We could have another child, if…

What if we had another child, and it was another child?

Beat.

DANNY What if we had another child?

HELEN Yes.

DANNY And that child came home covered in blood?

HELEN Yes.

DANNY The other child?

HELEN Yes.

Beat.

DANNY I thought… I thought you didn't want another child.

HELEN Did you?

DANNY Yes. I did.

HELEN Well.

nothing's been

decided. Yet. It's all

it's all up for grabs.

DANNY Is it?

HELEN I'm asking for your help. I'm asking for you to make up your mind.

Pause.

DANNY What if we had another child and that child came home covered in blood?

HELEN Yes. What would you do?

DANNY What would I…?

Beat.

I would…

I would…

Pause. Looks at LIAM. At her.

HELEN Is this a family? Tell me. Tell me, is this a family?

Beat. Suddenly DANNY goes into the bedroom.

Silence.

LIAM Is he…is he gonna help?

Hels?

She doesn't answer him.

Is he? Is he, Hels.

HELEN Don't talk to me.

Beat.

you make me sick. You make me sick, you make me so fucking…

You piece of…

How could you, what kind of person, how could you bring in here…

Don't talk to me.

Four

Late at night. No one here.

DANNY enters, coat on. Stares at the room as if he doesn't understand it.

Calms. Goes to sit, but doesn't. Decides to go into the kitchen, but HELEN enters. She has been in bed, but not asleep.

Pause.

HELEN Danny?

He opens his mouth to speak, but no words come out.

She stares at him. He goes to speak again, but instead goes into the kitchen. She doesn't know what to do. She waits.

After a moment he re-enters with a sandwich on a plate and a can of beer. Stops. Stares at her.

DANNY I haven't eaten.

HELEN No

DANNY I didn't have any

dinner

HELEN Yeah, no, you should…

He doesn't answer.

Where's…

Where's Liam?

DANNY He's alright.

HELEN Where is he?

DANNY He's alright, he's gone to the grave.

HELEN It's twenty past one.

DANNY Said he wanted to see Jeanie.

HELEN It's twenty past one.

DANNY Yes.

HELEN Are you okay?

He can't answer.

DANNY I haven't…

I didn't have any dinner, so…

Looks at the sandwich. Picks it up.

Puts it back down.

Can you hold my hand?

Beat. She goes to hug him.

No. Don't.

She stops, doesn't know what to do. Holds his hand. Pause.

He takes his hand away and uses it to drink the beer with. When he put the can down he doesn't take her hand again.

I went up the park. Went to look at the poster, the steam fair. There's a picture of –

it looks alright, it looks okay, actually –

there's a picture of a big steam engine and a family, blonde, all cheesy, but maybe that's the point. You know like circus posters, old ones, families and kids, people smiling, I couldn't tell whether it was a shit poster or whether that was supposed to be the point.

You know I kept looking at it and I thought

Beat.

is that the point, is that supposed to be…

Beat.

I stood there in the rain. For about an hour. I couldn't move.

She goes to hold his hand.

Don't touch me.

She stops.

He picks up the sandwich.

Can't eat. Puts it down.

HELEN What did you do?

DANNY I scared him.

HELEN Do you want to tell me?

DANNY No.

 Pause.

Liam had tied him to this workbench, just this shitty shed at the end of Ian's garden, he tied him so that, I mean it was too small, the bench, for his legs. So they were hanging down, you know, bended at the knees and, and he had no

shoes on, and he'd tied him, like strapped him with rope and those bungee cord things and he had lots of, on his body, there were quite a lot of

cuts, on his body, there were lots and lots of –

He'd cut him.

Quite a lot.

 Beat.

And his face was swollen. Like one side was like a balloon so that one eye was shut and the other was just staring like mad, a cow or something, just, you know, there was a lot of blood actually, speckles and spots, some of it was dried and black, I mean he looked like

a monster or something, a swamp

thing

or something, not human and I kept thinking why's he got no shoes on.

 Pause.

Oh yeah, and there were holes in him. Holes in his flesh.

Where Liam had stabbed him with the knife.

It's this really small knife, like with this stubby little fat blade, but because it's small it doesn't go too far, it just breaks the skin, he'd been poking holes in him. Belly, arms, upper legs, lots and lots, actually.

Pause.

There was one hole in his cheek and I could see where the blade had snapped a tooth, you know the force, a molar, I think, not an incisor, so it must've been quite, the force must've been quite, like metal on tooth, snapping and I thought 'that's painful'.

There was this weird smell, I kept thinking 'what is that? What is that smell?' it was, you know, excrement, yes, because he'd, the fear had made him, and I didn't know that really happened and the shed was, you know, musty, but there was something else I couldn't –

HELEN Why are you telling me this?

DANNY What?

HELEN What are you…

 What are you trying to…

DANNY Why am I telling you this?

Beat.

I screamed at him. I stood there in this balaclava and screamed into his face, 'tell me where you live, you paki. Not so fucking clever now, not so big without your fucking mates, you paki, you nasty paki, tell me where you live you nasty fucking paki.' I was like a fucking –

Beat.

because he wouldn't, he was scared we'd hurt his family so he wouldn't tell us, he just wouldn't. We got the gun, we broke into Ian's house and got the Luger and pointed it at him. I pointed it at him and

told him I was going to fire it into his eye and when that didn't work I smashed the butt of it into his cheek. I did that, me. That's who I was.

HELEN And

and did he tell you?

DANNY What?

HELEN Did he

you know…

DANNY Yes. He told us. We made him tell us what it looked like so we could be sure it was the right place, and then Liam went to check on it.

HELEN Liam went?

DANNY You think I was going to leave him alone with Liam?

> *Beat.*

So I just sat there. Staring at his feet. Listening to him crying. Just crying, you know. And in the end I thought 'I'll put his shoes on. At least I can put his shoes on', because I was, I was me again, I wasn't any more like and I felt, was feeling, and I picked up his shoes and I went to his feet.

It was petrol. The smell. Liam had taken his shoes off to pour petrol all over his feet, I think he'd tried to, I mean there were matches all over the floor, like from a book, but shitty ones, so, so he couldn't, they didn't work, the damp, so they wouldn't light, so that's…

You know.

> *Pause.*

So that's, you know, that's good, that's a positive, at least….

HELEN And

And is it okay?

DANNY Is it okay?

HELEN Was it…was it the place?

 Pause.

DANNY Yes. It was the place.

HELEN Right.

 And what did you do with…?

DANNY We drove him into the woods, left him there, said if he told anyone we'd torch his house, lock up the doors and windows first so no one would get out. He believed every word.

HELEN So it's okay? Danny?

DANNY Did you hear what I just said? Did you hear what I've just said?

HELEN Yeah, but –

DANNY He fucking tortured him. I fucking tortured him.

HELEN Well, you know…

DANNY What?

HELEN He went a bit

 far, but

DANNY What?

HELEN Yeah, yeah, he went a bit

DANNY Did you just say 'he went a bit far'?

HELEN Because he, he thought, this person was not

 Danny, this is not a good person.

 Beat. He stares at her.

 No, no, sorry, I know how that sounds and I do not mean that as an, but I mean Christ. This person, right, was not, he was someone, and that doesn't mean he should be hurt, of course not, but he was someone who hurts other people. He was not a good person.

DANNY What?

HELEN He was… Danny, he hurt, he was one of the people who hurt…you.

> *Beat.*

DANNY Who?

HELEN The lad.

DANNY What lad?

HELEN The lad, the lad, I'm talking about the –

DANNY What lad, there is no lad.

> *Beat.*

HELEN What?

DANNY There is no lad.

HELEN Yes there is, the lad

DANNY The man.

HELEN who, you've just, you've just

DANNY He was a man, he was a grown man

HELEN been…

> *Beat.*

What?

DANNY He was a grown man, thirty, thirty-five -years-old

HELEN I don't…

DANNY He was a man, just some fucking man, some Islamic man, that's all, on his way home. Some man with a beard, he wasn't a lad, he had nothing to do with anything, he had children, he was scared for his children, he was at least thirty-five.

> *Pause.*

HELEN What?

DANNY I hurt him, Helen. I had a balaclava on.

HELEN He was…

DANNY I've always wondered whether I'd be good at that sort of thing. Enjoy, or...something, you know, whether you... And now I...

I feel like I'm rotting.

HELEN He was a man?

DANNY Yes.

HELEN Not a lad?

DANNY No, no, not a fucking lad.

HELEN Just a man?

DANNY Just a man, just a man on his way home

HELEN An Islamic man?

DANNY Just an Islamic man on his way home to his wife and his children.

HELEN Oh.

DANNY Yes.

Yes. Oh.

Front door slams, really loud.

Moment later LIAM enters.

LIAM Shit, sorry, Hels. Sorry Danny, fuck. Sorry, I fucking let go and that door, I keep forgetting, I just, it slams, it...bit strong that door bit fucking –

Looks at them.

Pause.

Alright, Danny?

No answer.

Hels?

No answer.

Yeah. Yeah, fair enough, that's...

Sorry about that. Sorry about...well, I'm sorry. This is all wrong, I know it is and, and look I wanna say I'm sorry. Sorry, Hels.

Sorry, Danny.

Sorry, Hels.

> *They say nothing.*

Okay, okay, alright. Fair enough, I'm not saying anything different, and I have to say that I don't feel good about bringing you, not at all, I do not feel good at all about, you know, you've got this world, this beautiful world and it's like dragging a dead cat into it and leaving it on your sofa, on your beautiful sofa that you got from John Lewis and saying 'look, look a dead fucking cat.'

But there are dead cats in the world, Danny, there are dead cats, Hels.

> *Beat.*

You're pissed off at me, aren't you.

Okay. I deserve that. Alright, I deserve that, that is fair enough, but I'm gonna make it up to you. Hels? I'm going to make it up to you. I am going to make it up to you, Danny, I'm gonna make amends. There. That's a fucking contract. That is a fucking promise.

> *Pause.*

HELEN He was a man?

LIAM Well

HELEN Was he or wasn't he?

LIAM Well, yeah, but

HELEN He was?

LIAM he looked, I mean it was dark and…

> *Beat.*

Yes. He was.

HELEN Why.

LIAM I

dunno. I dunno, Hels, I just…

I dunno.

 Pause.

HELEN You don't know.

LIAM No.

HELEN Right.

DANNY I don't want him in my house.

LIAM Can I just say something? Can I just say one thing? I look at you, Danny, I look at you and I want, not to be like you, not to be you, but yes, in some way actually to be you, to actually be in some way a fucking part of you, but I want it to be me, I want you to be me. And if you and Hels weren't, I would still, and I look at you and I say 'Yeah, he's had all the breaks, so what? He's got a family, so what, he knows what he's doing, so what? He's got a good job and mates that he gets on with and a beautiful girlfriend, he's clever and he's had all the advantages in life and that may well be why he has all those things while another human being, a different human being gets to have shit thrown at them for years and then to top it all becomes a shit human being in the process, so what: he fucking deserves everything.' You deserve everything. And I say good luck to you because you are everything that man in this 21st century should be.

And I stand here, in your shirt, in your dirty fucking old T-shirt that you pulled out of the wash to give me and I feel privileged to wear it. I feel privileged to stand in your stale sweat. And I see someone like you and I can't help thinking that you should never have experienced this, that your blissful ignorance should be protected above all else, that I should lay down my life to keep you in that state, but part of me, Danny, and this is the part I hate, this is the bad part, the dirty part, the part that I'd like to cut out

with a knife, part of me, and I'm not saying I like that part, I'm saying I hate that part, but part of me thinks you should be dragged down off that fucking pedestal and be forced face down into the mud so you can eat the same shit and rotting flesh I've been eating, so that it gets in your mouth and up your nose and that you choke on it. And I saw you tonight, Danny. I saw you…

> *Beat.*

We're abandoned. There's nothing out there. It's like they've all been beamed up to another planet and just left us with the monsters.

HELEN Get out.

LIAM Right, Hels

HELEN The monsters? You're the monster, get out.

LIAM You're angry, okay, fair enough, but don't

 say something you're gonna regret.

> *Pause.*

HELEN Regret?

 Don't say something I'm gonna regret?

LIAM You're angry now, and fair enough, I'm not, not for a second saying otherwise, but all I'm saying Hels, is, I can be pushed as well, I have limits, there are limits and all I'm saying, Danny, is it's been a long and traumatic, so let's not –

HELEN I was going to go with that family.

> *Beat.*

 Brian was right. I told him, because I was so excited. I had to tell someone.

> *Beat.*

LIAM What…

 what are you…?

HELEN His name was John, hers was Jackie, John and Jackie, they lived in a lovely place, I remember, green and I remember the road was...lovely.

LIAM No, I don't...you didn't, this is, this is...

HELEN They had a boy a little older than me, Adam, he had a tree house in the garden, but it wasn't in a tree it was on the ground, they'd built it for him on the ground because he didn't like heights but it was all his, they never went in there, they respected his space.

 Beat.

LIAM Right, don't say...

Okay, okay, fair enough, but don't say hurtful, Hels, things, Hels, because that's not gonna get us, where's that gonna get –

HELEN She had a job, I don't remember what it was, but I remember she had it because mum never had a job, she just sat around smoking, he was a doctor and I thought that was amazing, that someone's dad could really be a doctor. And his face was lovely. He had a lovely face, I don't remember his face but it was lovely and their house was clean, not like our house, our house was filthy, I played a game with them, a board-game, I don't remember what it was, but we all sat down and played it together and I was amazed, all of us, just sitting there playing this game, John and Jackie as well.

 Beat.

Adam kept showing me things. And telling me things. Things I didn't know, I didn't know them and he could tell I didn't know them but he never laughed at me, never once, he never once laughed at me for not knowing. He just told me things, all these things, and he showed me his rabbit. He let me hold her. She was soft and warm and I held her for ages, for ages, I just held her for ages, and I

started crying, I was holding his rabbit and crying
and he didn't say anything, he just let me, he just let
me hold her and cry for ages and ages and ages and
ages

LIAM Right. Okay.

No you didn't, you're just

> *Beat.*

I don't care, I'm not… Fucking hell, I mean, I'm
not –

Anyway, that's not true, none of that is true, I mean
none of that is –

What? d'you think I'm stupid? D'you think I'm
fucking stupid, Hels? I'm not stupid. I'm not fucking
stupid, Hels, I know what you're –

> *Beat.*

I know what you're doing, I know, fucking stupid
is it? fucking, fucking, none of that, not one word is
true and you didn't, because you…

> *Beat. Suddenly takes a step towards her, so full of rage
> he doesn't know what to do with it. Wants to kill her,
> smash her face in, pound her to death. Stops. Masters
> it. Steps back from her.*

> *She has not flinched. He has calmed himself.*

You're angry. Yeah, and fair enough, you're, and so
you're

being a bit, you are being a bit…

Okay, I'll take that, fair enough

HELEN I loved them.

LIAM deserved that, fair enough, can't argue with

HELEN I begged them to let me go with them. But after you
attacked Brian we got moved away. I begged and
begged and begged.

LIAM I forgive you. I love you and I forgive you.

HELEN I don't want you to forgive me.

LIAM Well I do. I forgive you. I forgive you so much.

 The door swings open.

 SHANE stands there, bleary eyed.

 Beat. For a moment no one knows what to do.

 Shanie!

 Shane almost sleep-walks into the room, going straight
 to Liam, arms around him, lying into him, half asleep.
 Liam, genuinely moved.

 Ahh, look. Did I wake you up, Shay? Sorry about
 that, mate, that was the door, that flipping door
 again.

HELEN What are you doing up?

LIAM Ah, it's my fault, Hels, I woke him up.

HELEN You should be in bed.

LIAM You alright, Shay? You have a good time at your
 Gran's?

 SHANE nods.

 She's a lovely woman in't she. She give you ice
 cream?

 SHANE nods again.

 Did she! She's a cheeky monkey, in't she? Tell
 you what mate, you should get to bed, coz you're
 knackered.

 SHANE hugs harder into LIAM.

 Ahh, look. How about this; you go to bed and then
 on Saturday, if you ask your mum and dad very
 nicely and if you're a good boy, I'll take you up the
 park, would you like that? There's a steam fair up
 the park, it's all like engines and tractors and –

HELEN Shane, come here.

 Beat.

LIAM I'm just telling him about –

HELEN He's not going.

 Shane come here, now.

 SHANE does as he's told.

 LIAM is shocked.

 It's late.

 Beat. LIAM gets up.

LIAM Yeah. Yeah, fair enough. I'll just.

DANNY Tell him to leave the key.

LIAM Look, Danny, I'm –

HELEN Leave the key.

LIAM What?

 Pause.

 Hels…?

HELEN Leave the key.

 Pause.

LIAM Hels? Please don't tell me to leave the key.

HELEN Leave. The key.

 Beat. LIAM takes the key out of his pocket.

 Puts it on the table.

 Doesn't know what to do.

 Yeah, well, I'm a bit tired and…

 Bye Shane, I'm…

 SHANE is too sleepy too answer, hugged face into mum.

 Yeah.

 LIAM goes. SHANE waves at him, not looking up, but LIAM doesn't see it.

 A moment, then the front door slams.

 They sit. Together. Silence. SHANE is sleeping.

HELEN Are you alright?

 No answer.

 I could make something proper to eat. Do you want something proper to eat?

DANNY I can't eat.

 Silence, apart from SHANE's breathing.

 What do we do now?

HELEN I don't know.

 Carry on.

DANNY How?

HELEN I don't know.

 We find things to do and then we do them.

DANNY What things?

HELEN Things.

 Good things.

DANNY Good things?

HELEN Yes.

 We could…

 We could help people.

DANNY Could we?

HELEN Yes. We could help people.

DANNY What people?

HELEN People who

 people who need help.

DANNY Right.

HELEN We could do that, that'd be a reason to…

 you know, dedicate our lives to…

 or something.

DANNY Right.

Long pause.

HELEN I've been thinking. While you were out. I was here and I was thinking about lots of things and I got to thinking about you and me

and I think, I think I've been a bit…harsh

DANNY Harsh?

HELEN on us, yes, harsh.

DANNY I see.

HELEN I think I've been judging us and us together a bit harshly and judging us by some standard that isn't a real, for whatever reason, and maybe it's time to grow up and use real standards and, and, and

DANNY Right.

HELEN and accept. And once I'd thought like that, once I thought the word accept, I began to feel good.

DANNY Did you?

HELEN Yes. I began to feel good about our life, and about our family and about what we are and who we are and what we've made together, given the circumstances, given the hurdles and hiccups and I know this is going to sound mad, because of tonight and everything that's –

I know this is going to sound mad, you're gonna think I'm, but I began to feel warm. Here.

She puts her hand on her stomach.

DANNY Where?

HELEN Here.

Beat.

And I'm sitting there thinking this, all this is running through my mind and suddenly I'm

and this really is going to sound, you're gonna think I've lost the, but I'm gonna say it anyway because it's what happened but you're gonna think

I'm totally, but because of this feeling and these thoughts I…

Alright; I began to laugh.

DANNY Did you?

HELEN See? I told you. You think I'm mad.

DANNY I don't think you're mad.

HELEN Don't you?

DANNY No.

HELEN You sure?

DANNY You just sat here on your own

HELEN Yes.

DANNY laughing?

HELEN Yes. I just sat here on my own laughing, I just started laughing. I just started laughing, and that's terrible because of tonight and what you had to, god, I know, and I felt such

guilt, because I was, but then I thought, you know this is positive and positive things, I shouldn't feel guilt, I shouldn't

but I couldn't help it I just laughed because, I felt this feeling and I knew that this feeling was you and me.

Us.

You and me made me so happy that I laughed.

Pause.

I want this child. I want to have this child. With you

DANNY Do you?

HELEN Yes. I do.

DANNY Really?

HELEN Yes. Really.

DANNY You want that child. With me?

HELEN Yes. I do.

 Pause.

DANNY When I move my hand it feels wrong. When I open
 my fingers it feels, my fingers, when I open my
 fingers it feels

 wrong, it feels

 Beat.

 you know like when you've had a limb cut off, but
 you can feel it, still feel it, still feel it there, but it's
 not there, they say you can still feel it there like a
 ghost limb, it's called. I think it's called a ghost limb.
 But my entire body feels like that, my hand my arm,
 my legs my feet neck my lips my eyes, it all, it all
 feels… But it's all still there. It's all still…

 Beat.

 Is he sleeping?

HELEN Danny?

DANNY He's sleeping.

 Goes over to them, looks down at SHANE.

 He's sleeping. He's sleeping.

 Look at me, Helen. I'm not a coward anymore.

 Bends down picks SHANE up from her.

 He's sleeping. He's sleeping.

 Starts to take him out.

HELEN Danny?

 He stops, back to her.

 What about…

 Beat.

 What about the –

DANNY Get rid of it.

 Beat.

HELEN What?

DANNY I don't want it.

HELEN You don't…

DANNY I don't want that child. Get rid of it.

I don't want that child.

Get rid of that child.

HELEN I…

DANNY Take it out. Take that child out. Get rid of it. I want you to get rid of that child.

Pause.

HELEN I…don't want to get rid of it.

He stands there, hovering, saying nothing. She waits.

Danny?

But he goes. She is left there. Alone.

END

DNA

Characters

MARK and JAN,

LEAH and PHIL,

LOU, JOHN TATE and DANNY,

RICHARD,

CATHY and BRIAN, and

a BOY.

Takes place in a street, a field and a wood.

Names and genders of characters are suggestions only,
and can be changed to suit performers.

DNA was first performed in the Cottesloe Theatre of the National Theatre, on 16 February 2008, with the following Company:

MARK, Gregg Chillin

JAN, Claire Foy

LEAH, Ruby Bentall

PHIL, Sam Crane

JOHN TATE, Jack Gordon

DANNY, Benjamin Smith

RICHARD, Troy Glasgow

CATHY, Claire Lams

BRIAN, Ian Bonar

BOY, Ryan Sampson

All other parts played by members of the Company.

Director, Paul Miller

Designer, Simon Daw

Lighting Designer, Paule Constable

Sound Designer, Rich Walsh

Associate Video Designer, Paul Kenah

This play was commissioned by NT Education as part of its Connections project.

One

A Street. MARK and JAN.

JAN: Dead?

MARK: Yeah.

JAN: What, dead?

MARK: Yeah

JAN: Like dead, dead

MARK: Yes

JAN: proper dead, not living dead?

MARK: Not living dead, yes.

JAN: Are you sure?

MARK: Yes.

JAN: I mean there's no

MARK: No.

JAN: mistake or

MARK: No mistake.

JAN: it's not a joke

MARK: It's not a joke.

JAN: coz it's not funny.

MARK: it's not funny because it's not a joke, if it was a joke it
would be funny.

JAN: Not hiding?

MARK: Not hiding, dead.

JAN: not

MARK: Dead.

JAN: Oh.

MARK: Yes.

JAN: God.

MARK: Yes.

JAN: God.

MARK: Exactly.

　　Pause.

JAN: What are we going to do?

<center>＊　　＊　　＊</center>

　　A Field. LEAH and PHIL, PHIL eating an ice cream.

LEAH: What are you thinking?

　　No answer.

　　No, don't tell me, sorry, that's a stupid, that's such a stupid –

　　You can tell me, you know. You can talk to me. I won't judge you, whatever it is. Whatever you're, you know, I won't, I won't…

　　Is it me?

　　Not that I'm –

　　I mean it wouldn't matter if you weren't or were, actually, so –

　　Are you thinking about me?

　　No answer.

　　What good things? Phil? Or…

　　I mean is it a negative, are you thinking a negative thing about –

　　Not that I'm bothered. I'm not bothered, Phil, I'm not, it doesn't, I don't care. You know. I don't…

　　What, like I talk too much? Is that it? That I talk too much, you, sitting there in absolute silence thinking 'Leah talks too much, I wish she'd shut up once in a while' is that it, is that what you're, because don't, you know, judge, you know, because alright, I do. There, I'm admitting, I am admitting, I talk too much, so shoot me. So kill me, Phil,

call the police, lock me up, rip out my teeth with a pair of rusty pliers, I talk too much, what a crime, what a sin, what an absolute catastrophe, stupid, evil, ridiculous, because you're not perfect actually, Phil. Okay? There. I've said it, you're not…

You're a bit…

You're…

Pause. She sits.

Do I disgust you? I do. No, I do. No don't because, it's alright, it's fine, I'm not gonna, you know, or whatever, you know it's not the collapse of my, because I do have, I could walk out of here, there are friends, I've got, I've got friends, I mean alright, I haven't got friends, not exactly, I haven't, but I could, if I wanted, if I wanted, given the right, given the perfect, you know, circumstances. So don't, because you haven't either, I mean it's not like you're, you know, Mr, you know, popular, you know, you haven't, you know, you haven't, you know, you haven't, but that's, that's different, isn't it, I mean it is, it is, don't say it isn't, really, don't, you'll just embarrass us both because it is different, it's different because it doesn't matter to you. Does it. Sitting there. Sitting there, all…

all…

You're not scared. Nothing scares, there, I've said it; scared. Scared, Phil. I'm scared, they scare me, this place, everyone, the fear, the fear that everyone here, and I'm not the only one, I'm not the only one, Phil, I'm just the only one saying it, the fear that everyone here lives in, the brutal terror, it scares me, okay, I've said it and I am not ashamed. Yes, I am ashamed but I'm not ashamed of my shame, Phil, give me that much credit at least, thank you.

Everyone's scared.

S'not just me.

Pause.

We've got each other.

We need each other.

So don't give it all…

You need me as much as…

Don't give it all the…

Beat.

What are you thinking?

JAN and MARK enter.

Pause.

MARK: We need to talk to you.

LEAH: Oh, shit.

*　　*　　*

A Wood. LOU, JOHN TATE and DANNY.

LOU: It's fucked.

JOHN TATE: No, no, it's not, no, Lou, it's not

LOU: We're fucked.

JOHN TATE: No, Lou, we're not…it's not…we're not… nothing's…

LOU: It is.

JOHN TATE: No, no, no, look, there I have to, I really have to, you're going to have to listen to me on this one, and you are going to have to believe me. Everything is, everything's fine.

LOU: Fine?

JOHN TATE: Not Fine, no

DANNY: Fine?

JOHN TATE: not fine exactly, alright, fair enough, I mean things are bad, things are a little, alright, yes, I'm not trying to hide the, this is tricky, it's a tricky

LOU: Tricky?

JOHN TATE: situation, but it's not, because actually what you are saying is a very negative, and that's…

Look, haven't I looked after things before?

LOU: This is different.

JOHN TATE: Lou, are you scared of anyone in this school?

LOU: You?

JOHN TATE: Apart from me.

LOU: No.

JOHN TATE: Exactly

LOU: Richard, maybe

JOHN TATE: exactly, that's exactly, that's what I'm saying – Richard, you're scared of, are you…? – I mean you can walk down any corridor in this – I don't think Richard's – any corridor in this school and you know, no one bothers you and if you want something it's yours and no one bothers you and everyone respects you and everyone's scared of you and who made that, I mean I'm not boasting, but who made that happen?

LOU: You.

JOHN TATE: Thank you, so are things really that bad?

LOU: Yes.

JOHN TATE: Richard? I mean are you really?

DANNY: I can't get mixed up in this. I'm gonna be a dentist.

LOU: This is different, John. This is

JOHN TATE: Alright, it's a little bit

LOU: This is really serious.

DANNY: Dentists don't get mixed up in things. I've got a plan. I've got a plan John, I've made plans, and this is not…

JOHN TATE: It's a bit serious, but let's not, I mean come on, let's not overplay the, the, the

LOU: He's dead.

JOHN TATE: the gravity of… Well, yes, okay, fair enough, but

DANNY: This is not part of the plan. Dental college is part of the plan, A levels are part of the plan, dead people are not part of the plan, this is not dental college.

LOU: He's dead, John.

JOHN TATE: Alright, I'm not denying, am I denying? no, I'm

LOU: He's dead.

JOHN TATE: Well, don't keep saying it.

DANNY: This is the opposite of dental college.

LOU: But he is dead.

JOHN TATE: Well you just, you're saying it again, didn't I just –

LOU: Because he's dead, John, he's dead, dead is what he is so we have to use that word to –

JOHN TATE: Alright. New rule; that word is banned.

Beat.

LOU: What, dead?

JOHN TATE: Yes.

DANNY: Banned?

JOHN TATE: Yes. Banned. Sorry.

LOU: You can't ban a word.

JOHN TATE: and if anyone says it I'm going to have to, you know, bite their face. Or something.

DANNY: How can you ban a word?

JOHN TATE: Well just say it then.

Pause.

Say it and see what happens.

They say nothing.

Look, we have to keep together. We have to trust each other and believe in each other. I'm trying to help. I'm trying to keep things together.

RICHARD enters, with CATHY and BRIAN, CATHY grinning, BRIAN crying.

Pause.

RICHARD: He's dead.

JOHN TATE: Right, that's…now I really am getting a little bit cross, do not use that word.

RICHARD: What?

JOHN TATE: No one says that word, okay, no one.

RICHARD: What word?

CATHY: This is mad, eh?

JOHN TATE: You know.

CATHY: Talk about mad. I mean, it's quite exciting as well, though, isn't it.

RICHARD: What, 'dead'?

JOHN TATE: Don't say it again, Richard, or I'm gonna

CATHY: Better than ordinary life.

RICHARD: What?

JOHN TATE: I'm gonna

RICHARD: What?

JOHN TATE: I'm gonna

I'm gonna hurt you, actually.

Beat.

RICHARD: You're going to hurt me?

JOHN TATE: Yes.

RICHARD: Me?

JOHN TATE: Yes. If you use that word.

CATHY: I mean I'm not saying it's a good thing, but in a way it is.

DANNY: Shut up, Cathy.

CATHY: You shut up.

JOHN TATE: I am trying to keep everyone together. Ever since I came to this school haven't I been trying to keep everyone together? Aren't things better? For us? I mean not for them, not out there, but for us? Doesn't everyone want to be us, come here in the woods? Isn't that worth keeping hold of?

They say nothing. RICHARD steps forward, a little hesitantly.

RICHARD: You shouldn't threaten me, John.

JOHN TATE: I beg your pardon.

RICHARD: I'm just saying. I'm just saying, I've just walked in here. I've been with these two. I've walked all the way from school with these two, with him crying and with her being weird, and I've just walked in here and I've got you threatening me, you shouldn't threaten me, you shouldn't threaten me, John.

Pause.

JOHN TATE: Or what?

RICHARD: What?

JOHN TATE: No, I mean, you know, or what?

RICHARD: Well…

JOHN TATE: Because I'm interested.

DANNY: He's just saying, John.

JOHN TATE: Are you on his side, Danny?

DANNY: No, I'm just saying that he's just saying.

CATHY: Shut up, Danny.

DANNY: You shut up.

JOHN TATE: Don't tell Cathy to shut up, Danny, that's really, not…

DANNY: I'm not telling her to –

CATHY: He's on Richard's side.

DANNY: I'm not!

JOHN TATE: Are you, Danny? Are you on Richard's side?

DANNY: No –

CATHY: He is.

RICHARD: What do you mean by my side, there is no –

JOHN TATE: Have you got a side now, Richard?

RICHARD: No, no, there's no –

JOHN TATE: because that's a bit, is that what you've got?

DANNY: John, I'm not on –

JOHN TATE: Because if you've got a side that means you're not on my side and if you're not on my side that means you're setting yourself up against me and I thought we'd got over all that silliness.

RICHARD: We have, we –

JOHN TATE: I thought we were mates now.

RICHARD: We are, we are mates now, we –

JOHN TATE: So if me and Richard are mates now, which we are and all that silliness is over, which it is, and you're on someone's side, Danny, then you're on your own side, which is very, well, to be honest, very silly and dangerous.

DANNY: No, you've got it wrong, that's not –

JOHN TATE: Are you on my side?

DANNY: Yes, I'm on your side!

JOHN TATE: Which means you want..?

DANNY: I want to keep calm, I want to say nothing, just like you, you're right, you're right, John.

JOHN TATE: So what the fuck are you on about, Cathy?

CATHY: I'm –

JOHN TATE: Are you on my side? With Richard and Danny? Are you on our side, Cathy?

CATHY: Yes.

JOHN TATE: Good. Lou?

LOU: Yes.

JOHN TATE: You're on our side, Lou?

LOU: Yes, John.

JOHN TATE: You sure?

LOU: Yeah, I'm –

JOHN TATE: That just leaves you, Brian. You crying little piece of filth.

Beat. BRIAN stops crying. Looks up.

BRIAN: I think we should tell someone.

JOHN TATE begins to walk towards BRIAN.

MARK and JAN enter with LEAH and PHIL, PHIL drinking a Coke.

JOHN TATE stops.

Goes back to where he was.

JOHN TATE: I'm finding this all quite stressful. You know that? I'm under a lot of stress. You lot shouldn't put me under so much stress.

LEAH walks forward.

LEAH: Can I just say John, that we haven't done anything. First I want to say that, but if we have, John, but if we have done a thing, which we haven't, but if we have then we did it together. Whatever we did, we did, me and Phil, it wasn't just Phil, if that's what you're thinking, if you're thinking it might just have been him, on his own, without me, well that's not, we are completely, I am responsible as much as he, as much as Phil, but we didn't because –

JOHN TATE places a finger on her lips. She is silent.

JOHN TATE: Have you told them?

MARK: No.

JOHN TATE: Brilliant. Is there one thing that I do not have to do?

Beat.

JAN: So you want us to tell them?

JOHN TATE: Yes! Please.

He takes his finger away from LEAH's lips.

MARK: It's Adam. He's…

I mean we were just having a laugh, weren't we, we were all, you know…

You know Adam, you know what he's like, so we were sort of, well, alright, taking the piss, sort of. You know what he's like he was, sort of hanging around

JAN: Trying to be part of

MARK: Yeah, trying to be part of, yeah, yeah, so we're having a laugh

JAN: with him

MARK: yeah, with him, I mean he's laughing as well, see how far he'll go… We got him to eat some leaves.

JAN: Great big ones, dirty leaves off the floor, he ate them, just like that

MARK: Just like that, we were all

JAN: stitches

MARK: We were in stitches, weren't we

JAN: Adam too, he was

MARK: Oh yeah, Adam was, he was laughing harder than anyone.

JAN: Nutter.

MARK: Nutter.

JAN: complete

MARK: complete nutter

JAN: Big fist fulls of leaves, eh John

MARK: laughing his head off, eh John

JAN: He burnt his own socks!

MARK: Yeah, yeah, he did, that's right he, he set them alight

JAN: anything, he'd do, just a laugh

MARK: we got him to nick some vodka

JAN: you could tell he was scared

MARK: oh, he was terrified, he was completely, but like you know, pretending, you know, pretending he's done it before, big man, pretending he's

JAN: You know what he's like, he's

MARK: Do anything. And you're thinking 'Will he do anything? What won't he do?'

JAN: Let us punch him.

MARK: he was laughing

JAN: In the face.

MARK: He was laughing.

JAN: at first

MARK: Yeah, at first he was, I mean we took it a bit far, alright, half hour, forty minutes

JAN: I mean he was still joking all the way, but

MARK: you could tell

JAN: He weren't really

MARK: fear

JAN: well

MARK: you don't want to admit, you know what he's like, Phil…

JAN: Stubbed out cigarettes on him.

MARK: joking, we were

JAN: Arms, hands, face

MARK: having a laugh, really, he was laughing

JAN: and crying, soles of his feet

MARK: or crying, sort of, a bit of both

JAN: Made him run across the motorway

MARK: you're thinking what is this nutter, and with the vodka making you feel a bit, you know, you're having a laugh,

together, what is this nutter gonna do next, we can make him do, we can make him do –

JAN: That's when I went home

MARK: anything, yeah, only because you had to.

JAN: I wasn't there when –

MARK: Only because you had to, you would've been there otherwise, you did all the...

Beat.

We went up the grille. You know, that shaft up there on the hill. Just a big hole really, hole with a grille over it, covering, just to see if he'd climb the fence, really and he did, and we thought, you know, he's climbed the fence which we didn't think he'd do so walk, you know, walk on the grille, Adam, walk on the, and he did, he's walked on, you know, wobbling and that but he's walking on the grille and we're all laughing and he's scared because if you slip, I mean it's just blackness under you, I mean it's only about fifteen foot wide so, but it might be hundreds of feet into blackness, I dunno, but he's doing it, he's walked on the grille. He's on the grille. He is.

And someone's pegged a stone at him.

Not to hit him, just for the laugh.

And you shoulda seen his face, I mean the fear, the, it was so, you had to laugh, the expression, the fear...

So we're all peggin them. Laughing. And his face, it's just making you laugh harder and harder, and they're getting nearer and nearer. And one hits his head. And the shock on his face is so...funny. And we're all just...

just...

really chucking these stones into him, really hard and laughing and he slips.

And he drops.

Into...

Into the er…

So he's…

So he's…

So he's –

JOHN TATE: Dead. He's dead.

Cathy says you're clever.

So. What do we do?

Pause. They all stare at LEAH and PHIL.

LEAH goes to say something, but nothing comes out.

Silence.

More silence.

PHIL puts his Coke carefully on the ground.

PHIL: Cathy, Danny, Mark, you go to Adam's house, you wait until his mum's out, you break in

DANNY: What?

PHIL: through an upstairs window so it's out of the way, make sure no one sees you. Get in, go to his bedroom, find a pair of his shoes and an item of his clothing, a jumper or something, don't touch the jumper, that's very important, do not touch the jumper, but you have to get it in the plastic bag without touching it

CATHY: What plastic bag?

PHIL: The refuse sacks that you are going to buy on the way, do not use the first one on the roll, use the third or fourth, do not be tempted to use a bin liner you have knocking around the house as that will be a DNA nightmare.

Richard, you take Brian to the Head, tell him that you found Brian crying in the toilets, asked him what was wrong and when he told you, you brought him here.

RICHARD: Me? But I hate him!

PHIL: Brian, you cry

RICHARD: Me with Brian?

PHIL: and you tell them a man showed you his willy in the woods

BRIAN: Wha…what?

PHIL: by the bridge, last week, a fat Caucasian male, 5 feet 9 inches say, with thinning hair and a postman's uniform, sad eyes, softly spoken

DANNY: Who's that?

PHIL: The man who showed Brian his willy in the woods, please keep up, I'm making this up as I go along

DANNY: What were his teeth like?

PHIL: Bad, very bad.

DANNY: Thought so.

PHIL: Lou, Danny and Jan you take the shoes, Lou you put them on, and you enter the woods from the south entrance

CATHY: Which one's south?

MARK: By the Asda.

PHIL: Danny you enter from the east entrance with Jan on your back

DANNY: Is he taking the piss?

PHIL: the weight of the two of you combined should equal that of a fat postman with bad teeth, you make your way into the woods, do not put her down unless it's on concrete or a tree trunk, never when you're walking on mud. You meet Lou near the bridge, you move around a bit, you exit from the South,

MARK: By the Asda.

PHIL: Cathy and Mark you meet them there, but on the way you find a quiet street, you wait until it's just you and a man, you walk ahead of him and when you far ahead you drop the jumper. The man picks it up, runs after you covering it in DNA and then gives it back, make sure you let him drop it in the bag, say you're taking it to a charity shop. Take it to the south entrance, tear it a little, chuck it

in a hedge, all go home and wait a day or two until Adam's declared missing and then John Tate comes forward and says he thinks he saw Adam with a fat man in a uniform by Asda's but he can't be sure, they'll think he's been abducted, they'll be inquiries, police, a mourning service and if everyone keeps their mouths shut we should be fine.

Any questions?

They stare at him open mouthed.

He bends down. Picks up his Coke.

Starts to drink his Coke.

* * *

A Field. LEAH and PHIL sitting.

Pause.

LEAH: Apparently bonobos are our nearest relative. For years people thought they were chimpanzees, but they're not, they are completely different. Chimps are evil. They murder each other, did you know that? They kill and sometimes torture each other to find a better position within the social structure. A chimp'll just find itself on the outside of a group and before he knows what's happening it's being hounded to death by the others, sometimes for months. For years we've thought that chimps were our closest living relative, but now they're saying it's the bonobos. Bonobos are the complete opposite of chimps. When a stranger bonobo approaches the pack, the other bonobos all come out and go 'Hello, mate. What you doing round here? Come and meet the family, we can eat some ants.' And if a bonobo damages its hand, whereas the chimps'll probably cast it out or bite its hand off, the bonobos will come over and look after it, and they'll all look sad because there's a bonobo feeling pain. I saw it on a programme. Such sadness in those intelligent eyes. Empathy. That's what bonobos have. Amazing really, I mean they're exactly like chimps, but the tiniest change in their DNA... The woman was saying that if we'd

discovered bonobos before chimps our understanding of ourselves would be very different.

Pause. PHIL pulls out a bag of crisps.

You don't care, do you. I could be talking Chinese for all you care. How do you do it? You're amazing. You're unreal. I sometimes think you're not human. I sometimes think I wonder what you would do if I killed myself, right here in front of you. What would you do? What you do, Phil?

No answer.

Phil, what would you do? Phil?

Still no answer.

Suddenly she grabs her throat.

I'm gonna do it!

She squeezes.

I mean it! I'm gonna do it…

No answer. She strangles herself, her face turning red.

She falls to her knees with the exertion.

PHIL looks on.

She is in considerable pain. Grits her teeth and squeezes.

She strangles until she is lying prone on the floor.

(Gasping…) Phil! This is it…

She stops.

Lies there, panting.

PHIL opens his crisps and begins to eat them.

LEAH gets up, sits next to PHIL.

PHIL eats on.

Course, they fuck a lot. Bonobos. Always at it. Sex mad. Sex, sex, sex, sex, sex, sex, sex, sex, sex, constant sex, randy, in the bonobo world having it off is like saying I like your shoes. Partner-swapping, men and women, women

211

and men, women and women, men on men, fathers, mothers, children, oral sex, group masturbation, sub-dom, inter-racial, bestiality, the lot, it was like an orgy, when bonobos get going, it was fairly disgusting, actually.

Pause.

But that's bonobos for you.

Pause.

We're in trouble now.

We're in trouble now, Phil. Don't now how this'll pan out.

Trouble now.

Two

A Street. JAN and MARK.

Pause.

JAN: What?

MARK: He's not going.

JAN: What do you mean he's not going?

MARK: He's not going.

JAN: He's not going?

MARK: Yes.

JAN: That's what he said?

MARK: Yes.

JAN: He said he's not going?

MARK: Yeah, he said he's not, he's not…

JAN: What?

MARK: Going.

Beat.

JAN: Is he off his head?

MARK: I know.

JAN: Is he insane?

MARK: I know.

JAN: Is he joking?

MARK: I know, I know.

JAN: No, that's a question.

MARK: He's not joking, he's not going, he's said he's not going, I said you've gotta go, he said he's not going, 'I'm not going' he said.

JAN: That's what he said?

MARK: That's what he said, I'm saying that's what he said.

JAN: Fuck.

MARK: Exactly.

Beat.

JAN: What are we going to do?

*　　*　　*

*A Field. PHIL and LEAH, PHIL slowly eating a pack of Starburst.
LEAH has a Tupperware container on her lap.*

LEAH: Are you happy?

No, don't answer that, Jesus, sorry, what's wrong with me,
sorry –

Are you?

No, I'm just wondering. I mean what is happy, what's
happy all about, who says you're supposed to be happy,
like we're all supposed to be happy, happy is our natural,
and any deviation from that state is seen as a failure, which
in itself makes you more unhappy so you have to pretend
to be even happier which doesn't work because people can
see that you're pretending which makes them awkward
and you can see that they can see that you're pretending to
be happy and their awkwardness is making you even more
unhappy so you have to pretend to be even happier, it's a
nightmare. It's like nuclear waste or global warming.

Beat.

Isn't it Phil? Phil? Isn't it, like nuclear…

PHIL doesn't answer.

Yeah, you know, you know it is, you know more than
I do, I can't tell you any, you know. People getting all
upset about polluting the natural order? When this planet
is churning molten lava with a thin layer of crust on
top with a few kilometres of atmosphere clinging to it?
I mean, please, don't gimme all that, carbon dioxide?
Carbon dioxide, Phil? And look at the rest of the universe,
Venus, Phil, there's a, look at Venus, what about Venus,

hot enough to melt lead or Titan with oceans of liquid nitrogen, I mean stars, Phil, a billion nuclear reactions a second, I mean to be honest it's all either red hot or ice cold, so, so, so… No. It's life that upsets the natural order. It's us that's the anomaly.

But that's the beauty, isn't it Phil. I couldn't say this to anyone else they'd say 'That's a pretty fucking grim view of the world, Leah' but you can see the beauty, which is why I can talk to you, because you can see the incredibly precious beauty and fragility of reality, and it's the same for happiness, you can apply the same theory to happiness, so don't start Phil, don't come here giving it all the, you know, all the, all the…

Beat.

Can you remember the happiest moment in your life?

Beat. PHIL eats another toffo.

I know mine. I know my happiest moment. Week last Tuesday. That sunset. You remember that sunset? Do you? You don't do you. Oh my God, you don't.

He says nothing.

She opens the Tupperware container.

Shows it to PHIL.

It's Jerry. I killed him. I took him out of his cage, I put the point of a screwdriver on his head and I hit it with a hammer. Why do you think I did that?

PHIL shrugs.

No. No, me neither.

She closes the lid.

Everything's much better, though. I mean really, it is. Everyone's working together. They're a lot happier. Remember last month, Dan threatened to kill Cathy? well yesterday I saw him showing her his phone, like they were old friends. Last week Richard invited Mark to his party, bring a friend, anyone you like, can you believe that?

Richard and Mark? Yep. Everyone's happier. It's pouring into the school, grief, grief is making them happy.

They say John Tate's lost it though, won't come out of his room. Bit odd. Maybe that's what's making people happier. Maybe it's just having something to work towards. Together. Do you think that's what it is. Are we really that simple?

Where will it stop? Only been four days but everything's changed

Pause.

Adam's parents were on the telly again last night.

PHIL looks up.

Yeah. Another appeal.

To the fat postman with bad teeth.

What have we done, Phil?

MARK and JAN enter.

JAN: We need to talk.

* * *

A Woods. PHIL and LEAH, LOU and DANNY. PHIL has a muffin.

Pause.

LEAH: What?

DANNY: They've found…

They…

Well they've found –

LOU: The man.

DANNY: Yeah, they've found the man.

LEAH: They've found the man?

DANNY: Yeah.

LEAH: They've found the man?

DANNY: Yes.

LEAH: Oh my God.

LOU: Exactly.

LEAH: Oh my God.

LOU: That's what we thought, we thought that, didn't we, Danny.

DANNY: Yeah, we did.

LEAH: Are you sure? I mean are you…

DANNY: Definitely. He's in custody now. They're questioning him.

LEAH: But how, I mean who, how, who, who is, who is, how?

LOU: Dunno.

LEAH: Who is he?

LOU: He's the man who kidnapped Adam.

LEAH: Right. No.

LOU: Yes.

LEAH: No.

DANNY: Yes.

LEAH: No, no, yeah, no, actually, because that man, the man who, he doesn't actually, I mean I'm not being fussy or anything, but the man who kidnapped Adam doesn't actually exist, does he. Well does he?

LOU: No. But they've got him.

DANNY: I heard his teeth are awful.

LEAH: You know, I mean he doesn't, he doesn't… Phil? Any… any thoughts? Any words, any comments, any…ideas, any, any, any…thing? At all?

I mean this is, this is, isn't it, this is, is it?

Shit. Oh shit.

DANNY: He answers the description. Fat postman, thinning hair, his teeth are terrible, apparently.

LEAH: But that's just

LOU: Yeah. That's what we thought.

LEAH: we just, didn't we, Phil, we just, we just, I mean you just…

DANNY: What are we gonna do?

LOU: We're fucked.

LEAH: We're not…

LOU: We're –

LEAH: No, no, sorry, no we're not, are we Phil, I mean we're, no we're alright.

DANNY: They're looking for Brian.

LEAH: Why?

DANNY: Because he can identify him.

LEAH: No he can't.

LOU: Because he saw him in the woods.

LEAH: He didn't

LOU: He did, he –

LEAH: No he didn't because that wasn't the man in the woods because there wasn't a man in the woods.

Where's Brian?

DANNY: Hiding. Dan and Mark have gone to find him.

LOU: He's shitting it.

LEAH: I mean what, they just picked this bloke up, they just saw him and said 'You look dodgy, you're a murderer because you've got a postman's uniform'?

DANNY: Well, there's the teeth as well.

LEAH: You can't go to prison for bad teeth.

LOU: What if he goes to prison?

LEAH: He won't go to prison.

LOU: You just said –

LEAH: He won't get done for it because he hasn't…

DANNY: This sort of stuff sticks, you know.

LEAH: Look, everyone, everyone calm, okay. Isn't that right, Phil. Phil, isn't that, I mean things are, everything is, well, better and isn't everyone more, you know, and cheerful and stuff, so let's, please, let's –

DANNY: How am I gonna get references?

LOU: We're fucked.

LEAH: We are not –

DANNY: You need three references for dental college, how am I gonna get references?

RICHARD enters with CATHY.

RICHARD: We just came from the police station. It's full of reporters.

CATHY: It was great.

RICHARD: It was shit. Phil, have you heard?

LEAH: We heard.

CATHY: They wanted to interview me.

RICHARD: You've heard? You know?

CATHY: Didn't have time, but I'm gonna go back

RICHARD: So you know they've caught him?

CATHY: get on the telly

LEAH: How can they have caught someone who doesn't exist?

RICHARD: I don't know, Leah.

LEAH: Because that's impossible.

RICHARD: Why don't you tell them that? Why don't you pop down the station and say 'excuse me, but that fat postman with the bad teeth doesn't actually exist, so why don't you let him go'?

LEAH: sarcasm, that's the lowest

CATHY: they might even give me money for it, do you think I should ask for money?

LOU: He's gonna go to prison.

LEAH: Lou, they are not going to send him to prison because he answers a description they need more than that, they need fibres, they need samples, they need evidence.

RICHARD: DNA evidence.

LEAH: Exactly, they need DNA –

RICHARD: No, they've got DNA evidence.

Beat.

LEAH: What?

RICHARD: He answers the description, but they've got DNA evidence linking him to the crime.

LEAH: DN… What are you talking about?

RICHARD: We spoke to a reporter. They matched up the DNA evidence they found on the jumper to a police database and they came up with this man, this man who answers the description perfectly.

LEAH: That's impossible.

RICHARD: Well it's what happened.

LEAH: No, because, we made that description up and they got DNA from a random –

Beat. She turns to CATHY.

Cathy?

Pause. They all stare at CATHY.

CATHY: You told us to get DNA evidence. We got DNA evidence. We did what you said.

LEAH: Right.

Okay.

Hang on.

Where did you get the DNA evidence?

CATHY: From a man, like you said.

Beat.

A man down at the sorting office.

They stare at her.

LEAH: What?

CATHY: Well, we thought, you know, I mean you'd given a description so we thought, well, I thought, you know, show initiative, we'll look for a fat balding postman with bad teeth.

They stare at her.

There were quite a few.

DANNY: Oh my God.

CATHY: What?

LOU: Oh my God.

CATHY: We showed…initiative, we –

LEAH: And who asked you to do that?

CATHY: Richard, we showed initiative.

RICHARD: That is the most stupid –

DANNY: Oh, Jesus.

CATHY: Why?

LEAH: Why? Because there is now a man in prison who is linked to a non-existent crime, answering a description that Brian gave.

LOU: Oh, Jesus Christ.

CATHY: But isn't that…

LEAH: No, Cathy, it is not what we wanted.

RICHARD: What we wanted was to cover up what had happened, not to frame someone else.

LOU: We're fucked.

LEAH: Yes. We might actually be… This is a nightmare.

DANNY: We can't let them think it's him. I mean, I really can't be mixed up in something like that, it wouldn't be right.

LOU: What if he goes to prison?

RICHARD: What if we go to prison?

LEAH: Yes, I think now, we might just actually be a little bit, well, fucked.

JAN and MARK enter with BRIAN. BRIAN is crying.

BRIAN: I'm not going in.

RICHARD: You dick, Mark.

MARK: It was her idea!

LOU: Mark, you dick.

BRIAN: I'm not going to the police station.

JAN: He has to. They're looking for him.

BRIAN: I can't go in. It was bad enough talking to them before, saying what I said, but I can't do it again.

JAN: They're searching everywhere for him. They want him to identify the man.

BRIAN: I can't identify him, I can't go in there, don't make me go in there, I'm not going in there.

DANNY: This is terrible.

BRIAN: I can't face it. They look at me. They look at me like I'm lying and it makes me cry. I can't stand the way they look at me. And then, because I cry, they think I'm telling the truth, but I'm crying because I'm lying and I feel terrible inside.

LOU: We're going to have to tell them.

LEAH: Maybe we could do nothing?

DANNY: We can't do nothing, they want Brian.

BRIAN: I'm not going in.

LEAH: Phil?

No answer.

Phil?

Pause. PHIL walks over to BRIAN and lays a hand on his shoulder.

PHIL: This is a bad situation. We didn't want this situation. But we've got this situation. It wasn't supposed to be like this. But it is like this.

Beat.

You're going in.

BRIAN: No.

PHIL: Yes.

BRIAN: No, Phil –

PHIL: Yes, yes, shhhh, yes. Sorry. You have to go in. Or we'll take you up the grille.

Pause.

We'll throw you in.

RICHARD: Er, Phil.

DANNY: Is he serious?

LEAH: He's always serious.

PHIL: We'll take you up the grille now. Well get you by the arms. By the legs. And we'll swing you onto the grille. We'll throw rocks at you until you drop through. You'll drop through. You'll fall into the cold. Into the dark. You'll land on Adam's corpse and you'll rot together.

Beat.

We're in trouble now. We need your help. If you don't help us we'll kill you. Are you going to help us?

Pause.

BRIAN nods.

Okay. You go in there. Richard'll take you

RICHARD: Not me again.

PHIL: Richard'll take you. You take a look at that man and you say it's him. You say it's the man in the woods. That's what you do. Okay?

Slowly, BRIAN nods.

Everyone else stays calm. Keep your mouths shut. Tell no-one or we'll all go to prison. Just get on with things.

He starts to eat his muffin. They stare at him.

* * *

A Field. PHIL and LEAH, PHIL picking his teeth.

Silence.

Suddenly LEAH jumps up, shocked.

LEAH: Woah! Woah, woah, woah…

No reaction from PHIL.

I just had déjà vu, but really strong, I just…

and you were…

I was…

I mean we were just here and, and…

I was sitting like that and…

Woah. I've been here before, Phil. Phil?

PHIL carries on picking his teeth.

LEAH watches, then explodes.

That's exactly what you did when I said Phil! I knew you were going to do that, I said Phil and you picked your teeth, Phil, you just carried on picking your teeth!

Oh my God. This might be the real thing. Maybe I have been here before. Maybe this has all happened before. Phil? Do you think this has happened before? I know what you're gonna do next. I can see, I know, I know, you're gonna… you're gonna… you're gonna… do nothing!

PHIL does nothing.

Yes! Yes, yes, yes, yes, yes! You see? This is amazing, this is, the world has just changed, reality is not what we think, Phil maybe, this isn't real, maybe we're caught in some sort of… hang on, hang on, a bird is going to… a starling, a starling is going to land by that stone… now!

Nothing happens.

Now!

Still nothing happens.

Any minute… now!

Again, nothing happens.

LEAH sags. She sits back with PHIL.

Look at that sky.

Have you ever seen a sky like that? I've never seen a sky quite like that. Strange time we've been born in. No other time quite like this one.

Pause.

Do you think it's possible to change things? I know, I know, but I feel like this time… I dunno, this time… I feel like this is an important time. Do you think people always feel like that? D'you think we're doomed to behave like people before us did?

Phil?

No answer.

Phil?

Phil?

Phil?

Phil?

Phil?

Phil?

Phil?

Phil?

Phil?

Pause.

PHIL!

Slowly PHIL turns to her.

225

If you change one thing you can change the world. Do you believe that?

PHIL: No.

LEAH: Right.

Well I do.

I do, Phil.

Beat.

Phil?

Three

A Street. JAN and MARK.

JAN: Okay. Okay. Okay.

> *Beat.*

> Okay.

> No.

MARK: Yes.

JAN: No, no

MARK: yes

JAN: no. No way, that's

MARK: I know

JAN: that's

MARK: I know, I know

JAN: And are you…is this…

> I mean are you…there's no mistake or…

MARK: No.

JAN: Because this is

MARK: That's what I'm saying

JAN: this is really

MARK: Yeah, yes, yeah.

JAN: really, really

MARK: Exactly.

JAN: Are you sure?

MARK: Yes.

JAN: Where?

MARK: In the woods.

JAN: In the woods?

MARK: In the woods, Cathy found him in the woods

JAN: Cathy?

MARK: Yes.

JAN: Cathy found him...?

MARK: Yes, she

JAN: in the woods?

MARK: Yes.

 Beat.

JAN: Cathy found him in the woods?

MARK: Yes.

JAN: Oh.

MARK: I know.

JAN: I don't…

MARK: I know, I know.

JAN: This is…

MARK: Yeah.

JAN: Does anyone know?

MARK: You and me. And Cathy. For the moment.

JAN: Right.

 Right.

 Pause.

 Right.

<center>* * *</center>

 A Field. PHIL sits with a bag.

 Takes out a paper plate.

 Places a waffle on it.

 Takes out a pack of butter and a jar of jam.

 Takes out a knife.

LEAH turns up. She is carrying a suitcase.

He stares at her.

LEAH: I'm going. I'm out of here, I'm gone, I'm, I'm, this is it. I'm running away, Phil.

PHIL says nothing.

Where'm I going? I dunno. Wherever the universe decides that I should be. It's a big world, Phil, a lot bigger than you, it's a lot bigger than you and me, a lot bigger than all this, these people, sitting here, a lot bigger, a lot lot bigger.

Pause. PHIL starts to butter his waffle.

Don't. No words. There's no point, so… What's the point? 'Why are you going, is it me, is it us, is it what we've done, is it what we're becoming, why Leah, why, is it me, is it the impossibility of ever saying exactly what you mean?' There's no point, Phil. So don't even try. I'm outta here. I'm gone. I am part of history, I'm on a jet-plane, I'm moving, I'm discovering, I'm, I'm, sayonara baby, sayonara Phil and hello discovery and, yeah don't try and stop me, because, because, exit stage left Leah, right now.

Right now.

PHIL stops buttering the waffle.

Opens the jam.

Starts putting a thin layer of jam on the waffle.

Right now. right now, Phil, right, fucking… I mean it! I really, really…

Pause. PHIL continues with his waffle.

You're not going to stop me, are you. You're not even thinking of stopping me. You're not even thinking of thinking of stopping me. The only thing in your brain at the moment is that waffle. Your brain is entirely waffle, single-mindedly waffle and maybe a bit of jam, I don't know how you do it. I admire you so much.

PHIL decides that the waffle needs more jam.

LEAH sags. She drops her suitcase and sits with PHIL.

Did you see Jan at Adam's memorial? Floods of tears. It was wonderful, everyone felt wonderful, I felt terrible of course, but everyone felt wonderful. It's incredible. The change. This place. You're a miracle worker. Everyone's happy. You know that? You notice that? Cathy was on the telly. Used that clip on every channel. She's like a celebrity, there are second years asking for her autograph. Suddenly Adam's everyone's best friend. Richard's named his dog Adam. Mark's mum says if her baby's a boy she's going to call him Adam. Funny thing is they're all actually behaving better as well. I saw Jan helping a first year find the gym. Mark's been doing charity work, for Christ's sake. Maybe being seen as heroes is making them behave like heroes.

PHIL considers his waffle. Decides it needs more jam.

Yeah, everyone happy. Well it's not all roses, you know. Brian's on medication. Did you know that? Phil? Did you know that they've put Brian on medication?

No answer.

Yep, Brian's off his head, John Tate hasn't been seen in weeks, and the postman's facing the rest of his life in prison, but, you know, omelettes and eggs, as long as you've your waffle, who cares.

How do you feel?

PHIL turns to her.

Considers.

For a long time.

Opens his mouth to answer.

Stops.

Shrugs and goes back to his waffle.

LEAH stares at him.

I admire you so much.

The waffle is ready. PHIL looks pleased.

JAN and MARK enter.

JAN: You better come with us.

MARK: You really better come with us.

LEAH: What is it?

Beat.

JAN: You really, really better come with us.

LEAH goes with JAN and MARK.

PHIL looks at his waffle, looks after JAN, MARK and LEAH, then back at the waffle. Irritated he puts it carefully away.

* * *

A Wood. CATHY, BRIAN, PHIL, LEAH, MARK, LOU and JAN.

They stand around a BOY who looks like a tramp. His clothes are torn and dirty and his hair is matted with dried blood from an old gash on his forehead that has not been cleaned up. He stands there, twitchily, staring at them as though they were aliens and it looks as though he might run off at any moment.

Finally PHIL speaks.

PHIL: Hello Adam.

ADAM: Alright.

Pause.

CATHY: We found him up there, up the hill

BRIAN: I found him

CATHY: living in a hedge

BRIAN: a hedge, I found him, I found him, I found Adam living in a hedge, I found him

CATHY: It's like this hedge complex he's made, you have to crawl to get in

BRIAN: I crawled, I love crawling, I love crawling, Leah

CATHY: Like a warren in this hedge and he's dragged bits of cardboard and rags to make it better, more waterproof

231

BRIAN: I loved it, Leah, it was like a hideout.

CATHY: He's been living in there.

BRIAN: Living, she was shouting at me to get off the ground, but I love the ground, don't you like the ground?

CATHY: He was hiding away at the back.

BRIAN: D'you ever feel like the trees are watching you?

CATHY: Terrified.

ADAM: No I wasn't.

BRIAN: D'you ever want to rub your face against the earth?

JAN: No.

BRIAN: He wouldn't speak to us. I don't think he knew his name.

ADAM: Adam, my name's, I've got a name, it's…

BRIAN: Shall we do that? Shall we rub our faces against the earth? What do you think, shall we rub our faces against the earth?

CATHY: I think his head's hurt.

MARK: Who, Brian's or Adam's?

BRIAN: Don't they eat earth somewhere? Shall we eat the earth? I wonder what earth tastes like, what do you think it, do you think it tastes earthy, or, or…

He bends down to eat a handful of earth.

CATHY: I think he's been up there for weeks. Hiding.

I don't think he's very well.

BRIAN: *(Spitting the earth out.)* That's disgusting!

He suddenly starts giggling as he scrapes the earth from his mouth.

CATHY: I dunno how he's survived, what he's eaten.

BRIAN: *(Like it's hilarious.)* He's probably been eating earth!

He bursts into laughter.

CATHY: It took me half an hour to get him to come out.

BRIAN: D'you feel how wonderful this day is?

CATHY: I used violence.

BRIAN: She did.

CATHY: I threatened to gouge one of his eyes out.

BRIAN: She was gonna do it. She loves violence now. Can you feel the day licking our skin?

CATHY: He's a mess.

MARK: Which one?

BRIAN: Shall we hold hands? Come on, let's hold, let's hold, let's hold hands, come on, let's –

Suddenly CATHY slaps him.

For a second he looks as if he might cry, but instead he just giggles.

LEAH: Okay. Right. Okay.

Adam.

ADAM: Huh?

LEAH: Hello, Adam. How are you?

ADAM: …

LEAH: Yeah. Great. Phil?

PHIL says nothing.

Because this is a bit… isn't it. I mean this is really, talk about a bolt from the, yeah, shit. No, not shit, I mean it's good

LOU: Good?

LEAH: it's, yeah, yes it's

JAN: How is it good?

LEAH: it's, it's good, Adam, that found, but I mean yes, it does make things a bit

LOU: Fucked?

LEAH: tricky, no, not… don't say

LOU: We are fucked.

JAN: What are we gonna do?

LEAH: Don't panic.

MARK: What are we gonna do?

LEAH: I said don't panic.

MARK: We're not panicking.

LEAH: Good, because that's the one thing that's… So. Adam. How's…how's…how's things?

ADAM: I know my name.

LEAH: Yes you do.

ADAM: Adam, it's Adam, my name's Adam.

LEAH: Good. Well that's…

BRIAN starts giggling.

No, no, no Brian, that's, that's not gonna, so shut up. Please.

CATHY: What are we going to do?

LEAH: Phil?

What are we gonna…?

Phil?

Phil?

Say something Phil!

Pause. But PHIL says nothing.

LEAH: What happened.

ADAM doesn't answer.

LEAH goes to him.

What happened?

ADAM: I…

I was in a

dark…

Beat.

walking, crawling in this dark, when you're moving but with you hands and knees, crawl, crawling in this

dark

place and I don't remember

things

I fell, I falled into, I fell onto this…

wake, woke, wake up, I woke up with liquid on my head, leaves, dead and rotting, I remember leaves, but just dark maybe a light high, high, high, high, high…

above and, I drank the liquid it was blood, there was, it was mine, so I, it's not wrong because it was my

crawling for a long time, I thought, but that was hard to tell, tunnels, scared, I was, I felt like the dark was my fear, do you know what I mean? I was wrapped in it. Like a soft blanket.

And then I came out.

I saw this

light, this daylight light, I saw this light and went that way, towards, and I thought I died because that's what people

go to the light, you

and there was such a pain in my

I thought the light would make it go, but it didn't because the

light was…this.

Beat.

I was confused.

Beat.

Outside. I was sad, crushed.

Came outside.

I couldn't remember things.

I couldn't remember anything.

I was new.

A new

a new

a new me. And I felt

happy.

It hurt to laugh. But I laughed.

Beat.

Then night came and then I was

panicked, because, again dark, I panicked again

I ran

scratching there was lots of, scratching my skin

and I found my place where I live, and that's where I live now, I live there.

And I do know my name so you can shut, you can...

I live there. It's

mine, I

live

there.

Adam.

I'm not coming back.

Beat.

It's Adam.

LEAH: How've you been living?

ADAM: In the hedge.

LEAH: No, how?

What have you been eating?

ADAM: You can eat anything. I eat things.

Nothing dead, I don't

insects, grass, leaves, all good, but nothing, I caught a rabbit once and ate that, its fur was soft, warm, but nothing, I found a dead bird and ate some of that but it made me sick so nothing, nothing dead, that's the rule, nothing

Beat.

What?

JAN: Jesus Christ.

MARK: He's lost it.

JAN: He's off his –

LEAH: Okay. Now things are strange. Things are really, really strange, Phil. I mean with the greatest of respect, Adam, you are supposed to be dead.

ADAM: Dead?

LEAH: And I mean, there's been a service, there's been appeals, there's been weeping... They're naming the science lab after him, for God's sake.

ADAM: I'm...dead?

BRIAN starts giggling.

CATHY: Shut up.

ADAM: Am I dead?

LEAH: I mean now we really have, I don't know how we're gonna get out of this one because now we really have

ADAM: I thought I was dead.

LOU: You're not dead.

CATHY: *(To BRIAN.)* If you don't shut up you'll be dead.

BRIAN: I love this! This is great! Mates!

JAN: What are we going to do?

MARK: Yeah, what are we going to do?

LEAH: We're gonna, right, we're gonna... What are we gonna do?

PHIL: Adam?

ADAM: Yes?

PHIL: Do you want to come back?

ADAM: What?

PHIL: With us.

ADAM: I

PHIL: Or do you want to stay? Are you happy? Here?

LEAH: Phil –

PHIL: Shut up! Do you want to stay?

Pause. ADAM thinks. Looks at PHIL.

PHIL smiles, kindly. Nods.

Brian? Take Adam back to his hedge. Then come back to us.

BRIAN: This is great!

BRIAN takes ADAM off. They all stare at PHIL.

LEAH: What's going on?

PHIL: *(To MARK and JAN.)* Go back home. Don't say anything to anybody about this. You too, Lou.

LEAH: Phil…?

JAN: Are we going to be in trouble.

PHIL: If you go now and you say nothing to no one about this, you won't be in trouble.

JAN thinks. Nods to MARK. They go.

LOU stands there, unsure.

LOU: What about…

What about Cathy?

PHIL goes to her. Places a hand on her shoulder, smiles, warm, reassuring.

PHIL: Everything is going to be fine.

Beat. She goes off after JAN and MARK.

LEAH: Phil, what are you doing?

What? But he's…

Beat.

Phil, he's off his head. He's injured, he's been living off insects for weeks, he's insane Phil, he needs help.

PHIL: He's happy.

LEAH: He's not happy, he's mad.

PHIL: He doesn't want to come back.

LEAH: Because he's mad! We can't leave him here, I mean that's not, are you serious? Are you seriously –

Alright, yes, there'll be –

Phil, this is insane. I mean I've never, but this, because, alright, whatever, but this is actually insane. We can't just leave him up here.

PHIL: I'm in charge. Everyone is happier. What's more important: one person or everyone?

She stares at him.

LEAH: It's Adam, Phil, Adam! We used to go to his birthday parties, he used to have that cheap ice cream and we used to take the piss, remember?

PHIL: If he comes back our lives are ruined. He can't come back, Cathy.

LEAH: Oh, great, now you're talking to Cathy, like, I'm not, I'm not, because you don't like what I say and now it's Cathy, you sit there and you say nothing for years and suddenly now you're chatting with Cathy.

PHIL: Cathy?

LEAH: Let's, come on, let's, it won't be that bad, it'll be, we can explain. We can talk. We can go through the whole thing and make them understand –

PHIL: *(To CATHY.)* Do you understand?

LEAH: Understand what?

CATHY: Yeah. I do.

LEAH: Oh great, now you're at it.

BRIAN comes back, giggling.

(Pointing at BRIAN.) I mean I might as well talk to him for all the sense I'm getting. Phil, we can't do this, I mean what if he comes down next week, next year, in ten years, even?

PHIL: Take Brian.

CATHY: Okay.

BRIAN: We going somewhere?

LEAH: No, no, wait, you can't, no, this is… Cathy?

PHIL: Make a game of it.

BRIAN: We gonna play a game?

PHIL: You and Cathy are going to play a game. With Adam

BRIAN: Brilliant!

CATHY: How?

LEAH: How what? What are you, will you please talk to me as if

PHIL: Brian?

BRIAN: Who?

PHIL: Come here.

BRIAN goes to PHIL.

PHIL: I'm gonna do an experiment with this plastic bag. I want you to stay still while I do this experiment.

BRIAN: I love experiments! Will there be fire?

PHIL: *(Emptying his carrier bag.)* No. No fire.

Stay still.

PHIL places the bag over BRIAN's head.

BRIAN: It's all gone dark.

He pulls the handles back around his neck and to opposite corners, making it airtight.

BRIAN is giggling inside, looking around and breathing the plastic in and out of his mouth.

Bit stuffy.

PHIL looks to CATHY. She nods.

This is great!

LEAH: Phi… Phil?

PHIL takes the bag off.

BRIAN: That was great!

PHIL: You just do what Cathy says.

BRIAN: I am brilliant at doing what people say.

LEAH: No! Stop, don't, don't, Phil, don't, what are you doing, what are you…

PHIL: He's dead. everyone thinks he's dead. What difference will it make?

She stares at him.

LEAH: But he's not dead. He's alive.

CATHY: Come on Brian.

BRIAN: This is brilliant.

LEAH: No, Cathy, don't, stop, Cathy…?

But she goes, taking BRIAN with her. LEAH turns to PHIL.

Phil?

Phil?

Please!

Please, Phil!

But PHIL just walks away.

*　　　*　　　*

A Field. PHIL and LEAH, sitting
Complete silence.
PHIL takes out a pack of Starburst.

Opens.

Has one.

Chews. Thinks.

He offers one to LEAH.

She takes it.

She begins to quietly cry.

Crying, she puts the sweet in her mouth and begins to chew.

PHIL puts his arm around her.

Suddenly she stops chewing and spits the sweet out.

Gets up, stares at PHIL.

Storms off.

PHIL: Leah?

Leah?

Four

A Street. JAN and MARK.

JAN: Gone?

MARK: Yeah.

JAN: Gone?

MARK: Yeah.

JAN: What, she's gone?

MARK: Yes.

 Beat.

JAN: When?

MARK: Last week.

JAN: Where?

MARK: Dunno. No one knows.

JAN: No one knows?

MARK: Well, not no one, I mean someone must, but no one I know knows.

JAN: I mean she must've gone somewhere.

MARK: Moved schools. That's what people are saying.

JAN: Moved schools?

MARK: Yeah.

JAN: Just like that?

MARK: Just like that.

JAN: Without saying anything?

MARK: Without saying a thing

 Pause.

JAN: Oh.

MARK: Yeah.

JAN: Oh.

MARK: Yeah.

JAN: Oh.

MARK: I know.

JAN: Does Phil know?

<p style="text-align:center">* * *</p>

A Field. RICHARD sits with PHIL.

PHIL is not eating. He stares into the distance.

Silence.

Suddenly RICHARD gets up.

RICHARD: Phil, Phil, watch this! Phil, watch me, watch me, Phil!

He walks on his hands.

See? See what I'm doing? Can you see, Phil?

He collapses. PHIL doesn't even look at him.

RICHARD gets up, brushes himself down, and sits with PHIL.

Silence.

When are you going to come back?

PHIL shrugs?

Come on, Phil. Come back to us. What do you want to sit up here for? In this field? Don't you get bored? Don't you get bored sitting here, every day, doing nothing?

No answer.

Everyone's asking after you. You know that? Everyone's saying 'where's Phil?' 'what's Phil up to?' 'when's Phil going to come down from that stupid field?' 'wasn't it good when Phil was running the show?' What do you think about that? What do you think about everyone asking after you?

No answer.

Aren't you interested? Aren't you interested in what's going on?

No answer.

John Tate's found God. Yeah, Yeah I know. He's joined the
Jesus Army, he runs round the shopping centre singing
and trying to give people leaflets. Danny's doing work
experience at a dentist's. He hates it. Can't stand the
cavities, he says when they open their mouths sometimes it
feels like you're going to fall in.

Pause.

Brian's on stronger and stronger medication. They caught
him staring at a wall and drooling last week. It's either
drooling or giggling. Keeps talking about earth. I think
they're going to section him. Cathy doesn't care. She's too
busy running things. You wouldn't believe how thing's
have got, Phil. She's insane. She cut a first year's finger off,
that's what they say anyway.

Doesn't that bother you? Aren't you even bothered?

No answer.

Lou's her best friend, now. Dangerous game. I feel sorry
for Lou. And Jan and Mark have taken up shoplifting,
they're really good at it, get you anything you want.

Phil?

Phil!

He shakes PHIL by the shoulders. Slowly PHIL looks at him.

You can't stay here forever. When are you going to come
down?

PHIL says nothing. RICHARD lets go.

PHIL goes back to staring at nothing.

Pause.

Nice up here.

As I was coming up here there was this big wind of fluff.
You know, this big wind of fluff, like dandelions, but
smaller, and tons of them, like fluffs of wool or cotton, it
was really weird, I mean it just came out of nowhere, this

big wind of fluff, and for a minute I thought I was in a cloud, Phil. Imagine that. Imagine being inside a cloud, but with space inside it as well, for a second, as I was coming up here I felt like I was an alien in a cloud. But really felt it. And in that second, Phil, I knew that there was life on other planets. I knew we weren't alone in the universe, I didn't just think it or feel it, I knew it, I know it, it was as if the universe was suddenly shifting and giving me a glimpse, this vision that could see everything, just for a fraction of a heartbeat of a second. But I couldn't see who they were or what they were doing or how they were living.

How do you think they're living, Phil?

How do you think they're living?

No answer.

There are more stars in the universe than grains of sand on Brighton beach.

Pause.

Come back, Phil.

Phil?

No answer. They sit in silence.

END

THE GODS WEEP

Characters

COLM

CASTILE

JIMMY

IAN

GAVIN

NADINE

RICHARD

CATHERINE

MARTIN

THE ASTROLOGER

SECURITY GUARD

BETH

HUSBAND

BARBARA

OLD SOLDIER

Also: Waiter, Big Soldier, Officer,
Woman, Man and Soldiers

This production of *The Gods Weep* was first performed by the
Royal Shakespeare Company at Hampstead Theatre, London,
on 12 March 2010. The cast was as follows:

BETH, Nikki Amuka-Bird
ASTROLOGER, Karen Archer
IAN/MAN, Neal Barry
GAVIN, Babou Ceesay
THE SOLDIER/HUSBAND, Sam Hazeldine
BARBARA, Joanna Horton
COLM, Jeremy Irons
JIMMY, Luke Norris
NADINE/WOMAN, Sally Orrock
CATHERINE, Helen Schlesinger
RICHARD, Jonathan Slinger
MARTIN/WAITER, Laurence Spellman
CASTILE, John Stahl
SECURITY GUARD/BIG SOLDIER, Matthew Wilson

All other parts played by members of the company.

Directed by Maria Aberg
Designed by Naomi Dawson
Lighting designed by David Holmes
Sound designed by Carolyn Downing
Video and Projection designed by Ian William Galloway
 and Finn Ross for Mesmer
Movement by Ayse Tashkiran
Company Dramaturg by Jeanie O'Hare
Fights by Malcolm Ranson
Company text and voice work by Charlotte Hughes D'Aeth
 and Stephen Kemble
Additional company movement by Struan Leslie
Assistant Director, Lu Kemp
Casting by Hannah Miller CDG
Production Manager, Rebecca Watts
Costume Supervisor, Chris Cahill
Company Manager, KT Vine
Stage Manager, Heidi Lennard
Deputy Stage Manager, Caroline Meer
Assistant Stage Manager, Nicola Morris

Act One

Board meeting. COLM, CATHERINE, RICHARD, CASTILE, NADINE, GAVIN, MARTIN, JIMMY, and IAN, COLM at the head of the table.

COLM: …absolute panic, terror, sweating, drenched, I was drenched in my own sweat, all over my brow, my armpits, my chest covered, my groin, the backs of my knees and my upper lip, and I was screaming, although I wasn't screaming. I was screaming without screaming, my mouth was open and screaming but my throat was incapable of unclenching long enough for the air to sufficiently pass through my vocal chords and produce the required sound to scream, and so I was screaming without making a scream.

And I knew instantly that I was no longer dreaming. The dream was over, I knew that, the horror was gone but the fear still gripped my heart like a fist and I thought 'I'm going to die.' I knew I wasn't going to die, I was safe, I knew that, but I thought 'I'm going to die.' And here's the thing, the thing is, here's the thing, the thing was that I welcomed that thought. But I was horrified of it at the same time because I thought if I die, if I die, you see, who am I? Who have I been? Who have I been and what have I done?

Beat.

And I went down stairs. And I went into the study and I poured a whisky into a cut crystal glass, a good whisky, a very good whisky. And I took it into the downstairs bathroom, and I sat on the toilet, in my pyjamas, like it was a dining room chair, the smell of whisky engulfing me, surrounding me.

And I stared at myself in the mirror. I stared at this face and I thought 'who's that?' I mean it was me, I knew it was me, I wasn't insane or panicking I knew who it was, but I just didn't have a clue who it was.

Pause.

CASTILE: And… And what was the dream?

COLM: I dreamt that I was on a beach collecting shells.

CASTILE: Shells?

COLM: The most beautiful shells. Incredible. Beautiful. Iridescent. And there were hundreds of them, all different, all beautiful. And it gave me such joy. It gave me such a… joy, and peace, to collect these incredible shells. And it was just before dawn. And there was this thing on my belly, like, like a spot, a blackhead but large, and I squeezed it, like you would squeeze a blackhead and it squeezed out, but it was huge and it just kept coming, meters and meters of this, thick as your finger, it just kept on coming until there was a huge pile of it there on the floor. And it stank. And I looked at all my beautiful shells. And they were shit. They were just shit. They were shit shells. They were rubbish, just… shells, dirty, shit, dead things, just shit shells, just shit.

Silence.

CASTILE: Colm?

COLM: Richard. Catherine.

They step forward.

I have, in my life, done many bad things. But I have had to do bad things to make good things happen. When I took control of this company, thirty years ago, it was a third rate utilities provider. So I took it and I shaped it and I broke things to make things. I made you. All of you. I made you into beasts.

Thirty years on we now own subsidiaries across a vast range of fields; manufacturing, transport, security, petrochemical research. And it occurs to me now that perhaps we have fought enough. That perhaps growth has its limits.

Pause. They wait, not knowing if he's finished.

There has been disagreement between you two, and I have fanned those flames like a father forcing children to fight. But do we make things that can only destroy, ravenous engines of wealth that can only move in one direction? I

believe it is people like us that must inherit this earth. But are we monsters?

No. No we are not. We are not monsters.

Pause.

I have two things to tell you, one small and one large. The first is that I am taking control of Belize,

JIMMY: What? But… Belize is mine.

COLM: Belize is important. I want Belize. I'm taking Belize.

JIMMY: It's, it's mine, I've been, I've been working on, it's mine –

COLM: You've failed. It is not working. I'm taking it.

Second. I am handing over complete control of Argeloin and all our interests to Richard and Catherine.

CASTILE: What?

IAN: Sorry?

CASTILE: What did you just say?

GAVIN: Is he serious?

CASTILE: What, the whole thing? Everything, you're handing over –

NADINE: Richard? Why Richard?

RICHARD glares at her.

No I don't mean… but I just mean.

RICHARD: Keep your fucking mouth closed, Nadine.

CATHERINE: How?

COLM: I'm going to divide power. Richard will be responsible for the horn of Africa, Nigeria, Morocco and what states we provide in Europe and the Middle East: Catherine, you shall take the Americas, our Asian holdings along with all Russian exploratory work and Côte d'Ivoir

CASTILE: Are you mad, Colm?

COLM: and such states as Ukraine and Lithuania should they fall into our sphere of influence. I think you'll find that this divides the net worth of the company evenly between you both. Lest there be… squabbles.

CASTILE: Are you fucking mad?

COLM: I shall retain my title as Chairman, but shall resign as CEO. My position will be nominal, somewhere from which to help and advise. Castile, who has been by my side all these years, will retain his place in the boardroom, so as to be my eyes and ears. As Chairman all of your decisions will have to be signed off by me, but this will be a formality. Purely a safeguard.

GAVIN: He's serious. He is, he's fucking serious.

COLM: This is a test.

CASTILE: A test?

COLM: For all of us. For everything. For everything in the world.

CASTILE: A fucking test?

Martin steps forward.

MARTIN: Okay, okay, lets just, please, Colm, take a step back. Please. I mean, please. Because purely from a logistical perspective this throws up all sorts of, and I'm not saying, no, this is nothing to do with, I mean Richard, Catherine; they are both very brilliant, both of you brilliant and able, but you cannot, Colm, transfer power like this in one move and expect there not to be consequences. So, I think what we should –

COLM: Who is this?

MARTIN: Martin, I'm Martin, I'm head of –

COLM: Did I ask you?

Beat.

CASTILE: This is Martin. He's Executive Head of Communications.

COLM: Get him out of here. Clear his desk. Throw him out of the building. Tear up his contract. Let him know that if I see him again I will make sure that he remains unemployable for the rest of his life.

Beat.

HAVE I DIED? AM I DEAD? IS NO-ONE ABLE TO HEAR MY FUCKING WORDS?

Beat. CASTILE leads MARTIN out.

I have made this company. I have made decisions and my decisions have been right. This is right!

Pause.

Richard. Catherine. Together you shall forge the future.

The eyes of the world are upon us.

They all stare at him.

Yes. I think that's it.

They all leave. Except for JIMMY. Silence.

I thought your birth was a bad omen.

The pregnancy was very difficult, I couldn't help feeling relieved when you were taken out of her, I had begun to think of you as a kind of tumour.

JIMMY says nothing.

You were in an incubator for months, I couldn't touch your skin, you became this creature inside a plastic egg, this alien creature inside its plastic egg.

JIMMY says nothing.

When they put you in my arms I had to fight back the desire to swing you by your feet and dash your brains out on the wall, you were always sick and crying, you told tales on other children, you were smaller than other children, you cried in the presence of other children, you never laughed, not once, not until you were three when you saw a dog that had been run over, an animal with a broken back, dragging its hind legs, and you laughed and you laughed and you laughed. I had to fight to love you.

One of my key innovations was to fire the bottom performing eight percent of the sales team every year. That's who I have been.

I had to fight to love you. But I did love you. I do love you.

JIMMY: I can make Belize work.

COLM: No. You're failing. You're failing because you're in love.

JIMMY: How… how do you know about…?

COLM: It's my job to know. She's using your weakness. But I am so proud that I have a son with the capacity for love, Jimmy.

JIMMY: What is it I lack? What is it that they have that I lack? Tell me what they have that I don't. Tell me what I must have to be like you.

COLM: Strength. You have to have strength.

You must have the strength to take your own son's arm and break it across your knee if that is the right thing to do.

JIMMY: No. You're not, that's not, you're not that, that's not you, you're…

COLM: And then, if necessary, to take the other one and snap that too.

You don't have that.

JIMMY: When?

COLM: Two weeks. And I want you to do nothing in those two weeks, is that clear?

JIMMY: I'm so close, I can fix it. Please. I can be like you. I can.

COLM: No. No you can't. But that's good. That is good and I am so happy that you can't.

JIMMY is crying.

See? See how weak you are? But it's a wonderful thing. Cherish it.

* * *

CATHERINE and IAN.

CATHERINE: Thanks for this, Ian, I just wanted a quick word…

IAN: Oh yes, yes, of course.

CATHERINE: Because all this, it's all a bit of a shock, and…

IAN: Oh god, yes, I know. Congratulations, by the way.

CATHERINE: Oh, yes, yes, thank you, it's all such a shock and that sort of, I noticed that Richard went off with Gavin. Did you notice that? Straight away, straight away they went off together, what do you think that is?

IAN: They'll just be talking. Like us

CATHERINE: Not like us. Thick as thieves, those boys, thick as tealeaves.

Do you think Richard'll move against me?

IAN: What? No, of course not. After this? You're comrades. He'll be happy.

CATHERINE: Comrades? You think so?

IAN: Catherine, I… I think we should put problems behind us.

CATHERINE: Oh yes, yes, definitely, that's what I want to do, of course, that's exactly what I want to do. He accused me of misappropriating funds.

IAN: Catherine, listen to me. Deep down, Richard respects you.

CATHERINE: Last week he called me a cunt with a cunt

IAN: That… was inappropriate. Look, why would he move against you; he has nothing to gain by it. He's just not as smart as you.

CATHERINE: No. Neither's a rattlesnake. Poor Nadine. What an idiot, though. Did you see the way he looked at her? With his eyes, those eyes of his?

Beat.

Now, Ian; What's Belize?

IAN: Belize? It's food security.

CATHERINE: Right, right.

What's that?

IAN: Food security. It's the new thing.

CATHERINE: Is it? Great.

IAN: It's food security. We've just acquired 1.7 million hectares in Belize to secure it for farming to lease it out to wealth rich nations.

Food security is the new thing. Governments have been doing this for years – Dubai leasing land from Somalia, etc etc. China, Sweden, Libya, they're all grabbing land in Africa, South America, it's a real growth industry and it's only going to go one way. This acquisition represents the largest move in from the private sector, Colm thinks Belize is the crucible of all our hopes.

CATHERINE: Right.

Sorry, what does that mean? Is that good, a good thing, I mean don't you burn things in, aren't they for burning things?

IAN: Or forging things.

CATHERINE: Right. Right.

Actually, I think that's a forge.

IAN: Thirty billion dollars last year.

Beat.

CATHERINE: Wow. Nice.

IAN: Buy land – they're not making any more.

CATHERINE: Oh, I like that, that's very clever, you're very clever.

IAN: Actually it's Mark Twain.

CATHERINE: Yes, but you were clever enough to repeat it.

IAN: And there are rumours of something else.

CATHERINE: What else?

IAN: Some deal in the background, some huge deal. Colm's playing it close to his chest. But there are rumours.

CATHERINE: So what's the problem, with Belize?

IAN: Well; there are… rebels. And we have to send some guys over, expert soil analysts, I think, about eight guys, you know, experts. But these rebels. Marxist or Maoist or something they see this whole thing, they're very

blinkered, they don't see the benefits. So there is a fear that, these experts might get, well, killed or kidnapped. So we're having difficulty getting them… insured.

CATHERINE: What? Insured? The problem… is insurance?

IAN: Potential negligence suits for sending eight men into rebel territory are huge. We need these men insured.

CATHERINE: Fucking… insurance? Why can't we get them insured?

IAN: Jimmy.

CATHERINE: Oh. Jimmy.

IAN: Jimmy can't get the insurers to insure.

CATHERINE: Do you think it can work? Me and Richard. Together?

IAN: Catherine, I'm a team player, I don't want divisions…

CATHERINE: Oh no, me neither, I'm a team player, I'm definitely a team player, I'm the most team player of all, but the thing is I like people on my team, not the other team, not their team, in fact I don't want there to be a their team, that's how much of a team player I am.

I really like what you've been doing, and I'd like to expand that. You have a wonderful knowledge of the Americas, quotes and things, you have so much expertise. I'd like you to look after the Americas for me.

IAN: Wow. I… Thank you, I… I don't know what to say…

CATHERINE: Say yes. Would you do that for me?

IAN: Christ, yes, this is… Thank you.

CATHERINE: Well. Can't do it all on my own, now can I. It's all about being in a team. Our team. My team.

* * *

RICHARD, GAVIN and the ASTROLOGER.

RICHARD: I'm going to rip Catherine to shreds.

Beat.

I'm telling you this because you're either with me or against me. If you're with me I'll make you rich. But now you know what I'm going to do, so if you're against me I'll have to tear you to pieces too. Are you with me or against me?

GAVIN: Fucking hell, Richard, this is a bit –

RICHARD: Are you with me or against me?

Pause. GAVIN thinks.

GAVIN: How rich?

RICHARD smiles. Turns to the ASTROLOGER.

RICHARD: What's going to happen?

Pause.

ASTROLOGER: It's not a complete picture.

RICHARD: Give me an incomplete picture.

ASTROLOGER: An incomplete picture is…

Long pause.

GAVIN: Incomplete?

ASTROLOGER: incomplete, yes.

Beat.

Conflict. You're going to war.

RICHARD: With Catherine? Or with Colm?

ASTROLOGER: I can't see. Possibly one. Possibly the other. Possibly both. You will win, though. Probably. Just be careful who you lie to. Four planets are now forming The Cardinal Cross. Saturn, Uranus, Pluto, Jupiter, it's very rare. Very exciting. Happens at big times; the great wars, great depression, fall of the Roman Empire things like that. Very exciting. Happening… now.

RICHARD waits. She has finished. He turns to speak to GAVIN.

However…

Mars is in conjunction with Saturn.

In a progressive sense.

Beat. They stare at her.

Mars is in conjunction with Saturn.

RICHARD: And?

ASTROLOGER: Mars is in conjunction with Saturn. It's very
rare. It hasn't happened in over five hundred years.

Beat.

RICHARD: What does it mean?

ASTROLOGER: It means…

…be careful who you trust.

RICHARD: Can I trust you?

ASTROLOGER: We've been together for twenty years, dear,
I've never lied to you yet.

RICHARD: *(To GAVIN.)* Do you believe this? You believe he's
handing over power?

GAVIN: He's done it. He's off the board, I mean that's it he's

RICHARD: What about Castile?

GAVIN: What about him?

RICHARD: What do think of Castile?

GAVIN: He was a salesman. He's a tough bastard. He was in
sales.

RICHARD: He's still in sales, technically.

GAVIN: Technically yes, but it's been twenty years since he's
had to sell. He's Colm's right hand. He commands a lot of
respect.

RICHARD: Is he dangerous?

GAVIN: Well, he's –

RICHARD: I wasn't asking you.

Beat.

ASTROLOGER: Mars is in conjunction with Saturn.

RICHARD: You keep saying that but what does it mean.

ASTROLOGER: It means Mars is in conjunction with Saturn.
You asked was he dangerous. I really don't know how
much clearer I can be.

* * *

A company foyer, JIMMY, drenched, a security guard in front of him. BETH shows up.

BETH: Jesus Christ, Jimmy, what are you doing here?

JIMMY: Hi Beth, how's, how's, I was just… How's it going, I was passing and

SECURITY: He can't come in.

BETH: Passing?

JIMMY: and I thought, yeah, passing sort of, and I thought I'd say hello, you know, friendly or

SECURITY: Sir, I've explained before, you can't come in, he can't come in.

BETH: You can't come in Jimmy.

JIMMY: No, no, I don't want to come in, I just want to say hello, I mean Christ.

SECURITY: We have an employees only policy after 7.30 it's 9.15 you can't.

BETH: It's nine fifteen, Jimmy.

JIMMY: I fucking know the time!

SECURITY: There's no need for language, sir.

JIMMY: I'm not giving you language, I'm not giving him language, Beth.

SECURITY: I don't get paid to be sworn at.

BETH: Don't swear at him Jimmy.

JIMMY: I'm not fucking swearing I just want to get in out the fucking rain and say fucking hello!

Pause. She nods to the security guard. Reluctantly he leaves.

JIMMY stands in front of her. Goes to say something, but doesn't. Pause. Stands there.

How's… how's your dad?

BETH: What? How's my dad?

JIMMY: Yeah, I just thought, chatting, small talk or.

BETH: My dad is terrible, what are you doing here, Jimmy?

Pause. He wipes the water from his hair.

JIMMY: Wet.

In there are you?

All in there? Making your mind up? Going over the deal?

BETH: We... we are going over, yes, we are.

JIMMY: Are you going to insure us?

Laughs. It is not funny.

Joking, joking, you can't say, of course, I'm just...

Pause.

Look no, I just thought – sorry about the joke, Beth, that was inappropriate, that was – no, I just thought, as I was passing you know, if there was any other data that you might need, I thought... Well here I am.

BETH: We don't need any other data

JIMMY: Great. So you have all the data?

BETH: Yes.

JIMMY: You have all the data you need?

BETH: Yes

JIMMY: So are you near a decision?

BETH: I can't say.

JIMMY: Jesus Christ, Beth, I'm just asking if you're near a fucking decision, you can tell me that at least.

BETH: How is that going to help?

He doesn't answer.

Right. Look. There is a process going on. We are in the process of evaluating your application and there are systems to go through. Now we have all the data, we have the statistical reports, we have more than five independent studies from which to draw upon, we have everything. I cannot pre-empt the results of that –

JIMMY: Last week I was brushing my teeth and I must've hit something in a funny way or something, maybe triggered a sort of nerve response but suddenly I could taste your vagina.

Really clearly. Really, really clearly. Isn't that odd?

Beat.

And I thought that maybe I had absorbed some of your body into mine, and I thought that for that to happen some of your molecular structure must've mingled with mine.

Beat.

And it was such a beautiful moment that I began to fantasise about being cryogenically frozen so that this moment could last forever, and I began to think that this was potentially a great business opportunity, so that you could stop time at this perfect moment and stay there, and all the pain that you've experienced since that moment had happened, the feeling that your soul had been sucked out by a vacuum cleaner and shredded into tiny pieces, the waking up in a panic and screaming, the feeling that you now had liquid shit for blood, those feelings might disappear and you might be able to stay in that perfect moment.

Beat.

What do you think? Do you, do you think that's possible?

BETH: Jimmy…

JIMMY: Could it be an investment opportunity? I wanted to ask you about that. I wanted to ask you if you consider insuring that?

Beat.

BETH: I… think that you would soon find that there was a significant gap between your technology and your projected aims.

JIMMY: I'm falling to pieces, Beth, look at what you've done to me.

BETH: I haven't done –

JIMMY: I love my wife. I love her so much. I would die if she found out. And I'm lying there looking at her and suddenly I'm thinking 'oh my god you're going to find out, you're going to find out and I'm going to die' and I swear Beth that my heart falls into a pit in my stomach that I didn't

even know was there, and yet at the same time I can't stop thinking about your hair.

BETH: Okay, Jimmy, you just have to hold it together.

JIMMY: Okay.

BETH: Okay?

JIMMY: Okay. Your husband's a fucking student how is that better than me?

BETH: Don't bring my husband into, this has nothing to do with my… And actually, he has given up a good career to go back to full time, which is something I respect very much, so –

JIMMY: How's your dad?

BETH: I'm not talking about my fucking dad!

JIMMY: You see the thing is I'm not a bad looking man. I'm not a great looking man but I'm not a bad looking man so sometimes women want me, for, for, for say a one night thing, like you would want a normal person, a real person. And I think great, but no sooner have they touched my flesh than my heart aches for them with every fibre of my body and all pretence collapses and I just want them to want me but they can suddenly see inside of me and see my weakness and hunger and they are repulsed. And when I say they, Beth, I mean you.

Are you going to reject this bid because of my weakness?

Pause. She is staring at him. Pause.

BETH: He's terrible. My dad. He's still drinking. He stinks. Smells like someone defecated in him. But every so often he does this smile and you think I know you and then it disappears under the waves of snarling filth that he uses for an expression these days.

He's on a list. For treatment.

They haven't got enough places. He'll die before he goes in.

JIMMY: My father's the same. Completely different, but exactly the same.

Pause. She comes closer.

BETH: Jimmy… we are not necessarily going to reject –

JIMMY: *(Recoiling.)* Oh Jesus, oh Jesus Christ you are, you're –

BETH: It's not because of what you said!

They don't want you Jimmy. Rebels or not. These are not… these regions are poor. You're buying land in poor regions, investment, you can talk all you like in your reports about vast injections of capital into growing economies but I have to deal in facts and who sees that? where's that going to go, officials? what corrupt officials? siphoning? these farmers, local farmers aren't…

Look, that aside, there are rebels everywhere. These men are a target. There's not enough provision for Security. And if you put more into Security the whole thing becomes untenable, you can't win. You're sending workers in there, they will be kidnapped. They will be killed. You will lose these men.

Pause.

JIMMY: If it was someone else you'd be saying yes. My Father would make this happen.

BETH: No, he would not make this happen.

JIMMY: He would. His would strong this. His would strong this to happen.

Pause. He moves away. She waits. Waits.

BETH: Jimmy?

JIMMY: Give me two weeks.

BETH: What for, no, we've been over everything, there's no –

JIMMY: Please, please, please fucking please, Beth, please, look at me, look at what I am, you have taken everything from me, you saw weakness on me, you saw the weakness of my love for you on me and you used that knowledge to decide about this, please.

Pause.

BETH: That is not what happened.

JIMMY: Two weeks. I'll sort everything out. I'm begging.

BETH: One week.

JIMMY: I think about you all the time.

BETH: Don't… fucking think about me ever.

* * *

RICHARD and CATHERINE, RICHARD bursting in, carrying a folder.

RICHARD: I have had enough!

CATHERINE: What? Jesus Christ, Richard, what are you

RICHARD: This, this, this… shit! This shit? Belize, this Belize… shit…

CATHERINE: Oh. I see. The report.

RICHARD: Fucking report? This, what, this?

CATHERINE: You've read the report. It's my fault, I shouldn't have sent it to you. You know it came to me, my desk, the Americas, and I thought, well, that you should see, Richard should see, but I knew it'd get you all –

RICHARD: Have you read this fucking report?

CATHERINE: You're angry, aren't you.

RICHARD: And are you happy with this? Tell me you are not happy with this

CATHERINE: I'm not happy with this

RICHARD: Are you happy with this?

CATHERINE: I am not happy with this at all

RICHARD: You are CEO, I am CEO, Colm is not the CEO. He was the CEO, now we are the CEOs, if he wanted to stay CEO he should've fucking…

CATHERINE: Twenty five percent.

RICHARD: Twenty fucking five percent. I mean fuck! It's impossible! Humanitarian provision bullshit, twenty five… have you see this?

CATHERINE: Twenty five percent of all produce to be sold locally at below market value.

RICHARD: I mean what is this Ghandi peace prize shit all of a sudden?

CATHERINE: This is just the start, I mean a thing like this? Where does it end?

RICHARD: Ghandi is it, fucking Ghandi?

CATHERINE: How does it work?

RICHARD: It doesn't fucking work!

CATHERINE: This is legacy stuff.

RICHARD: Exactly!

CATHERINE: Legacy… nonsense. The search for absolution

RICHARD: Thank you, exactly. I mean have you seen these projections?

CATHERINE: Statues in the plaza, local hospital named after you, welcome to Colm international airport and do not forget your landing cards.

RICHARD: The old Colm would never do this, I mean what book did he get this from, a book? Reading is it, night-time reading, reading at night?

CATHERINE: It's going to make success in Belize impossible.

RICHARD: *Das Kapital?* Fucking…

CATHERINE: I mean where does it all end? So: what are we going to do?

Pause. He is staring at her.

What?

RICHARD: We should take this. We should take this from him.

CATHERINE: What did you just say?

RICHARD: You heard.

CATHERINE: Yes. Yes, I did.

Beat.

RICHARD: You are CEO. I am CEO. We decide who does what. We decide who looks after what. We decide that people who design operations that will never, ever, ever be profitable do not look after said operation.

CATHERINE: Are you suggesting taking this from him?

RICHARD: I am suggesting taking this from him.

Pause.

CATHERINE: Okay.

RICHARD: Shit. I mean shit. This is big.

CATHERINE: I know, I know. Can we do it?

RICHARD: No.

CATHERINE: What?

RICHARD: The board. The others on the board. Them.

CATHERINE: Right. Them. There's a lot of loyalty on the board.

RICHARD: Loyalty? Cowardice.

CATHERINE: Colm created them, they're loyal.

RICHARD: They're cocksucking maggot fuckers.

CATHERINE: Ian, Gavin, Jimmy. Nadine…

RICHARD: Do not say Nadine's name in my presence.

Pause. He is staring at her.

CATHERINE: What?

RICHARD: What if one of us was one of them?

CATHERINE: What?

RICHARD: What if one of us was one of them.

CATHERINE: How could one of us be one of them. We're us.

RICHARD: No. Only one of us becomes us.

We hand over Belize to one of us, not both of us.

Beat.

CATHERINE: The whole thing?

RICHARD: That way the other one stays there. In the bosom of the beasts.

CATHERINE: What about Castile? He's a big presence on the board.

RICHARD: He's a big cunt on the board.

But if it looked like one of us was one of them… That one could manoeuvre. That one could ensure there was no rebellion, smooth the transition. We just hand over Belize to just one of us, fuck Castile.

269

CATHERINE: Everything has to be signed off by Colm. You think he'll sign this off? Us taking his own operation from him?

RICHARD: Deal with this. Then let's deal with that.

CATHERINE: Which one? Which one of us?

Beat. He shrugs.

RICHARD: I don't mind taking it.

CATHERINE: You don't?

RICHARD: No.

CATHERINE: That's good of you. So you would…

RICHARD: Yes.

CATHERINE: Be in control of…

RICHARD: Yes.

CATHERINE: be in control of Belize, then?

RICHARD: I would

CATHERINE: Right. Right.

Have you heard rumours? Of some huge deal connected with Belize?

RICHARD: No.

CATHERINE: No?

RICHARD: No, nothing? Have you heard rumours?

CATHERINE: Rumours? No, I haven't heard rumours. I haven't even heard of the rumours.

Beat.

RICHARD: So?

CATHERINE: Well, it's just that if one of us had Belize… our turnover is currently equal and this would tip the balance. And what with all eyes on Belize if that person made a success of Belize then in the eyes of the board that person would, well, kind of be the winner between us.

RICHARD: Right.

CATHERINE: Not that there's competition, all that's behind us, of course. But if someone had Belize, that would be the balance sort of…

RICHARD: That would tip the balance.

CATHERINE: That would tip the balance, yes.

RICHARD: Right.

Of course if they fucked up that would tip the balance the other way.

I mean this insurance thing that Jimmy's been in charge of is likely to sink the whole thing.

CATHERINE: Jimmy. I mean, Jimmy. Lovely guy, but…

RICHARD: Couldn't get cunt-fucked in a brothel.

CATHERINE: Quite. So… What do we do?

Would you be willing to let me take Belize?

RICHARD: You?

CATHERINE: Yes.

RICHARD: No. Absolutely not. No offence.

CATHERINE: None taken, but you see my position?

RICHARD: I do, I do. One of us needs to take it, though. It's the only smart play.

CATHERINE: And the annoying thing is that we're essentially a team.

RICHARD: Plenty of room for both of us. Those days are over.

CATHERINE: But here we are.

RICHARD: Yes. Yes. Here we are.

Pause. Richard gets up.

Toss you for it.

He pulls out a coin, steps back.

CATHERINE: Sorry?

RICHARD: Leave it in the hands of the gods. Let fate decide.

CATHERINE: Are you serious?

RICHARD: Yes. What do you think?

Beat.

271

CATHERINE: Okay.

RICHARD: Heads or tails.

CATHERINE: Heads

He tosses the coin, catches it, flips it onto the back of his hand.

No, tails. Fuck it, heads.

They exchange a look and the he looks at the coin.

RICHARD: Shit.

CATHERINE: What?

RICHARD: Congratulations. You won.

He puts the coin away.

CATHERINE: You didn't show me the coin.

RICHARD: What?

CATHERINE: You didn't show me the…

RICHARD: Didn't I? Of course. Sorry. You wanna do it again?

Pause. She stares at him. He takes the coin out again. Waits.

CATHERINE: No. I'll take it.

RICHARD: Sure?

CATHERINE: Yes. Why not?

He holds out his hand to her. She shakes it.

RICHARD: It's nice to be working with you. Together.

CATHERINE: Yes. Aren't we.

He goes. She presses a button on her desk. Waits, lost in thought. After a moment JIMMY enters from another door. He goes to her, tries to kiss her, but she pulls back, still miles away.

For reasons I don't yet fully understand… I now have Belize.

He does not respond.

I think we'll go ahead with our plan.

He says nothing.

What's wrong? Don't you want Belize? Don't you want it back? You make it a success for me and I'll give it back to you. Don't you want it back?

JIMMY: Yes, I do, but… I don't know if I can do this.

CATHERINE: Of course you can. You're my brave little boy.

JIMMY: I just… I'm not sure if I can do this, I'm not sure if –

> *She slaps him across the face. He is shocked. Looks like he might cry. She can't help but laugh, a kind laugh, but immediately regrets it. Kisses him.*

CATHERINE: I'm sorry. I'm so sorry. My beautiful boy, my beautiful, beautiful brave little soldier-boy. You can do this. Are you going to do this?

JIMMY: Yes.

CATHERINE: Are you going to do this for me?

JIMMY: Yes, I'm going to… I'm going to do this.

CATHERINE: See? See? See what you can be when you put your mind to it? So brave. My brave little soldier.

<p style="text-align:center">* * *</p>

COLM, sits, coat still on. Lost in thought. CASTILE enters, taking his own coat off.

CASTILE: I've got Gavin outside. I have him outside and now we'll find out what's going on. He sitting there, terrified, like a –

Do they think they can just cut programs out of your projects? Just fucking cut, like –

I told him. I said, I said you were furious and he shat himself, Colm, he shat a house-brick. I said, I said 'I spoke to Colm on the phone last night' I said 'and let me tell you I could hear the blood rattling in his throat, Gavin' and he shat a, he's shaking, Colm, he's practically…

Beat. Notices COLM. Stares at him. Silence. For a long time.

COLM: Last night I'm sitting there having dinner with my wife. And we're not speaking. Not in a bad way. Not in a 'I've got nothing to say to you, pass the salt' sort of way but in a loving silence, a warm silence. So I'm sitting there having dinner with my wife in a warm silence. I think it was lamb. And I said 'Is this lamb?' and she said 'Yes.

It's lamb. Don't you like it?' and I said 'Yes. I think I like it.' and she said 'Think? You think you like it?' and I said 'Yes. I think I like it' and she said 'Shall I tell Angelina to make you something else?' and I said 'Why would you do that when I think I like it? Isn't that a positive?' and she said 'No, that's not a positive. Not if you think you like something. It's only a positive if you like something' And I said 'well what about us? I think I like you, yet we've been married for twenty five years.' And there was a… catch,

in her being, a microsecond of shock. And I thought 'Oh Christ, I've done it now' and I didn't mean to, Castile, I really didn't, I just thought this was a given, but she's always had remarkable powers of recovery and we just carried on, we just carried on talking.

And we carry on eating. And there are silences, yes. But comfortable silences. The silences of deep understanding. And we're chatting, and she's telling me about her brother and there's no hint of what was said, so much so that I'm beginning to think that it never really happened and then, then in the middle of a sentence, she looks up at me and says 'What do you mean "think"? What does "think" mean?'

Beat.

And I looked at her. And I saw in her face that one word from me, and she would collapse behind that smile. And I thought 'God, don't say the wrong thing' but I found myself saying 'Well, on the way home I almost asked Mario to drop me off at a brothel so I could pay a prostitute to let me fuck her in the mouth.'

CASTILE: You said…

COLM: Yes.

CASTILE: You said that to

COLM: Yes.

CASTILE: Miriam, you said that to Miriam?

COLM: Yes. Yes, I did. And she looked so… surprised. And I said, 'Look, I'm saying this because I want to be honest,

don't you want to be honest? I think I love you, I think I've loved you for twenty five years, isn't that enough? Please don't tell me that that isn't enough.'

And for a second, for a fraction of a second I thought 'Here we go. Here it comes, the eruption, she's going to explode…'

And she looked at me and opened her mouth and said 'You're in a funny mood tonight.' And then she went back to the lamb.

Beat.

'You're in a funny mood tonight.'

And suddenly it occurred to me, Castile, that we had in fact been sitting in a 'pass the salt' sort of silence. That we had been sitting in that sort of silence for twenty five years. And I cried. I cried my lungs out. Inside. I cried my lungs out inside. Outside I just carried on eating the lamb.

Pause.

What do you think of me, Castile?

CASTILE: I… admire you.

COLM: Is that good? Because I'm not sure if that's good anymore.

Pause.

CASTILE: Colm, are you –

COLM: Show him in.

Beat. CASTILE opens the door.

CASTILE: Get in there, you.

GAVIN: *(Entering.)* Colm, Listen, this really has nothing to do with –

CASTILE: Shut up, you.

GAVIN: I'm just saying that this has –

CASTILE: I said to shut your fucking fuck!

GAVIN: Look there's no need for that kind of –

CASTILE: Why are you standing?

GAVIN: Because… I don't know. Do you want me to sit?

CASTILE: What do you think?

GAVIN: I think –

CASTILE: Do you? Is that what you think? That's really fucking interesting, sit your arse down before I break your legs to sit you down.

He sits.

GAVIN: Listen, Colm, I really had nothing at all to do with –

COLM: Why is he sitting?

CASTILE: Why are you sitting?

GAVIN: Because you told me to –

COLM: I didn't say for him to sit.

CASTILE: He didn't say for you to sit!

GAVIN: Look, I'm not impressed with this, all this, I'm not scared of –

CASTILE: Stand up you fucking cunt!

He stands.

You fucking cunt. You fucking cunt. Can I just kick him out, Colm, can I just fucking destroy him please, Colm, just let me fucking destroy him, Colm, you owe me that at least, please?

GAVIN: Look this is nothing to do with me!

COLM tosses a folder to GAVIN.

COLM: My humanitarian provision has been cut from this. Where is it?

GAVIN: Okay, look –

CASTILE: Shut your fucking mouth when he's speaking!

COLM: Answer my question!

CASTILE: Answer his fucking question, cunt!

GAVIN: Can I speak or are you just going to shout at me?

Beat.

Look, we did a feasibility study, this is not… This can't work. You know it can't, look at the margins, look at the… We did a feasibility study.

Pause.

COLM: Belize is mine. Belize is my project, I make decisions about what goes in and what gets cut out of my –

GAVIN: It's… it's not yours. Not any more.

Beat.

Catherine and Richard, they… they gave it to Catherine.

CASTILE: What? What did you say?

GAVIN: It's their right, you made them CEOs they are CEOs.

CASTILE: What did you say? What did you fucking –

COLM: Castile!

Beat. CASTILE steps back. COLM stands.

I want my provision back in. I want you to put my provision back in.

GAVIN: Okay. Okay, right.

No.

Beat.

They… they can do more to me than you can. They are CEOs. You made them CEOs.

COLM doesn't move. But he is shaking.

COLM: You… you little… you little… You little, you, you little you, you…

CASTILE: Colm?

COLM: you little, you little you, I will… I will, you, I will…

Beat.

Get out.

Beat. GAVIN goes. CASTILE stares at COLM.

CASTILE: What? are you going to just let him go? Don't let him go. Don't let him go like that! We can do things, we can break him, we can do so many things! They'll think you're weak! Colm.

But COLM says nothing.

Colm!

* * *

JIMMY sitting, waiting, soaked, drenched. He has not taken his jacket off.

BETH enters, wearing a nightgown.

BETH: You fucking

JIMMY: Sorry, sorry

BETH: You fucking

JIMMY: sorry, sorry, sorry –

> *Husband enters. Sees JIMMY. Smiles.*

HUSBAND: Wow.

JIMMY: Yes.

HUSBAND: Cats and dogs.

JIMMY: Completely soaked.

BETH: This is Jimmy.

JIMMY: You must be the Husband.

> *The HUSBAND laughs. They shake hands.*

> I'm so fucking glad to meet you.

HUSBAND: You're so wet.

JIMMY: Sorry. That's what I was saying when you came in, I was saying sorry because I'm so wet.

BETH: Are you going out?

HUSBAND: I'm going out.

JIMMY: It's wet out.

> *They laugh.*

> No, it really fucking is.

HUSBAND: You swear a lot, don't you.

JIMMY: Not normally.

HUSBAND: Yeah, I'm gonna get some ice cream.

JIMMY: Do they sell ice cream now?

HUSBAND: They sell it at the garage.

JIMMY: Yeah. They do. Of course they do.

HUSBAND: Insurance bores the pants off me; you're going to talk insurance –

JIMMY: It was really fucking lovely to meet you, and sorry about the swearing.

Holds out his hand. Beat. HUSBAND smiles and shakes it. Goes.

BETH sits, almost collapsing, can't look at JIMMY.

BETH: Oh god.

JIMMY: He's nice. He doesn't seem depressed, you said he suffers from depression, but he doesn't seem at all, were you lying?

BETH: Oh my god.

JIMMY: Ice cream. See I'd never do that, that's quite American, isn't it? Popping out for ice cream, I wouldn't do that. If I popped out at night it would be for petrol or eggs or some meat, cold meat, or –

BETH: What are you doing here?

Beat.

JIMMY: Can I ask you a question? About him?

BETH: No.

JIMMY: Just one.

BETH: No.

JIMMY: Just one.

BETH: No.

JIMMY: Does he wake up in the morning and think about your breath? Does he wake up every morning with an ache in his chest because in his mind he can hear you breathe and it's causing him actual physical pain because your breath is the most beautiful thing that a human being has ever done with their actual physical bodies ever?

Does he do that?

BETH: What are you going to do?

JIMMY: I'm sorry, Beth. This is wrong. I'm having some kind of

BETH: Breakdown

JIMMY: Awakening.

I need to tell you a thing. About the country we are doing this deal in.

BETH: You don't know anything about me. You talk about, what, talk about me breathing? Is that it, talk about me fucking breathing? I just breathe, breath, that's all, he doesn't think about it because he wakes up next to it, and then I get up, I go to the bathroom I shit and shower and sometimes I don't shower, sometimes I just wet my hair and pretend I've had a shower and I get dressed and I get a train and read a paper, or not, sometimes I don't, but I get to work and I just work, I just fucking work in this boring job, but no, not always boring because sometimes I like it but yes, I do drink too much sometimes, which was why I slept with you, no other reason just stupidity, that's all.

JIMMY: The country we are doing this deal in has applied for an international development loan. And it has somehow become linked to our deal.

Beat.

BETH: What?

JIMMY: And this loan is huge. Enormous. Very, very large. But the World Bank has said it's conditional on them opening up to private enterprise, water, transport, etc, they want them to be like us. How's your dad?

BETH: What? How's my…?

JIMMY: Yes, how's your dad, how is he?

BETH: Why are you asking?

JIMMY: Please just tell me about your dad, Beth, is that too much to –

BETH: Better. He's…

Beat.

He's better, he's much better. He's got a place in a treatment centre, it just came up last week out of the blue, he's in, gone in there already, he's much better already, he's in some place called / new –

JIMMY: New Vistas Care and Recovery Centre.

Beat. She is staring at him.

But the thing is the locals have been dragging their heels about selling off, well they see it as selling the family silver, water, transport etc, you can understand it really. And the World Bank has got a bit miffed, and it's now saying 'are you serious, are you serious about becoming like us' and somehow our little project has become, well, a sort of symbol. Of intent. Of whether the locals are serious about letting in private enterprise. And somehow, Beth, the whole loan, the whole fucking – and this is nearly trillions, Beth – hangs in the balance on whether this deal is done.

BETH: How did you know where my dad went?

Door slams. HUSBAND enters. Looks at them. Smiles.

Goes into the kitchen, returns with the ice cream and a spoon.

Sees that they are silent. Beat.

HUSBAND: Sorry, do you want some?

Beat.

BETH: No thanks.

JIMMY: What flavour?

HUSBAND: Cherry.

JIMMY: No thanks.

HUSBAND sits with his ice cream, looking at some papers and books, studying. Eats.

We are not monsters. We can make this a good thing. We do good things. Good projects. We help people who need help.

Now, their government has given us, what I like to think of as a cash back incentive. It's large, very large.

BETH glances at her HUSBAND.

BETH: That's… that's not, strictly speaking, legal.

JIMMY: No. It's very not legal. But what I am here to tell you Beth, is that this money is all going into Security. For these men. They will be safe.

She glances at her HUSBAND again, but he's lost in his papers.

Why would we want these men harmed? If they are harmed the whole thing collapses. Why would we want that, what would be in it for us?

BETH: No. I can't go on… You shouldn't have told me, you should not have –

JIMMY: I left my wife. Did I tell you that?

Beat. HUSBAND has not noticed.

I hope we can make this work, Beth.

I really need this to work, Beth.

I'm being completely honest, Beth, I really need this to work, Beth, or I don't know what I might do, Beth.

BETH: I… can't approve without evidence that proper Security is –

JIMMY: I can give you my rock solid assurance as evidence.

BETH: I need to see something, something

JIMMY: I can just say 'Beth. Please trust me. You fucking owe me that.'

She glances again at the HUSBAND.

I might have some ice cream.

BETH: Don't.

JIMMY: I might.

BETH: Don't.

JIMMY: I might.

BETH: Don't.

JIMMY: I might. I might have some.

Beat.

BETH: You're… you're giving me an assurance? They'll be okay?

JIMMY: Yes. Absolutely. I can give you a rock solid assurance that everything that has passed between us, everything will be okay.

She glances again at her HUSBAND. But again he just studies and eats ice cream.

* * *

NADINE waiting in a bar. COLM arrives. Stares at her.

COLM: Nadine?

NADINE: Yes.

COLM: Hello, I'm Colm.

NADINE: I know. I've worked for you for eight years.

Beat.

COLM: Can I sit?

He sits.

I've had a bit of a morning.

NADINE: Do you want a drink?

He thinks.

COLM: No, I don't think I do.

NADINE: Do you want to take your coat off?

He thinks.

COLM: Yes. I'll take my coat off. I'll take my coat off and put
 it here.

He takes his coat off and puts it on the seat.

NADINE: Are you okay?

COLM: I've just been to see someone. An old…

NADINE: friend?

COLM: friend, yes, no, not a friend, no. Someone I've never
 actually met.

Sorry I didn't recognise you. I think I did recognise
you but if I'm honest I probably didn't put two and two
together, I'm not good with names but now that I sit here I
find that I know you quite well.

Pause. He is overcome.

NADINE: Colm?

COLM: *(Recovering.)* Do you think I might actually have a
 drink? do you think I might have a whisky sour?

NADINE: *(To a passing waiter.)* Whiskey sour. Please.

She waits for him.

COLM: Castile says you're willing to talk.

Pause.

NADINE: Belize has come through. They have the insurance, it's going to work, they are sending the men out there within days. Do you see? It was with Jimmy nothing happened, it was with you: nothing happened, it's with Catherine for a day and it's working like a dream. They are getting stronger than you. I believe they are going to move against you.

COLM: They're moving against me?

NADINE: Yes.

COLM: They're destroying me?

NADINE: Yes. Yes, they are, Colm.

His drink arrives. He drinks. She continues.

Look, this is really, I don't mind telling you, this really is very risky for me. I mean I don't know, I don't even know what the fuck I've done, but Richard, he has, he's at me in everything I do and every time he looks at me, it's, I mean I'm scared. I'm actually scared –

COLM: Have you ever destroyed someone?

NADINE: *(Beat.)* What?

COLM: Have you ever destroyed a person?

I have. Ken. He was called Ken.

And there was a rivalry. You know, friendly enough, this was when I was a younger man. Full of, you know. And he was too, we were both full of, we were the hot ones, you might say, the hot ones in town *(Little laugh.)* And one day Ken wrote something about an acquisition I was making in a trade paper, I mean ridiculous really, a circulation of a few thousand, tens of thousands, but he wrote something that was critical of me and of how I was handling the acquisition. And it was a bit off. Everyone said it was a bit off, but it wasn't exactly the *Daily Mail.*

But somehow this really got to me and I thought 'fuck you, Ken' and I decided to destroy him and I set about blocking

everything he did, every time he made a purchase we would get there first, every time he moved into a market we moved in harder and no-one knew what I was doing, it was my little secret and I would do these things and then look at them and think 'I did that. Look at what I did.'

And poor Ken, he didn't have a clue, he just thought that he was losing his touch and pretty soon Ken became a jinx and then he was facing bankruptcy, but that wasn't enough for me, Nadine, because once you've tasted blood, so I hired a Private Detective who uncovered some minor infidelities which I had revealed to his wife and his family fell apart and his son became dependant on prescription medication which I made sure he got plenty of and eventually he overdosed and died and some years later when I read that Ken had taken a gun and blown his brains out I thought 'I did that. That was me. Look at me. That was me, look at what I did.'

Pause.

He had daughter as well. Barbara. Actually that's quite a lovely name now, it wasn't then, but now... She was very young. I went there today. She's grown up now, she lives in one room, I saw it from the outside, I watched, she seems like a very nice young lady, I don't know what she does, but she seems...

I wanted to say something. But what could I say? Nadine? Do you know what I could've said?

Beat.

NADINE: You could've said sorry?

COLM: Do you think that would've meant something?

NADINE: No.

COLM: No. Neither did I. So I just stood there. I stood there watching her. Wondering why on earth I did all that.

Pause, COLM lost.

NADINE: Colm, they are moving against you.

COLM: Yes. But what if I deserve it?

Beat.

NADINE: What?

COLM: No, no, that's stupid, silly, sorry, I'm being a bit, I am being a bit

NADINE: Deserve? What if you –

COLM: Yes. Yes, I am. Can I… can I count on your support, Nadine?

Beat.

NADINE: Yes. Yes, of course, Colm.

COLM: And who else? Who else do I have?

NADINE: You, me, Castile. Gavin will go with a push, you won't get Ian but the four of us will be enough. That's great. This is great, Colm.

Pause.

Colm?

But COLM is a million miles away.

* * *

Board meeting.

CASTILE , IAN , CATHERINE , GAVIN , NADINE and RICHARD and the ASTROLOGER , CASTILE glaring at all of them.

CASTILE: The purpose of this meeting?

The purpose of this meeting is to establish what the fuck is going on.

IAN: I just asked

CASTILE: And I just told you.

CATHERINE: He just asked, Castile, he wasn't accusing, we're all friends here.

CASTILE: Are we? And how do friends behave towards each other?

CATHERINE: What does that mean? I have no idea what that even means.

RICHARD: Can I remind you, Castile that you are speaking to the joint CEO of this corporation?

CASTILE: You've got very big, haven't you, Richard. I remember you when you started, you had nothing in your mind but the things Colm occasionally whispered to you when he found time away from running the company

RICHARD: Don't speak to me like –

CASTILE: Is Colm dead? Did he die in the night and no-one told me? Do you wish him dead? Who wants Colm Dead? Who here wishes the death of Colm? Shall we make him gone? Lets make him gone. Lets vote him gone. Let's vote, let's vote on making Colm gone.

I call a vote. Raise your hands if you want to get rid of Colm.

They stare at him.

CATHERINE: What are you doing?

CASTILE: I'm calling a vote of no confidence in Colm.

RICHARD: Sit down, Castile, you're making a fool of yourself.

CASTILE: Constitutionally it is my right, let the record show that.

CATHERINE: This is stupid, I mean Colm will, he'll be here any second, and –

CASTILE: I am calling a vote!

RICHARD: Ian?

IAN: He… it's his right.

CASTILE: So. Raise your hand if you want to get rid of Colm.

They look at each other, uneasy. They look to CATHERINE. To RICHARD. CATHERINE looks away. RICHARD's seems to be on the verge of something… But no-one makes a move. CASTILE glares at them. Sits.

Colm is not dead. Colm is not gone. Please do not imagine that because a lion sleeps that it has no teeth.

CATHERINE: Oh my god, it's lions and teeth now. Castile, you are so…

This wasn't a good idea.

CASTILE: Maybe not for you.

RICHARD: Maybe not for you.

Pause.

CASTILE: There are a number of points to discuss. Point one is that control of Belize has been handed over to Catherine.

GAVIN: She was successful!

CASTILE: So far, yes, and that's good, but –

CATHERINE: So far, Castile? That's a bit…

CASTILE: Point two: the performance related pay structure.

NADINE: What about point one? Don't you want to talk about point one?

CASTILE: Point two: the performance related pay structures.

CATHERINE: Which Colm brought in.

CASTILE: Which Colm brought in, yes, but you're taking things too far, you're turning everyone into savages. And what's this about culling the bottom fifteen percent?

CATHERINE: Christ, you seem to be attacking us for being more Colm than Colm.

CASTILE: But fifteen percent?

GAVIN: Don't worry, Castile, you're a board member, you're exempt.

They laugh.

IAN: When was the last time you made a sale, Castile?

They laugh.

CATHERINE: Castile's Colm's boy, he doesn't need to justify his existence like the rest of us mere mortals

CASTILE: Three: general obstruction and hostility towards me, in carrying out my duties as the representative of –

CATHERINE: Oh for heaven's sake, what is he saying now?

GAVIN: What are you saying now, Castile?

CASTILE: Don't think I don't see it! I'm talking about calls ignored, emails ignored, memos ignored. I'm talking about you, Catherine, knowing that I've been trying to talk to you for days, seeing me coming down the corridor and ducking into the ladies, you, when you –

CATHERINE: Oh my god. This is insane. I needed a wee!

IAN: What about you? You didn't even reply to my mail about this meeting.

CASTILE: Two can play at that game. If you think I'm just going to –

RICHARD: Where's Colm?

Pause. They all stare at Castile.

Where's Colm, Castile? Is Colm coming?

CASTILE: Colm… has important business that he can't get out of.

Pause. They stare at him

GAVIN: Colm's not coming?

CASTILE: I am here as his… Colm is here though me.

CATHERINE: What business keeps Colm away from the board meeting that Colm called?

No answer.

RICHARD: So… you're here on your own?

Castile? All on his little own?

CASTILE: What… What's your point?

RICHARD doesn't answer.

I'm not scared of you, Richard.

RICHARD: No-one speak to Castile.

Pause.

GAVIN: What?

NADINE: What you want us to… just not speak to…

RICHARD: Do you have a problem with that? Nadine? Fucking, Nadine?

NADINE doesn't answer, can't.

Castile has got ahead of himself. Years of service to Colm has left Castile thinking that he is Colm. Castile is threatening us. Castile is accusing us. No-one is to speak to Castile.

CASTILE: This is childish. You really think…

Catherine? Ian?

They don't answer.

Nadine? Nadine?

NADINE looks at the others. She doesn't answer.

CASTILE turns to RICHARD.

What's this to going to prove? I'm not scared of you.

RICHARD: Yes. And that's a very serious mistake.

Beat.

I vote we remove Castile from the board.

CASTILE: What?

CATHERINE: Seconded.

CASTILE: You can't –

RICHARD: All those in favour?

CATHERINE and RICHARD raise their hands. Pause. Suddenly NADINE's hand shoots up. CASTILE is stunned. IAN and GAVIN follow.

Carried.

CASTILE: This is…

RICHARD: Shhhh. You're not a board member. You can't speak here.

Ian? What are Castile's targets like?

IAN: Sorry, what do you mean?

RICHARD: Well, he's a salesman. What are his targets like?

IAN: But… Castile doesn't sell. He hasn't sold in eighteen years.

RICHARD: So he's in the bottom fifteen percent, then?

IAN: Well, yes, technically, but –

RICHARD: Catherine?

They exchange a look.

CATHERINE: You want to do this?

RICHARD: Don't you?

Beat. CATHERINE buzzes an intercom.

CATHERINE: Send Security up here, please.

Takes her finger off the intercom. Looks at CASTILE. The others are stunned by the speed at which things have happened.

RICHARD: I love Colm. I will do anything, anything to protect Colm. I will lay down my life. I will kill to protect Colm. I will kill you, I will kill you, I will kill you, I will kill all of you to protect Colm.

I'm tired of waiting for everything I do to be approved. This company is stalled. What CEO has to have things signed off like a schoolboy getting their homework approved? How can I work like this?

Beat.

GAVIN: But, it's just a failsafe, Richard, just to ensure –

CATHERINE: Do you think he needs to be watched?

RICHARD: Like some sort of cunt?

CATHERINE: Are you calling him a cunt?

GAVIN: No, no, I'm not calling him a

CATHERINE: So you think he doesn't need to be watched?

GAVIN: Yes, yes, of course, I

RICHARD: Does anyone here think I need to be watched?

Silence.

CATHERINE: Does anyone here think I need to be watched?

Silence.

RICHARD: I propose that decisions no longer need to be signed off by Colm.

CATHERINE: I second it.

RICHARD: Those in favour?

RICHARD and CATHERINE's hands go up. Beat. Then NADINE's. Then IAN's and GAVIN's.

Approved.

He sits.

CASTILE: You think that's gonna be it? You think that's the end of it?

291

RICHARD looks at his watch.

RICHARD: Don't say anything. Let's just wait for Security.

<p align="center">* * *</p>

JIMMY in a nightgown. BETH fully clothed, coat on, soaked.

BETH: What have you done?

> *Beat.*

> What have you done?

> *No answer.*

> Eight men. Eight men kidnapped, they've been, straight away, as soon as they landed, why? Eight men have been… where was the Security? Where was the extra, you said, you said there would be extra, where was it, There was nothing just…

> You said there would be Security, you said –!

> *Pause.*

JIMMY: You're wet. Would you like some tea?

BETH: Fucking tea?

> I've been on the phone all day. I'm losing my job, there are journalists outside my house, my Husband is, he is falling to pieces, he can't take this, I've watched him crumble all day, he's breaking down, he's weeping, they are blaming me, fucking tea?

JIMMY: Yes. Sorry, sorry about the journalists. The press have moved very fast, they jumped on Catherine. She was in control of Belize. And of course she had to throw them something and she threw them… you. Much good it'll do her.

> Our public relations have said that you, well you insured us. You did reports, surveys, you insured us, gave us the go ahead. You, Beth.

> *She stares at him.*

BETH: You sent them out there. You sent them out there with no extra provision? Where is the extra provision?

<p align="center">292</p>

JIMMY: There was no extra provision. There was never any extra provision. We kept those monies. I diverted those monies. I put those monies into other projects, there was never going to be extra provision.

BETH: What?

JIMMY: I'm sorry. I'm so sorry, Beth. And yet another part of me just isn't. A part of me is saying 'good, fuck you and the way you breathe. Fuck you and your beautiful hair. Fuck you and the smile that you have only ever smiled to me three times but each time it was like being washed in light' and yet I'm dying, seeing you like this. I've been crying. I've been crying today, Beth. Crying and smiling.

BETH: Why?

It makes no sense. The whole project's collapsed. Eighty million has been wiped off your share price this afternoon. Why?

JIMMY: There were… internal reasons.

Beat.

BETH: What?

JIMMY: My father says that if you can't be a warrior with every single aspect and particle of your being then you can't be a warrior. He says that real men turn their weaknesses into weapons.

BETH: Internal reasons? What internal reasons?

JIMMY: The battle has become

internal.

Pause.

BETH: I'm going to come clean. I'm going to tell them. I'm going to tell them what you said. Call your people right now and tell them that they have to come up with something else or I will tell everything.

He stares at her. Stands. Goes to the phone. Picks it up. Dials. Waits.

JIMMY: Danny? Yeah, it's me. I'm afraid we're going to have to pull the funding. All of it. Right now. The treatment centre will close? That's terrible. When? Well, we're going to pull it now, so… Yes, I know you're committed to the expansion. Yes, I know every penny you have is tied up in… When would they be out on the streets? So soon? That is bad. Am I sure? I'll just check.

Puts a hand over the mouthpiece, talks to BETH.

What do you think?

What do you think?

No answer.

Beth?

No answer.

Beth?

What do you think, Beth?

She says nothing. Looks down.

He goes back to the phone.

Forget what I just said, Danny, everything's fine. Yeah, my mistake. Sorry about that. Have to go now. Talk to you about it tomorrow.

Hangs up.

BETH: Please. I'm going to lose my job. My Husband, he's not… you've no idea what he was like before, you… his studies, they keep him, you know, they sort him or something, you have no idea what he was like. He's falling to pieces. I can see it. Please help. Please help me.

JIMMY: Why? Why should I?

Beat.

BETH: Let's go to bed.

Do you want to go to bed? We can go to bed.

Stop this. Please.

JIMMY: If I stop this we'll go to bed?

BETH: Yes.

JIMMY: Just the once? We'll go to bed just the once?

Beat.

BETH: More than once.

JIMMY: How many times?

BETH: Many times.

JIMMY: We'll go to bed many times?

BETH: Yes.

JIMMY: We'll have an affair?

BETH: Yes.

JIMMY: You'll be mine?

BETH: Yes.

JIMMY: Body and soul?

Beat.

Body and soul?

BETH: Yes.

JIMMY: You'll love me?

BETH: Yes.

JIMMY: You'll fall in love with me?

BETH: Yes. I will fall in love with you.

Beat.

JIMMY: Which is what I want more than anything in the world.

JIMMY suddenly sags, sits again, but heavily.

Except strength.

I understand now what strength is in this world. It's terrible.

You'd better go. Your Husband needs you.

BETH: Jimmy… please…

JIMMY: No.

* * *

RICHARD, GAVIN and JIMMY. COLM enters. He carries a hold-all.

GAVIN: Hello, Colm.

He doesn't answer, doesn't seem aware of their presence.

Colm?

COLM looks up. Stares. Pause.

What's in the bag, Colm?

COLM looks at the bag as if for the first time. Looks up again.

COLM: I've killed a cat, Gavin.

GAVIN: You've…?

COLM: I've killed a cat.

I was driving here. I love driving and I never get the chance to drive, I can't remember the last time I drove and I said to Mario 'I'll drive' and he looked at me and he said 'Don't drive.'

Beat.

And so I was driving here, thinking about what Mario had said, because it disturbed me, it disturbed me deeply and I hit something. And I got out, I mean my heart it was, I got out and went up to this shape in the dark, this cat. Just lying there. Perfect, you couldn't see any mark. And it was alive, it was watching me, but not moving a muscle, just it's eyes calmly following me. It was the strangest thing. And I went to the boot. And I took out a bag I have for my gym stuff, and I took my gym stuff out of the bag. And I put the cat in the bag. Very gently.

And I'm driving here and the cat is on the passenger seat, sitting there in the bag, looking at me. And I'm thinking, you know, after. After I'm going to take this cat to a vet and make sure it gets well again. And all the time the cat's watching, very calm. And I get to this building. And I go in, with the cat in the hold all, because it didn't seem right to leave this cat in the…

And I'm in reception and the cat's alive.

And I go up to the lift and the cat's alive.

And I'm in the lift on my way up here and the cat's alive.

And I'm walking down the corridor and the cat's alive, I reach the door and the cat's alive, I put my hand on the

handle and the cat's alive, I open the door and the cat's alive.

I walked over the threshold into this room and the cat's dead.

It's dead, Gavin.

Pause.

GAVIN: Have… have you looked?

COLM: No. But I know.

He puts down the hold all. Takes out the cat. It is dead. He offers it to GAVIN.

It's still warm.

Not knowing what else to do, GAVIN takes the cat.

GAVIN: Catherine has presided over a disaster. Eight men kidnapped, millions wiped off our share price. Richard is assuming complete control.

COLM sees JIMMY.

COLM: Oh no. Oh no, Jimmy, don't tell me this is you, you did this, don't tell me… this is not you, no, no…

RICHARD: Jimmy… is a good boy.

Beat. COLM falters, stumbles. GAVIN goes to help him.

Leave him!

Leave this sack of shit and bone. What does he have? Who is he? Without the things we gave him. Without the respect and fear we gave him he's just a sack of shit. A sack of shit and bones.

COLM: Those men are going to die. You did this? What have you done?

RICHARD: They were insured.

RICHARD leaves. Pause. COLM goes to GAVIN. He reaches out his hand to touch the cat.

COLM: Still warm. You can feel it. Except in the extremities, you can feel the extremities getting cold.

He takes the cat back. Puts it in the bag, hugs it to his chest.

GAVIN: You're out. Sorry, Colm.

He leaves.

COLM: If there was one thing in life you could hold on to. You know? One thing, just, just one, just one and it wouldn't have to be a big thing, like maybe a feeling, or a smell or a card that someone gave you or a stone or something.

JIMMY: You said I wasn't strong. You said I lacked strength. But I have shown you what strength is. I am showing you what real strength is.

COLM: I have made this. Have I made a nightmare? I've made a nightmare, haven't I. Oh god, Jimmy? What have I made you? What have I –

Suddenly, JIMMY punches him in the face. COLM staggers back, shocked. He reaches up and there is blood on his lips. JIMMY almost seems to be waiting for something, but when it doesn't happen he walks towards COLM, slowly. Pulls his fist back again, but slowly, deliberately. COLM watches. JIMMY punches him again, COLM collapsing onto the floor. JIMMY looks down at him. Moves to him, COLM trying to crawl away, but failing. JIMMY helps him into a kneeling position, then takes COLM's right arm, COLM staring into his son's eyes, but not speaking. JIMMY places the arm below the elbow across his knee. Applies pressure, leaning, pain hitting COLM.

The arm snaps with a cracking sound. COLM screams out, absolute agony. JIMMY steps back. COLM tries to gather himself, looks up at his son. JIMMY takes the other arm, placing it across his knee. About to apply pressure.

I'm so sorry. I am so, so sorry.

JIMMY freezes. Stays there. Straining. Can't push.

Suddenly JIMMY walks out, without snapping the arm.

COLM reaches for the bag, hugs it to his chest, hugs it into him.

Act Two

A hillside, late evening, dark. Soldiers, Militia, noise.

JIMMY led in by more soldiers, not a prisoner but not treated gently. A chair is brought. GAVIN enters, stands one side of the chair. RICHARD enters with the ASTROLOGER (who stands on the other). RICHARD sits. Sudden quiet. RICHARD stands.

RICHARD: The conflict with Catherine is not over.

She spreads hate about me, she spreads venom against me, she spits poison at me and my leadership – she lies to the North with a small force and the traitor Ian and together they defy the legitimacy of my place as rightful leader of Argeloin by not bending to my will.

GAVIN: Hello Jimmy.

RICHARD: We have chased and chased, and she has depleted the land of supplies as she has gone before us, she has supplies and we do not, she lies before us, breathing, in defiance of my will.

GAVIN: She's been very clever. We're over stretched. We have a superior force but we're overstretched, supply lines and what have you, we're running out of food. And now she stops, so the place of battle is of her choosing too, very, very clever.

JIMMY: Why don't you attack?

GAVIN: Good question…

RICHARD: I'm waiting for a sign.

GAVIN: … and there's your answer.

Essentially what we would like you to do is to stay on Catherine's side.

JIMMY: What? She'll kill me.

GAVIN: We think she won't. She hasn't yet, so we think she mustn't know that you're with us. We think –

JIMMY: You think?

GAVIN: We think this could be a very useful position.

JIMMY: I… I don't want to do this.

RICHARD: You'll do what I fucking tell you.

GAVIN: There is either Richard or Catherine. Or oblivion. Surely you don't want to go back to oblivion, Jimmy?

JIMMY: You want me to betray her again?

GAVIN: We'd like to settle this amicably. We'd like her to see sense.

RICHARD: We'd like her to die.

GAVIN: Or just see sense. We'd like to have you in there with her.

JIMMY: I'm her lover. We make love.

GAVIN: We'll get word to you with the details nearer the time. But essentially when battle does come we'll send a force to confront yours. She'll be expecting you to defend, but instead you'll unite with our force and round on her. She'll be devastated. We'll win. She'll see sense. She'll see it's for the best. I'm sure we can wrap this up without… mess.

JIMMY: How many more times do you want me to betray? When can I stop?

RICHARD: Never. Cunt. When you're dead. Cunt. This is it and you're in it now.

GAVIN: You chose this, Jimmy. This was what you wanted.

Pause.

JIMMY: When I walked away from my father I felt nothing. I just felt… nothing.

Is this what you feel like? Like this? Why do you fight so hard to feel like this? Maybe my father was right. Maybe I don't have this in me, maybe I'm lucky not to have this. I feel sorry for you. I look at you and I feel sorry. But now I'm like you, so how does that work?

RICHARD stares at him. GAVIN stares at him. Beat. RICHARD walks past JIMMY, pats him on the back.

RICHARD: Never mind. It's fine. That's fine.

Moves behind JIMMY. Takes a gun from a soldier. GAVIN sees.

GAVIN: I strongly advise that you begin to understand that things have changed. I strongly advise that you see this is a different time. Do not reject the realities of this time as it is the logical conclusion of previous times and I strongly advise you to begin to understand that. Now.

RICHARD is behind him, raises the gun.

JIMMY: Is this who I am, then? Now?

Alright, I'll do it.

RICHARD stands there gun raised. Almost seems to be considering doing it anyway. Suddenly GAVIN hugs JIMMY.

GAVIN: Well done! Well… done.

RICHARD lowers the rifle, heads back, puts it down. GAVIN starts to take JIMMY away.

You should take some comfort in the fact that you have no choice. Catherine doesn't know what you've done. But if you don't do what we ask then she will. You're on our side, whether you like it or not.

GAVIN shows him out. RICHARD turns to the ASTROLOGER.

RICHARD: You still want me to wait?

ASTROLOGER: Saturn is retrograde. Have you noticed? Can you feel it? But you must strike at the right time. Wait until the right time. Wait for the sign.

RICHARD: My men are starving.

ASTROLOGER: Why do you bother me with unimportant facts? The stars are speaking to you, please listen. They don't like to shout.

RICHARD: Will I win?

ASTROLOGER: Probably.

You have committed a great many crimes. Is that right is that wrong? Who cares? The real question is have you committed enough? Saturn is retrograde. Your greatest crime will destroy you, unless you destroy it first. You can't do things by halves, dear. In for a penny…

RICHARD: You once said be careful who I trust – does that mean I can trust you?

ASTROLOGER: Yes. You can trust me. You can always trust everything I say. Our fates are bound together. You can always trust everything I say because the moment I lie to you will mean my end.

RICHARD: Fucking tell me who my greatest crime is! Tell me now.

ASTROLOGER: *(She recoils.)* Oh. I can smell your fear from here. It's repellent.

RICHARD: You know I could ask anyone of these men to put a bullet in your eyes.

But she just laughs and moves away, genuinely amused. RICHARD goes to follow but GAVIN enters with BETH. She looks completely different, lost, not of this world, but for a moment RICHARD doesn't notice her, his mind racing.

(To GAVIN.) You. Find me Colm.

GAVIN: What? But Colm's not important anymore, he's –

RICHARD: Find me Colm.

Beat.

GAVIN: This is Beth.

RICHARD: Gavin says you've lost everything.

BETH: What?

RICHARD: Gavin says you've –

BETH: Things which I gone, things, yes, gone, things, my Husband, we had some life or other, some form of life or other and he found discrepancy, or some such other word which escapes me now, but yes, betrayed or some such other thing which, this thing, this force, this dark force which some such force or other came and upon me, sat upon me my life until the breath left its lungs, expiration. Gone. Dead. Father dead, Husband dead, despair. Dead. Life dead, I would like

Beat.

satisfaction.

RICHARD: You would… like satisfaction?

BETH: Yes.

RICHARD: Revenge? Revenge on Jimmy?

The name hits her like a tidal wave, but only on the inside, on the outside she barely registers it.

BETH: Yes.

Pause.

RICHARD: Does she always talk like that?

GAVIN nods.

You are beautiful because you have been snapped in two and you are still moving. Will you do anything?

BETH: Yes.

Beat. He considers. Pulls out a pistol.

RICHARD: See this gun?

BETH: Gun, yes.

RICHARD: Have you ever used one?

BETH: No.

RICHARD: This is the safety. Pull back to this position, point, pull the trigger.

She nods. He puts the gun back in the holster, takes the holster off, throws it to the ground. Steps back. Points at GAVIN.

RICHARD: Use it to kill him.

GAVIN is stunned, but without a second's hesitation she begins to pick up the holster and extract the gun.

GAVIN: What…? What the fuck, Richard, what the…?

She has the gun out, works the safety.

No, look, Jesus, alright, you've made you're point, so let's –

She points the gun at GAVIN s face.

No!

She fires it repeatedly, but it is empty. She fires it again and again and again, GAVIN terrified of every click. She continues to fire the empty gun until RICHARD takes it from her.

She just stands there.

RICHARD: Perfection.

* * *

Countryside. Early morning. CATHERINE and IAN enter.

CATHERINE: Right. Okay.

>What, here? He's…? He's just…?

IAN: Yes.

CATHERINE: Right. Okay. Shit. What does he want?

IAN: He wants to see you.

CATHERINE: He wants to see me?

IAN: Yes, he wants to see you.

>*Silence.*

>Catherine?

CATHERINE: What's morale like?

IAN: Not great.

CATHERINE: He's Colm's son, you see. Morale, I mean he'd be good for morale, legitimacy or, you know…

Do you think he betrayed me?

IAN: I…

>*But he cannot finish. Long pause.*

CATHERINE: Morale. He's Colm's son. You know, morale is…

IAN: Yes, yes, of course morale is… morale is…

>*Pause.*

>Catherine, if… If he has betrayed you…

>*Beat. She waits for him to finish.*

>is it wise to keep a viper at your breast?

CATHERINE: What?

IAN: Is it wise to –

CATHERINE: What? What are you taking about? Vipers?

IAN: I'm just asking -

CATHERINE: Jesus Christ, I mean where do you get this… vipers and breasts?

IAN: Catherine, I am just trying to –

CATHERINE: Look, just please stop!

>*Silence.*

Why is Richard waiting? He's just sitting there waiting.

I mean they must be running low on supplies, and here we are, this land, you know, food, whatever, but look at them. Across there.

IAN: I… I don't know.

CATHERINE: There's something here, you see. Something in it, I can't quite…

Pause.

So you think he did or didn't betray me?

IAN: I… think he did.

CATHERINE: Right. Bit negative. There's something in it, you see, some play, some stratagem I haven't yet…

I think… I think I'm going to welcome Jimmy with open arms.

Beat.

IAN: What if he comes back and he has betrayed you?

CATHERINE: If he comes back and he has betrayed me then I have the advantage because he won't know I know he's betrayed me.

IAN: But if he comes back and he has betrayed you the reason he's coming back is to betray you again.

CATHERINE: Then I will stop that.

IAN: How?

CATHERINE: With my feminine wiles.

IAN: Are you in love with him?

CATHERINE: What?

She suddenly laughs.

Don't be such a fucking idiot, you –

Where did you learn to be such a fucking –

Why are you such a fucking –

Suddenly JIMMY shows up. They stare at each other. She throws herself at him, hugs into him. He returns it. They hug, both desperate for it. IAN watches. They pull back, kiss, pull back.

My love…

JIMMY: My love.

CATHERINE: My… fucking love.

* * *

A room, small, very basic, packed with stuff, junk. BARBARA stands, CASTILE has just come in. COLM lies unconscious on a tatty couch. Shows CASTILE to COLM. CASTILE goes to him.

BARBARA: He just, he just came here. I don't know why, he just turned up at my –

I found your number. In his pocket. I wanted to call, nothing works these days, so it's taking me ages, ages to find a working –

Careful!

Castile stops.

His arm. It's broken.

CASTILE: Is it?

BARBARA: Yes. I set it. I think it's a clean break. I mean I don't know, but I think it is. I think it'll heal. Probably.

CASTILE: Thank you.

BARBARA: Do you know him?

CASTILE: I know him.

Do you know him?

BARBARA: No.

CASTILE: Why did he come to you? Have you met?

BARBARA: No, never.

CASTILE: Then why did he come to you?

BARBARA: I don't know, I don't know why he came to me.

CASTILE: Did he say anything?

BARBARA: Just ramblings, he just rambled, like rambling on and on.

CASTILE: You've looked after him. Thank you.

BARBARA: No, I mean I couldn't just... I mean he's, I couldn't just –

My daughter!

CASTILE: What?

BARBARA: That's what he kept saying, he kept saying my daughter, he kept calling me his daughter. He thinks I'm his daughter. Do I look like his daughter?

CASTILE: He doesn't have a daughter.

BARBARA: Oh. Right.

I didn't want to let him in. I mean I haven't got much, you know, and I saw him and I thought, I mean he needs, stuff. Food and... And I haven't really got much, but you have to feed, sustenance, he needs... so I've been feeding but it's not easy because he doesn't want –

Castile gets up and goes over to her. Takes out his wallet.

What are you doing?

CASTILE: *(Pulling out cash.)* Compensating you.

BARBARA: What?

CASTILE: You have no need to worry, you will be adequately compensated for –

She slaps the money out of his hands. He is shocked. Silence.

BARBARA: Fuck off.

Fuck off, alright? With your money and, who do you think you are?

CASTILE: I was just...

BARBARA: This is my house, okay? coming in here, in here, with your money and your suit and your fucking suit like a tramp, actually, I don't get bought.

CASTILE: No, no, I didn't mean

BARBARA: This is my house, you can take your money, I don't want your –

He bends down to pick the money up.

Leave that.

Leave that now, I'll have that now, on the floor, but don't come in here with your, don't you try that again, alright?

CASTILE: I'm sorry

She picks up the money.

BARBARA: Yeah. Well. Okay, but…

CASTILE: I wanted to say thank you.

BARBARA: Well just say thank you.

CASTILE: Thank you.

BARBARA: You're welcome.

(The money in her hands.) Useless now anyway.

CASTILE: He's an important man. People are looking for him.

Beat. She looks at COLM, doubtfully. She indicates the gym bag.

BARBARA: He had that with him. It's got a dead cat in it.

He looks at her.

Yeah I know.

CASTILE: Are you… Is there anyone else here?

Family or, a mother, a father…?

BARBARA: All dead. Years ago. My mother last. A long time ago, though, so…

CASTILE: I'm sorry.

BARBARA: Yeah.

CASTILE: I can't move him.

She stares at him.

I've nowhere to take him. You've been so kind, you really have. He's an important man. I believe he might be able to stop all this, but I need time, he's important, people will be loyal to him and if I can just contact –

BARBARA: See you're worried about him then.

Pause.

Right. Right. So you can't… shit.

So you're not gonna… Right. Right.

Beat.

CASTILE: What's your name?

BARBARA: Barbara.

Beat.

CASTILE: What?

BARBARA: Barbara, it's Barbara.

He is staring at her.

What?

CASTILE: No nothing, no reason. I just… knew, knew of someone with that…

BARBARA: What's his name?

Pause.

CASTILE: What?

BARBARA: What's his name?

CASTILE: Him?

BARBARA: Yes.

Beat.

CASTILE: Bob.

BARBARA: Bob?

CASTILE: Yeah, he's called… Bob.

Beat.

BARBARA: Bob. That's nice. You don't meet many Bobs these days do you?

CASTILE: No. No you don't.

BARBARA: No, I like that. Bob.

* * *

BETH on the hillside, RICHARD sits watching. It is as if BETH is trying to do something but isn't. RICHARD, fascinated. She seems unaware of him even though he is close. Back further is the ASTROLOGER, watching them both. Suddenly she stops. Silence. RICHARD waits. ASTROLOGER waits.

She pulls a peach out of her pocket, raises it to her mouth. Stops. She is overwhelmed with something, but it is gone almost instantly. She continues to try to get the peach to her mouth.

DENNIS KELLY

RICHARD sits in front of her, makes eye contact. Finally she looks at him.

RICHARD: My name is Beth and I am eating a peach.

> *Beat.*

BETH: With what intention within, in which some destruction finds.

RICHARD: No. My name is Beth and I am eating a peach.

BETH: Fragments of, exploding, disintegrating, into plumes of pain, agony, screaming frivolous devastation with cuts and cuts and cuts –

> *He grabs her arm.*

RICHARD: My name is Beth and I am eating a peach.

BETH: I… which land thereof contains a soul crushed in a… peach.

RICHARD: Peach, yes. My…

> *Beat.*

BETH: My…

RICHARD: Name is Beth.

BETH: Nam ee Bet.

RICHARD: And I am eating a peach.

BETH: And…

> *GAVIN enters, furious. NADINE in tow.*

GAVIN: Ask her why she –

> *RICHARD holds up a finger for him to wait, but still remains entirely absorbed in her. GAVIN holds his tongue.*

BETH: …and, and, and… I am crushing my love with broken limbs.

> *Beat. RICHARD lets go, sits back. She begins to eat the peach.*

GAVIN: Ask her what she's done. Ask her! Two men in Nadine's command were accused of stealing food. Okay, right. Punishment, yes. But this creature, this pet of yours, storms in with her fucking boys, with –

RICHARD: You mean my bodyguard.

310

GAVIN: I mean with her fucking animals! She storms in and takes them. Ask her what she did. Ask her!

RICHARD: I can't ask her, she doesn't understand, just tell me.

GAVIN: They took them into the woods. Hacked them to pieces. With mattocks, rakes, implements, farm implements, they cut them into chunks of meat, they decorated a tree with their guts. Then, Richard, then, she goes back to the storeroom they were accused of raiding and sets light to it, sets light to the food, to the fucking food, Richard!

RICHARD: She did that? Beth did that?

GAVIN: Yes! When you gave her control of the bodyguard I said nothing. When you put her in charge of camp discipline I kept quiet, but this?

NADINE: Look, Richard, I know this is not my place, but I have to say something, I mean look; the men are… We have to attack. We have to attack, Richard, the food is running out, she's destroying food, we're sitting here, the men are getting, we have to do something, we –

RICHARD: Do I look different? Nadine?

Pause. She is thinking, hard.

NADINE: Yes.

RICHARD: How?

ASTROLOGER: Mad. You look mad.

RICHARD ignores her, keeps his eyes on NADINE.

RICHARD: Last night as I lay in bed, the window open I began to sweat. Despite the fact that it was a cold night I began to sweat. And it was the sort of sweat that stings you, across your forehead perhaps, but this was across my entire body, my face, my arms, my toes, my anus, my scalp, everywhere, it felt as if my skin was burning, do you understand? But a good burning, it felt like my skin was burning a good fire that was incinerating the outer layer of my body.

And as this went on, as this good fire burnt the flesh from my body, I became convinced that the room was

becoming brighter. Almost imperceptibly brighter, but it was perceptible because I perceived it, I perceived it becoming imperceptibly brighter. And then I noticed that at the end of my bed sat a small squirrel. Just sitting there, watching me. A small squirrel had come in through the window, climbed over my dresser, crossed my floor, up the leg of my bedstead and now sat there looking at me, looking at me sweating a good fire in that imperceptibly brightening room.

And I was not afraid. I showed no fear.

Because fear was no longer in my body, do you understand? I no longer have fear.

And because I showed no fear the squirrel was joined by friends. Other squirrels. Slowly at first, cautious, yes, popping in through my window, but more and more, with more confidence, and they were joined by other woodland creatures; rabbits, pigeons, badgers, field-mice and voles, songbirds, thrushes, chipmunks and hedgehogs, even earthworms and ants, all manner of woodland creature including an antelope came into my room to sit and watch me.

Pause.

What do you think of that?

She has no idea what to say. Thinks hard. Suddenly she kneels.

NADINE: I kneel before divinity!

RICHARD: Do you?

NADINE: Yes. I do. Yes I fucking do.

RICHARD: Come to me.

Beat. For a second she is unsure, then she goes to him. He indicates that she should sit on the ground at his feet. She does so and he looks back up at GAVIN, stroking her hair.

Society is a type of madness. The trick of being successful in any given society is to promote the kind of madness that is most profitable to your desires at that time. Beth is a genius.

Where's Colm? I asked you to find Colm.

GAVIN: I… I have information, I think I know where he is, I have, someone, someone who can tell me, information about…

RICHARD: Will you kill him for me? I want you to kill him for me.

Beat.

GAVIN: I… I thought you just wanted me to find –

RICHARD: Things have changed. Something's coming. Can't you feel something coming? I need Colm gone before it gets here. Kill him for me. Go on. Go on, please. You're my only true friend. I love you. Kill Colm for me, please. I want you to kill Colm. Do you have a problem with that?

GAVIN: No. No, I don't.

Beat.

RICHARD: Beth is genius. We must all learn from Beth.

They watch her finishing her peach. She looks at the stone. Tries to eat it.

*　　*　　*

Barbara mixing food. Goes to COLM, sits him up, starts feeding.

BARBARA: Come on…

He is practically unconscious, but his eyes are open. She pushes his top half up so she can sit on the couch. She gets the spoon with the food to his mouth, but his head sinks down onto her lap.

No, look, don't…

But his head is now on her lap. Sighs, tries feeding him again.

Eat.

Again.

Eat!

But he is unconscious. She holds his nose. His mouth opens. She feeds food into his mouth with a spoon. Waits for him to swallow. He holds it in his mouth for a while, then slowly pushes it out.

Bob!

She begins to try and scoop the food back in with the spoon, but too much is coming out. The spoon is no good, she uses her fingers. Suddenly COLM is sucking the food from her fingers. She is shocked. He eats all the food from her fingers, goes still. She thinks.

She uses her finger to mop the food around his mouth into it, and he eats it all until her finger is clean. She begins to finger the food from the bowl into his mouth, COLM sucking the food from her finger and eating it. This goes on for a while.

CASTILE enters, unseen. Watches. Suddenly she becomes aware of him, stands, shocked, like someone caught in the act, COLM's head falling from her lap. She stares at CASTILE.

Porridge. He… he likes porridge.

Beat. CASTILE gathers his things. She watches. He has everything. Pause. Turns to her.

CASTILE: I've got to go.

War is coming. Battle is a breath away, you must be able to feel it? But there are forces within those forces who will unite behind him, do you see? Now, I have made contact with certain people and they will…

BARBARA: I knew you were useless as soon as you walked in the door.

Beat.

You know that? I looked at you with your money and your suit and your I rule the world and I thought 'what use is he? What actual and physical use is he? What can he actually do?'

CASTILE: It's not like that, he's important, we can stop this, he can –

BARBARA: Go on then, fuck off. Fuck right off.

Beat. CASTILE leaves. Silence. Then COLM curls into her, like a cat. She gets the food and begins feeding him again. With her fingers.

* * *

Night. CATHERINE and JIMMY, hand in hand, wandering. She stops.

CATHERINE: This is where we shall fight.

I shall be in the centre, here. Ian shall take the west, along the tree line to the sea. And then beyond that ridge, to the east there, is the high ground. The high ground is my weakest and strongest point. If they were to take the high ground they could move onto that ridge. And if they take that ridge… well, the battle's lost.

Pause.

Do you know what I feel when you say that you loved her? I feel a pain like you can't imagine, like a piece of metal, a piece of ice cold metal has somehow materialised inside my chest, into the place just under and slightly to the back of my heart. And maybe the metal is not metal, because it runs out into my veins, so maybe it's liquid metal, yes, liquid metal suddenly runs through my veins and into my capillaries and it freezes, you see, and I am like a skein of tendrils of frozen metal so that if you hit me with a sledgehammer I would shatter into a thousand pieces. That's how it feels.

She sits on the grass. Invites him to lie in her lap. He hesitates, then does so. She strokes his hair. Silence.

JIMMY: I don't know what I feel when I'm with you. I'm not sure if I'm alive. I'm not sure if I don't feel that I'm a corpse, a living corpse in the arms of another living corpse. But I don't want to leave. I want to rot with you. Is that a good thing? I must love you. Mustn't I?

CATHERINE: I think it's going to be tomorrow. I think this is our last night like this. Look at those stars. I'm going to give you the high ground.

Beat.

Ian thinks you're going to betray me. 'You have such a dark view of human nature', I said, but that's not true at all, he's really quite… rosy. I think he might be right. I think you might be about to betray me.

JIMMY: Then… then, why are you giving me the high ground?

She smiles. Slowly she take out a knife. She gently but firmly grabs JIMMY's hair with one hand and places the tip of the blade to his jugular with the other. He freezes.

CATHERINE: When I first saw you I thought 'Look at that boy, that silly, gangly boy. Look at that silly, gangly boy.' You were so awkward and… silly, and I looked at you and you moved to scratch yourself or something and my heart broke. Do you love me more than her?

Pause.

JIMMY: Yes.

CATHERINE: I'm showing you my faith in you. I'm giving you everything. So that you know, if you were going to betray me, who I am and what I feel. So you could just betray him instead. The choice is yours.

JIMMY: I did such a terrible thing to her. I wake up and I see her, I see her weeping.

What are you going to do? Are you going to kill me?

CATHERINE: No. I'm going to bind us to each other, because I believe we have a thing that is love, or the shadow of love, or even love, but I want it to be deeper and more agonizing, so I'm going to bind us together.

We're going to sleep out here tonight.

JIMMY: It's freezing. It'll be well below zero, it's… We'll freeze to death.

CATHERINE: Lets wrap ourselves around each other for heat. Lets pull ourselves into each other so that it becomes the only way we can survive, so that the only way we can possibly live through this night is to cling to each other with every fibre of our beings.

JIMMY: We'll die.

CATHERINE: Probably.

Slowly they lay down together, face to face, entwining completely, CATHERINE keeping the tip of the knife to him, so that eventually she is holding it to spine at the back of his neck.

JIMMY: Are… are you keeping the knife?

CATHERINE: Yes.

JIMMY: We might die.

CATHERINE: We might. But imagine what we'll be to each other if we survive.

JIMMY: Oh god. Is this what it's like to be you?

CATHERINE: There, there. My silly boy.

JIMMY: Oh god.

CATHERINE: My silly, gangly boy.

* * *

RICHARD in a woods. Waiting, looking at the sky.

Suddenly there is a meteor shower, very, very beautiful.

The ASTROLOGER enters.

RICHARD: I don't have Colm.

ASTROLOGER: Now is the time.

Pause.

Just do your best, dear.

* * *

Soldiers. RICHARD, GAVIN, NADINE, looking over a map.

GAVIN: They've formed a line across the hills in the east to the sea in the west. Ian has the west, Catherine is in the Centre, with the bulk of their force. But Jimmy's has the east.

It's a good plan. Ian has the sea so we can't go round him and Catherine can use the town as cover. And Jimmy has the high ground. Even then there's the ridge between the centre and Jimmy, so if he looked like he was losing the high ground, well, there's the ridge, they re-enforce the ridge. It's a good plan.

Except if they lose the ridge. Then it's a shit plan. Then we'd come down on them and push them into the sea. The ridge is the key, if we get over that ridge, then –

RICHARD: We attack from the south.

Beat.

GAVIN: They're strongest from the south. That's where Catherine is. If we go east we can unite with Jimmy on the high ground. From there –

RICHARD: We attack from the south.

Pause.

GAVIN: Whose plan is this?

RICHARD: Beth's. It's Beth's plan.

GAVIN: Beth doesn't know that Jimmy is on our side. And, well, pardon me for saying this Richard, but she is actually insane.

RICHARD: She's plugged into the universe.

NADINE: It's a great idea. That's a fucking great plan.

RICHARD: We attack from the south. They'll hardly believe their luck, they'll put all their strength into the south, they'll imagine they can cut us to shreds. Then we shall come down on them. Show them in.

Beat. GAVIN goes.

NADINE: Can I just say that is genius. And I'm not saying that just to butter you up, I don't know what his problem is, I mean I think that it's brilliant.

RICHARD: It doesn't matter. There was a meteor shower last night. In my sign. We can only win.

NADINE: Absolutely. Abso-fucking-lutely. We can only win. Because we have the strength –

RICHARD: Because of the meteor shower

NADINE: because we have the strength and the meteors. We have the meteors as well, yes. Which is great. You are a great man.

GAVIN enters with some officers.

RICHARD: A sign has been given to me from the powers that control the universe.

Nadine, you head west and engage Ian's force, hold him there. Gavin, you take a small force, head east like you're going to engage Jimmy. Beth and I will attack Catherine, full on in the front, from the South

NADINE: Brilliant.

RICHARD: and at the right moment you will unite with Jimmy, move over the ridge, and come down on their flank.

NADINE: Yes!

RICHARD: Destroy all rations. Let the men know that Catherine has surplus, let them know they win or starve.

NADINE: Sorry?

RICHARD: I have decided that anyone who doesn't fight well enough will be executed after the battle. The bottom fifteen percent. The bottom fifteen percent will be executed. And stop looking so scared.

<p style="text-align:center">*　　*　　*</p>

Sound of shelling, not too far away, getting closer.

BARBARA is staring out of the window to get a view, but with the curtains closed. COLM lies unconscious on the couch. He opens his eyes. Lies there. For some time.

COLM: I had the most incredible dream. I dreamt I was powerful and rich with so much in my life. A family, a house, a wife, a son, I had so many things. And then I woke up and I was trapped inside my own nightmare, inside the things I had created and things that I had created had decided to destroy me. And I could only agree.

Beat.

I saw a meteor shower. A terrible meteor shower. Like fire raining down on us. Are you real?

BARBARA: How do you feel? How's your arm?

COLM: Are you my daughter?

BARBARA: You haven't got a daughter.

COLM: Maybe you aren't real then.

Loud shell too close for comfort. BARBARA ducks down.

BARBARA: Jesus Christ!

COLM: What's that noise? Is that my heart? Is that what my heart sounds like?

BARBARA: The fuckers are shelling the town!

COLM: Yes. They did that in my dream. With meteors.

BARBARA: Well these aren't meteors.

She watches. Shells seem further away again. Turns to COLM.

How are you? Are you feeling better?

COLM: I feel like my soul has been bathed in acid, I feel pain, I feel dry, I feel like I've lived a thousand years in a single second. Is that good? Should I be feeling that?

BARBARA: I'm gonna get you some water, do you want some water?

Pause. She goes to gets him some water.

You looked peaceful lying there. Sleeping. Looked like my dad. You know, the sofa, he used to sleep on the sofa. Maybe that's all dads, I don't know. You smell like him. Your hair. Not really, but a bit.

COLM: *(Suddenly frightened, feeling his hair.)* Maybe this is his hair.

BARBARA: Does anything hurt?

COLM: Suddenly I feel like crying.

BARBARA: Don't cry. Don't fucking cry.

COLM: I suddenly feel this immense, you know, this immense, this incredible, but if I do, if I do, you see, it will all go, I will cry and cry and cry until I cry all of the liquid out of my body and then I'll be desiccated and the slightest breeze will blow me away.

Beat. He seems to be crying.

BARBARA: Bob?

COLM: I… seem to have liquid coming out of my eyes. Is… is that normal?

She is near him now.

BARBARA: Look, it's okay, don't worry, it's… look, drink this, you need –

Suddenly he sees her and cries out, recoils as if he had seen a demon, climbs back into the sofa as far from her as is possible.

COLM: I'm dead, aren't I? Have you come to torment me in?

BARBARA: You're not dead, Bob, you're just not well. You
 need to –

COLM: Bob? Is… that my name? Is… that who I am?

BARBARA: Yes. Yes it is. You're Bob.

COLM: I thought I was someone else. I thought my name
 was –

*Suddenly a shell bursts nearby, shaking the rooms. BARBARA falls
to her knees. The shelling continues, the same intensity, deafening,
but all of a sudden COLM is in rapture.*

BARBARA: Sit down!

Another shell, this time blowing the door off its hinges.

Bob!

COLM: This is here for me! Oh god, this is here for me!

Suddenly COLM heads for the door.

BARBARA: What are you doing? What are you –

*But the shelling has become deafening. COLM flings the remains of
the door open. His face glows in the fire.*

*Suddenly he grabs his bag and runs out. She stares after him. She
moves to the door, looks out. Beat. She runs out after him.*

* * *

Enormous shelling. Subsides.

*An OLD SOLDIER comes on, spooked, looking around, pointing his gun
at shadows. Sees something coming, hides in debris.*

*MARTIN enters wearing a soldier's uniform, terrified, no weapon. The
OLD SOLDIER leaps out, gun pointing at the him.*

OLD SOLDIER: Down, down!

MARTIN: I'm, I'm on your side, I'm –

OLD SOLDIER: Now!

MARTIN kneels.

MARTIN: I'm on your side, I'm on your side!

OLD SOLDIER: Liar.

MARTIN: no, honestly, I'm…

OLD SOLDIER: Make your peace, boy.

MARTIN: No, no, I'm on your side, this isn't, it's not my
uniform it's –

OLD SOLDIER: Make your peace with god.

MARTIN: I'm with Catherine! I am with you, your side, please!
I put this on to get away, it's dead, a dead man's uniform,
see? The, the, the blood and this hole, it's not, I haven't,
can I, can I show you?

MARTIN starts to move, slowly, starts to open his shirt.

See? Look, no hole. I'm not, hurt or, I put this on, I'm with
Ian, we were with Catherine, I've been with Catherine
for…

*The OLD SOLDIER considers him. Beat. Lowers his gun, but still
has it ready.*

OLD SOLDIER: Talk.

MARTIN: What?

OLD SOLDIER: Don't make me repeat myself, boy.

MARTIN: Right.

They, they, they just fucking, they just started fucking –

OLD SOLDIER: Calm. Breathe.

Beat. MARTIN calms. Breathes.

MARTIN: We were in the town.

We had the town so they started shelling. We pulled out,
and the civilians, we said this town is ruined, get out. You
know, in shops, coffee shops, banks, we said 'you'd better
get out' and they would nod and agree, but they just…
they just stayed. And they shelled, they shelled the whole
town. And we went back in and we'd pass the people we'd
told to get out and they'd still be in the same places, but
dead, you know like you might see someone at a counter
of a ruined bank but with the side of their face missing, or
someone having a coffee but dead, burnt, blackened flesh.
We waited with the dead.

They came up the street. And we were dug in so we just cut them down, your finger became tired from the trigger, but still there was more, we just cut. Piles of dead. So they shelled us. All of us. Us, them, the whole town, firebombed the town. It was madness. You had no idea who you were killing, we killed with bottles and bricks, with teeth and hands. And the corpses just watched, with their tills and coffees thinking 'who's clever now, eh?'

I woke up, alone, and my clothes had been burnt from me. So I stripped a corpse. And then this man, one of theirs, and he was really kind, he saw my fear and he helped me, he took me through the debris, rubble, through the fighting, their lines to their sick bay, and as soon as I was in the clear with him I slit his throat and ran. He was really kind.

Pause.

OLD SOLDIER: You did right. He was the enemy.

MARTIN: Are you going East?

OLD SOLDIER: Re-enforcing the ridge.

MARTIN: What? Has Jimmy lost the high ground…?

OLD SOLDIER: Hasn't lost it. Just not doing anything. Just sitting up there, men waiting, doing nothing. Catherine got scared, sent us. Just in case.

MARTIN: On your own? Where's your unit?

OLD SOLDIER: All dead.

Beat.

MARTIN: Are they back there as well?

OLD SOLDIER: They're everywhere.

MARTIN: But where's the line?

OLD SOLDIER: There is no line. Just fighting.

OLD SOLDIER opens his pack. Pulls out a cake.

MARTIN: What's that?

OLD SOLDIER: *(He looks.)* Black forest gateaux.

Found it in a cake shop. Carnage. Looked liked someone had filled a weather balloon with blood and meat and burst it in there.

MARTIN: Are you gonna eat that?

OLD SOLDIER: Cut away all of the bloody bits. Want some?

Beat. MARTIN sits with him. They clear a space in the debris, place the cake down. They stare at it. MARTIN pulls out a flask and begins to open it. Sees the OLD SOLDIER looking at him.

MARTIN: Tea.

OLD SOLDIER: Tea?

MARTIN: Yeah. Found it.

OLD SOLDIER: Fucking tea?

He pours some into the inner cap.

Is it warm?

MARTIN dips a finger in. Nods. Offers it to the OLD SOLDIER. The man takes it, MARTIN pours himself a cup and they sit there having tea and gateaux for quite some time.

Bliss.

What did you do before?

MARTIN: I was an Executive Head of Communications. You?

OLD SOLDIER: Financial advisor. Futures and Hedge funds.

MARTIN: No wonder you're so calm.

They eat.

What do you think things'll be like? After this?

OLD SOLDIER: Things'll be shit. For a thousand years.

MARTIN: Right. Cheerful.

OLD SOLDIER: S'all in the bible. We make our own hells. As ye sow, so shall ye reap.

MARTIN: Bird in the hand.

OLD SOLDIER: You taking the piss.

MARTIN: No.

Pause. They have finished eating.

Look, if we worked together, you and me, maybe we could find a way out. Out of this.

OLD SOLDIER: There is no out. Read your bible. This is the end of days.

MARTIN: Jesus Christ.

OLD SOLDIER: Yes.

OLD SOLDIER gets up.

MARTIN: Where are you going?

OLD SOLDIER: The ridge. We were sent to re-enforce the ridge.

MARTIN: No, no, what are you doing, your unit's dead, no that's stupid, that's

OLD SOLDIER: Come on.

Beat.

MARTIN: What, me?

OLD SOLDIER: Yes.

MARTIN: No. No, no, no. No way.

OLD SOLDIER stares at him.

Mayhem. That ridge is going to be mayhem. I'm not going with you.

OLD SOLDIER: Let's go.

He heads off.

MARTIN: Are you deaf, I'm not…

But the Soldier has gone. Beat. Realises he's alone. He runs off after the OLD SOLDIER.

* * *

The ASTROLOGER, humming. RICHARD enters, bloodied, fresh from battle, followed by NADINE. Lastly BETH.

RICHARD: What do you see?

No answer.

Nadine is being held by Ian, Gavin has yet to reach Jimmy and in the meantime I am down here trying to keep

Catherine's attention away from the high ground, but we are being hacked to pieces, cut to shreds, what do you see?

Pause. The ASTROLOGER says nothing. Looks scared. RICHARD turns to BETH. About to speak, but…

ASTROLOGER: Don't. Don't do what you're about to do.

NADINE runs on, looks terrible. RICHARD turns to BETH.

RICHARD: Beth? Do you want Jimmy?

BETH: What? What, yes, I did something, there was something, passing over now with flayed eyes yes, yes. Please, yes.

RICHARD: He's with Catherine.

BETH: Is he? This Jimmy then?

Beat. She goes. RICHARD turns to NADINE.

RICHARD: Let her cut us a path to Catherine. Where's Gavin?

NADINE: What? He's, he's on his way to the high ground, he's… I don't know, I don't know, Richard, I don't know what he's doing he's taking forever he's like a fucking snail, he's, I don't…

Pause.

RICHARD: What? What is it?

NADINE: Jimmy. Jimmy's gone.

Beat.

RICHARD: Pulled back. You mean, you mean he's pulled back he's waiting for –

NADINE: No. He's gone. He's left. He's abandoned the field without so much as firing a shot, he's not with us or them, he's fled, he's gone.

Richard?

Beat.

Richard!

RICHARD: *(To the ASTROLOGER.)* What. Do. You. See?

ASTROLOGER: I don't want to say. I told you to look to your greatest crime!

Pause.

Your end. It's over.

RICHARD stunned. Recovers. Stares at the ASTROLOGER.

RICHARD: When you say 'your end'… do you mean our side's end or my end?

ASTROLOGER: Don't make me lie to you. Please.

RICHARD: Are you saying we will lose the battle or are you saying I will die?

ASTROLOGER: Which would you prefer?

RICHARD: Listen to me; are you saying the battle's lost or I am lost?

Says nothing. RICHARD points his gun at the ASTROLOGER's chest.

Say or I'll execute you.

Pause. The ASTROLOGER thinks. Thinks.

ASTROLOGER: The battle is lost.

RICHARD executes the ASTROLOGER.

RICHARD: She said that her end comes when she lies to me. I have brought about her end, Therefore what she has just said is a lie. I will live, we will win the day. I have made things this way.

Tell Gavin to attack the ridge. Now.

NADINE: Attack the…? Right. He's not gonna like that. I mean it's a great idea and everything, but him and Jimmy were going to do that together –

RICHARD: I have mastered the skies. Take this betrayal into your hearts, pump it like blood through your limbs. Now is the time for madness, lose sense, lose intellect. Kill all the prisoners

NADINE: Kill…?

RICHARD: then kill ten men who look weak, wipe blood on your face, find a corpse, eat flesh, eat the brains, find madness and on! On!

He runs off. She stares after him. Looks to the ASTROLOGER's Body.

NADINE: Jesus Christ.

She runs off after RICHARD.

* * *

Battle. BARBARA has COLM sat down, but he is trying to get up.

BARBARA: Bob, you just have to sit where you are okay? You just have to –

COLM: Did I make this? Tell me, please, do you know? Do we make our gods? Did I make the wrong god?

(To the sky.) Talk to me! Tell me I haven't made a mistake!

BARBARA: Bob it's okay. Some people are coming. Some people are coming to help. Bob?

COLM: I had a daughter once, no, not a daughter, I didn't have a daughter, I had a son, only I didn't have a son because to have a son you must be a father and I was no kind of father. I would ask you for a kiss if I didn't fear it might kill you. I'm praying this storm has been sent to strip me bear, my mind, my thoughts, my flesh, my possessions, my eyes, my heart and my memories, but I have a voice in this arm that screams a kind of agony into my mind and I fear that I will never be free of my sins.

GAVIN enters, armed. CASTILE comes after. BARBARA sees them, but is wrapped up in COLM. They watch.

You are so… What's your name?

BARBARA: Barbara. My name is Barbara.

COLM: I… know you

BARBARA: Do you?

COLM: Yes. I do.

BARBARA: Where? Where do you know me from?

COLM: I… can't say. They're listening.

BARBARA: Who?

COLM: The gods we made in our dreams. We dreamt such terrible gods and they throw down their agony into our lives for no other reason than to keep themselves amused. Have you noticed the agony of life Barbara?

Looks into her eyes.

Oh Christ. You have. You have, haven't you. So much.

GAVIN steps forward.

GAVIN: Do you recognise me?

BARBARA: Help him. He needs help.

GAVIN: Do you recognise me!

Pause. COLM looks up at GAVIN. Reaches for him, but is suddenly distracted by his own hand, staring in wonder as if he had never seen one before. Beat. GAVIN starts to pull out his gun, load it.

BARBARA: What are you doing? What's he doing?

GAVIN: *(To CASTILE.)* Are you insane? This? We can't follow this.

CASTILE: He's a little… he's, he's not himself but if we –

GAVIN: Not himself? Did you say not himself?

CASTILE: Look, I have made contact on the other side, his son, if you can –

BARBARA: You said he was going to help him!

GAVIN: There is no help for him. This is the best help for him.

CASTILE: Jesus Christ, don't do this, not this, Gavin, please…

GAVIN: He is fucking mad! He is insane, Richard wants him dead, and I must be mad to even be talking to you, and you? you're serving a madman!

Suddenly COLM gets up. Stares at GAVIN. GAVIN steps back.

COLM: How did it get to this? How did we all become servants of insanity?

GAVIN stares at him. Looks at the others. They say nothing. Looks back at COLM, but COLM just stands there. Staring at him.

Without warning GAVIN goes. Pause. CASTILE starts to follow.

BARBARA: What are you doing?

CASTILE: I have to stop him. I have to… we need him.

CASTILE follows GAVIN. BARBARA goes to follow him when a shell lands nearby. She cowers down, but COLM responds to it standing. Suddenly runs in the other direction, into the battle.

BARBARA: Not that way, that's fucking… Bob!

She goes after him.

* * *

MARTIN runs on, out of breath, terrified, looking for somewhere to hide. Nowhere. Panics.

A Big Soldier enters, a large terrifying man, grinning, pointing his gun at MARTIN, who backs away. MARTIN sees his uniform.

MARTIN: No, no, look, I'm one of you, I'm…

(Trying to show him his uniform.) I'm one you, look, the uniform, look, I was just with him, because, because… I'm one of you.

The bigger man raises the gun, points it at MARTIN. Pulls the trigger. Nothing. Just a click, no bullet. Pulls again. Same. Again. Same. Beat. MARTIN suddenly picks up a piece of wood, brandishes it, trying to look threatening. The Big Soldier pauses, then smiles. He turns his gun round and advances on MARTIN, using it as a club.

MARTIN doesn't know what to do, there is nowhere to run, so out of panic, swings the wood wildly, catching the Big Soldier on the tooth with a lucky blow, who steps back, shocked.

Pause. The Big Soldier touches his tooth, which is now chipped. Stares at MARTIN.

Sorry. Sorry, I'm, no, look I'm sorry, I'm really, really –

The Big Soldier charges, enraged. MARTIN somehow manages to parry the first few blows, but it is clear that he cannot win.

Suddenly the OLD SOLDIER steams on and barrels into the big man, knocking him to the ground, going with him, rolling together. The OLD SOLDIER uses the momentum to get on top of the Big Soldier and head butts him immediately before he has a chance to recover, keeps doing it, again and again and again, until the man is definitely unconscious.

Pause. The OLD SOLDIER breathes heavily. Looks around. Finds a rock. Smashes the Big Soldier's head with it until he's sure that he's dead. Gets off him. Looks at the rifle. Throws it away.

OLD SOLDIER: Useless.

Notices that MARTIN hasn't moved. He is staring at the corpse.

Told you not to fucking stray. Come on.

He goes. MARTIN is still rooted to the spot, wants to speak, seems to want to tell someone about what has just happened, but there is no-one there apart from the dead man. He runs off after his friend.

* * *

Massive shelling. Smoke.

COLM runs on. He is shouting at the bombs, but the shelling is too loud for a word to be heard. Shells go off around him, earth and smoke filling the air. He shouts, the shells, the craters and the sky.

BARBARA enters, head down, trying to keep out of harm's way. She is calling his name but he doesn't notice her.

BARBARA: Bob! Bob!

But he cannot hear.

COLM: Do you want me to live? Is there such a thing as mercy? Then give me a sign! Give me a sign!

She runs forward to him, desperate, ducking down.

Suddenly the shelling stops.

At exactly the same time that COLM sees her. She sees him. Silence. He looks around, sees that it is calm. She does too.

Pause. COLM looks down at the bag. Opens it. Takes out the cat. It is alive. Stares at BARBARA. Goes to say something but instead suddenly walks away. She moves as if to call, but…

COLM: Ow!

He comes back, without the cat.

He scratched me.

BARBARA: The shelling's stopped. Bob?

COLM: That's not my name. I have another name. A darker name, a name of brutality, stupid, pointless brutality, but my name, I revelled in my name, loved it, why? Why did I love such a name?

BARBARA: The cat. Did you see the cat –

COLM: Colm, yes, yes, yes, yes, Colm. That was it. That was my name.

Pause.

BARBARA: What?

COLM: Colm. My name was Colm.

Beat.

So quiet. It's suddenly so… fucking quiet.

BARBARA: Your… your name is…

He looks up at her.

COLM: You have his eyes. Who? His. Who's? Who's eyes? His eyes, you have his eyes. I knew a man once, Ken, you have his eyes, you have Ken's eyes.

She is stunned, can't hardly speak, can hardly stand.

I used to believe that the universe was cruel, that gods made things this way so that cruelty was the only way of existence. But now I see the truth. That they watch us and what we make and what we do with our lives to each other and they weep. They watch us and weep.

BARBARA: You're him?

Pause.

COLM: Have you seen a cat? I've lost my cat.

Suddenly he gets up, looks around.

Where is that cat?

Goes after the cat.

BARBARA has not been able to move. Stands there like she's made of straw and might collapse. Suddenly she's gripped with a fury. Looks around. Moves. Stops. Fury. Looks around, sees something sharp on the ground, a broken knife. Picks it up, heads after COLM, consumed by blood. But the OLD SOLDIER enters. They both stop. Stare. Pause. She runs off the other way. He stares after her. Wondering.

MARTIN enters trying to keep up. OLD SOLDIER sees him.

OLD SOLDIER: The ridge has collapsed. Richard's men have over-run the centre, they're everywhere. All gone, all lost. We have to go.

MARTIN: What? We lost the ridge, then?

OLD SOLDIER: We've lost everything.

MARTIN: And Catherine?

OLD SOLDIER: Forget Catherine, boy, she's lost they're all lost. Time to get out. You and me. Head somewhere, stay low, survive quiet, off the land. Years if need be, wait this out. Live.

MARTIN: Jesus Christ. That's what I've been fucking saying! Thank god.

OLD SOLDIER: *(Gives him a knife.)* Take this. Stay close. They're all around.

MARTIN: Right. I'm really not very good with –

OLD SOLDIER: Follow me. Stay close.

Begins to go, MARTIN following. Stops. Puts his hands in the air, moves back. MARTIN looks, almost lets out a cry. RICHARD's troops enter, guns raised. Beat. MARTIN panics, thinks, looks at his uniform. Grabs OLD SOLDIER from behind and puts the knife to his throat.

MARTIN: I'm… I'm with you, look, look at the uniform, I'm with you, I'm with, got this one. This one's… filthy –

OLD SOLDIER: Boy, don't –

He slits the OLD SOLDIER's throat. The OLD SOLDIER collapses.

MARTIN: See? See? Filthy dog!

Spits on him. The OLD SOLDIER dies. The troops come over to him, guns still raised. They look at his uniform.

OFFICER: Come with us. Catherine's surrounded. Last stand. We need men like you.

They go. MARTIN, looks at the OLD SOLDIER. Might say something. Doesn't. Heads off after them. Back into the madness.

* * *

CATHERINE waits, anxious.

IAN bursts in with two bloodied officers.

IAN: It's gone, it's over, we've lost the ridge.

We've lost the ridge, they're coming down the ridge. The east is gone the west is collapsing, they've taken the ridge and they're coming to –

CATHERINE: Where's Jimmy?

Beat.

They told me he'd gone. But I don't think that's true because if that was true I might've heard my heart crack. And I don't think I have. I don't think I've heard it crack, Ian. Have you heard it crack?

Ian?

Pause. IAN goes to her.

IAN: Catherine he's gone.

She stares at him. Suddenly she pulls IAN's gun out of his holster. Points it at him, tries to fire, he cowers, but she cannot fire. Points it at an officer, tries to fire, he cowers, but she cannot fire. Puts it to her head, tries to fire, can't, puts it to her heart, tries to fire, but she cannot fire. She drops the gun. IAN goes to her, but she pushes him back, turns away, from them. They wait.

CATHERINE: …I told you not to love him.

She turns back, completely composed.

CATHERINE: Okay.

Okay. Good. There. That's fine.

IAN: Catherine we should run

CATHERINE: Yes, that's all… that's fine then, that's fine.

IAN: we should flee, we should –

CATHERINE: No.

Where to? There is nowhere. No, I am not… I am…

I am not…

Beat.

We shall wait. Put your arms down, everyone, put your weapons down. *(To an officer.)* Tell them to put their weapons down.

IAN: But –

CATHERINE: *(To the officer.)* You, go out there, tell them to put their weapons down.

He doesn't move.

Now!

He goes.

IAN: Catherine, Richard's going to be here any minute.

CATHERINE: Yes, and I am going to greet him like joint CEO.

IAN: What?

CATHERINE: Yes. We've had our differences, but now… I am going to convene a, a board meeting.

IAN: What?

CATHERINE: Yes. A board meeting, I think there will be enough of us, I am going to convene a board meeting, whereupon I shall immediately put forward the motion that Richard take full control of Argeloin.

We shall take up our previous offices. Everything will be fine.

IAN stares at her.

I have the board room table here. It is within.

IAN: Catherine…

CATHERINE: Trust me.

She sits to wait, indicating that the officer and IAN should do the same. The Officer sits, slowly. IAN sags.

IAN: I always have.

He sits. Waits. Silence. Noise outside. Shots fired close, the officer moves.

CATHERINE: Wait!

He does. The doors are kicked open. Troops enter, guns raised, followed by RICHARD and GAVIN, all a bloody mess. Pause. CATHERINE stands, regal.

Richard. I welcome you.

She holds out her arms to him. He stares at her, doesn't move. She still holds her arms out, but he doesn't move a muscle. Slowly she lowers them.

We… have had our differences, yes, but now I think it is time to put all this aside. I propose a board meeting.

Silence.

RICHARD: A… board meeting?

CATHERINE: Yes. Yes, Richard.

I have had the boardroom table brought here, inside. We can sit down. We can settle this. The boardroom table is here. It is within.

RICHARD: Within?

CATHERINE: Yes.

RICHARD: In there?

CATHERINE: Yes.

You're thinking that this has gone too far, that maybe we are beyond –

He goes straight to her, grabs her by the hair and drags her into the other room, kicking the door shut, behind him..

Silence. GAVIN indicates something to his troops and they take the officer out, leaving him alone with IAN. Stares at him. Looks down.

GAVIN: God help us all now.

IAN is about to reply when more troops burst in, bloodied, wild. BETH follows. She looks around. GAVIN goes to speak.

BETH: Where is he?

GAVIN: We thought you were dead, Jesus Christ, we thought you –

BETH: Jimmy. Where?

GAVIN: What?

She heads straight to IAN, pulls out a blade. GAVIN goes to stop her, but her troops point their weapons at him. He freezes. BETH watches him.

BETH: I have in this day been reborn with them we are in some such way and you are as nothing, we know what a life is lived in there bodies and we know what precious fragile of death awaits all who so there is dark, dark, a new, a new me, actually, but one thing, one thing remains.

She turns to IAN.

Where. Is. Jimmy.

IAN: I… I don't know.

She grabs him.

Why are you asking me? I don't understand why you are asking me, you know where he is, he's with you, he's always been with you.

Beat.

BETH: What?

IAN: He's your man, he's Richard's man.

BETH: Ri…

IAN: Yes, of course he's always been Richard's, from the beginning, from the very beginning.

BETH: What?

IAN: Ask Richard where he is.

BETH: What?

What?

Pause.

What, then?

She goes to speak again, but can't. Something hits her inside, but immediately passes. IAN watches. GAVIN watches.

RICHARD comes out of the room. CATHERINE does not. Sees BETH.

RICHARD: You're alive.

She lets go of IAN, points her gun at RICHARD's head.

Pause. He stares at her. At IAN. Back at her. Opens his arms.

And?

You cannot hurt me. I am beyond you now.

I am a god.

She shoots. He collapses. She goes to his body, looks. Sees he is dead. Turns to her men.

BETH: A tyrant death, gone, over, gone. Now is a new, now is our, now is a new time, our time. We shall remake the world in our image.

GAVIN: Beth?

BETH: Execute all prisoners. Distribute food to the people. Assess the people. Assess the people by value.

GAVIN: Beth?

BETH: Assess the people by usefulness and value. Cull the bottom twenty five percent.

GAVIN: Beth?

BETH: A new day is here. My day.

She leaves, followed by all except GAVIN, who stands there, alone. He looks at the door that RICHARD came out of. It is still open. He takes a step towards it. Stops, as if afraid of what's inside. Goes to it. Stops. Goes in.

* * *

CASTILE enters with JIMMY and troops. They search the debris.

JIMMY: Are you sure it was here?

CASTILE: Yes. They were here. This was her house. I thought they might come back, I thought…

We'd better go.

JIMMY: They might be alive. They might have survived, they –

CASTILE: We have to go. This whole place is crawling with…

We have to go.

Beat. JIMMY nods. CASTILE and the troops start to go. JIMMY lingers a moment, then leaves with them.

Third Act

A hillside, remote, secluded, bushes at the back a tree poking through, all under an overhang. Quiet.

COLM runs on, terrified, his eyes wild. He looks around for somewhere to hide. Sees the tree, runs over, grabs at the trunk trying to shinny up it, but his arm is still damaged.

BARBARA enters, a huge, heavy stick in her hands, a weapon. Sees COLM. He sees her, stops. They stare at each other, panting.

Suddenly she runs at him. He scrambles to put the tree between them before she reaches him, just managing to do it as the branch cracks down on the trunk snapping in two. BARBARA picks up the broken wood, a piece in each hand glares, at him. Beat.

He goes to speak but she suddenly goes for him, causing him to leap to the opposite side to dodge the blow. She goes for that side, but again he moves, keeping the tree between them. They circle the tree. Without warning she feigns one way, causing him to move back, and throws herself the other, coming so close to COLM that he has no choice but to bodily throw himself into the bushes, disappearing completely.

She stands, staring at the bushes. They are still. She begins to wade in but is immediately scratched back by the brambles. Frustrated and furious she throws one half of the stick into the bushes where COLM disappeared. Nothing happens. Thinks. Puts down her stick and gathers rocks from the ground. Returns to the bushes. Starting at one end she throws a rock in as hard as she can. Nothing. She moves along a little and pegs another in. Nothing. Moves alone, throws another. Nothing. Moves along, throws another. Nothing. Continues.

Moves, near the end now, pulls her arm back to throw the rock, when suddenly COLM scrambles out of the bushes on his hands and knees. She runs, gets her stick, explodes into rage, swinging it at him like a club. He stumbles, lands on the floor. She advances. He turns round to face her, just as she stands over him. She raises the stick above her head. He raises himself onto his elbows, but petrified, seems to make no attempt to shield himself from the blow.

She hovers there for a second, shifting her weight to get the maximum force into the stick. He doesn't move. All he can do is stare up at her.

She brings the stick down as hard as she can, but instead of hitting him she lets go of it and hurls it off into the distance.

Silence.

She walks away from him towards the tree, leans on it, panting. He lies back on the ground exhausted. She is crying, silent tears. Covers. He does nothing, looks up at the sky.

COLM: I think it's going to rain.

> *They stay like that for a long time. She gains control of herself.*

We could do with it. We could do with the rain.

The clouds are so close. I could touch them.

> *Reaches out his hand. Cannot touch the clouds. Pulls back disappointed. Sits up.*

BARBARA: Why were you following me?

COLM: I… didn't know where else to go. I've been following you these past few days. I didn't know where else to go. And then I ran out of food –

BARBARA: You'd better go. I mean it. I swear, you'd really better fucking go.

COLM: Yes, yes, of course, I'll go.

> *Beat. Doesn't move.*

There's sheep. On the mountainside. Alone. They're alone. No-one looking after them. Did you see?

> *Beat.*

I'd like to apologise.

> *She stares at him.*

I can't remember anything before this. I can remember, I think I can remember if I want to, but if I'm quite honest I think I might be slightly terrified to remember. I think I feel that loosening those memories will be like opening a cupboard and everything will fall out on me and crush me. So I hope you won't mind if I don't open that cupboard because I don't want to be crushed by who I've been and what I've… done.

But I think I'm better now.

BARBARA: Do you know what I look at when I see you? I see a waste of flesh. I see a waste of molecules. I see something that looks like a human being but walks around being so far less than human that it's impossible even to feel pity for you. These past few days? All I could think of these past few days was what it would feel like to stick a knife in you.

COLM: I'm... sorry.

Beat. She pulls out a knife. He watches, suddenly scared.

What are you going to do with that knife?

BARBARA: I'm gonna kill you.

COLM: Are you?

BARBARA: Yes.

COLM: Don't.

BARBARA: I am. I'm gonna fucking... scalp you. I'm going to cut your scalp off.

COLM: Don't. Please don't cut my scalp off.

BARBARA: You're nothing to me. You're filth. There's no-one here, miles from anywhere, I'm going to kill you, I'm going to kill you with this knife.

Goes to him grabs his hair, pulls his head back.

COLM: Don't, please don't kill me with that knife.

She puts the blade of the knife to his hairline.

Please, don't...

She is straining to make the cut.

BARBARA: I'm gonna do it, I'm gonna fucking...

Strains. Strains. Nothing. Beat.

Alright, I'll cut your finger off. Give me your hand.

COLM: No, please. Please don't cut my finger off, please...

He tries to withhold his hand.

BARBARA: give... me...

She pulls it out. Puts the knife to his little finger. Strains to do it. Strains. Strains.

Suddenly she lets him go and walks away. Pause. He gathers himself.
She turns on him.

What use are you? Tell me one thing that you are useful
for.

Silence.

COLM: I'm hungry. Are you –?

BARBARA: No. Because I've got food. I found food, my food,
it's my food.

COLM: I could hold things.

Beat.

BARBARA: What?

COLM: I could… hold things.

BARBARA: What things?

COLM: Yes, I could, I could hold things, if you were doing
something, if you need someone to hold something while
you fixed the other end or

BARBARA: I don't need anyone to hold things.

COLM: You might.

BARBARA: I don't

COLM: Or I could forage.

BARBARA: What for?

COLM: I could find things.

BARBARA: What things?

COLM: Rocks.

BARBARA: What the fuck would I need rocks for?

COLM: Or sticks, I could find.

BARBARA: I've got sticks, these sticks, all the sticks in these
bushes and on this tree they're all mine.

COLM: I'm good with contract law.

Beat.

No, that's not very, sorry, that's a stupid.

Mathematics. I've always you know had a razor sharp, in
that department, you see I'm of a generation that had to

342

multiply and I've always thought that I had a very good sense of balance. I've always been secretly quite proud of my sense of balance.

You're going to build a shelter, aren't you. Here, under this tree.

Beat.

I could hold things. One always need someone to hold things.

BARBARA: Yes, I'm going to build a shelter. I do not need a grasp of contract law.

I do not need mathematics. I do not need your sense of balance and I do not need you to hold things.

I do not need you, I do not want you. Leave me alone.

Pause.

COLM: I'm sorry about before, really, I really am –

BARBARA: Before when?

COLM: Before… now, following, these past few days, I shouldn't've –

BARBARA: Not the last twenty years, then? Not about killing my family?

He suddenly doubles up, as if the memory had caused him physical pain. She watches.

Does that hurt? Does memory hurt? You are less than nothing to me.

Goes off in the direction from which they came. After a moment she returns with a backpack, ignores him. She begins to take stuff out. Looks up at him. Tries to ignore him. Can't.

What? Are you crying? Is that what you're doing, you're crying?

Little cry baby, crying?

Pause.

I cried. I cried a lot, but I was a child when I cried, not some desiccated old cunt. I was a child.

I could kill you now. Killing you would be like squeezing a spot.

She stares at him, but he is lost in his agony.

Stop crying.

Stop fucking crying!

She goes back to unpacking her stuff. He recovers. Watches her. Watches her in wonder.

COLM: You are the greatest thing I have done.

She looks up at him. Pause. He is on his knees. Holds his arms out wide.

I am so sorry, daughter.

Beat. She storms over to him, grabs his hair again, puts the blade to his hairline. He pulls back this time, sensing that this is different, but she has a good grip. Begins to cut. Blood starts to run down COLM's forehead.

Suddenly she lets go and he collapses. She goes back to her stuff. He touches his head, then looks at the blood on his hands.

Oh my god. I deserve so much more.

BARBARA: You'd better go.

COLM: Yes, yes, of course. I can't.

BARBARA: I'm building a camp, you'd just better go, you'd just better stay away.

COLM: Yes, yes, of course. I can't, though. I can't.

BARBARA: You'd better. You'd just really, really better.

* * *

BARBARA is working at the back, under the tree, alone. In front of her there is now what seems to be a make-shift shelter, branches, corrugated plastic, bits of wood and old door, along with the bushes at the back, now raised. The entire construction is about 15 foot wide and goes back about 10 foot, and has created a three foot tented crawl-space inside. From a key point in the centre a rope runs up to a strong looking branch in the tree above and then down to a tangle of bushes to the right, but the rope is slack and supports no weight.

COLM enters, his head now bandaged. He is dragging behind him a collection of branches loosely held together to form a kind of mat, seven or eight feet across, but the whole thing looks ridiculous, a mess, as if a storm had somehow blown a collection of sticks and leaves together so that they happened to lock into this shape. He stops. Puts it down. Looks at what she has made. Looks at what he has made.

COLM: I made this.

She looks at him. Beat. Goes back to her work. He doesn't know what to do.

It's a shelter.

I thought shelter but then it became more of a, well, mat, I think or, yes a mat and I thought, pursue the mat idea, proceed with, because if one had a waterproof, then that would be…

Pause. She goes back to her work.

I just picked these things up. I just picked them up and I fashioned them. I fashioned them into something useful. It was wonderful.

Beat. She has finished putting the branch in. She checks that the rope is secure. She goes to the other end of the rope.

Of course next to yours it's perhaps not quite so incredible, as my feelings first led me to believe.

Would you like to have this?

She stares at him, holding the rope.

I mean, the front of yours is open and there's not much space to –

And that's not a criticism, good lord no. But the truth is, Barbara, that when it rains, from a certain angle, I think the rain might, to some extent, come in.

Beat. She leans back and pulls hard on the rope, causing it to go taught and to begin to pull the centre of the shelter up. She heaves on it, hand over hand, lifting the roof of the shelter higher and higher, the walls coming up after as they were obviously designed to do. COLM watches as the space inside the shelter grows until it is tall enough to stand in. The entire thing looks waterproof and windproof and there is already a nest of pine leaves put together inside, creating a bed.

She ties the rope around the root of one of the bushes. Steps back to look at it. COLM is staring at it, mouth open. It is very impressive. He looks at her. At the shelter. At the rope. He looks at his mat. It looks like a bush that someone has dropped a shed on. He lets go of it without thinking.

BARBARA wipes her hands and goes inside.

I'm hungry.

BARBARA: There's plenty of food up here. If you want food, catch some food.

COLM: Have you caught anything?

BARBARA: I

I haven't got the traps right. The design, it needs…

Beat.

COLM: You're very good at all this. I mean that's just… amazing.

How did you know what to do?

BARBARA: I… I don't know, I

I just looked at what needed to be done and then I did it.

COLM: Can I look at it?

BARBARA: What?

COLM: Can I?

BARBARA: Get the fuck away from me.

COLM: Oh, no, no, I just thought that –

BARBARA: Step back, or I will… Step back there.

COLM: But –

BARBARA: Back!

He takes a step back.

More.

Another.

More.

Another. Pause.

Why should I care about anyone other than me, just give me one reason, one good reason.

COLM: One?

Thinks.

I can't.

I'm hungry.

BARBARA: Don't keep saying you're fucking hungry, I'm not here to feed you.

COLM: No, of course. I didn't mean that, that just came out, it was, it was

She goes back into her shelter.

I was up there on my own, making my mat and I just said it up there as well, I just said 'I'm hungry' just like that, 'I'm hungry' to no-one in particular, it just came out, I was completely alone.

You're right, there is a lot of food around. Getting hold of it seems to be quite tricky. It moves quite fast.

I fashioned a spear.

She looks at him.

Yes, I fashioned a, a spear, it was very difficult because I didn't have a knife, but I used a stone that I found that looked quite sharp, it wasn't sharp, not what we would call sharp, but I hacked at this piece of wood with this supposedly sharp stone until I had something that resembled a point. But in truth it looked like I'd chewed it into a point.

I threw it at a squirrel. Then I threw the stone at it.

BARBARA: Okay.

COLM: Pardon.

BARBARA: You can look at it.

Just don't touch anything.

Beat. He goes to the shelter. Begins to look at it, the roof, the walls, at how the branches interlock and at the leaves and pine branches that have been woven in for waterproofing.

COLM: Amazing. It's amazing.

BARBARA: It's not amazing.

COLM: And it's all supported on this rope?

BARBARA: Not all, but mostly –

COLM: Absolutely amazing. *(Beat.)* And you think that's strong enough?

BARBARA: What?

COLM: The bush where it's rooted. You think that's strong enough, do you.

BARBARA: Yeah, why?

COLM: You don't think it'll come out?

BARBARA: No, why would it –

COLM: Come loose? I mean in the rain, when the soil gets wet might it –

BARBARA: Right, out.

She ushers him out. She goes back in, starts work on the walls. He looks at his mat. Thinks.

COLM: What if I dig a hole? I mean I was looking at my mat and I thought if I dug a hole and put it on top, wouldn't that create some shelter?

BARBARA: A hole? In the mud? A hole in the mud with some sticks over it?

COLM: Well, it would be something…

BARBARA: And you'd be sitting in it, would you?

COLM: I could line it with leaves. It would be like a nest, or a set, or

BARBARA: A set?

COLM: I think it could be quite – yes, a set, don't badgers live in sets? – yes, I think it could be quite snug. I could dig it here in the mud and –

She glares at him. He moves ten feet further away.

I mean here. And when you think about it why should shelter always be above the earth? I could line it with leaves.

BARBARA: It wouldn't work. For two reasons.

Water. It would fill with water when it rains. It would be a big puddle. You'd be living in a big puddle.

COLM: And what's the other reason?

BARBARA: The other reason is that if you dig a hole there or anywhere near there I'll come over in the middle of the night with a big fucking rock and smash your brains in.

Beat. She goes back to her work. He looks up at the sky. Sits. Continues to stare upwards as she works on.

COLM: I can't help feeling that being here is beautiful. I'm hungry.

Beat. She goes deep into the shelter. She comes back out with a spear in her hand and immediately marches over to him. For a second he thinks she is going to stab him with it. For a second she seems to be considering this. But she thrusts it into the ground in front of him and walks back. He stares at it. At her. Pulls it out of the earth.

Thank you.

BARBARA: I've got plenty more.

COLM: Have you caught anything with them?

She says nothing, gets on with her work. He looks at his new spear.

It's a shame, isn't it. With all those sheep sitting out there.

BARBARA: Stay away from the sheep.

COLM: No, no I was just

BARBARA: Those fields are exposed they can be seen for miles, if anyone was watching, stay out of those fields. Stay the fuck away from those sheep or I will stick that spear in your eye.

COLM: Do you think there is anyone? To be watching, I mean?

She doesn't answer.

I'm hungry.

Beat. For a minute she seems to be considering hitting him. Instead she heads back into the shelter, to her pack. She comes back with a tin. Pulls back the lid. He tries not to look desperate. Pause.

I've thought of a reason. Why you should care. You said give me one reason why I should care about anyone other than myself, yourself and I've thought of one. I've thought of a reason.

For you, Barbara. Your kindness. So there'll be something of you left.

She stares at him, suddenly furious, but unable to move. She spits in the tin. Hands it to him. He takes it from her and looks inside. He can't help but feel slightly disgusted. She goes back into her shelter. He continues looking into the tin.

Is this…? It's custard.

BARBARA: Yes.

COLM: Right.

What should I… I mean, what should I… did you have something in mind that I should… I mean how should I eat it?

BARBARA: Well, what you should do is take your new spear, pop out there and hunt yourself down a nice treacle sponge.

She continues working. He looks back into his custard. Suddenly he drinks it all off in one go, greedy, desperate. Gone.

COLM: Thank you.

He sits with his tin and begins to use his finger to work the last bits out. If he could get his face in there to lick it, he would. She continues to work. The tin is clean. Pause. Suddenly he gets up and goes over to her. She stops, stares at him. He seems to be struggling with something.

I… I'd like to offer you a job, Barbara.

Beat.

BARBARA: What?

COLM: I could use someone like you, strong, bold, I mean you have so many qualities, my organisation could

BARBARA: A job?

COLM: Yes. When things are better, I mean, yes.

BARBARA: You're offering me a job?

COLM: You don't have a business background, but that is not the hurdle it once was. These days we understand that experience, knowledge, these things can be acquired, and are as nothing next to –

What you have, Barbara, is backbone, spirit, drive. Courage. Strength. Power. What you have, these things, these things are…

Beat. She is still staring at him.

I have seen in you such ability, such strength and I cannot pass that by.

Pause. Suddenly she laughs, genuinely amused. He smiles. Her laughter subsides.

BARBARA: Colm, I was wrong. The big hole idea is great. Go and dig a big fucking hole, sit in it, cover yourself up and wait for the rain. Please.

* * *

It is raining, pouring down.

COLM sits on the ground (though not in a hole) trying to use his mat for cover. It is less than useless. BARBARA sits in her shelter, bone dry. She has a blanket around her keeping her warm and she should be happy, but she cannot drive COLM out of her mind.

He realises the ground under him has become wet. He shuffles a little to his left, crouches back down. But this area is wet and very cold. Faffs for a minute, trying to stand or sit in a position where he isn't in cold/ wet, but it is not possible. Looks at the place where he was just sitting. Shuffles back there, sits. But it is now wet and cold.

BARBARA watches, fuming, his every move making her stand or sit in frustration at his stupidity. He stands there looking around him for somewhere dry to sit, his mat held above his head. There is nowhere, so he crouches, awkwardly, holding the mat on his shoulders. BARBARA cannot believe it. The idiocy of this position seems almost a personal affront to her. She throws the blanket off and sits facing away from him. But a moment later she is pacing, looking at him, absentmindedly covering herself with the blanket she discarded only a moment ago.

She stops, stares at him. Thinks. Goes to say something. Doesn't. Throws the blanket down again, furious. He's just fucking crouching there. Beat.

He moves one pace to the right. She can take no more. She leaves her shelter and heads straight for him. She has taken no more that a couple of paces when the bush that she tied the rope to is suddenly yanked out of the now wet ground into the air, roots and all, causing the shelter to collapse down in on itself.

She runs to it, trying to lift it up, COLM turning to notice. She pushes and pushes, but the now wet shelter seems too heavy. She goes to the end of the rope, unties the bush, lets it fall, then tries to heave the shelter up, but it seems to have fallen into a position where it is locked together. She goes to the front of the shelter again, tries to loosen it with brute force, but it is no good.

COLM is standing nearby, watching, the mat over his head.

She takes the rope back as far right as it will go to get maximum pull, heaves, but it hardly seems to move. COLM watches. Beat. He watches, she heaves.

Suddenly he runs to the centre of the shelter and pushes it with all his strength. She pulls, he pushes. More. More. The shelter shifts free from its locked position and begins to go up. More. More. One final huge effort and it is back to where it was. COLM supports the weight while she looks for somewhere to tie the rope off. She brings it round to the tree, checks to see that COLM has the weight then ties it to the lowest branch, wrapping it around several times for support.

She runs back into the shelter with COLM, taking the weight now with him. Tentatively they let go. It holds. She pushes and prods at it, pulling it to see how firm it is, but it seems fine. They stand there, breathing heavily, soaked. Beat. They are both in the shelter. They look at each other. COLM looks at his mat, then back at her. Beat. Slowly he sits, not taking his eyes off her. Beat. She sits as well, looking out into the rain. When he is sure that she is not going to do anything he too looks out, into the rain. They sit there, watching it rain.

<p style="text-align:center">* * *</p>

Morning. BARBARA is out front of the shelter, experimenting with a new trap. There is a large flat part with sharp wooden spikes attached, weighted with rocks, propped up with a thick twig at an angle. Underneath, a platform with a morsel of food. She moves back. Picks up a nearby stick. Slowly she pushes it into the trap. Immediately the

twig gives and spikes fall heavily on the stick. She stands. Looks down at the trap, confused, no idea at all what the problem is.

COLM comes on in triumph. He has his spear in his hands, on the end of the spear a dead squirrel. The look at each other, COLM beaming. Pause.

COLM: Squirrel!

BARBARA: Is that your squirrel?

COLM: Yes. I got it, yes, I got a squirrel.

BARBARA: Really?

COLM: Yes, look, we can eat it, we can eat squirrel! It's mine, it's… It's ours.

BARBARA: How did you get it?

COLM: I speared it.

BARBARA: You speared it?

COLM: Yes, Look. It's on my spear. I speared it.

Food at last, at last we can, Barbara, something other than, because the tins are running out, no, I know, I've seen, and you've worked so hard, so very hard and your traps are so elegant and perfect it makes absolutely no sense to me at all that they haven't caught anything, but we do need to get something, don't we. It's a beautiful squirrel.

Beat.

BARBARA: How do we eat it?

COLM: We cook it.

BARBARA: We can't have a fire, I keep saying, the smoke, the smoke will

COLM: We cook it at night.

Beat.

BARBARA: At night?

COLM: No-one can see smoke at night.

Soup.

BARBARA: Soup?

COLM: Or stew. It'll make it go further. We could make a soup/stew, I could get some water, we could fill the old cans with water and meat.

BARBARA: Meat

COLM: Squirrel meat and maybe there are some potatoes left and there are nettles up there, tons and tons of nettles it would be amazing, soup, stew, I think we should get two meals each out of this one squirrel.

BARBARA: I've got some salt.

COLM: You've got some salt!

BARBARA: Maybe there are some wild herbs

COLM: Oh my god: herbs!

BARBARA: It's small, isn't it.

COLM: Well it's a squirrel

BARBARA: Are they all that small?

COLM: Yes, they're squirrels I mean squirrels are small, but

BARBARA: But it's something.

COLM: It is. I mean if it was a rabbit, now a rabbit would be – I told you, I said it was worth it, the spear, your spear, I mean look.

BARBARA: You think cans?

COLM: Yes.

BARBARA: We could place them in the embers, they could cook in there.

COLM: Yes! Yes.

Beat. She almost smiles at him. Goes over to the squirrel.

I feel alive. Can I say that? I know it seems wrong, but I was up there, just waiting and hunting and whatever, but I just felt so… alive.

She pokes the squirrel. Looks up at him.

BARBARA: Did you kill this squirrel?

Pause.

COLM: It's a squirrel, yes.

BARBARA: Did you kill it?

COLM: It's dead, it's not…

BARBARA: Did you catch this?

COLM: I got it, yes, and

BARBARA: You got it or caught it?

COLM: caught it, I caught it, yes.

BARBARA: You caught this squirrel?

COLM: Yes, I got it, up there, I

BARBARA: Got it or caught it?

COLM: I got, caught, I got, it's dead. It's on my spear, I
 speared it.

BARBARA: Was it alive when you speared it?

> *No answer.*

> Colm?

COLM: Yes?

BARBARA: Was the squirrel alive when you speared it?

> *Beat.*

> It's cold.

COLM: Yes, well it's dead, it's…

She is staring at him. He cannot keep eye contact.

BARBARA: You fucking idiot. You found this, didn't you?

COLM: I speared it, I put my spear into

BARBARA: Was it alive when you speared it?

> *No answer.*

> Was it alive when you speared it? Was it alive when you –

> This is shit. You can't eat this.

COLM: No, no, look it's meat, it's good meat.

BARBARA: You found it, didn't you. You fucking… you found
 a dead squirrel lying on the ground, you stuck your spear
 into it and you brought back home like a puppy with a rat,
 didn't you. This isn't meat, okay? This is poison. This is
 death. This is lying around in your own shit for a couple of
 days?

COLM: It looks good.

BARBARA: What?

COLM: It looks… like a good…

Beat. Suddenly she snatches the spear from him. For a minute she looks like she might stick in his flesh, but instead she flings the squirrel into the bushes. He instinctively takes a step after it, but stops. She throws the spear down and goes back to her traps.

We need to eat.

BARBARA: Not dead things, you fucking… How stupid can one person be?

COLM: I wanted to bring you meat, I wanted us to have meat.

BARBARA: Stupid old bastard. You can't just find things and eat them.

COLM: Isn't that what foraging is?

BARBARA: No, it is not what foraging is.

COLM: Hunter gatherer, isn't that –

BARBARA: You could've killed us!

COLM: I felt so alive…

BARBARA: *(Mimicking.)* 'I felt so alive, I felt so alive' fuck your alive, with your dead squirrel stew.

Beat. She goes back to her trap. He watches.

COLM: The irony is we're surrounded by food. Nutrients in the soil.

All of that energy. Beaming out of the sun. If only we could use it.

BARBARA: Why don't you grow some leaves, then?

COLM stretches out his hand. Seems to be considering growing some leaves. Stops. Watches her. She is fiddling with the trap.

COLM: Sorry. I'm sorry Barbara.

Beat. She carries on. He comes over to her. Looks down.

They're not working are they. Your traps.

She doesn't answer.

I don't understand. I mean you've done such a great job.

BARBARA: Not that great if they know it's a trap.

COLM: Do you think they know?

BARBARA: How could they know, they're animals.

COLM: I mean some instinct.

BARBARA: I don't know. There's too much stuff, all this stuff scares them away, yes some instinct, definitely some instinct.

COLM: Because the mechanism is… Is it too light?

BARBARA: No, look.

She demonstrates. Again it works.

COLM: Perfect. It's perfect, it makes no sense. I mean people do trap.

BARBARA: Oh yeah, they do. People trap, trappers trap, but it's the knowledge.

COLM: Trappers have some knowledge that we don't?

BARBARA: You have to know, you need the knowledge.

COLM: We could dig a pit. Cover it with leaves.

BARBARA: I tried that. They just go round.

COLM: This trap is beautiful. It should work.

She notices something.

BARBARA: Have you changed your dressing?

He stares at her

Colm, have you changed your dressing?

COLM: I think so.

BARBARA: You have or you haven't?

COLM: I… think I did.

BARBARA: Today?

COLM: Today?

Yes. Yes, I'm sure I did.

BARBARA: You fucking haven't have you?

COLM: Today, you mean?

BARBARA: Jesus Christ. You have to clean it every day…

COLM: Right, right. Sorry, of course

BARBARA: Because otherwise out here, if you get infected

COLM: I won't do that, I won't get infected

BARBARA: If you get infected out here you can die.

COLM: Sorry.

BARBARA: Sit down.

> *He does as he's told. She goes in, returns with some water and a bag. Slowly undoes his dressing, the wound is angry and red.*

Fuck. Colm, you have to look after this

COLM: I know, I know, sorry.

BARBARA: I'm not looking after this for you.

COLM: I mean why should you? I prefer it when you do it. It's better when you do it.

> *She takes a deep breath. Opens the bag, takes out a small bottle of vodka, pours it on a clean rag, dabs at COLM's wound, causing him to wince. She dabs again at the wound, this time more gently.*

I can't help thinking about the sheep.

BARBARA: Forget the sheep.

COLM: No, I have. I've forgotten them. I've completely forgotten them, but I can't help thinking about them nearly constantly.

Up there. Eating grass. We can't eat the grass. I keep looking at the grass, this feeling in my stomach, this emptiness and of course I feel I'd like to eat it but I can't. But the sheep can.

BARBARA: Well, they're sheep.

COLM: Yes.

BARBARA: Forget the sheep.

COLM: I've forgotten them. But how can we eat the grass? I think I've figured out a way we can do it. Do you want to hear? do you want to hear how we can eat the grass?

> *She doesn't answer.*

We get a sheep to eat the grass and then we eat the sheep.

BARBARA: Are you delirious?

COLM: We need food.

BARBARA: It's too exposed.

COLM: Yes, but you see, I've had this idea. Do you want to hear the idea?

She finishes cleaning the wound. Beat. She takes out a needle, dips it in the vodka.

BARBARA: No.

She works on getting the grit out of the cut. He stays silent as long as he can.

COLM: We go up there at night. Unseen.

She says nothing.

We have a fire at night, smoke at night. No-one will see us at night. We go up there at night, we get ourselves a sheep and we eat it.

She has got the grit out.

BARBARA: There.

She puts the needle away, goes back to cleaning,

It's a good idea.

COLM: Is it?

BARBARA: Yes. I tried it.

I went up there at night. Night before last.

COLM: You didn't tell me.

She cleans.

And?

BARBARA: Are you eating sheep? Do you see a fucking sheep?

It's too dark. You can't see a thing. They're up there on the mountainside, you'd break your neck before you get up there.

Forget it. Forget the sheep.

She cleans. He is silent.

COLM: It was a nice idea, though, wasn't it?

BARBARA: Yes. It was.

Beat.

COLM: All that sheep.

Mutton. Lamb. Minted lamb. Lamb cutlets. Lamb chops.

Rack of lamb.

Lamb tikka masala

BARBARA: Do you mind?

COLM: Sorry.

Beat. She pulls out a clean rag to use as a bandage.

What did you do? For a living?

BARBARA: I don't want to talk about before.

COLM: No, no, of course.

Did you have a boyfriend?

BARBARA: I don't want to talk about –

COLM: In my mind I imagine you very good at school.

She puts the bandage around his neck and pulls. He is shocked, for a second choking.

BARBARA: I don't want to talk about my childhood with you. Okay?

He nods. She lets go. He sits there, trying to catch his breath. She lets him and then finishes dressing his wound.

COLM: I can't stop looking at the sky.

BARBARA: Right. When we make a fire tonight you make sure you clean these.

Suddenly it starts to snow. They look up.

What?

They hold their hands out.

COLM: Snow? It's not cold.

She rubs some in her hand.

BARBARA: Ash.

COLM: Ash? Falling out of the sky. Someone must be burning something. It's not from near here. What do you think they're burning?

They stand for a moment. They suddenly run into the shelter, away from the ash. They brush it off them, desperate to get it away from their bodies. They stare at each other. They watch the ash fall.

* * *

Night. They are sleeping, the fire having gone out.

COLM suddenly wakes with a start, sits up, stares around. He is muttering to himself, wild eyed. Seems to be seeing things, frightening things. He scrambles over to BARBARA. Sits there, rocking. Wakes her.

COLM: There's cats, cats, there's cats.

BARBARA: What? What's wrong, what's…?

COLM: Cats, look at these… there's, I mean everywhere, look, there's…

(Suddenly looking up.) Up there, look in the, look, they're in the tree, how did they get…? What are they doing?

Barbara is sitting up now.

BARBARA: Colm?

COLM: Yes?

He looks at her as if for the first time.

Are they here for the food?

Beat. She watches him. He points at nothing.

He's licking his lips. Why's he doing that? Why's he licking his lips?

He looks around, everywhere, the trees, the ground, the bushes.

(The one licking his lips.) Look at him? Look at his eyes. His eyes are so big. He's the leader, he's the one. What does he want?

She puts her hands on him, feels him shaking. Touches his forehead.

BARBARA: Jesus Christ, you're burning up.

COLM: Am I?

BARBARA: Yes. You're shaking.

COLM: That's the cats.

BARBARA: No, it's a fever, sit down.

He goes back to the fire and sits. She tries to restart it.

Jesus Christ, you fucking idiot, I told you to look after this.

COLM: Sorry Barbara

BARBARA: I said. I said look after this, for Christ's sake, you're such a child!

She has started the fire.

How do you feel?

COLM: Freezing.

She puts her blanket around him, then hers.

No, no, that's yours, that's

BARBARA: Shut up.

COLM: They're not real, are they. The cats.

BARBARA: Can you still see them?

COLM: Yes. I can see them. I can see their fur, their eyes, their paws, their tails. I can see their eyes.

She goes in to get something. COLM looks at the cat-leader.

He's smiling. He's smiling at me. He knows something. Oh god.

She goes to his bandage.

BARBARA: Look, I'm gonna take this off, okay?

He nods. She undoes his bandage. He winces. She pauses, then continues, carefully until it is off. She is not at all happy with what she sees. She begins to clean the cut.

All you had to do was look after this. Change it, clean it, look after it, that's all you had to do.

COLM: Thank you.

BARBARA: Shut up.

COLM: Okay. Thank you.

BARBARA: I said shut up.

COLM: Okay.

Thank you.

* * *

Later. BARBARA sits, tending COLM. He is half asleep, half awake, muttering to himself, shivering, delirious. His teeth are chattering. She has taken the bandage off his head, now cleaning the cut again. Leaves it open to get some air. Mops the sweat from within his clothes. Continues. Beat. She stands, looks up at the sky. In the east it is getting lighter. She goes to kick the fire out. Stops. Looks at COLM. Long pause. She leaves it burning and sits with COLM instead.

* * *

Morning. The fire is still going. COLM's head is in BARBARA's lap. She watches over him. He opens his eyes. Looks up at her.

COLM: I did such a terrible thing to you.

 Silence.

 We should, we should put the fire out.

BARBARA: It's okay, don't worry. Are the cats still there?

COLM: Yes.

BARBARA: You just have to rest. You just have to rest for a while.

COLM: I did such a terrible thing to you, Barbara. I did it for no reason.

BARBARA: Don't talk.

COLM: I had a son once. He was my son. I was terrible to him.

BARBARA: Don't talk, Colm.

COLM: But I was so terrible to you. I want to ask your forgiveness, but I don't want you to forgive me.

BARBARA: Just rest.

COLM: I don't deserve forgiveness. Your forgiveness would break my heart.

BARBARA: Colm – just rest.

COLM: Okay. Yes, of course. Okay, I'm going to just rest, then.

 He closes his eyes. Silence. She dabs at his cut. It seems cleaner, less angry. She changes the part of the cloth she is using, trying to find

a clean part, but no part that she finds satisfies her. Finds a bit. Examines it. Isn't happy. Very carefully she gets out from under COLM, not wanting to disturb him, gently placing his head on the ground. Goes over to her pack. Roots around.

Barbara? The cats have gone.

BARBARA: Well, that's good then, isn't it.

It takes a while for her to find a cloth that she is happy with. Tears it into a couple of strips. Goes back to COLM, picks up the alcohol, seeing that there is only a little left. Looks down at him.

Colm?

No answer.

Colm?

No answer. She kneels, touches him. Snatches her hand back. Beat. Feels for a pulse on his wrist. None. Feels for a pulse at his neck. None. She puts her head to his chest, listens. Nothing. Stands. Silence.

Oh.

Right.

She is staring at him. Absentmindedly she puts the fire out. Stares at COLM. COLM does not move.

* * *

BARBARA sits, staring at COLM. He now has a blanket over him, head and all. She has the alcohol in her hand. Goes to put it away. Stops. Drinks it off, wincing at the taste. The bottle is empty, she drops it. She gets up, looks at the sky. Looks at COLM. Goes back into the shelter, continues to look at COLM.

* * *

Later. Night.

COLM still, the blanket over his head, BARBARA preparing some food. She opens the can, pulls out two plates, automatically scoops food out onto one, then goes to put food on the other. Stops. Realises there is no point. Her hand hovers there, indecisive. For a long time. She seems to be fighting something. She puts food on the other plate too, then puts the food away. She eats her food. Gone in an instant. Looks at the other plate. Looks at COLM. She wolfs his food down too.

* * *

Morning.

BARBARA stands, looking down at COLM. She looks around. She goes to his head, bends down and grabs him under the arms. She adjusts her weight and begins to drag him away from the camp.

> *Drags.*

> *Drags.*

> *Drags.*

Suddenly COLM sits up with a start, bolt upright, scaring Barbara almost to death, so that she scramble/falls so away and begins to run as fast as she away, having to stop herself. She stands there panting, heart pounding, staring at him. He is looking up at the sky in wonder. Long silence.

COLM: Is this the afterlife?

* * *

BARBARA is working on a snare made from string. It is pegged to the ground. COLM enters. His arms are full of rocks. A moment.

COLM: Shells.

> These are shells.

BARBARA: Those rocks?

COLM: Yes.

BARBARA: Those rocks are shells?

COLM: I was up on the hillside, right up the top there, I wanted to get closer to those clouds. Right up on the top.

> And It was scree. But not scree, I don't even know if scree's the right word, in fact I don't even know what scree is, but it seems like the right word doesn't it, it seems to fit so yes, scree, so I'm sitting up there on this scree, stones strewn around.

> And in my hand is this stone. This lovely, rounded rock, about the size of a fist and suddenly I thought 'flint'.

> And I remembered my spear and how useless it was and I thought people used to make flints and they used flints to cut things, people not dissimilar to you and me, in fact

365

people just like you and me, and I looked at this stone in my hand, this rock, and I smashed it down on this boulder as hard as I could.

I cracked it down. And broke it in two.

Pause.

BARBARA: And did it make a flint?

COLM: No. Flint is a type of rock, this wasn't flint. A flint needs to be made of flint. It was useless.

But when I looked at the rock I saw this shell inside.

Beat.

BARBARA: Inside the

COLM: Inside the rock, yes. I saw this fossilised shell inside the rock, the shell of a sea creature. Inside the rock. Look.

He shows her.

See?

BARBARA: Oh, yeah.

COLM: You see?

BARBARA: Yeah, I see.

Wow.

Beat.

COLM: There are hundreds of them. Thousands, hundreds of thousand, probably, lying on the ground, you can just pick them up.

I began to realise that this tip, this piece of rock being pushed up through the hillside had once been the bottom of an ocean.

And I was struck still by time.

I was struck still by time.

And I suddenly saw my infinitesimal place in it and it was… Infinitesimal

And I felt such a peace, such a weightlessness, that I had never known since I was a boy.

Pause.

BARBARA: And… and the rocks?

COLM: They're all shells, Barbara. I realised the hill was strewn with ancient shells and I gathered as many as I could and I brought them here.

BARBARA: Right. Why?

COLM: Why?

BARBARA: Why did you gather them?

Beat.

COLM: They're shells.

BARBARA: Yes. But what do you need them for?

He is staring at her. Looks at the rocks. Looks back at her.

COLM: I don't. I don't need them for anything.

Beat. He drops them. Looks up at her. Smiles, broad and clear.

BARBARA: How do you feel?

COLM: I feel absolutely fine.

She touches his forehead, then his cheek.

BARBARA: It's completely gone.

COLM: What are you making?

Beat.

BARBARA: A snare.

He comes over.

The animal goes in here and –

You have to make sure there's only one way in, but that's easy. Then you peg this end down, they go in here

COLM: Right

BARBARA: and it closes

She demonstrates.

around it's neck. They struggle to get free, but it just makes it worse and… they die.

COLM: And we eat them.

BARBARA: And we eat them. I tested it.

And it works.

COLM: Really? That's fantastic.

BARBARA: I know.

COLM: Oh, Barbara, that's fantastic. So you caught an animal?

BARBARA: No. I've only got string, cloth. It bites its way through. We need wire.

COLM: Do we have wire?

BARBARA: No.

Sorry.

COLM: Oh no, no, I mean… It's not your… I just thought we might have…

He sits, deflated.

We haven't got any food now, have we?

She doesn't answer, sits with him.

I think we need some food. I think we really need some food.

BARBARA: I'm sorry I thought you were dead.

COLM: Maybe I was dead.

BARBARA: You can't be dead for that long.

COLM: I should've looked after my cut.

BARBARA: Yes. You fucking idiot.

He smiles. Her too, almost. A silence between them.

COLM: I had this idea. And I think it might not work, but it might, so I'm going to tell you anyway.

BARBARA: Okay.

COLM: Tonight is the full moon.

BARBARA: Right.

COLM: I mean if these clouds clear. I think these clouds might clear.

There might be enough light. We could get a sheep.

Beat.

What do you think?

BARBARA: I think…

You think these clouds might clear?

COLM: I think they might.

BARBARA: I think… then I think…

I think if there's no clouds…

Then I think…

* * *

They sit, looking up at the sky, waiting. Waiting.

* * *

Morning.

COLM and BARBARA sit eating cooked meat. They are silent, fully focused on what they are doing, not wolfing the food, but not messing around either. This goes on for some time.

BARBARA indicates a can of water, by COLM. He passes it to her, no words needed. She drinks half of it. Offers it to COLM. He shakes his head, then changes his mind, indicating that he would like some. She hands him the can. He drinks half of what remains, then remembers her, offers it back. She considers but then shakes her head. He smiles his thanks to her and drinks the rest off. They both return to their meat.

They eat. Quiet, focused. COLM finishes, all that is left is bone, all meat sucked and winkled from it. He looks at it. Gives it a bit of a gnaw, but that doesn't really work. He places it down on the blanket in front of him for consideration later. She notices that he has finished.

BARBARA: Do you want some more?

COLM: Is there more?

BARBARA: Yeah, there's loads,

COLM: Don't we need it for

BARBARA: There's loads

COLM: later, or

BARBARA: There's loads for later, get some more.

Beat.

COLM: I might have a little more.

He goes back inside the shelter, returns with some warm meat.

Would you like some more?

Shakes her head, not looking up from her eating.

I might have a little more, just this little bit. I don't want to be greedy.

BARBARA: Fuck, eat, get full, fill up.

He looks at the meat in his hand. Puts a bit back. Sits back with her. They eat. Finish. They sit, satisfied. Exchange a look. Suddenly they are laughing. Subsides. They enjoy the silence and the feeling of being full.

COLM: How long do you think it'll last?

BARBARA: Raw? A couple of days?

COLM: We could cook it. It's a lot to cook. How long do you think? Cooked?

BARBARA: Week? Maybe? I mean out here?

COLM: What if we were to take it higher? Isn't it colder the higher you go?

BARBARA: Is there ice?

COLM: No.

BARBARA: Snow?

COLM: Snow, no.

BARBARA: Right. I don't think it'll make a difference then.

Pause.

COLM: You can preserve meat though, can't you?

BARBARA: Oh yeah, you can preserve meat. You can preserve meat with salt.

COLM: Do we have enough salt?

BARBARA: Nowhere near enough.

COLM: We won't be able to get another one until the next full moon.

Beat.

BARBARA: Look, we'll put it into the coldest part of the shelter, we'll cook most of it and it'll last as long as it lasts.

COLM: We can put rocks round it. That'll keep the temperature down.

BARBARA: Good idea.

COLM: Yes. I can gather the rocks.

Long pause.

Can I tell you, I think that's the best sheep I've ever eaten?

BARBARA: You don't think it was a bit tough?

COLM: It was beautiful

He lies back on the grass.

BARBARA: It was.

She starts fiddling with the bones. Pause.

(Almost to herself.) Keep these for soup.

Long silence. She sort of sings under her breath.

COLM: It's probably wrong of me to say this, but I feel happier now than I've ever felt in my entire life.

Suddenly he sits up.

Wire!

BARBARA: What?

COLM: Wire! I got wire! While we were searching, I almost forgot

He pulls out some coiled up wire.

Wire.

They stare at it.

When we split up to search, there was a fence, I think it was an electric but with no electric anymore and I saw this wire and I thought wire. So I took it.

She takes it.

BARBARA: We can trap with this.

COLM: With your snares, you can make beautiful snares with this.

BARBARA: We can trap and eat.

COLM: We can eat animals

BARBARA: Yes. We can eat animals.

Pause.

Thank you.

COLM: You're welcome.

Beat. Suddenly they both jump up and look to the left, both completely silent and focused. Pause. They speak in whispers.

Was that…?

BARBARA: Did you hear that?

COLM: Shhhh.

They listen. Silence. In the distance a voice. A second of indecision.

They leap into action, BARBARA heading to the ropes, lowering the shelter. COLM packs everything into it. The shelter goes back down to the size of the hedges and BARBARA pulls the rope down so it cannot be seen. COLM grabs the mat that he made and pulls it back with him, over the shelter, waiting for her to get in, then they cover the entrance with the mat (plus a few branches).

They are relatively hidden.

A Woman walks on with a prisoner, bound and gagged, a Man carrying a gun following. The prisoner is MARTIN, terrified. They walk slowly, bored and tired. They are almost gone, when the Man stops.

MAN: Can you smell meat?

WOMAN: Can we just do it now?

MAN: What?

WOMAN: Can we please just do it now, please?

Beat. The holds out his hand for the gun. But instead she hands him a length of rope.

New initiative. Save bullets.

He glares at her, but takes the rope. He gets a grip on the rope, puts it round MARTIN's neck, strangles him, putting all his strength into cutting off the air supply. MARTIN bucks, but the Man holds tight. While this happens the Woman steps back. Raises the gun.

MARTIN stops kicking. Man keeps the pressure on for some time then lets go. MARTIN falls, dead, the Man pants. Behind him the Woman the points the gun at his head. Catches his breath. Stops. Stands.

MAN: You know, I really can smell mea –

She shoots him in the head. He collapses. Beat. She frisks his body, takes what she needs. Sniffs the air. Sniffs again. Sniffs the dead Man. Sniffs her own armpit. Shrugs. Leaves the opposite way from which she came.

Silence. After a while the hedge moves. BARBARA and COLM come out. COLM goes immediately to the bodies, looking down, BARBARA looking to make sure that the Woman is gone. COLM suddenly recognises MARTIN. Shock. Goes to say something. Doesn't. Looks up at BARBARA, as she turns to him. They exchange a look. Beat.

They begin to drag the bodies off.

* * *

COLM sits in front of the shelter, which has been returned to full size. In front of him is a big pile of nettles and he is stripping the leaves from them with his bare hands, happy in his work. Also in front of him are the furs of ten or more small animals, along with a sheep's fleece.

He works. BARBARA comes in. She has a clutch of small animals with her, a couple of squirrels, a rodent, a rabbit. He sees her. Smiles. She holds up the animals.

COLM: Another rabbit.

BARBARA: He's a beauty.

COLM: *(Coming over inspecting.)* He's a beauty, look at that…

BARBARA: And I caught a couple of squirrels and I don't know what this is.

COLM: Is it a rat?

BARBARA: It's not a rat, no, but

COLM: A vole, maybe? Maybe it's a…

BARBARA: There's meat on it.

COLM: There is, there is. Lets call it a vole.

BARBARA: A vole then.

COLM: Look at that rabbit!

BARBARA: She's a beauty, isn't she?

COLM: She is a beauty!

BARBARA: Is there water?

COLM: *(Going to get up.)* Let me get you some.

BARBARA: No, no, don't worry. I'm up.

> *She goes into the shelter. COLM continues to inspect the catch. She comes back drinking a can of water. Looks at him.*

Nettles?

COLM: Yes.

BARBARA: You're not wearing gloves.

> *She goes over. Touches a nettle, immediately snatches her hand back, stung. He picks it up and strips the leaves off, demonstrating to her that he is not stung at all. Pause.*

COLM: I can't help seeing it as a positive sign.

I know I've probably just built up an immunity, but I can't help seeing it as a welcoming, or

Beat.

I know. I know, it's stupid and I don't really believe that, but as I've sat here, stripping these nettles I can't help feeling that I've become, a little bit, of late, animistic.

BARBARA: Animistic is it?

COLM: I've imbued everything around me with a kind of spirit, I know it's just my mind, my fancy, but it feels so real, that I find it hard not to believe in it. In fact I do believe it, knowing it can't possibly be true.

And I feel that these nettles are in fact absolving me. They are delivering absolution to me. But, try as I might, I cannot find one single, solitary reason on this earth why I should be absolved.

Pause. He carries on stripping the nettles. She comes over.

BARBARA: You've got the skins out.

COLM: I've been looking at ways to bind them.

BARBARA: Did it work?

COLM: They need to dry a little more, but I think we can sew and tie them together.

It's getting colder. Have you noticed?

She doesn't answer. He is cautious.

I've… been thinking about winter.

I thought maybe, if we were, you know, if by some chance, if by some chance we were still together then warmth would be…

Pause.

Sorry. I'm sorry, forget what I said, forget, that's not… I'm sorry.

He can't look at her. She watches.

BARBARA: Another two months before it gets really cold. At least another two fleeces. Factor that in.

He is stuck by what she has said. He turns to her, but she is walking back to the shelter returning the water can. He recovers.

COLM: I think… I think autumn will be good.

BARBARA: Yeah?

COLM: For gathering, yes. There's oak, so acorns, you know. I think you can eat acorns. In fact I remember reading about a society that lived almost exclusively on acorns, though that's not a good example as they died out, largely because they lived exclusively on acorns, but still I think they would be good to eat as a supplement. And I believe, I believe that these people made flour from the acorns.

BARBARA: Acorn flour?

COLM: Acorn flour, which is a great way to preserve and make it go further.

BARBARA: We could make acorn bread.

COLM: Yes, yes, some form of flat bread, I imagine.

BARBARA: I think there gonna be a lot of blackberries down there.

COLM: Oh, there are going to be tons of blackberries and fruits and nuts in general, I imagine. The trick will be to store.

I've always been frightened of winter. But I don't feel frightened of this one. This is the most frightening winter I've ever faced.

She sits. Pause.

BARBARA: We went to Italy one winter. When I was about eight. Because my dad hated the cold, hated it, every winter he'd moan. So this one time he said 'no way' and we went to Italy, Milan, I think it was. The whole lot of us. For two whole months. Said he was going to war on winter, said this year we were going to win.

Beat.

It snowed and snowed and snowed. I mean it really fucking snowed, my dad was fuming, he was, I mean this was one of those places that never snowed, I mean maybe it wasn't Milan then because I think it snows there, but wherever it was it just kept snowing, and all the locals are out in the streets in wonder, because they've never seen, they're celebrating, because it never snowed and dad was… fuming, it was…

We just laughed. To see him sulking, you had to laugh.

We made a snow man. Dad called him 'Giovanni, il uomo neve'.

COLM: I remember he hated the cold.

Pause.

If I could do only one thing different, Barbara…

BARBARA: Well.

Let's leave that.

COLM: Yes. Yes, of course.

Silence. She lies back, enjoying the sun. The silence persists, but comfortable, COLM stripping nettles.

BARBARA: Sun. Sunshine.

He looks up.

COLM: Only ten per cent of all of the energy that a plant absorbs in its lifetime goes into the fabric of the plant. The fibres, the leaves the cells and sap. Only ten per cent. And when an animal eats the plant it's really eating that ten percent, it's eating ten percent of the sunshine the plant absorbed in its lifetime.

And only ten percent of all the plants that the animal eats, only ten percent of *that* energy goes into *its* body. Ten per cent. Isn't that amazing? And on and on, all the way up the food chain, whether it's a rabbit or vole, or caterpillar or bacteria or you and me, ten per cent, and no-one really knows why, but we only get to keep ten per cent. The rest of it...

Beat.

And we put so much store in that ten percent. The bits we keep. But what about the other ninety? We hardly notice the ninety. Day to day it dissipates in the most beautiful ways, incredible ways, but so concerned are we with the ten per cent, we just... hardly notice.

Life hardly noticed.

Beat. She lies back on the grass.

I'm confused by the amount of sense this makes.

I'm in love with the amount of sense this makes.

BARBARA: Are you going to talk all afternoon?

He thinks.

COLM: I might.

Is that alright?

Beat.

BARBARA: Yeah. Knock yourself out.

Beat.

COLM: The universe has been here for fifteen billion years. We've waited fifteen billion years for this moment. For this moment.

And now it's here.

He picks up a nettle to strip, but immediately drops it, stung. He looks at it, shocked, but BARBARA hasn't noticed. Beat. There is a faint crack in the distance. BARBARA sits up.

BARBARA: What was that?

Beat.

Was that...

a shot?

There is another crack. Beat. BARBARA slowly and gently slumps forward, until she is lying prone on the ground. She doesn't move.

Silence. COLM stares at her. He is frozen. He reaches out his hand. Hesitates. Touches her back. His hand comes back covered with blood. He stares at her.

COLM: What?

Beat. Soldiers enter, guns raised pointed at COLM. He stares at them. One comes forward. COLM shows him his hand.

This is blood. Is… is this blood?

The soldier raises his gun.

CASTILE: *(Off.)* STOP!

CASTILE runs on.

Stop! Stop, stop, it's him, it's him, it's him, this is –

Put your guns down, this is him, it's… Guns down, now!

Beat. They wait for the soldier closest to COLM. He seems to be considering shooting, but lowers his gun, nodding to the others. They do likewise. CASTILE turns to COLM. He is staring at BARBARA.

COLM: Oh dear. Oh no. Oh no, no, no, not that, that's…

That is… That is…

No, no, no, no, no, not that, that's…

CASTILE: Colm? Colm it's me, Castile.

COLM: What is this? This can't be right, this can't be

I mean this can't be right, or… I thought it was alright. I thought it was, I thought I'd, everything had, you know, I thought, I thought I'd, I thought I'd…

I thought everything was fine. This can't be right. Is this right? this can't be right, not now, please. Please. Come now, please.

CASTILE: Colm? Colm, sorry about the girl, it was… no-one meant –

COLM: Who are you?

What are you doing here, who are you, who invited you? You're not invited, none of you, what do you think you're doing? You're breaking it. Look at what you're doing!

Go! Go on go, all of you, get out of here, go!

CASTILE: Colm, it's me, I've found you, we've come to find you.

COLM: No, no, that's not right, this doesn't make any sense at all. Please, enough now, this is silly, go, please, you are not supposed to be here, you are not supposed to…

Tries to push them out. They don't move. CASTILE stops him.

CASTILE: I've been looking for you, we've been looking for you. We've come to take you back, your son, Colm, your son has changed everything, everything is –

JIMMY enters. He wears fatigues. Looks very different. All the soldiers stand back. It is obvious he is in charge.

You're son is here. He's in control. Richard is dead, Beth is dead, Gavin is dead, there are no more tyrants, this –

JIMMY: Father?

COLM stares at him as if he were a ghost.

COLM: My…? My son?

JIMMY kneels. COLM slowly moves over to him.

My son?

JIMMY: I've been searching for you, I've been looking for you.

I want you to come home. I just want you to come home, everything's different now, I've changed so much, everything that passed between us, that's over, I want that over, I want you to come home. You were right. I'm not like you. But just come home.

COLM: Home?

Can you bring her back?

JIMMY: What?

JIMMY stares at him. Looks at BARBARA. Stands.

No. No I can't.

For a second COLM looks like his heart might break, but suddenly realises something. Sags with relief.

COLM: She's sleeping.

No, no, yes. That's it.

Yes, that's it.

He is suddenly filled with relief.

379

Oh god, yes, that's it, she's sleeping.

The reprieve almost overwhelms him.

Oh good god, I thought… I thought the most terrible –

I had this dream. This awful terrible dream, a dream raped, I dreamt that I would regain myself, that I would live, that I would breath, that I would in fact come to an understanding of beauty so that this moment could be snatched away from me while I watched.

JIMMY: Father, forgive me, please, I want your forgiveness, I want –

COLM: Shhhhh! She's sleeping. Who are you? Do I know you?

JIMMY: It's me!

COLM: Me?

He is suddenly confused.

Are you… me? I thought I was me.

CASTILE: Please, Colm, listen –

COLM: Can you tell me something?

I want you to tell me something, can you tell me something?

I've just had this horrible dream and I have this feeling that there is something terrible, just down here, there, something terrible and I know there isn't and it's stupid and yes, yes, but I need you to look. I need you to look down there and tell me what you see.

Beat.

CASTILE: A body.

COLM stares at him. He suddenly notices the blood his hand. His eyes widen. He recoiled, as if trying to get away from his own hand. He wipes it frantically on the ground as if getting rid of the substance will get rid of the nightmare.

They watch, silent. He suddenly stops. Looks up at BARBARA. Sees her. Sees that she is dead, like discovery.

COLM: Please. Please, not that. Not that, no, no, no, not that, that's, please.

CASTILE steps forwards.

DON'T TOUCH ME!

Who are you? What are you doing here? Why are you breathing? Why are you breathing, when she isn't?

JIMMY: Who is she?

COLM: She is my daughter. My daughter is dead.

CASTILE: No, no, Colm, you –

COLM: Yes, she is! I know when someone is alive and when they are dead and she is dead.

They watch. He looks up at JIMMY.

Take this moment back. Please.

JIMMY: I can't.

COLM: Please. It's easy, just take it back? What? Not easy then? Oh. Sorry. So sorry, but please, please do this thing, please.

JIMMY: Father it's me! It's your son!

But COLM can only see BARBARA's corpse.

SOLDIER: He's broken.

CASTILE: Colm?

SOLDIER: What use is he to us?

CASTILE: He is a great man.

SOLDIER: Not any more.

ANOTHER SOLDIER: We should put him out of his misery.

COLM: Please.

SOLDIER: What are we going to do?

JIMMY: Take him with us. He's my father.

COLM: Please.

JIMMY: I love him.

COLM: Please.

He is staring at BARBARA.

Not this. Not this.

Please, darling.

Not this.

END

OUR TEACHER'S A TROLL

Our Teacher's a Troll was first performed at Mull Theatre, Druimfin, on 16 April 2009, before embarking on a Scottish tour with the following cast:

Angela Darcy

Jo Freer

Lewis Howden

Joyce Falconer

Owen Whitelaw

Marc Brew

John Kielty

Director, Joe Douglas

Designer, Kenny Miller

Lighting Designer, Lizzie Powell

Composer, David Paul Jones

Musical Director, John Kielty

Choreographer, Marc Brew

-

-

- Mrs Spike, the head-teacher, was found in the sandpit

- eating

- eating

- sand

- she was found in the sandpit eating sand and mooing like a cow.

- Nervous breakdown.

- She'd had a nervous breakdown brought about by the actions of two quite naughty children

- Sean

- and Holly

- the twins

- the terrible twins

- She'd just finished teaching class 2b about the Vikings when a little hand shot up at the back of the class

- Why?

- said Holly

- Mrs Spike turned around.

 Why? she said.

- Yes, why? said Holly, perhaps a glint of mischief in her eye?

- perhaps, I'm not sure

- perhaps a bit, yes

- Why did the Vikings invade? said Mrs Spike.

- Yes, said Holly – why?

- Well, because they wanted more land, said Mrs Spike, turning to the blackboard and imagining the matter was closed, but another hand had shot up at the back of the class

- Why?

- This was Sean.

- Why did they want more land? said Mrs Spike.

- Yes, why did they want more land, said Sean.

- Because they wanted to increase their wealth and grow more crops

- Why? Holly again.

- Because they wanted more food.

- Why? Sean.

- Because it's good to have more food.

- Why?

- Because they wanted to feed more people

- Why?

- Because their population was expanding

- Why?

- Because they were having more children

- Why?

- Because, because they were breeding more

- Why? This was little Tommy Anderson who – though not as smart as Sean and Holly – had begun to understand the game…

- Because they were healthier

- Why?

- Because they were eating better

- Why?

- Because…

 Because…

 Because…

> *Beat.*

- Two hours later Mrs Spike was found in the sandpit

- eating sand

- and mooing like a cow

- everyone said that she was highly strung and had been going through a difficult divorce and was – perhaps – becoming a little too fond of her sweet sherry after dinner

- but that didn't explain why she mumbled whywhywhy all the way to the insane asylum.

- Mrs Spike's replacement

- Mrs Spike's replacement

- Mrs Spike's replacement

 Was a Troll.

> *The Troll comes forward.*

- It's a Troll

- It's not a Troll

- It's a Troll

- It's not a Troll

\- It's a –

\- It's not a –

 Oh. It's a Troll.

\- It was indeed a Troll. A hush descended over the assembly as the Troll slovered forward. He had green scaly skin, short stubby horns protruding from a tuft of red hair, eyes like saucers of mud, dripping yellow teeth with sharp gnarly fangs and a spiky tail which – it has to be said – dragged behind it scratching the floor of the main hall enough to make poor Mr Plad, the caretaker, have nightmares for weeks.

\- It's a Troll

\- Mr McCreedy, the deputy head, a fierce old man with wisps of tobacco-ey hair sticking out of his ears introduced the new head teacher.

\- Now Children

\- said Mr McCreedy.

\- This is Mr Aaaaarrrrggghhh!

 The Troll roars.

\- Er, yes…

\- said Mr McCreedy, his voice wobbling slightly, which was strange for someone who had a reputation for ferocity

\- Mr *(Roars like a Troll.)* Sorry.

 Mr *(Roars like a Troll.)* is our new head teacher. Isn't that…nice.

 Isn't that nice, children?

 Children?

 Isn't that nice?

Isn't that Nice, children…?

- But it was quite obvious to the children that this might not at all be nice. If fact, it was quite obvious to everyone in the hall that this might in fact be very, very, very not-nice indeed, so poor Mr McCreedy was floundering in the most uncomfortable silence wondering what was going to happen next

- when suddenly the Troll solved the matter by letting out a roar so huge that the children in the two front rows had to hold onto each other to stop themselves being lifted bodily from the floor and Mr McCreedy's face, chest and neck were completely covered in Troll spittle

- *Troll roars.*

- Yes, it's nice

- nice, yes, nice, it's

- very nice

- that's very

- that's very, very

- very nice, the nicest thing that's ever

- Mr *(Roars like a Troll.)* would like to announce one or two changes

- Said Mr McCreedy, wiping the Troll goo from his eyes and trying to pretend that this was the most natural thing in the world

- and at that moment a small hand shot up at the front of the assembly

- Why? said little Tommy Anderson, who had enjoyed the joke with Mrs Spike so much that he thought it might be fun to repeat the experience

389

- Why? said Mr McCreedy, nervously eying the huge Troll that was standing to his right and sensing that this might be exactly the moment for questions

- Yes, Why?

- said little Tommy Anderson, a mischievous glint in his eye?

- perhaps?

- perhaps, but we shall never know

- because no sooner had he said 'Why?' that the Troll opened his mouth and a huge purple tongue, twenty foot long and covered in suckers whipped out of his mouth and curled around little Tommy Anderson's neck.

- Little Tommy Anderson just had time to squeeze out an expression of mild surprise before the Troll yanked him towards him at breakneck speed, took him in one huge claw and bit off his head.

 Beat.

- A hush descended on the hall

- the only sound the gentle crunching of a Troll chewing on quite a stupid boy's head.

- Any more questions?

- said Mr McCreedy

- as the Troll began to eat the rest of little Tommy Anderson, a thoughtful expression on his big sad face

- Then I shall read out Mr *(Roars like a Troll.)*'s changes.

- The Troll, having finished Tommy completely, let out a huge burp

- a burp that smelt like little Tommy Anderson's feet

- Tommy really did have very smelly feet

- Number one;

- said Mr McCreedy

- Children are never – repeat, never, never – to be naughty.

- It has to be said that every teacher in the hall smiled just a little at this, even Mrs Trelik, a desiccated music teacher who was at least a hundred and twenty-five and who didn't approve of people changing their facial expressions and so hadn't smiled since a particularly exciting evening on a park bench in 1963

- Sean caught the sound of her make-up cracking

- Number two;

- said Mr McCreedy

- Number two, all teachers are

- slight pause

- Mr McCreedy gave a little cough

- The new headmaster turned his head towards him…

- All teachers are never – repeat, never, ever, never and neverer – to be…

 naughty.

- Huge intake of breath all around the hall as all the teachers gasp

- Now see here, head teacher…

- said Mr McCreedy

- I really don't think that –

Troll spits.

- But the Troll spat out the undigested shoes of little Tommy Anderson

- the left one with the foot still in.

 Beat.

- I really don't think I've ever heard a better idea in all my life.

- And Mr McCreedy started clapping

- joined by the teachers

- even Mrs Trelik joined in, something she never usually did because – like all music teachers – she was without a sense of rhythm.

- The Troll held up one huge claw.

- Instant silence.

- Mr *(Roars like a Troll.)* indicated that Mr McCreedy should carry on

- And…

- said Mr McCreedy

- …number three…

- all children should be put to work on the ripping out of the playground and the construction of a new gold mine for them to work in, so that gold can be mined to make a statue of His Most High and Inviolable Self, Mr *(Roars like a Troll.)*, our new head teacher.

- There was absolute silence as everyone took this in

- It looked for a minute – just for a minute – that big-hair Kylie might cry

- She cried at everything

- When the Troll opened his mouth and prepared to roar…

- And suddenly the entire hall burst into applause

- realising that this was the only way to keep a Troll happy

- cheering and whooping

- calling out his name

- stamping their feet

- and fainting in the case of Mr Biyani, a thin and sensitive man with long golden locks.

- The Troll again raised his hands for silence

- Mr *(Roars like a Troll.)* would like to say a few words

 The Troll walks forward.

 Pause. The Troll speaks.

- Ak.

 Ak ak ak ak. Ak ak ak ak ak, ak ak ak ak, ak ak.

 Ak. Ak.

 Ak ak ak ak ak ak ak ak ak

 Roars.

 ak ak.

 Pause. Thunderous applause.

- And with this the new regime was installed.

 Pause.

- So the playground was torn up

- ripped to shreds

- and work commenced on the building of a goldmine

- and not a single child

- not even Sean and Holly

- dared to be naughty.

- We've got to do something about this

- said Holly as she sawed through some timber

- But what?

- said Sean, hacking a way at a rock with a child-sized pick-axe

- I don't know, but this is wrong. Children shouldn't be sawing timber.

- Children shouldn't be picking rocks.

- Children shouldn't be working in mines.

- Let's tell mum.

- Good idea. Let's tell our mum.

- And so they carried on working, hardly daring to be naughty at all

- though Sean did manage to put some worms in Jamie's sandwiches.

- Later that evening

- Sean and Holly spoke to their mother

- Mum…

- said Holly

- Yes?

- Said their mum

- Can we tell you something?

- You know you can tell me anything, Holly.

- Good. Our new headmaster is a Troll.

- Holly!

- What?

- You know it's naughty to call people names!

- But he is!

- Holly!

- No, but he is.

- He is what?

- He's a Troll!

- Now I'm going to get very angry if you call him names.

- I'm not calling him names. I'm just telling you hat he's a Troll.

- Right. Bed.

- What?

- Bed!

- But… Sean!

- said Holly, pleading for help

- Well…

- said Sean

- he is a Troll.

- You too?

- said their mum

- Well, I'm very shocked at you Sean, shocked and disappointed. Off you go to bed until you've learnt some manners.

- But he bit little Tommy Anderson's head off

- I'm sure Tommy deserved a good telling off then.

- He's got us digging for –

- Bed.

- He's called –

- Bed.

- But he's a –

- Bed!

- It was no good. Sean and Holly traipsed off to bed, thinking sadly of little Tommy's shoes.

- The next morning an assembly was called.

- Everyone sat, tired and dirty from building the mine.

- Mr McCreedy came in

- Followed by Mr *(Roars like a Troll.)*

- A fearful silence floated through the hall

- then the Troll stepped forward

> *The Troll roars.*

he said.

- And he handed a scroll to Mr McCreedy.

- Mr McCreedy unfurled the scroll and read the contents.

- It…

- He gulped.

- It appears there has been some…naughtiness.

- Everyone gasped.

- It appears that worms were placed in a little boy's sandwich.

- he said

- The eating of worms by children is illegal. Worms are a delicacy and are only to be eaten by head masters and people who have earned special privileges though actions of greatness and wonderment. So…as a punishment, from now on all the childerains shall only be allowed to eat brussel sprouts in peanut butter

- every single child's stomach turned into a knot

- while the teachers secretly smiled as many of them had thought this is what the children should have been living on for years, and in fact one or two of them actually gave a little bit of a snicker

- and

- said Mr McCreedy

- the teachers shall have chips and baked beans

- teachers smiled happily thinking of their two favourite foods

- But…

- said Mr McCreedy – and at this point he gulped again

- the beans shall be on top of the chips.

- huge gasp of horror from the teachers and once again Mr Biyani swooned to the floor

- Would Jamie please stand up.

- said Mr McCreedy

- and no sooner had Jamie got to his feet than the Troll's suckered tongue flicked out of his mouth, curled around

Jamie's neck and Jamie was devoured whole within the blink of an eye.

The Troll burps. Steps forward.

\- Ak. Ak ak ak. Ak ak.

Beat.

\- No one quite knew whether he had finished or not because – and this is a bit embarrassing – no one spoke Troll

\- not even the teachers

\- especially not the teachers

\- But they gave it a second and then the entire hall burst into applause and foot stamping and whooping.

\- Only Sean and Holly, who exchanged a worried look, seemed less than pleased at the turn of events.

\- Later, while hammering some wood together with hammers and nails especially designed for child-sized fingers, they got the chance to chat.

\- This is stupid

\- Said Holly

\- he's a Troll.

\- A very hungry Troll.

\- A very hungry Troll and a very angry Troll

\- We've got to do something.

\- But what?

\- We have to tell someone.

\- But you saw what happened when we told mum.

\- We can't let this go on.

- Poor old Jamie

- said Sean, who was feeling a little guilty at having put the worms into Jamie's sandwiches – though not too guilty as Jamie had once chased Sean around the playground with a stick that he claimed had been dipped in dog poo

- We'll have to tell the school inspector

- said Holly

- he lives on the way home, so we'll stop in there this evening.

- That's a great idea! said Sean, who had always had a great deal of faith in the competence of adults

- We've got to try, said Holly, a steely glint in her eye.

- Though that might have just been the sprouts giving her wind.

- and they said no more

- spending the rest of the day hammering bits of wood together for the mine

- Holly barely finding time for the tinniest bit of naughtiness

- slipping some mud into Mrs Trelik's high heeled shoes.

- Later that evening

- Holly and Sean had a quiet word with the school inspector.

- Children, children

- said the school inspector, laughing, happily

- the school inspector was one of those grown-ups who seemed to think that everything was a joke

- though it was never really clear if this was because he was incredibly happy or quite unbelievably stupid

- Our teacher is a Troll.

- Said Holly, not really wanting to mess around

- Is he!

- Said the school inspector, laughing away like she had just said the funniest thing in the world

- Yes, said Sean

- a little bit surprised at his reaction, as he failed to see what was funny about Trolls

- Yes. He is.

- The school inspector gave a huge blurt of laughter at this.

- He ate Jamie because I put worms in his sandwiches, said Sean, persevering

- and he's making us work in a gold mine, joined in Holly

- and he's making us eat sprouts and peanut butter

- and he's said that no one is allowed even the slightest hint of naughtiness ever

- not even the teachers.

- The school inspector suddenly stopped laughing and looked at them

- and though he was still smiling, they took this as a good sign.

- Children

- he said

- indicating that they should come closer

- which they did, eager to hear what he might have to say.

- He paused thoughtfully, looking off into the distance, and then smiled down at them.

- There are all sorts of people in this world. Some of them like us. Some of them…not so like us. And it's important to reach out and accept them, even if their ways are a little…strange.

- Yes, yes, we know that but he's not a person he's a Troll.

- Its important that we all get along

- He's a Troll!

- Said Holly, as directly as she could, beginning to suspect that the school inspector was much less incredibly happy and much more unbelievably stupid than she had up to this point imagined

- How would you like it if you were headmaster of a Troll school?

- He said, and – much to the children's annoyance – beginning to chuckle again

- We wouldn't like it because they'd eat us!

- You'd be looking for a bit of acceptance wouldn't you?

- chuckle, chuckle

- They'd bite our heads off before we spoke.

- So perhaps what we should do is show Mr *(Roars like a Troll.)* some tolerance.

- laughing away, as if tolerance was the funniest word

ever invented

\- But he ate little Tommy Anderson!

\- And spat out his shoes!

\- suddenly the school inspector stopped his chuckling

\- and looked and the twins with a sudden air of
 seriousness

\- Ate him and spat out his shoes, you say?

\- Yes.

\- Hmmmn

\- Said the School inspector.

\- Well…strictly speaking spitting isn't allowed, but…

> *Beat.*

\- I say we let him get on with it.

\- But –

\- Yes, his methods are a little unorthodox but the proof
 of the pudding is in the eating.

\- and he laughed and laughed and laughed and laughed

\- so much so that Sean and Holly knew that that

\- was that.

> *Beat.*

\- The next day an assembly was called.

\- Mr McCreedy stood at the front looking terrified.

\- The Troll handed him a scroll, which he unfurled.

\- Mud

\- said Mr McCreedy

- in the shoes is a privilege to be earned. The incredulously tremendatious sensation of mud on one's feet is only to be felt by head masters and those who have earned the greatness and the glory. Only head masters are allowed to have mud in their shoes

- at this point Sean looked at Mr *(Roars like a Troll.)*'s shoes, which indeed were overflowing with mud

- so henceforth shoes shall not be worn, except by teachers

- the teachers breathed a huge sigh of relief

- but the men must wear the women's shoes and the women must wear the men's

- a gulp of terror from the teachers, particularly the less secure ones

- Mrs Trelik…

- and within a few seconds the Troll was chewing on her dried out old head

- the rest of her he threw in the bin, because – to be honest – she wasn't very tasty

- and back the children went to the mines

- after huge applause for their new headmaster, of course.

- Later, Sean and Holly got a chance to talk.

- We've got to do something

- said Holly, as she prepared a charge of dynamite that had been especially manufactured for the use of children

- everyone's getting eaten.

- And brussell sprouts make me sick

- said Sean, twisting some tiny wires around a tiny detonator

- let's see a policeman.

- Do you think they'll listen?

- Holly paused, thinking, then said

- Yes. I think they will. Eating people *must* be illegal

- And forcing children to mine gold is surely against the law, said Sean

- We have to try something, said Holly, and I think this time it's going to work.

- And that was all they managed say as Sean had to push the plunger on the child-sized detonator and they both had to run for their lives before the dynamite exploded with a deafening roar

- Sean later on barely finding the time for the slightest bit of naughtiness

- putting a pinch of itching powder into Latisha's knickers.

- That evening they stopped at the police station and spoke to the sergeant

- who was polishing his buttons in preparation for the policeman's ball.

- A *what*?

- Said the sergeant?

- A Troll!

- Shouted Sean and Holly together, becoming more than just a little bit frustrated at the inability of grown ups to

grasp the simplest of concepts.

- A Troll?

- said the sergeant, looking at himself in the mirror

- Yes!

- said Holly

- and he's eaten little Tommy Anderson, Jamie and Mrs Trelik and he's got us building a gold mine

- That's not very good at all

- said the sergeant, putting on his hat and pouting into the mirror

- No, it's not

- said Sean

- so what are you going to do about it?

- Let me tell you this

- said the sergeant

- eating people is wrong. And making children work in gold mines is almost certainly against the law.

- That's what we thought!

- cried Holly

- However...technically speaking

- said the sergeant, selecting a truncheon to match his particularly elegant policeman's hat

- Trolls do not exist

- But –

- and therefore are outside of the scope of the law.

- Can't you arrest him?

- How can I arrest someone that doesn't exist?

- Said the sergeant, looking at Sean like he'd suggested sticking a sausage up his nose

- Besides, I don't have a jail cell with toilet facilities for mythical creatures.

- But he's eating people! Do something! He's actually eating real and actual people!

- which is something I quite definitely do not approve of, but I have to tell you that arresting this Troll is quite out of the question – the paperwork would be a nightmare and all my friends would laugh at me. Now; do you think the brass handcuffs with this hat, or the silver?

- And that

- was that.

- There was nothing they could do.

 Beat.

- Scratching

- said Mr McCreedy

- next morning in Assembly, reading form the scroll that Mr *(Roars like a Troll.)* had just handed him

- Mr McCreedy, it has to be said, was now a shadow of his former self

- and had taken to carrying around an umbrella permanently open in case the Troll decided to roar

- Scratching, the great and most Volatile sport of The Scratching of the Buttocks is not allowed to be played by children. Scratching must only be done in a safe and controlled environment by people who are fully and utterly qualified. Scratching and all actions connected

with scratching, ie, itching, scraping, atching and screeching are only allowed with written permission from His Most High and Inviolable Self, Mr *(Roars like a Troll.)*, and only to those with a certificate of Scratchiness

- and indeed Sean looked behind Mr McCreedy to see a framed certificate of Scratching on the headmaster's desk, with a picture of Mr *(Roars like a Troll.)* collecting the award, a big grin on his face

- and it occurred to Sean that this was the first time he had seen the Troll smile, which made him feel slightly sad.

- So…

- said Mr McCreedy as he stood awkwardly, wearing of course a pair of ladies shoes

- from now on everyone shall be forced to wear boxing gloves to prevent this most heinous of acts

- thunderous applause

- Latisha?

- Latisha stood up very slowly

- and a huge purple tongue flicked from the Trolls mouth, curled around her neck and she was gone in a flash, nothing but the sound of a Troll swallowing.

- The Troll stepped forward and spoke.

- Ak. Ak ak. Ak.

- Thunderous applause from everyone though secretly many of the teachers were beginning to worry about how they were going to smoke wearing boxing gloves.

- Later, in the depths of the mine, as Holly helped Sean climb into a mechanical digger that had been especially designed for the under eights, they exchanged a few words

- This is ridiculous

- said Holly

- children shouldn't be looking for gold in a mine

- Children shouldn't be having their heads bitten off for being just a little bit naughty

- just a little bit naughty

- echoed Holly

- But we've tried everything

- said Sean.

- Not quite everything.

- Well where else can we try?

- I think it's time to try…the Prime Minister of The United Kingdom of Engerland

- she said, saying it in a slightly wrong but wonderfully dramatic way.

- The Prime Minister

- said Sean.

- He'll help us

- And they said nothing for the rest of the day as they had so much digging and mining to do

- Holly pausing only to drop a slug into Kylie's hair.

- Later that evening Holly and Sean found themselves at No.10 Downing Street

- Where the Prime Minister was holding a press conference

- bulbs flashed and the Prime Minister's teeth sparkled as he announced some cuts in something or other and an increase in the general thing or something.

- Holly and Sean ran up to him

- the police trying to stop them

- but the Prime Minister – who knew that Prime Ministers looked good when they were talking to children – shouted…

- Let them through

- they are my people and I am their Prime Minister!

- thunderous applause

- Now, children

- said the Prime Minister

- How can I help you?

- Our head teacher is a Troll

- He's biting the heads of anyone who disagrees

- He's got us working down a goldmine

- And all the teachers are wearing the wrong shoes.

- Hmmmm. Yes. Well.

- Said the Prime Minister, a very thoughtful expression in his eyes as he gazed down at the young faces below

- a hundred reporters hanging on his every word.

- mistakes have been made.

 Beat.

- Sean and Holly looked at him

- Didn't you hear what we said?

- But the point is

- said the Prime Minister, beginning to pull out one of his favourite smiles for the cameras

- that we will learn from our mistakes.

- But we just said that he's eating children!

- We shall learn that there have been mistakes, that the mistakes were definitely mistakes, and we were mistaken to make those mistakes.

- But he's making us work in a mine!

- but what I'm hearing from the British people is that every one is very much mistaken if you make the mistake of thinking that no one can make a mistake or two. Therefore, make no mistake about it…

- the teachers can't smoke because they're wearing boxing gloves

- We will learn…

- He's eaten three children and a teacher!

- We will do better…

- He's got a big purple tongue with suckers! You've got to stop him! You've got to do something!

- We will win!

- And that

- was it.

 Pause.

- It was with heavy hearts that Sean and Holly made

their way home

- They sat on the bus for the longest time in absolute silence.

- It seemed as if it was impossible to get anyone to listen to them

- Not their mum

- nor the school inspector

- not the sergeant at the station

- nor even the government of the whole country seemed the least bit interested in their problems

- and they had begun to think that they were destined to spend their entire lives mining gold and waiting in dread for the feeling of those suckers and that long, purple tongue curling around their necks, knowing that a second later their heads would be in the mouth of a Troll, and then...

 Pause.

- This is terrible

- said Holly

- no one will listen to us.

- We've only been a little bit naughty, we didn't deserve this.

- Isn't there anyone else we can try

- said Sean, who made it a point to always try to see the brighter side of things.

- Who? said Holly.

- But Sean couldn't answer, because even he knew there was no one.

- I wonder why he's doing it?

- Why don't you ask him?

- said Holly, a little sarcastically, actually

- Because I can't speak Troll.

- Suddenly Holly stopped in her tracks.

- That's it!

- What?

- You can learn to speak Troll and ask him why!

- Sean stared at his sister, his eyes wide…

- Brilliant!

- And immediately they ran to the bookshop to find a copy of *Learn to Speak Troll in a Matter of Hours – A Beginner's Guide.*

- And that night, Sean

- who was gifted with languages and could already count to eight in French

- Un, deux, trios, quatuors, cinq, six, sept, huit.

- learnt how to speak Troll

- The next morning in assembly, everyone was very upset, because Mr McCreedy had just announced that due to a recent naughty event all the children were have their hair removed

- but it was the teachers who were most upset

- as they were to have their heads removed.

- Kylie had just stood up and the Troll had just curled his purple tongue around her neck when

- suddenly a voice rang out across the hall

- Ak!

- It was Sean, of course, who had become fluent in Troll in just one evening.

- Ak?

- said the Troll

- Ak ak ak

- said Sean.

- What did he say?

- Said Holly

- He said 'at last, someone who can speak the gloriousness'. I think he's been lonely.

- Ask him why he's been eating all these children's heads

- Ak ak ak ak ak ak ak ak ak ak ak.

- Ak ak ak ak ak ak ak ak ak ak ak ak ak ak ak ak ak ak ak ak.

- Said the Troll

- He said that he's a Troll and that's what Trolls do. In general Trolls are known for eating childrens' heads and making them work in appalling conditions.

- Ask him if he'll stop.

- Ak ak ak ak ak ak ak?

- Said Sean.

- Ak ak. Ak ak ak ak ak ak ak ak ak. Ak ak ak ak ak ak ak ak ak ak ak. Ak.

- He said no.

\- But tell him it's upsetting everyone.

\- Ak ak ak ak ak ak ak

\- said Sean.

\- Ak ak ak ak ak ak ak. said the Troll.

\- He said that he has to do it because the children have been in and of the naughtiness.

\- Well tell him that's because we're children and that's what we do.

\- Really?

\- said Sean.

\- Yes, said Holly

\- You want me to say that? To him?

\- Yes.

\- Okay. I'll give it a go

\- and Sean repeated what Holly had said

\- but in Troll, of course.

\- The Troll looked long and thoughtfully down at Sean

\- and then at Holly

\- and then he seemed to come to a decision.

\- Ak ak ak ak ak ak ak ak ak ak ak ak.

\- He says that he's very happy that a childercrunch hath bothered to speaketh of the glorious to him and indeed in his own language, but he is a Troll and not of the intention to not Troll, no sir, no how, not for anybody who speaketh of anything.
 I think that means he's going to continue

\- added Sean, helpfully.

- Hmmmmn

- Said Holly, lost in thought and scratching her chin, something that Sean knew meant that some plan was working inside her mind.

- He waited while Holly thought.

- He waited for what seemed like an age, particularly for a boy who was in the middle of a discourse with a Troll

- But he knew it was best to let his sister think when she had an idea brewing

- but finally he could wait no more

- Holly?

- he said, noticing that the Troll had begun to make a gentle but quite terrifying growling sound deep in the back of his throat.

- When suddenly Holly turned to Sean.

- What's the Troll for 'why'?

- She said

- For 'why'? said Sean

- Yes. What's the Troll for 'why'?

- Sean thought for a moment.

- I think its… ak.

- Right, said Holly, turning squarely to face the Troll and planting her hands firmly on her hips.
 Ak?

- she said in a loud and clear voice.

- Silence. You could have heard a worm sneeze.

- er… Holly?

- said Sean, who trusted his sister of course, but wasn't at all sure that this was the time for –

- Ak?

- Said the Troll, for the first time looking slightly confused.

- Yes, said Holly. Ak?

- Well…because I am a Troll and Trollerous I am

- said the Troll, but in Troll of course, with Sean translating.

- Ak?

- Holly again.

- Because….because I was a born a Troll. I am a Troll.

- Ak? said Holly again, not even pausing to think.

- Ak am I a Troll?

- said the Troll?

- Yes, ak? said Holly, as brave as any mountaineer or astronaut or knight in shining armour. Ak?

- I am a Troll because my body is Trollerfied, my tongue is Trollerous, I am not of the humankind.

- Ak? said Sean, suddenly at his sister's side, defiantly slipping his little hand into hers, though in reality he was much more scared than he looked.

- Because…because we are differings in kind and nature

- Ak? said Holly

- Because you are childertrons and I am Troll and Trolls shall eat of the childertrons' heads as you might eat of a pickled onion. And that is that and we'll have no more about it.

- Ak? said Sean

- Because, because, look I have just made of reply to –

- Ak?

- Rang out a voice, wobbling but clear, this time from behind the Troll, and when the Troll stepped aside, there to everyone's astonishment stood old Mr McCreedy, frightened but fierce once again and standing as tall as he could in his boxing gloves and his ladies shoes.

- Ak? said Mr McCreedy. Ak?

- Because...world was in such a way created!

- Ak?

- And this was big-hair Kylie now, if you can believe such a thing, suddenly brave for the first time in her life

- Because –

- Ak?

- Mr Plad, the caretaker, who had never forgiven the new head master for what he had done to the parquet flooring

- because

- Ak?

- Mr Biyani, as loud as he could

- because, because, because...

- But all of a sudden aks were ringing out from all over the hall, everywhere, from teachers and children alike, ak, ak, ak, ak, ak, ak, ak!

- The Troll stood trembling, staring wildly about him and

looked for a second like he might explode or collapse
or cry or even run away

- When suddenly he let out quite the loudest roar that
this planet has ever known.

 The loudest roar that this planet has ever known.

- And with that his huge purple tongue flicked out and
curled around Holly's neck, and within a second she
was in one of his great claws looking up into those huge
eyes.

- No sooner had Holly's feet left the floor than Sean leapt
to her defence with enormous courage

- enormous courage which was, I'm sad to say, useless, as
the Troll grabbed him up in his other huge claw.

- And there they were, the terrible twins, trapped in the
claws of a great big and quite furious Troll, awaiting
their fate, which could only possibly surely be a double
crunching

- Sean!

- said Holly, guilty that her brother was going to get
crunched because of her plan.

- It was worth a go

- said Sean, understanding his sister

- at least we tried. Goodbye.

- Bye

- and they clamped their eyes tight shut, waiting to lose
their heads.

 Pause.

- But no bite came.

- They opened their eyes.

- And to their surprise the Troll was looking down on them with what they thought was an expression of…

- No, they must be wrong

- They must be…

- that couldn't be…

- But they could've sworn

- And they would swear to it now

- that the Troll was looking down at them with

- an expression of…

- admiration.

 Beat.

And slowly he lowers them to the floor

- letting their feet gently touch the ground they thought they would never feel again.

- And slowly…he begins to think.

- And then

- then

- then he spoke to Sean in a very quiet voice

- and this is what he said.

- I am, indeed, a Troll. And as of a Troll, I am a Troll and the most Trollerous in nature. And it is in my most high and glorious nature to the bite the heads off the naughty childerains and to crunch and to crunch and to eat and to crinch, for this is what I was creationed to do. But I can see that you, a child and a childerainian as well, and the other ones, the childs the childers, the kids

and brats and beasts and the boodlums alike, have unto you a nature of your own, and – though not as glorious as mine – are in fact of a nature. And it is in your naturedness to commit acts of the naughtiness. You just can not help it. So. I have decided, in my wisdom of the infinatinity, to make a decree that if you shall maketh of the attempt to try not to be and therefore not to commit acts of the naughtiness, I shall try and therefore to make of the attempt to not be biting the heads off any more of the childerains with the crunching and the crinching and the eating no more. No more, I say!

- silence, then…

- Huge applause and cheering and stamping of feet

- and furthermore to this

- said the Troll

- let everysinglethingamy thing go back into the way it was

- Tumultuous applause

- except for the mine, because I do like gold

- but no one heard Sean because they were too busy dancing and clapping and embracing each other.

- And they threw out all the sprouts

- and the teachers had their beans and chips on separate sides of the plate

- and the children put their shoes back on

- and the teachers pulled off their boxing gloves and sparked up

- and they swapped their shoes back again, though this did lead to a fight between Miss Voluptu and Mr

Biyani, as he had become rather fond of her crushed velvet kitten heels.

- And, yes, they all lived happy ever after

- except, of course for the ones had had their heads eaten

- because, of course, they were dead.

- and in years to come, when people passed the school

- they would see a huge golden statue

- glinting and shining in the sun

- and that statue was of

- Holly

- and Sean

- The Twins.

- The Terrible Twins.

End.

OTHER DENNIS KELLY TITLES

WWW.OBERONBOOKS.COM

Follow us on www.twitter.com/@oberonbooks
& www.facebook.com/oberonbook